Artists Reclaim the Commons
New Works / New Territories / New Publics

Edited by Glenn Harper and Twylene Moyer

Sculpture magazine and ISC Press are programs of the International Sculpture
Center, a 501(c)3 nonprofit corporation.

isc Press

19 Fairgrounds Rd., Suite B
Hamilton, NJ 08619, USA
www.sculpture.org

Distributed by
University of Washington Press
PO Box 50096
Seattle, WA 98145-5096
www.washington.edu/uwpress

Artists Reclaim the Commons: New Works / New Territories / New Publics
edited by Glenn Harper and Twylene Moyer

ISBN 978-0-295-99339-3

Library of Congress Control Number: 2013937663

Design and production by Eileen Schramm visual communication.
Printed on acid-free paper.

FRONT COVER: Jene Highstein and Steven Holl, *Oblong Voidspace*, 2003–04.
Harvested ice, dimensions variable. From "The Snow Show," curated by
Lance Fung.

NATIONAL
ENDOWMENT
FOR THE ARTS

FSC
www.fsc.org

MIX
Paper from
responsible sources
FSC® C068100

Perspectives on Contemporary Sculpture: Volume 5

From the Publisher

In 2006, *Sculpture* magazine celebrated its 25th anniversary. To mark the occasion, the International Sculpture Center (ISC), the publisher of *Sculpture*, inaugurated ISC Press with *A Sculpture Reader: Contemporary Sculpture Since 1980* (a compendium of more than 40 articles that first appeared in *Sculpture*). That book has since grown into the "Perspectives on Contemporary Sculpture" series. These books, which provide essential documentation of developments in the field serve as tools for educators, students, and those interested in contemporary sculpture. Already required reading for many sculpture programs in universities and art schools around the world, the contents of these volumes provide a much-needed resource and are an important ISC educational program. In addition to *A Sculpture Reader*, the series features *Conversations on Sculpture* (interviews with contemporary artists), *Landscapes for Art: Contemporary Sculpture Parks* (an anthology of articles on sculpture parks and gardens around the world that focus on contemporary art), *The New Earthwork: Art, Action, Agency* (a collection of updated and new articles focused on art as a force of environmental and ecological/social innovation), and now *Artists Reclaim the Commons: New Works / New Territories / New Publics*.

The ISC, a member-supported, nonprofit organization, was founded in 1960 as a conference at the University of Kansas presenting new technologies to sculptors from across the U.S. Subsequent conferences expanded to encompass a wide range of aesthetic and professional interests and attracted attendees from around the world; today, the ISC's biennial conferences continue under the title International Sculpture Conference and alternate with smaller, subject-focused symposia. The ISC also supports sculpture and sculptors with a variety of other programs, including *Sculpture* and ISC Press, <www.sculpture.org>, the annual Lifetime Achievement in Contemporary Sculpture Award, the Outstanding Sculpture Educator Award, the Outstanding Student Achievement in Contemporary Sculpture Awards, and the Patron's Recognition Award.

On the occasion of the fifth book from ISC Press, *Artists Reclaim the Commons*, we want to thank *Sculpture* magazine's editor, Glenn Harper, and managing editor, Twylene Moyer, for their work on this and the other ISC Press publications. We also want to thank the ISC Board of Trustees, for their continued support of the organization's publication program, as well as the University of Washington Press (our distribution partner for the project). We also owe a debt of gratitude to the National Endowment for the Arts, for their generous support of this volume and the ISC.

—*Johannah Hutchison*
Executive Director, the International Sculpture Center

Table of Contents

Foreword

by Twylene Moyer

Artists Reclaim the Commons demonstrates how art can effectively impact life beyond the confines of the gallery or museum. In many ways, this book continues the direction taken in our previous publication, *The New Earthwork: Art, Action, Agency*; but in this case, we have widened the focus to examine art in the public arena, beyond percent for art. As important as such government-sponsored commissions have been for the growth of public art over the last half century, percent-for-art programs are not, and should not be, the sole support structure for artists working in the public realm. Intended to instill and preserve civic norms, in addition to adding an aesthetic veneer to buildings, plazas, and government facilities, these projects represent only the official face of a field with the potential to contribute to public dialogue and public life in myriad other ways. As inhabitants of a world facing ever greater homogenization, privatization, and surveillance, we also need a public art of experimentation, questioning, and even dissent, one that challenges the public realm as usual and offers the promise of imaginative, if not always literal, liberation. This book features a selection of just those kinds of projects, across a wide spectrum of models and definitions of public art.

Discussions of public space, whether physical or virtual, presuppose a zone open to all and belonging to none, a place of social, intellectual, and political exchange characterized by freedom of movement and expression. More often than not, however, what passes for the public realm today is, in fact, cleverly disguised private property. Like the traditional commons, these are spaces bounded by behavioral codes (unwritten, but tacitly understood and rigorously enforced), with public use (by the right people) tolerated within limits, as long as it conforms to acceptable standards and as long as it pleases the owners to allow it. In recent years, we have witnessed an updated, 21st-century version of enclosure, with rights of assembly increasingly restricted, public libraries and support structures closed, public lands repurposed, and digital access closely monitored. Mitt Romney's dismissal of 47% of the U.S. population is just the latest iteration of 18th-century social controls dividing "us and the poor who work for us."

The works gathered here, initiated by nonprofits, independent curators, and individual artists and groups around the world, endeavor to assert the rights of liberty and creativity against the privatization of public life. Some projects take an overt approach, occupying neighborhoods, back streets, and vacant lots, even attempting to re-make entire towns; some function more implicitly by opening alternative spaces of imagination that subvert ordinary interactions and assumptions; some use the past as a tool for understanding the present and future; and others attempt to redress specific social inequities and political injustices.

Regardless of strategy or duration, these projects demonstrate an expanded role for art in the public sphere, creating a genuinely open, cultural commons where everyone is welcome. By shaping new kinds of spaces and establishing new kinds of relationships (between individuals, between groups, and between people and their surroundings), they enable us to escape the world as received, shake off the familiar, try on different personas, and think through the minds of others. This is not the same as a utopian remaking of society: change can remain personal or it can spark from one individual to another. The goal is to destroy the collective delusion that the world we know—the world as presented to us through commercial, media, and economic interests—is the best of all possible worlds. By creating places where tensions converge in unexpected configurations, public art can help us see past the illusion. It may even offer solutions and improve lives, but ultimately, accountability lies beyond its scope. Public art is not going to relieve urban blight, eliminate violence, redistribute wealth, or curb the police state by itself, but it can insert doubt and defy rote expectations. It can inspire us all—viewers, direct participants, or casual passersby—to re-evaluate what we mean by quality of life, to reassess what we think we know, and to reconsider how we choose to live with ourselves and each other. In the world of art, critique, pleasure, and insight can come together to reimagine and forge new modes of public life.

Introduction: Beyond Percent for Art (2013)

by Barbara Goldstein

Born of civic pride and a commitment to public enlightenment, government-managed percent-for-art programs have engaged the work and thinking of artists in a range of American public places since the mid-20th century. Starting with landmark legislation in Hawaii and Philadelphia, the principle of setting aside a percentage of construction funds for public art gained significant momentum during the 1970s, with Seattle leading the way. Today more than 400 cities, states, and other government entities use the percent-for-art mechanism to fund art in public places. The result has been a bonanza of projects that channel artists' creativity toward infrastructure, community building, and ennobling the work of government—from freestanding artworks to site-integrated art, artist residencies in communities and government offices, and temporary, event-based projects.

While the artistic results of government funding have been diverse and often uplifting, the road to public support of the arts has been rocky, and the path is narrowing with the decline in public capital investment. Public art programs are often beset with limitations both technical and political, and, as the country's mood moves toward smaller government, support for public art has been waning. The reduction of funds for the National Endowment for the Arts and elimination of "enhancements" from the federal highway bill are only two examples of how political leaders are viewing public support of the arts. It's encouraging, then, to think about all the other ways that art in public places is supported outside of government and to examine how art arrives in the public realm.

Beyond the percent-for-art framework, there are many ways that publicly accessible spaces have been enriched by the work of artists. Without formal government support, art has been installed in streets and parks, abandoned buildings, and even in former prisons and military bases. Art arrives in public places through a dizzying array of mechanisms and can draw people to explore places they wouldn't normally visit, stimulating social interaction and enhancing urban, rural, and suburban landscapes.

The fact is that art happens, whether anyone funds it or not. Passionate artists with an interest in the public realm have always found ways to place their work there, understanding that the process itself is an essential element of the art. Others, by simply taking guerrilla action, deploy their art as political and social statement.

The act of creating public artworks may be a performance in itself, as in the case of process-heavy projects like Judy Baca's *The Great Wall of Los Angeles* or Christo and Jeanne-Claude's *Running Fence* and *The Gates*. These types of projects require the logistical skills of a general and the street-fighting instincts of a politician. *The Great Wall*, developed in the Tujunga Flood Control Channel over a five-year period, engaged more than 400 teens, in addition to historians, ethnologists, and community members, in the process of uncovering California's many ethnic stories from pre-history to the

Jon Rubin and Dawn Weleski, Conflict Kitchen's Kubideh Kitchen (Iran), 2010.

1950s. Baca then translated the collected stories into a half-mile of historical vignettes painted on the channel walls. Funding came from a variety of sources, including the Army Corps of Engineers, government agencies, and donations.

Christo and Jeanne-Claude's projects, whether the wrapping of the Reichstag in Berlin, *Running Fence* in Northern California, or *The Gates* in New York City, required pure political theater, years of patience, community building, private fundraising, and armies of volunteers. Their ephemeral works may survive only in documentation, but they have forever transformed public perception of the places where they were installed. The artworks exist in millions of photographs and in the memories of the hoards of people who experienced them.

The Waffle Shop, created as a community project by Carnegie Mellon University art students participating in Jon Rubin's Contextual Practice class, is a real restaurant, a community gathering place, and the studio for a reality television show. Launched in 2008, the Waffle Shop transformed an abandoned corner in East Liberty, a marginal Pittsburgh neighborhood, into a community hub that reaches residents and people beyond the neighborhood through its live streaming of a community-driven talk show. The project has grown to include a changing rooftop message board and Conflict Kitchen, a take-out window featuring foods from countries in conflict with the U.S. Conflict Kitchen cuisine is served in paper patterned to echo the cultural origins of the food and printed with facts about its country of origin. The exterior of the take-out window is repainted to reflect every change of menu and country. To date, the kitchen has served foods from Iraq, Afghanistan, and Venezuela, and Cuba is next on the docket. Food at Conflict Kitchen is served with a healthy dose of performance, discussion, and events.

While the Waffle Shop, *The Great Wall*, and Christo and Jeanne-Claude's projects actively engage community, other artists initiate projects that focus almost entirely on anonymous provocation. Guerrilla artists make their mark more cheaply and clandestinely. Usually installed in secret, these unauthorized quasi- and overtly political works creep into our cityscapes on subway walls, utility boxes, and billboards, often disappearing as quickly as they are created. Guerrilla artworks are unauthorized, ranging from the tags of semi-anonymous aerosol street artists to the elaborate creations

of more recognizable artists like Keith Haring, Robbie Conal, Banksy, and Shepherd Fairey. Projects like these require little or no money but some, like Conal's broadsheets, rely on teams of volunteers for their installation.

Curators, too, can initiate public art. Julie Courtney, a Philadelphia-based independent curator, has been programming unusual public spaces for many years. In 1990, with artist Todd Gilens, she initiated a commissioning program at the defunct Eastern State Penitentiary. The installations began when the penitentiary opened for historic tours. The building was, essentially, a stabilized ruin not slated for restoration. Courtney's first exhibition at Eastern State launched a tradition of juried projects, including "Prison Sentences: The Prison as Site/The Prison as Subject." Artists were invited to visit the prison before developing their proposals. The program has continued to be a success, and Courtney has gone on to curate projects in other non-traditional public sites, including Philadelphia's Main Line and, more recently, the Catskills. Like artists initiating their own projects, independent curators, such as Courtney and Lance Fung, raise funds from many sources in order to realize their projects.

A number of organizations have evolved to support artist-initiated projects. Some offer specific, location-based opportunities, like Socrates Sculpture Park in Long Island City, and others, like Forecast

Virgil Marti, *For Oscar Wilde*, 1995. Live sunflowers, ceramic plaque, silk lilies, handprinted wallpapers, cotton velveteen, and iron bed, cell: 106 x 96 x 216 in. From "Prison Sentences: The Prison as Site/The Prison as Subject," curated by Julie Courtney and Todd Gilens at Eastern State Penitentiary.

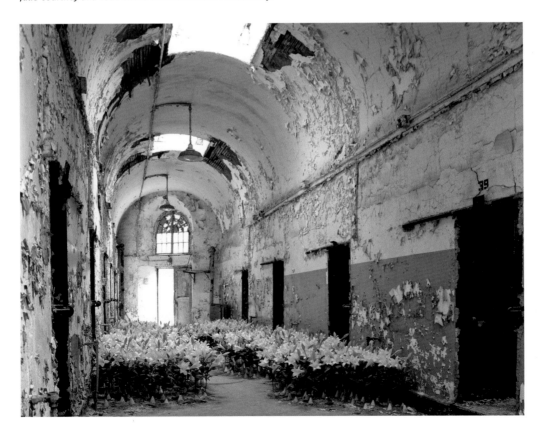

Public Art, provide technical assistance and grant support. Socrates began in 1986, under the leadership of Mark di Suvero, who helped catalyze community members to clean up an illegal waste dump and transform it into an art park. Over the last 25-plus years, the site, which features dramatic views of the Manhattan skyline, has become a park, educational facility, and place for artists to develop works in residence. Socrates supports and provides funding to emerging New York artists and sponsors a variety of other artist-initiated projects exploring a range of ideas and scales.

In 2012, Socrates launched "Civic Action," a collaborative project with the nearby Noguchi Museum aimed at addressing the serious threats facing their Queens neighborhood. A mix of large open spaces, waterfront access, industrial buildings, residences, and studios, this once undesirable area is falling prey to speculative development. In response to these incursions, the museum and sculpture park invited Natalie Jeremijenko, Mary Miss, Rirkrit Tiravanija, George Trakas, and their teams to create visionary alternatives to developer-driven expansion. Their initial designs debuted at the Noguchi Museum in the spring, and in the summer, Socrates hosted concrete proposals for building an accessible, sustainable urban environment. "Civic Action" included sculpture, site-specific installations, earthworks, and participatory, social activities for the entire community; residents could evaluate the artists' visions for a future neighborhood rich in public amenities, affordable housing, and jobs, as well as recreational and creative outlets.

Forecast Public Art in St. Paul, Minnesota, provides funding and logistical support for artists to develop community-based projects in locations of their choice. The grants are intended to help jump-start careers in public practice. Forecast has supported a broad range of multidisciplinary projects for more than 30 years. The organization also commissions new works for specific locations and occasions, such as its 30th anniversary. *F-30 Public Art Car*, by Black Bean Associates, was a human-powered vehicle cobbled together from a 1974 VW Beetle rear suspension and a 1979 VW Bus front end attached to

Natalie Jeremijenko, *UP2U — BIOCHAR MARKS THE SPOT*, 2012. Encendia Urban Blend biochar, existing soil, compost, and lawn seeds, 60 x 60 ft. From "Civic Action," a collaborative project by Socrates Sculpture Park and the Noguchi Museum, Queens, NY.

Cheryl Pope, *Shove*, 2011. Found anniversary plates, found china plates, drywall, wood, and compound, dimensions variable. From No Longer Empty's "This Side of Paradise."

bicycle frames and propelled by 10 people. The contraption was topped by umbrellas painted like clouds "raining" crystal raindrops.

Biennials and other festivals are also becoming a common testing ground for public art. The relatively new concept of the one-night festival, pioneered in Paris as Nuit Blanche, has been sweeping across the U.S. and Canada, with events like Santa Monica's Glow, which attracted 250,000 people in its first year, and Northern Spark in Minneapolis, which is sponsored by Northern Lights. The 2011 Northern Spark event featured indoor and outdoor visual arts, performance, films, and interactive media in Minneapolis and St. Paul. Organizers teamed with 60 partner organizations and sponsors to offer works by more than 200 artists at 34 venues. Glow, which is produced by the City of Santa Monica with privately raised funds, takes place on the beach and Santa Monica Pier. Works by both regional and international artists have ranged from Greenmeme's *The Migration of the Marine Tumbleweed* (2008) to Rafael Lozano-Hemmer's interactive *Sandbox* (2010). Other biennials, such as ZERO1 in San Jose, include public art as key components: In 2006, 2008, and 2010, ZERO1 used San Jose's City Hall as the canvas for a series of dynamic light-based artworks by Akira Hasegawa, Craig Walsh, and Rockwell Lab.

Another, place-based genre of public art has also been gathering momentum. Nonprofit organizations like FOR-SITE Foundation in San Francisco and No Longer Empty in New York have been commissioning artists to create site-specific installations in non-traditional and underused community settings. FOR-SITE, funded by individuals, grants, and foundations, includes an artist residency program in Nevada City, California, an education program for students interested in developing public projects, and an installation program. Following the success of "Presidio Habitats" (2010–11) at a national park

and former military base, FOR-SITE is celebrating the 75th anniversary of the Golden Gate Bridge by occupying Fort Point, a former fort at the base of the bridge. Installations have ranged from Allison Smith's *Fort Point Bunting* to Cornelia Parker's haunting, suspended bugle sculpture, *Reveille*, and Doug Hall's *Chrysopylae*, a high-definition film installation that shows container boats slowly moving beneath the bridge.

No Longer Empty's core mission is to broaden the audience for contemporary art by presenting site-specific installations and exhibitions in community settings, usually underused or vacated spaces. Its ambitious 2010 "Sixth Borough" exhibition at Governor's Island, a former National Guard base on an island in the East River beyond Manhattan, consisted of a series of installations that accompanied a summer festival. The show employed a group of curators who commissioned site-specific works in a variety of genres, including Pablo Helguera's *Uryonstel*, with historical re-enactments and books, and Adam Cvijanovic's site-integrated landscape painting, as well as room-scaled installations, projection works, and video projects—all exploring the island and reflecting on its 300-plus years of architecture, environment, and Native American and military use.

Many curatorial programs trace their roots and inspiration back to several long-established, private, nonprofit public art programs. These revered organizations, such as Creative Time and Public Art Fund in New York and the Association for Public Art (formerly the Fairmount Park Art Association) in Philadelphia have been enhancing cities and stimulating conversation for longer than most government-funded programs have been in existence, financing their commissions through private donations and grants. Creative Time, founded by Anita Contini in 1973, focuses on temporary works in multiple media, including performance, that explore the social and political realm. Its smart, provocative projects take place throughout New York. The Public Art Fund, begun by Doris Freedman in 1977, concentrates more on the temporary placement of visual art in public locations and partners with several permanent exhibition venues, including Metrotech Center and City Hall Plaza. It has also supported major installations such as Takashi Murakami's *Reverse Double Helix* at Rockefeller Center (2003) and Olafur Eliasson's *New York City Waterfalls* (2008).

The Association for Public Art, founded in 1872, has commissioned and installed hundreds of artworks throughout Philadelphia. Under the leadership of Penny Balkin Bach for over 30 years, APA aims to "commission, preserve, promote, and interpret public art in Philadelphia," and it has fulfilled those objectives through many strategies, most recently using bike tours, a smartphone application, and a robust public art maintenance program. The organization has commissioned permanent artworks in Fairmount Park and throughout Philadelphia, and, in September 2012, it produced a light event by Rafael Lozano-Hemmer.

This broad variety of independent artistic activities in the public realm has created richer, more provocative, and enticing environments that everyone can enjoy and discuss. At the same time, these activities do not replace the equally important role that artists can play in enhancing our civic buildings and infrastructure. As government services shrink, it is still worth reflecting on what artists have contributed and can continue to contribute to civic dialogue through their eyes, hearts, and hands. Our civic buildings, monuments, and gathering spaces would be impoverished without the work of artists. So, as we move beyond current political strife and economic challenges, we should see independent artistic contributions to the public realm as a challenge to our political leadership to continue employing artists to reflect our times, our history, and our values.

Public Art: The Point in Between (1992)

by Patricia C. Phillips

"To understand place requires that we have access to both an objective and subjective reality. From the decentered vantage point of the theoretical scientist, place becomes either location or a set of generic relations and thereby loses much of its significance for human action. From the centered viewpoint of the subject, place has meaning only in relation to an individual's or group's goals and concerns. Place is best viewed from a point in between."[1]

Questions abound when it comes to public art, but perhaps the most pressing concerns are these: What is public art's relationship to traditional art forms? And what strategies might provide new theoretical directions and practical applications? Although it is premature to announce arrival at some ultimate destination, public art has certainly advanced beyond the starting gate of conventional

Bolek Greczynski, *The Living Museum*, 1984–. View of collaborative project with patients at the Creedmoor Psychiatric Center, Queens, NY.

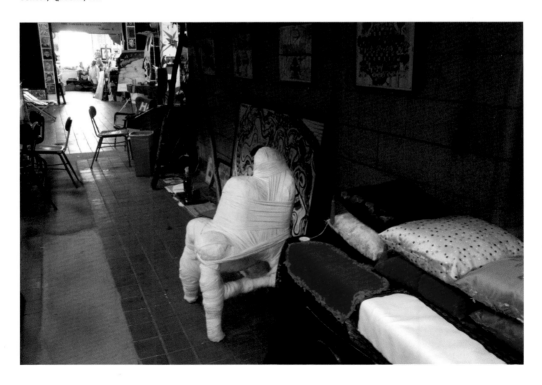

Bolek Greczynski, *The Living Museum*, 1984–. View of collaborative project with patients at the Creedmoor Psychiatric Center, Queens, NY.

practice and monumental objects. Some of the most ground-breaking and provocative works of the 1980s and '90s found their footing on the points in between previously accepted boundaries, thereby charting entirely new theoretical topographies. The in-betweenness of this new public art mediates between extremes. Heretofore dichotomous notions, such as object and event or autonomy and partnership, no longer seem to be at odds.

The very notion of "public" has been rethought to embrace both specific constituencies and generic conceptions. This has led to certain dangers, however. Always a difficult concept to define, the term "public" has become so fragmented that there is danger of losing it as an operative idea. This makes any discourse about public art quite speculative. Since at least the early 1980s, it has ceased to operate as a genre with clear features and conditions — it is too unwieldy and unshapen to be a firm category.

For many artists and critics, however, art divides itself neatly into two categories: private art, aligned with stalwart institutions of culture, and public art, which skirts gallery and museum circuits to form new affiliations with the world. But what about works that fall between being private and public in any conventional sense? There are many examples of artistic practice that reside between this clumsy dialectic. New productions, methods, and questions are guiding cultural criticism to a more constructive model for the consideration of an art of process and possession — a public art that identifies a new geography of art, audience, production, and involvement.

These artists, curators, and critics share a staunch belief that avant-garde art is still possible and that it is situated not in the protective exile of the artist's studio, but in the messy vitality of the streets. If the mythology of the vanguard artist once placed him or her beyond the normative edges of society, there are now artists whose work is profoundly searching and often disruptive, who locate their aesthetic practice right in the thick of things. Although their work may be experimental and too

imperfect to form a model, it offers systems and strategies for a fresh examination of public art, its audiences and implications.

These instigatory examples of aesthetic practice are methodical, philosophical, and inherently critical from first intention through final implementation. Together, they propose a form of public art that serves as encounter and experience, as well as an instrument through which audiences — the public — can become active players in cultural production rather than estranged recipients.

Some artists create work committed to a particular community or constituency. For example, John Malpede and his performance program LAPD (Los Angeles Poverty Department) are located in an economically depressed area of L.A. Since 1985, Malpede has lived among the poor and homeless to sustain an ensemble of community members/participants in experimental street theater.

Bolek Greczynski's work at the Creedmoor Psychiatric Center in Queens, New York, offers an extraordinary example of an artist's long-term commitment to a particular community. The people who hired him in 1984 may have originally had a conventional therapeutic objective for the artist-in-residence, but Greczynski had other ideas about how to engage patients. Armed with a strong activist background (developed while living in Poland and Argentina), he saw art not as a means to pacify or divert, but as a tool for discovery, disclosure, and ultimately, the disruption of crushing social systems. Greczynski and his collaborators (i.e., the patients) have pursued an evolutionary, cooperative, and political process of art-making.

When Greczynski arrived, there were many empty rooms at Creedmoor due to deinstitutionalization policies. He appropriated one of the buildings as a site for installations. Room by room, the artists at Creedmoor have made ambitious installations drawing on the realities of the psychiatric setting, as well as on larger themes of revolution and repression. All of the patients-cum-artists (who call themselves the Battlefield Project Crew) work on this continuous project. Greczynski is neither a dogmatic director nor a diffident spectator. He sustains conversation and production through his attentive, involved presence.

The Living Museum at Creedmoor grows and changes. The installations assume many forms and include different media. Ironically, the joining of many minds and hands has yielded a singular intensity. In *I Miss the Revolution* (1988), Greczynski and his collaborators constructed a wall of 26 televisions whose screens were stenciled with drawings and texts written by the Creedmoor artists. The inscriptions partially obscure the broadcasted programs, reflecting the patients' diminished influence over their lives and their desire for change. The artists also address perceptions of art and mental illness as they revolt against established power. In *Revolution Bound* (1987), an ordinary chair is wrapped in layers of linen. The linen both protects and restrains, and the chair becomes a powerful suggestion of a bound and mute figure. Several projects, including *I Miss the Revolution*, have been installed at art institutions, such as the galleries at SUNY-Old Westbury, New York University, and Artists Space. While the productions of *The Living Museum* have never had an isolated, hermetic quality, these excursions to other cultural sites have brought a new dimension to the work; the participants at Creedmoor have gained an important identity as artists, not merely incarcerated patients. Through his aesthetic and emotional partnership with a frequently ignored and rejected community, Greczynski has expanded the permissible venues for public art.

Issues of public art and community sometimes occur unexpectedly and with disturbing results. When Lynne Sowder became director of the visual arts program at First Bank System in Minneapolis in 1980, her primary responsibility was to amass a distinguished collection. Dennis Evans, who was then president of the bank, wanted a collection that represented the radical changes occurring in banking operations and gave Sowder license to challenge the tenor of the conservative collection that she had inherited. In the first years of her tenure, she acquired and sold art in a fairly standard way. She shrewdly purchased works by emerging artists and sold established works at respectable profits, using the proceeds to buy riskier work.

The second part of her decade, however, offers lessons for public art, participation, and the empowerment of audiences. Sowder began to realize that the newly acquired art, some of it politically controversial or sexually explicit, irritated bank employees. The discontent could easily have been ignored or dismissed (after all, does it really matter what employees think of a corporate collection?), but Sowder saw a fissure in the corporate structure where a new atmosphere of candor and critical discourse might escape. Through astutely planned events, she made employee reception and interpretation of art—the inevitable and uncomfortable moments of controversy—part of the bank's internal culture.

Sowder invented many strategies to make the management of the collection more democratic, publicly encouraging employee consideration and control. For example, any work that received six negative responses was moved to "Controversy Corridor," a hallway for banished art. Through location and consolidation, the disputed works became conspicuous, open to other complaints or staunch defense. Works could also be "rescued" from the corridor. It soon became obvious that much of the hostility directed toward the collection expressed a deeper level of dissatisfaction with hierarchical, corporate culture itself. Many workers were enraged that they were required to live with art whose acquisition they could not influence.

Sowder left First Bank in 1990, and new leadership later sold much of the collection, preferring less evident and certainly less agitational art. A positive disturbance in corporate culture was quieted when banking practices and policies returned to normal. Sowder then formed Y-CORE with partners Nathan Braulick and Brad Trayser to encourage the agency of art in other improbable settings. In col-

laboration with client Liz Claiborne, Inc., Y-CORE developed a project called *Women's Work*, enlisting author Leah Komaiko and artists Meg Webster, Carrie Mae Weems, Barbara Kruger, Diane Tani, Margaret Crane, and Jon Winet for community-based projects that addressed illiteracy, the abuse of women, and other social and environmental issues. Weems, for example, created a series of black and white photographs on abuse for installation in bus shelters. While raising awareness, such works are also intended to create a positive image for the corporate sponsor.

Sowder's marriage of capitalist corporations and provocative public art causes discomfort in those who see a fundamental philosophical and political incompatibility. For many, such partnerships inevitably portend compromises and consensual art. Sowder, on the other hand, maintains that difficult art will always be a marginal pursuit unless it engages with the nation's business culture. Her pragmatics are convincing: the corporation gets positive reception, and artists have an opportunity to work in exceptional circumstances and to address serious public issues. Everyone is a winner. It is a fascinating and problematic model, but the success of such a program may be questionable when executed by others with less political acumen than Sowder.

Exploring more traditional kinds of community, Kate Ericson and Mel Ziegler bring public art to rural and suburban neighborhoods where it is seldom seen or heard.[2] They have used classified ads and other media in quiet and persistent ways to reach collaborators in particular communities. In early projects, they advertised for residents to create art in their homes—using the domestic (private) environment as the subject and material for public projects. Though Ericson and Ziegler have also done public art commissioned through competitions, selection panels, and other invitations,

Barbara Kruger and Carrie Mae Weems, *Women's Work*, 1991. Images on kiosks and bus stops throughout the Union Square area of San Francisco, organized by Y-CORE and sponsored by Liz Claiborne, Inc.

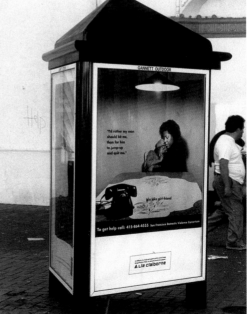

Kate Ericson and Mel Ziegler, *Peaks and Valleys*, 1991. Approx. 2200 asphalt roof shingles (each with a handwritten name of a San Francisco street) on roof, 2700 sq. ft.

many of their most powerful works result from their own initiatives, projects aligning inquiry, intention, circumstance, and development.

While this kind of subtle guerrilla activity operates eloquently and powerfully on a domestic scale or in a small agricultural community, Ericson and Ziegler faced challenges when elaborating their strategy on a more ambitious temporal and spatial scale. "Travel Project" extended both their classified ad projects and a residency at Capp Street Project in San Francisco. *Peaks and Valleys* (1991) took the form of a gallery installation with 2,200 asphalt shingles, each one noting a San Francisco street. During the show, the artists found (through advertisements and word of mouth) a building where the shingles could later be permanently installed; the "art" materials were used to roof a multi-family dwelling in the neighborhood. Ericson and Ziegler's brand of art-as-activism also directs revenues and resources back to the community.

In 1987, Montreal-based Martha Fleming and Lyne Lapointe developed a multifaceted, collaborative project for an empty, decaying vaudeville theater, one of several projects that they installed in abandoned buildings during the 1980s. *La Donna Delinquenta*, inspired by a 19th-century text by Cesare Lombroso, resurrected a history of spectacle and explored new ways for communities to engage in the production and revival of art. Paintings, objects, and performances were orchestrated throughout the derelict building, challenging the abandonment of cultures and the marginalization of communities.

Fleming and Lapointe are skeptical about public art. They speak of the difficulties in understanding a local site or situation as ex officio members of a community. Often the invitation to develop a

project is itself an alienating prospect; public art has created cottage industries that produce "piece-work" and that don't respond in any real way to the communities in which they are based. They feel that many of the conditions of public art production discourage energetic aesthetic practice: "spontaneity is evacuated from practice." After doing brilliant projects in New York City and developing proposals for Melbourne, Paris, and other cities, they have returned to Montreal—where their early public projects rescued abandoned buildings and gave them renewed viability—to pursue a critique of contemporary artistic practice that may inform their future work.

The artists and curators mentioned here all demonstrate that earnest, ongoing attempts to create a more supple language for public art—less driven by formal conventions and more engaged in situational factors—are very much alive. This revised type of public art dismisses the old model in which an artist develops ideas in the isolation of his or her studio and then triumphantly unveils the work at a public site. The artist is now called on to be an interventionist and to accept that his or her work may also be subject to change and adjustment by local communities.

This is not a time for unrestrained enthusiasm or secure satisfaction. Although important points in between convention and speculation have been identified, the conceptual geography of public art is incompletely mapped. All of this restless discovery calls for a new conception of the artist as negotiator. The public artist of the future must navigate between the contrasting desires and characteristics of diverse communities. These projects point out new directions for the exploration of process and participation as key elements of contemporary public art.

Notes

1 Nicholas Entrikin, *The Betweenness of Place: Towards a Geography of Modernity* (Baltimore: Johns Hopkins University Press, 1991), p. 5.

2 Kate Ericson died in 1995, after the original publication of this article.

Art, Space, and Publicity (2013)

by Malcolm Miles

I want to ask how contemporary art involving public participation illuminates the idea of a public sphere of social determination, looking at the *Monument Against Fascism* (1986–93) by Esther Shalev Gerz and Jochen Gerz, in Harburg, a suburb of Hamburg, Germany; and *The Public Bench* (2003) by Jochen Gerz, in Coventry, England. Both works are sited in public spaces and involved public participation in their development or execution. Both raise issues of the significance of participation in contemporary art, and of what constitutes a public sphere. But while the *Monument Against Fascism* is overtly political, *The Public Bench* resembles an expanded form of street furniture within an urban regeneration scheme (though it is more than that), more a sign of civic values than a site of contested claims. Nonetheless, both works invited participants to bring an aspect of their personal lives into a public domain — a site of publicity.

Of the three terms that I use in my title, "art" and "space" have multiple definitions but are not too contentious. Art, despite the rejection of a traditional canon of great art, remains that which is validated by art institutions, today by a consensus of curators, dealers, critics, and a few artists as to what is included in or excluded from museums of contemporary art. Space is a dimension like time and is mapped by geometric coordinates. Space is also a medium experienced somatically and psychologically. In cities, spaces are claimed as sites of visibility, of emotional as well as legal ownership. Patricia Phillips, in her 1988 article "Out of Order: The Public Art Machine," saw urban spaces not as blank grounds but as contested domains; if art derives its publicness from its site, then that location is a "psychological, rather than a physical or environmental, construct."[1]

This idea links to the concept of "publicity" as discussed by critical philosopher Hannah Arendt in the 1950s. Publicity, for Arendt, is a social condition through which — and through which alone — a person may evolve a sense of a mature self amid the perceptions of others. For Arendt, a German Jew writing in North America, the condition of publicity was the condition systematically denied to Jews in 1930s Germany as a prerequisite of their annihilation.[2] Publicity means being seen and heard openly in public, and may involve conflict as well as interaction. Publicity is the activity of the *polis*, which Arendt defines not as an object (the city) but as a process: "the organization of the people as it arises out of acting and speaking together."[3]

By linking art, space, and publicity, I am not claiming that art is a means to social or political formation. Successive avant-gardes have demonstrated art's inability in that sphere, from Realism in the 1840s to Color Field painting in the 1970s. The preoccupation with art's internal dynamics represented by Clement Greenberg's reductive, de-politicizing, art historical trajectory extends a turn to states of psyche as legitimate subject matter for art that began in the 1880s with French Symbolism: the Romantic retreat from industrialization became a retreat from a deeper uncertainty.[4] The bleakness

of the world after the 1940s may render art close to silence, uncomfortable to perceive and bereft of any comforting quality. Art at best parodies, but does not erase, the absurdity of society's organizational structures, as Theodor Adorno saw in Samuel Beckett's plays.[5] Similarly, Herbert Marcuse argues that art "does not quit its own dimension: it remains non-operational."[6] Art contributes only tangentially, though Marcuse saw beauty as other-than the world of oppression, evoking a remembered joy. All this is an oblique opening to a discussion of art and public participation; both of the works that I critique here are in part shaped by loaded historical contexts and are explicitly modern works of minimal formal qualities.

The *Monument Against Fascism* is a 12-meter-high, square column encased in lead sheeting, which was gradually lowered into a pit. Attached to the column were two steel pens. The artists invited residents and visitors to endorse vigilance against fascism by writing their names on the monument. As an area of the surface was covered, the column was lowered to expose a fresh area above. When the shaft was completely covered, it became a buried monument leaving a public memory of its presence. But what appeared on the column was a mix of the envisaged endorsements, graffiti tags, lovers' hearts, and race-hate messages. There were anti-Nazi messages, too, like "Nazis Raus" (Nazis out). Literary scholar James Young writes that the artists, "hoped for row upon row of neatly inscribed names" echoing "the war memorials of another age," but adds that "[they] were taken aback by...an illegible scribble of names scratched over names, all covered over in a spaghetti scrawl."[7] This included Stars of David, swastikas, and acid faces. Some residents viewed the monument

Jochen Gerz and Esther Shalev Gerz, *Monument Against Fascism*, 1986–93. Work installed in Harburg, Germany.

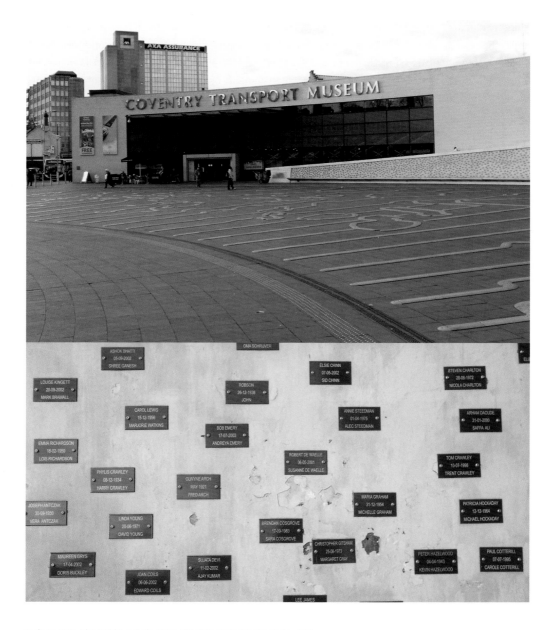

Jochen Gerz, *The Public Bench*, 2003. Work installed in Coventry, U.K.

as a focus for negativity, but a local newspaper retorted, "The filth brings us closer to the truth than would any list of well-meaning signatures."[8]

I would add that these responses should be read in the context of an erasure of memory not only of the Nazi period (which is easier to deal with as the last generation of active Nazis dies), but also of the destruction of the city center by area-bombing in July 1943. W.G. Sebald writes, "A firestorm of an intensity that no one would ever before have thought possible arose."[9] The fires rose 2,000 meters.

More than 100,000 people died. Sebald argues that after such extreme destruction, it is a "quasi-natural reflex" to suppress memories of the event.[10] This enhances the hypothesis that the proliferation of buried monuments in Germany in the 1980s represents a buried history — not only of Nazism but of the terrible bombing as well. When I visited Harburg in 2009, the word "Judas" was scrawled in black felt-tip over photographs of the work at different stages on the viewing platform.

The Public Bench is a different kind of work, though Coventry was also heavily bombed and its cathedral destroyed (it remains a ruin as memorial, with a new cathedral built beside it). While participation was invited after the unveiling of the Monument Against Fascism, in Coventry, it came in the design stage of the long, curved bench: participants were invited to nominate themselves, another person, and a date. Gerz explains, "The reasons for the choice were not revealed. The second name could belong to a person either living or deceased. It could recall a fictitious figure from a novel, a myth, a dream, or a fairy tale…Sympathy, admiration, support, memory, or love determined many choices."[11] There was no vetting of the names, which were inscribed on small red metal plates permanently fixed to the wall above the bench. Gerz used similar plaques in The Living Monument (1995–96) in Biron, France, though to record more complex personal memories of wartime activity that were then affixed to the local war memorial.

The Public Bench is sited in Millennium Place, commissioned by the city council to mark the millennium (though it was not completed until three years later). This new public space marks the end of a walk through the city that begins at the cathedral and takes in surviving historic buildings and empty spaces, mainly turned into gardens, where other buildings once stood. On one side of Millennium Place is a Transport Museum; on the other, across a bus lane, stands a bronze statue of Frank Whittle, inventor of the jet engine.

Gerz's selection prompted anxieties that controversy might arise. The city's press officer stated, "Public art is never intended to be liked by everybody. It ought to be disliked by as many people as like it."[12] There has not, as far as I know, been any graffiti; the main problem is that few people enter the square; many take a longer route around its edges. When I was there, I could not see why this space existed except as a blank space in plans, given over to art and, trading on the participatory aspect of the commissioned work, affirming a notion that public space ensures democracy.

Still, there are several ways in which to read The Public Bench. It brings elements of the private lives of the city's multi-ethnic population into public view, taking over the form of the public monument. But it can equally be argued that graffiti and fly-posting do this and that a stronger claim to multiple visibilities occurred in Harburg when the names of participants were not fed into the design stage of the project. I think it can also be argued that other ways of taking over the monument — like siting bronze likenesses of show-biz figures at street level where tourists are photographed next to them — merely affirm differences of status: star-dust does not rub off. A difference between such monuments and The Public Bench, however, is that, in Coventry, the individuals involved were ordinary citizens, their names and those with whom they are paired being significant to themselves more than to others. But this leads to another way to read both projects — as the performance of a public sphere in which the personal and the social, or civic, merge.

Phillips argues that public space is a psychological zone. I argue similarly that a public sphere arises in the process of publicity — entailing both consensus and dissensus. The public sphere remains metaphorical (despite references to social mixing in the agora of classical Athens), a utopian dream at a time when cities are increasingly zones of social clearance and control. Still, the idea of a public

sphere is vital to future prospects of democracy. Planner Leonie Sandercock sees a "cosmopolitan urbanism" as "a utopian social project" for negotiating the formation of human settlements, constituting "a love song to our mongrel cities, rather than a war against them."[13] *The Public Bench* is more prosaic than that, and the *Monument Against Fascism* became a vehicle for conflict, drawing negativity into the open rather than leaving it buried. What may be significant in both is that the personal act of endorsement brings the realm of private life into public action.

I think both projects offer glimpses of an incipient publicity, demarcating a transitional zone in which public and personal realms overlap. This will not change the world but may slightly inflect its perception. Arendt writes, "The space of appearance comes into being" where people act and speak together; "unlike the spaces which are the work of our hands, it does not survive the actuality of the movement which brought it into being, but disappears..."[14] I leave it there.

Notes

1 Patricia Phillips, "Out of Order: The Public Art Machine," *ArtForum*, December 1988: p. 93.

2 Hannah Arendt, *The Human Condition* (Chicago: University of Chicago Press, 1958); see also Kimberley Curtis, *Our Sense of the Real: Aesthetic Experience and Arendtian Politics* (Ithaca, New York: Cornell University Press, 1999).

3 Arendt, op. cit., p. 198.

4 Clement Greenberg, "Avant-Garde and Kitsch" in *Perceptions and Judgements 1939–1944, Collected Essays and Criticism*, vol. 1, edited by John O'Brian, (Chicago: University of Chicago Press, 1986), pp. 5–22.

5 Theodor W. Adorno, *Aesthetic Theory* (London: Athlone Press, 1997), pp. 30–31, 81–82.

6 Herbert Marcuse, *Counter-Revolution and Revolt* (Boston: Beacon Press, 1972), p. 105.

7 James E. Young, *At Memory's Edge: After-Images of the Holocaust in Contemporary Art and Architecture* (New Haven: Yale University Press, 2000), p. 138.

8 Quoted in Michael Gibson, "Hamburg Sinking Feelings," *Art News*, Summer 1987: p. 107, cited in Young, op. cit., p. 139.

9 W.G. Sebald, *On the Natural History of Destruction* (London: Penguin, 2003), p. 27; see also Hans Erich Nossack, *The End: Hamburg 1943* (Chicago: University of Chicago Press, 2004).

10 Sebald, op. cit., p. 30.

11 See <www.gerz.fr>.

12 See <www.artdesigncafe.com/Coventry>.

13 Leonie Sandercock, "A Love Song to Our Mongrel Cities," in Jon Binnie, Julian Hollway, and Steve Millington and Craig Young, eds., *Cosmopolitan Urbanism* (London: Routledge, 2006), p. 50.

14 Arendt, op. cit., p. 199.

Socially Engaged Art (2013)

by Patricia C. Phillips

In 2011, Pablo Helguera published a slender, succinct primer titled *Education for Socially Engaged Art: A Materials and Techniques Handbook*.[1] The book, he says, was prompted by an invitation from Harrell Fletcher and Jen de los Reyes to teach a course in the Arts and Social Practice program at Portland State University. Helguera is a public and performance artist, and since 2007, he has served as Director of Adult and Academic Programs at New York's Museum of Modern Art. Some may suggest that he has come belatedly to his topic, but his book sensitively, if briefly, recounts the history of socially engaged art, including influential artists such as Allan Kaprow and Suzanne Lacy, as well as writers and critics who have helped to contextualize and theorize this work, including Tom Finkelpearl, Claire Bishop, Miwon Kwon, Grant Kester, and Shannon Jackson. Unsurprisingly, the target audience for the primer is art students. Though it highlights the past five decades of this still-emergent work, it more importantly functions as a user's manual for artists seeking to develop and dissect, contextualize and understand, their own socially engaged practices.

Rick Lowe, *Project Row Houses*, 1993–present.

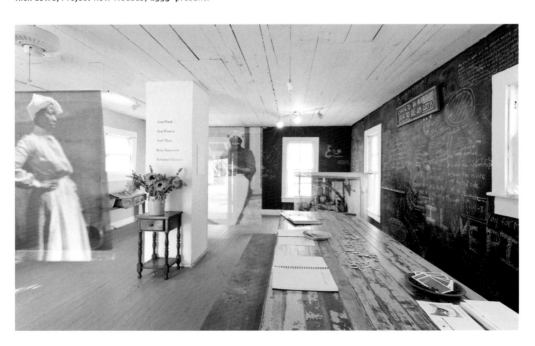

Socially engaged art rests between "something for everyone" and "anything for someone." It occurs in specific sites and expanded fields; its duration (temporal formats) and participants (audience, collaborators) are strikingly variable; it takes diverse and discursive forms; and its content ranges from the intimacies of the everyday to the intricacies of social justice and the ethics of social and economic disparity. It clearly has conceptual and theoretical affinities with a wide range of disciplines, including education and pedagogy, anthropology and ethnography, performance and theater, philosophy and ethics, and sociology and communications theory. Socially engaged art is neither formless nor fully formed. Thanks to the work of artists and critics (some cited above), there are well-documented and analyzed models, as well as a continuing unfolding of new forms, methods, and critiques.

Some of the works that have been formative in my own thinking about this seemingly unbounded area of art practice present a compelling compendium of case studies that raise critical and generative questions. Without placing a value on ephemeral versus more enduring forms, a subliminal organizing device might be the scale and durational dimensions of socially engaged art—though it must be acknowledged that duration has exceptional elasticity, particularly in the realm of the social. There are intense passages and singularities in long-term work, and the arc of short-term projects can produce remarkably expansive resonances. Whatever the form, however, all of these works are shaped and revised by the many different ways in which artists work with—and within—communities, as well as by the ways in which those individuals and communities assert or enfold themselves into the process.

Rick Lowe's deservedly renowned *Project Row Houses* (1993–ongoing) emerged out of the despair of economic fallout and the consequent abandonment of a historically black district in Houston. An independent artist living in Houston, Lowe affiliated with a community center that was inventorying the scope of deterioration in the neighborhood, including 22 abandoned "shotgun" houses. While common sense confirmed that these derelict buildings had declined to an intolerable level of urban blight, Lowe (inspired by his study of Joseph Beuys and John Biggers) saw opportunity in the forfeited and neglected site. With grants and other support, he purchased the houses and worked with city residents and students from the School of Architecture at Rice University to rehabilitate them, while developing social and cultural programs for the small structures. Some were designated as transitional homes for single mothers seeking independence and self-sufficiency through education and support programs; other houses provided artists' and writers' residencies and sites for temporary installations and interventions. Almost 20 years later, *Project Row Houses* continues to serve as a vibrant catalyst and strategic summons for community and civic revitalization, individual and institutional renewal.

Over time, many stakeholders have become involved, and Lowe's role has evolved. First an artist who physically transformed the physical detritus of a dying neighborhood into an inhabited and living community, he has become a strategic planner, cultural collaborator, and skillful negotiator who works within and across different sectors of citizens, community leaders, and city officials to advance an agenda of affordable housing and redevelopment that resists the voracious and opportunistic forces of gentrification. *Project Row Houses* remains a radiant example of persistence and practiced agility within changing social conditions and public spheres. To ensure its survival, mission, and progressive symbolism, it has had to expand its radius of engagement. This expansion has been guided in large part by Lowe's growth as an artist whose practice has become inextricably defined by the dynamic social conditions of a neighborhood caught up in pernicious economic forces and competing visions of development.[2]

Marion Wilson continues Lowe's legacy in Syracuse, New York. Smaller in scope and scale, her diverse projects offer compact, adaptable, and replicable models of socially engaged interventions that act as a cultural probe for community revitalization. Like Lowe, Wilson has seized a stereotypical symbol of hopelessness and transformed it into an iconographic alternative of agency and potential. A faculty member of Professional Art Practice and former Director of Community Initiatives at Syracuse University, she has worked with students and community groups to transform an aged recreational vehicle into MLAB, a Mobile Literary Arts Bus that serves as a peripatetic gallery, classroom, and learning lab for Syracuse public schools, offering after-school art programs.

Wilson's most recent project, 601 Tully Street (2009–ongoing), is located in a west end neighborhood designated the ninth poorest in the nation by the 2010 U.S. Census. Over the past three years, Wilson has worked with community members and Syracuse students taking her New Directions in Social Sculpture course to transform a former drug house into an active and sustainable community center. Current programming includes nutrition education for low-income adults (in collaboration with a local grocery store), barista certification programs for teenagers (with a local coffee distributor), and a gallery for rotating exhibitions. When I visited, Wilson described a fascinating process of working with supportive and skeptical neighbors, a city zoning board that presented countless hurdles, and both eager and less motivated high school and college students. The interior renovations (floors, walls, and furnishings) relied on recycled materials harvested from abandoned warehouses (another sign of Syracuse's economic challenges and opportunities for repurposing). The space is filled with light, delightful ad hoc furnishings, books and art, and a fully operational kitchen.

Wilson holds most of her classes at 601 Tully Street so that students can continue to work on the building and develop programming in collaboration with the local community. She sees the site

Marion Wilson, work at MLAB and 601 Tully Street, Syracuse, NY, 2008–12.

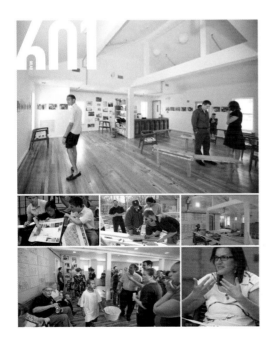

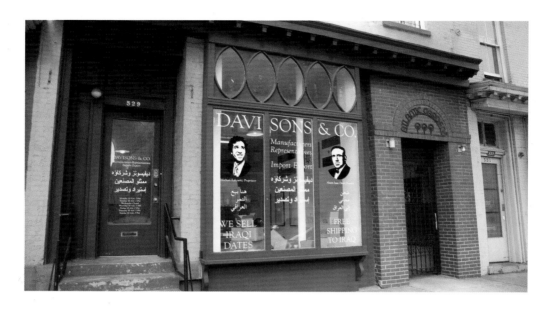

Michael Rakowitz, *Return*, 2006. Storefront and shop, 529 Atlantic Avenue, Brooklyn, NY. Sponsored by Creative Time.

as an ongoing, perpetually unfinished, and constitutively vulnerable work of art and identifies "neighboring" as a new, dynamic form of sculpture. Through this work, she has become a skillful and resourceful orchestrator of individual and collective capacities, marshalling the positive, productive aspects of expert, local, and amateur knowledge.

Direct engagement, though sometimes an end in itself, can also serve as a means or conduit (sometimes provocative, sometimes poignant) to areas of concern. Questions of food and diet have become national and global issues, central features in discussions of health disparity. From artisanal foods and the Food Channel to food access and justice, to malnutrition and obesity, everyday eating has radically different implications and consequences based on geography, economics, race, and class. We all eat, however, so the procurement of food and the sharing of meals remain galvanizing opportunities for conversation and conviviality—key conditions for spontaneous social engagement.

Michael Rakowitz's *Return* (2006), created through the support of Creative Time in New York, used a small storefront on Atlantic Avenue in Brooklyn to invoke the expectant and disquieting poetics incumbent in its title. Rakowitz reopened, after many years, Davisons & Co., an import/export company operated by his family in Baghdad. When his grandfather was exiled from Iraq in 1946, he re-established the family-run business in New York. Rakowitz's store offered free shipping to Iraq for patrons including the local Iraqi community and American families with military personnel serving in Iraq. The central aspect of *Return* extended the scope of connection even further, to the negotiation of a contract to import one ton of Iraqi dates to New York. This transaction was both a great failure and significant success. Most of the dates were "detained" and rotted at the Iraq/Jordan border. Only 10 boxes (having made their way through a thicket of exorbitant export charges, loopholes, and other restrictions) successfully arrived in New York. The succulent fruits—the first to be shipped to the U.S. in more than 30 years—became surrogates for the Iraqi diaspora and global conditions of exile and displacement. The small storefront—with its purchase and selling of the dates and other

daily transactions — became, simply and strikingly, an affective decoy of difficult and entangled local and global issues.

If Rakowitz's fugitive dates were short-term prompts of sociality, another more persistent form of critical entrepreneurialism has developed in Pittsburgh, where a modest storefront (really just a little hole in the wall) is home to Conflict Kitchen (2010–ongoing). Unlike countless other little shops that sell specific ethnic foods, this site has an expanded and serial mission. Artists and cooks Jon Rubin and Dawn Weleski prepare and serve a particular cuisine, generally for six months, from a part of the world in acute and/or continuing conflict with the U.S. During the run of a particular cuisine (Iran, Venezuela, Cuba), Conflict Kitchen provides great meals, as well as an enticing range of public programs, performances, discussions, Skype dinners (with filmmakers from Afghanistan or young people from Iran, for example), and information on the historical and current conditions of the conflict. Like Rakowitz's imported dates, the fare at this restaurant offers many forms of potential nourishment and engagement.

Jon Rubin and Dawn Weleski, Conflict Kitchen façades and products, 2010–12.

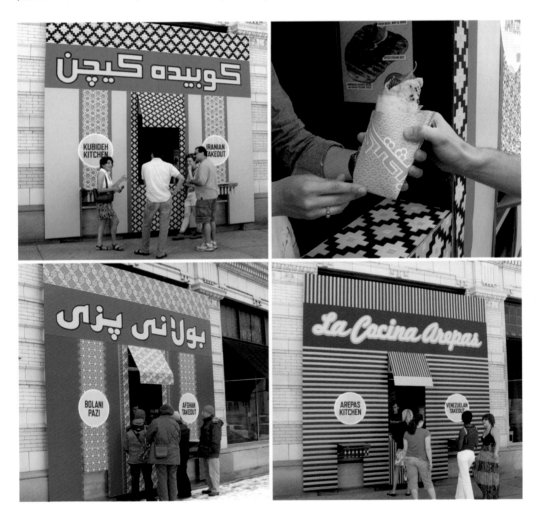

Other artists deploy more indirect forms of socially engaged art to re-contextualize and reconsider concepts of self-representation. Alfredo Jaar, for example, has devoted his 30-year practice to diverse means of public engagement and creative co-production. In Montreal, his *Lumières dans la Ville/ Lights in the City* (1999) appropriated and intervened in a prominent building that once housed the Canadian Parliament and now hosts upscale commercial businesses. Damaged by fires and rebuilt several times during its volatile history, the building is a well-known landmark, readily identified by its prominent cupola. Less visible and shockingly overlooked at the time of Jaar's project was the alarming number of homeless people living in nearby shelters.

Lights in the City brought a stealth visibility and municipal accountability to the city's homeless population while protecting individual privacy. At the entrance to each cooperating shelter, Jaar placed an instructional message—"This artistic intervention aims to inform people of your presence. While respecting your dignity and privacy, it transforms the cupola into a danger sign"—above a button that, when pushed, activated brilliant red lights in the cupola. The spontaneously, irregularly, and unpredictably triggered chromatic alarm represented a significant invisible crisis. Jaar described his act of extreme indirection as a form of "anonymous photography."[3]

He had begun to explore this means of engagement in an earlier project for the Museo del Oeste in Caracas. Invited to produce a work for an inaugural exhibition in the museum's new building, Jaar felt that the troubling conditions of disparity exacerbated by that structure required a different kind of aesthetic response. Built in a poor, working-class neighborhood, the museum was fiercely controversial. Rather than developing an individual project or exhibition of his own work (undoubtedly what museum officials expected), Jaar chose to work as a community organizer and independent curator of a dispersed form of creative representation. For *Camera Lucida* (1996), he distributed 1,000 disposable cameras around the area. Individuals were invited to take a camera, shoot photographs of their choice, and return the camera at a designated collection site for processing. The citizen photographers (from young children to seniors) could then pick up their processed prints and choose one for enlargement and inclusion in the museum's inaugural exhibition. Of the 1,000 cameras distributed, 700 were returned for processing. Of these, 407 people selected images for presentation in the show.

With considerations of temporality, direct action and indirection, and concentration and dispersion as a substrate, Mierle Laderman Ukeles's work as a voluntarily embedded artist in New York City's Department of Sanitation has one of the longest legacies, with multiple trajectories, of any socially engaged art project. While the Department of Sanitation remains a significant conceptual platform for her many projects, she also works globally on issues of maintenance, conditions and environments of waste, recycling and repurposing initiatives, and the shared bonds, multiple scales, and common cause of maintaining individuals, communities, cities, and the world.

In 1969, Ukeles wrote a *Manifesto for Maintenance Art*, and 10 years later, she embarked on her now legendary, 11-month project to shake the hand of every sanitation worker in New York (there were 8,500 at the time). Working with a map of the city, she devised a series of arcing and intersecting "sweeps" that enabled her to cover five boroughs and every sanitation district across three days of eight-hour shifts. With each handshake, she said, "Thank you for keeping New York City alive." Reaching out to each "sanman," Ukeles engaged in an act of re-representation of public work that, paradoxically, was considered isolating, alienating, and frequently degrading. She continues a socially committed practice that includes collaborative performances, as well as participation in the repurposing

of landfills into public spaces and parks. People—along with all of the stuff that they once needed and desired and then reject and toss—and the collective maintenance of an expanding scale of sites and conditions are central to her prodigious work.

These diverse and discursive projects—ephemeral and long-term, focused and expansive, singular and serial, coordinated or co-produced—only partially represent the scope of socially engaged art. Helguera takes some pains to differentiate between "symbolic" and "actual" socially engaged art. Though often politically or socially motivated, some artists represent ideas of the social and engagement, addressing issues on an allegorical, metaphorical, or symbolic level.[4] Citing Paul Ramírez Jonas's *Key to the City* (2010), which was sponsored by Creative Time, Helguera makes a more granular distinction between symbolic acts and communicative actions. In other words, Ramírez Jonas's act of giving people a key as access to New York City is a symbolic act enfolded within the developed concept of a "meaningful conceptual gesture."[5] Socially engaged art requires some kind of social action and interaction; it is not proposed, prospective, imagined, or speculative. The social dimension is key—even if the social is troubled, troubling, acrimonious, agonistic, disturbed, or difficult.

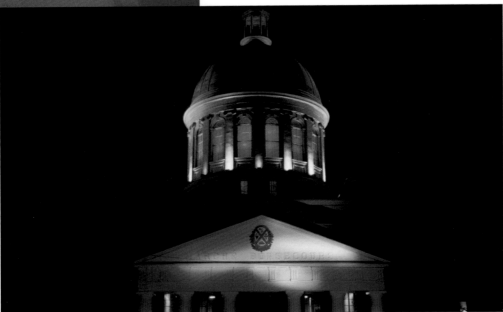

Alfredo Jaar, *Lights in the City*, 1999. Approx. 100,000 watts of red lights installed in the cupola of the Marché Bonsecours, with activation devices located at nearby homeless shelters.

While the "social" is the context and frequently part of the content of the work, other issues and objectives also drive artists' socially engaged practices. In her essay, "Art, Politics, and Climate Change," Adrian Parr cites the theories of Jacques Rancière in *The Politics of Aesthetics* (2006).[6] Rancière analyzes the "sensible" as the "apportionment of parts and positions...based on a distribution of spaces, times, and forms of activity that determines the very manner in which something in common lends itself to participation and in what way various individuals have a part in this distribution."[7] Parr elaborates that "there are fundamental divisions already in operation between what is visible and invisible, audible and inaudible, sayable and unsayable. The political condition of art struggles to visualize, give voice to, and render audible those who remain excluded from the dominant organizational system of knowledge, law, and social position. The power of Rancière's thinking comes from his original description of how this system of inclusion and exclusion operates."[8]

In its many forms, socially engaged art inevitably—and always—raises questions about conceptions and formations of the social realm, power and patterns, authority and access—and how artists prepare themselves to negotiate and intervene in these complex and contingent dimensions. As Shannon Jackson writes, "Once again, the trick will be to place social systems in the foreground of analysis despite the fact that they usually occupy the background of experience."[9]

Notes

[1] Pablo Helguera, *Education for Socially Engaged Art: A Materials and Techniques Handbook* (New York: Jorge Pinto Books, 2011).

[2] See Grant Kester's striking analysis of this project in his book, *The One and the Many: Contemporary Collaborative Art in a Global Context* (Durham, North Carolina: Duke University Press, 2011).

[3] See Nancy Princenthal's thoughtful essay "The Fire This Time: Alfredo Jaar's Public Interventions" in *Alfredo Jaar: The Fire This Time—Public Interventions 1979–2005* (Milan: Charta, 2005).

[4] Helguera, op. cit., p. 6.

[5] Ibid., p. 8.

[6] Adrian Parr, "Art, Politics, and Climate Change," in Adrian Parr and Michael Zaretsky, eds., *New Directions in Sustainable Design* (New York, Routledge, 2011), pp. 6–12.

[7] Jacques Rancière, *The Politics of Aesthetics: The Distribution of the Sensible*, translated by Gabriel Rockhill, (London: Continuum, 2006), p. 12.

[8] Parr, op. cit., p. 8.

[9] Shannon Jackson, *Social Works: performing art, supporting publics* (New York: Routledge, 2011), p. 6.

Good Works: The Impetus of Ethics (2013)

by Suzaan Boettger

In 2005, Rirkrit Tiravanija, speaking of "the land," a compound that he and others built in northern Thailand to facilitate village dialogue and communal and individual growth, said, "We're not interested in a sculpture park. We're much more interested in the conditions of living."[1] To observers of current art, Tiravanija's renouncement of the specular experience of the sculpture park format—displays of untouchable art objects sequestered in an arboreal setting—in favor of social relations, is not surprising. Even so, his reductive dichotomy articulates an unusually succinct statement of values, particularly

Francis Alÿs, with Cuauhtémoc Medina and Rafael Ortega, *When Faith Moves Mountains*, 2002. Photographic documentation of action in Lima, Peru.

among artist-originated public works. Despite being designed by persons whose primary identity is "visual artist," such work does not derive its impact from its material manifestation of the artist's sensory attention—its aesthetics. The land's mixed-use buildings and site offer little to sustain one's scrutiny. Instead, the instigation of this work is subject matter, or more specifically, social matters, as determined by the artist's decision (often, as here, in collaboration with others) to address community and environmental well-being. To that end, the construction is directly functional. Without visual enrichment or symbolic form, it provides a place to gather. In art in the public arena, this is an increasingly common way of making good work: driven by an altruistic spirit toward the greater communal and/or environmental benefit, that is, by doing good works.

This is "public art" that you won't be seeing in all the old familiar places—the urban plaza, the park across the way, the transit hub—but in sites accessible to community members (though they may be unusual platforms for art). For *HighWaterLine* (2007), New Yorker Eve Mosher visited many such sites. She spent a few months of weekends pushing a line-making machine filled with powdered chalk to demarcate the perimeter of an increasingly likely extreme flood zone in Lower Manhattan and Brooklyn. Over the course of the project, Mosher traversed many neighborhoods and struck up environmental-consciousness-raising conversations among curious passersby. This was an artist-instigated project not produced under institutional auspices. Conversely, the Belgian-born, Mexico City resident Francis Alÿs rounded up 500 volunteers outside Lima, Peru, to form a line spanning a sand dune. Shoulder-to-shoulder, they shoveled its crest a minuscule distance. *When Faith Moves Mountains,* organized for the Lima Biennial in 2002, enacts an encouraging metaphor of collective activism or a dramatic allusion to the futility of faith—it provocatively illustrates both. In either case, Alÿs's action, in the context of Peru's difficult development of democracy after the ambiguous exit of President Alberto Fujimori two years earlier, implicitly acknowledged the need for "mountains" of poverty and governmental corruption to be "moved" by society.

A large contingent of artists involved with ecology extend engagement with social problems into actual environmental repair, eroding traditional distinctions between fine art and design or craft utility. While works of art will not change the world as directly as political advocacy and legislation, these projects fix one local problem at a time. A good example of an independently originated solution by an individual is Lillian Ball's *Waterwash* (2009) on Mattituck Inlet, Long Island, which controls the regular flooding of a public boat ramp during storms. After obtaining permits and various forms of local support, she managed a construction crew that replaced asphalt paving with a graded and attractively curved permeable pavement framed by native grasses, wetland plants, seating, and explanatory signage. The project is decidedly cross-disciplinary, drawing on her training and experience as a sculptor, her administrative and negotiation skills with planning departments and school volunteers, and others' scientific knowledge of hydrology and climate, landscape design, construction materials, and procedures. As such, this work demonstrates the substantial heterogeneity of such public work by artists, both in its sources and its position as "art."

Such practices imply a rejection of the commercial seductions that Guy Debord described in *The Society of the Spectacle* (1967; in English, 1970) and a revulsion against materialism and essentially trivial art-market *objets* in favor of humanitarian engagement toward the social good. More direct stylistic predecessors are the post-conceptual, non-object, activist social engagement from the 1970s that Joseph Beuys termed "social sculpture" and which in the 1990s Suzanne Lacy grouped as socially engaged "new genre" public art.[2]

WochenKlausur, *Home Improvement Service*, 2012. Artist-performed apartment renovations in the Jessy Cohen neighborhood in Holon, Israel, at no cost to residents.

Curator Nicolas Bourriaud has described the model of sociability central to relational aesthetics as "learning to inhabit the world in a better way, instead of trying to construct it based on a preconceived idea of historical evolution [of artistic style]."[3] Such idealism is not customarily associated with the convivial mode of relational aesthetics, but the Alÿs project certainly qualifies. More direct affinities can be found in the local, community-based, interactive projects that Grant Kester advocates as "dialogic" and Claire Bishop ambivalently analyzes as "participatory." A few years ago, Bishop was influential in describing the "social turn" of contemporary art.[4] However, since such "social practice" works, as they are now commonly called, often go beyond socializing to enact a sense of responsibility for others, Bishop's recent reference to them as "Christian" is more pertinent, in the sense of the idiom "Christian *caritas*" or selfless charity. (Of course, this concept of spiritual generosity is fundamental to moral goodness across religions—the Hebrew phrase is *Tikkun olam*, to "repair the world"—and the idea pertains irrespective of religious affiliation.) As the Viennese artist group WochenKlausur, whose work consists of projects such as a three-week *Home Improvement Service* (2012) in a debilitated neighborhood of Holon, Israel, puts it, they "develop concrete proposals aimed at small, but nevertheless effective improvements to socio-political deficiencies...translating these proposals into action, artistic creativity is no longer seen as a formal act but as an intervention into society."[5] These artists are not merely doing good deeds for a specific need: social practice, as well as environmental, artists think of themselves as agents of change, enacting a stewardship ethic for the greater societal good.

The designation that unites social practice and eco or environmentalist art both in terms of their ameliorative approaches and complementary absence of attention to sensory and aestheticized object-making is "ethical." Analyzing the "ethical turn of aesthetics and politics," philosopher Jacques

Rancière provides an apt definition: "Before signifying a norm or a way of being, the word 'ethos' signifies two things: ethos is the dwelling and the way of being, the way of life corresponding to this dwelling. Ethics, then, is the kind of thinking which establishes the identity between an environment, a way of being, and a principle of action."[6] Applied to projects in the community or environmental realms, this is not about an intra-artwork ethics—procedures in the process of producing the work, acquiring the materials, professional relations to staff, dealers, and clients. Those professional ethics are a given. Nor does this attribute of ethics imply, at other extremes, a stance of moralizing denunciation or direct advocacy of an action or political activism—though this work has political implications and may even compensate for inadequate governmental policies.

Rather, this designation of a public art project as being driven by an ethical position is very much about a conception of what it means to be an artist in relation to the world. Although in conversations and statements, these artists strongly identify as "artists" per se, they do not perform that role by creating a distinctive form that dialogues with the art world about art's formal and ontological identity or evokes an emotional resonance in relation to the greater life/world. Instead, their work in the public domain displays a strong ethical commitment to improving the situations and elements of our "dwellings," however they are conceived.

Swiss artist Thomas Hirschhorn pointedly emphasized the connection between his public art and ethics in the title of his 2009 project for Street of Sculptures, a two-month publicly and privately funded festival in Bijlmer, in southeast Amsterdam. Named for the locally born philosopher Baruch Spinoza, *The*

Thomas Hirschhorn, "Running Events: Dichters concours," from *The Bijlmer Spinoza Festival*, Amsterdam, 2009.

Bijlmer Spinoza Festival celebrated the classic 1677 text *Ethics*, which argues that everything in nature (the world, the universe) is one reality, of which everyone is a part, and everything/one is subject to only one set of rules. Bijlmer's population consists mainly of Christian and Muslim immigrants from the former Dutch colony of Suriname, most of whom live in public housing. Hirschhorn used his characteristic materials of cheap wood, cardboard, and duct tape to construct, along with 12 paid residents, a pavilion with areas for exhibitions on Spinoza and Bijlmer, a library, and places for lectures, seminars, performers, computers, a bar and snack bar run by locals, and a work bench. His primary creations were events and encounters. Visiting scholars lectured on Spinoza and on art history, helped produce a newsletter, and wrote a play performed several times by residents. Twenty events, including poetry readings, debates, art presentations, and performances, were proposed by local residents.

Hirschhorn has noted that "during the festival, the spectators became actors, the audience became performers, and there was no depth [separation] between the platform and public space. I have always wanted to work for a non-exclusive audience."[7] The egalitarian spirit of this project is overt, turning customarily passive art viewers into active participants and even creators. The model of proactive engagement that can be continued in everyday experience is clear.

This widespread ethical basis of art in the public realm corresponds to what has been termed a broad "ethical turn" in society. A *New York Times* "Ethicist" columnist, for example, recently exulted that "ethics may be having a moment"; the newspaper also reported that prominent business support of ethical nonprofits has become a marketing tool.[8] In academia, Americans and Europeans recognized this ethical phase two decades ago as a corollary of increased interest in human rights and environmental justice. German scholar Hubert Zapf has aptly described a "return of ethics in literature and literary studies" as "a shift from a self-referential to a more pragmatic conception of cultural signification processes…[e.g.,] from text to life."[9]

Indeed, the very profusion of social practice art suggests that, for many observers, art's protective autonomy—its detachment from social and environment exigencies—is no longer an adequate response to worldwide social and environmental degradations. Kelly Baum, an art historian and curator, has incisively stated, "Put simply, art is now defined by its dis-identification with the discipline of art…Contemporary art seems desperately to want to exceed the parameters that formerly set it apart as a specialized endeavor and to shed many of the attributes that make it recognizable as art." Similarly, Kester argues that "contemporary collaborative practices [productively] complicate conventional notions of aesthetic autonomy" such that "some of the most challenging new collaborative art projects are located on a continuum with forms of cultural activism."[10] As an illustration of this, the Web site for Documenta XIII, at least nominally a gigantic "exhibition" of art, lists everyone involved in the programs, including the artists, as "participants."[11] Yet Bishop persuasively resists this sort of leveling as what she terms a "slide into sociological discourse," mediating the ethics/aesthetics dialectic by stating, "Participatory art demands that we find new ways of analyzing art that are no longer linked solely to visuality, even though *form* remains a crucial vessel for communicating meaning." Bishop distinguishes herself among art world theoreticians by insisting that "the discursive criteria of participatory and socially engaged art [is based on] an ethical reasoning that fails to accommodate the aesthetic or to understand it as an autonomous realm of experience."[12]

Ethics or aesthetics: Must we choose? As alternative forms of art in public places, social practice and eco art play on the borders of fine art and non-art social utility, of personal creativity and communal projects, and of contemporary aesthetics and social ethics. Much of the strongest art—

Thomas Hirschhorn, "Running Events: Jam Session," from *The Bijlmer Spinoza-festival*, Amsterdam, 2009.

frequently discussed and illustrated in publications—leaves that line fluid. Patricia Johanson designs her remediation and functional habitats around repeated shapes and diverse representations of local flora and fauna—for instance, the San Francisco garter snake is the motif of her baywalk *Endangered Garden* located above the city's sewage treatment plant (which she also co-designed). Likewise, the large blue circles affixed to tree trunks and building façades throughout Boulder, Colorado, in Mary Miss's *Connect the Dots: Mapping the Highwater Hazards and History of Boulder Creek* (2007) combined the concision of a signal and the allusiveness of abstraction to call up water and stimulate visceral apprehension about the height of a potential extreme flood. And a main reason that Allora and Calzadilla's projects related to U.S. Navy weapons testing on the island of Vieques are so well-known is the stirring beauty of their "documentary" images, particularly the mesmerizing close-up of an upside-down table—legs projecting into air—affixed with an outboard motor being piloted on a turquoise sea (*Under Discussion*, 2005).

The prominence of ethical positions as a source of new forms of art in public places, particularly those originated directly by artists, suggests a need for attention not met in other domains of society. For many social and environmental problems, what is lacking is not scientific research or technical knowledge, it is social imagination and the ethical will to envision and enact changes in our ways of living. While this work's conceptions of the object, and objective, of art in relation to history and present-day society are unsettled, and thus unsettling, that in itself is productive, prompting engagement and reflection on both the status of art and crucial issues of our times.

Notes

1 Paul Schmelzer, "the land, Paul Schmelzer Interviews Rirkrit Tiravanija," in Max Andrews, ed., *Land Art: A Cultural Ecology Handbook* (London: RSA, 2006), p. 53. Tiravanija and co-founder Kamin Lertchaiprasert do not capitalize the land—"it's a kind of 'un-name.'" See p. 61.

2 "Implicit or explicit in the artists' references to a larger social agenda is their desire for a more connected role for artists." See Suzanne Lacy, ed., *Mapping the Terrain: New Genre Public Art* (Seattle: Bay Press, 1995), p. 32.

3 Nicolas Bourriaud, *Relational Aesthetics*, translated by Simon Pleasance and Fronza Woods, (Paris: Les Presses du Réel, 2002), p. 13.

4 See Grant H. Kester, *Conversation Pieces: Community and Communication in Modern Art* (Berkeley, Los Angeles, London: University of California Press, 2004) and *The One and the Many, Contemporary Collaborative Art in a Global Context* (Durham: Duke University Press, 2011). Claire Bishop, "The Social Turn: Collaboration and Its Discontents," in *Artificial Hells: Participatory Art and the Politics of Spectatorship* (London, New York: Verso, 2012), pp. 11–40. An earlier version of this essay was published in *Artforum*, February 2006: pp. 178–83; a critical response from Kester, with Bishop's reply appeared in the May 2006 issue, p. 22. Their critiques of each other's positions continue in their most recent books.

5 From the group's Web site <www.wochenklausur.at/methode.php?lang=en>. Under the FAQ section, the group has the confidence and eloquence to directly confront the question "What do WochenKlausur's projects have to do with art?"

6 Jacques Rancière, "The Ethical Turn of Aesthetics and Politics," *Critical Horizons*, 7:1, 2006: p. 2.

7 <http://www.youtube.com/watch?v=y1gZaI6tY78>.

8 See Ariel Kaminer, *New York Times*, April 27, 2012, <http://www.nytimes.com/2012/04/29/magazine/so-long-farewell.html_r=1>. On ethics as a selling point, see <http://opinionator.blogs.nytimes.com/2012/05/09/shopping-for-a-better-world/?hp>.

9 Hubert Zapf, "Narrative, Ethics, and Postmodern Art in Siri Hustvedt's *What I Loved*," in Marjorie Garber, Beatrice Hanssen, Rebecca L. Walkowitz, eds., *The Turn to Ethics* (New York and London: Routledge, 2000). By "return," Zapf undoubtedly refers to the early 20th-century and postwar Modernist periods when abstraction as a rejection of more easily consumed representational styles signified an ethical affiliation with art's autonomous value as a manifestation of progressivism, a rejection of "commodity culture," and an expression of personal freedom. See, for example, Meyer Schapiro, "The Liberating Quality of Avant-Garde Art," *Art News*, Summer 1957: pp. 36–42, reprinted as "Recent Abstract Painting" in Schapiro's *Modern Art*, 1978, pp. 213–232. See also David Parker, "The Turn to Ethics in the 1990s," *Critical Review*, 1993: pp. 3–14; and Astrid Erl, Herbert Grabes, and Ansgar Nünning, *Ethics in Culture, The Dissemination of Values Through Literature and Other Media* (Berlin, New York: Walter de Gruyter, 2008).

10 Kelly Baum, in Hal Foster, ed., "Questionnaire on 'The Contemporary,'" *October* (Fall 2009), p. 95. Kester, *One and the Many,* op. cit., pp. 9–10 and 37.

11 <http://d13.documenta.de/#/participants/participants/?tx_participants_pi1%5BshowUid%5D=9>.

12 Bishop, *Hells*, op. cit., pp. 17, 7, 39, and 284. Underlying this last point is the concern that prominent attention to ethical matters, an aspect of rising engagement in human rights, could shift the responsibility for social change to individual accountability and nongovernmental agencies, displacing citizens' demands of the state and responsibility toward collective political change. WochenKlausur addresses this point at <http://www.wochenklausur.at/faq_detail.php?lang=en&id=21>.

The Stuart Collection: Challenging Conventional Public Art on Campus (2013)

by Barbara Goldstein

Imagine you are 18 years old, far from home and just arrived at a college campus filled with unfamiliar buildings and spaces. Do Ho Suh's *Fallen Star* at the University of California San Diego (UCSD) perfectly captures that confusing moment of wonder, exhilaration, and fear. The ordinary wooden cottage, scaled down in size, has apparently landed, askew, in the most extraordinary location — at the top of a building. Walk across the greensward of Warren Mall toward the Jacobs School of Engineering, look up, and there it is, a pale blue clapboard house teetering precariously overhead. Take the elevator to the roof, and you are greeted by a curiously familiar sight: in front of the house is a garden, complete with lawn, path, and flowerbeds. Steam, mimicking smoke, rises from the chimney. Inside the house are wallpapered rooms, a fireplace, windows with curtains, furniture, and a television. Standing inside, however, tests your sense of domestic tranquility. Everything slants, and the view from the windows looks out on a diagonal horizon, tilted trees and buildings.

Fallen Star is the 18th and most ambitious work to be commissioned by the Stuart Collection, directed by Mary Livingstone Beebe. In describing Suh's project, Beebe says: "He came to the U.S. to go to the Rhode Island School of Design and to Yale for graduate school, and he felt totally displaced. He had to find himself again. Many students have been through a [similar experience], leaving their homes for the first time and coming to this place where there isn't anything resembling a home." Because the house is "cantilevered over the edge of the building, it creates an intense experience of displacement and that's part of the point of the work." Your world is disrupted, a fallen star landing on an unfamiliar planet.

Beebe, who has directed the Stuart Collection since its inception in 1981, has never wavered from commissioning provocative works. In describing the collection, she says, "It's not about taste, it's not about decorating the campus in a cosmetic way, it's about providing an experience for people to think about…The fact that the works are there and that people remember them means that they come back to students in ways that they didn't think about when they were here. Art is really about paying attention, and that's what we need to do in order to understand the world that we live in."

Realizing Suh's sculpture required a combination of diplomacy, persistence, and persuasion. Irwin Jacobs, the person for whom the engineering building was named, was concerned that people might mock the building because of *Fallen Star*. "No," Beebe argued, "the artwork will make the building famous." She also raised the money to fund what became the most costly work in the collection and brought in architects and engineers to help make it a reality. *Fallen Star* is without a doubt, a true star in an unusual collection of public art and a guidepost for students.

Unlike a traditional sculpture garden, which places existing artworks in a landscape, or a percent-for-art program, which requires artists to work with an architect and stakeholders to fit a site and

Do Ho Suh, *Fallen Star*, 2012. 2 views of steel-frame house with concrete foundation, brick chimney, garden, lawn chairs and table, hibachi-style grill, bird bath, and bird house, approx. 15 x 18 ft.

social context, the Stuart Collection commissions artists to develop proposals for unique context-specific works on campus sites of their own choosing, without the pressure of specific deadlines or programmatic requirements. Since 1980, more than 40 artists have been invited to develop proposals.

Beebe describes the collection as "an ongoing, living program commissioning contemporary artists to come to the campus and think about doing a project that will somehow relate to what goes on there. We take the proposals to our advisory committee, which is composed of people who have spent their lives thinking about contemporary art, and when that group approves the proposal, it's

Robert Irwin, *Two Running Violet V Forms* (detail), 1983. Plastic-coated, small-gauge chain-link fencing and stainless steel poles, approx. 28 ft. high, 3000-sq.-ft site.

my job to integrate it with the campus and raise the money. We do not use any university or student funds for these works. The UCSD Stuart Collection is unique in this respect." The combination of independent funding and independent oversight structure has enabled the collection to thrive.

The Stuart Collection began as the vision of James Stuart DeSilva, a businessman with a highly developed passion for contemporary art. The son and husband of artists, DeSilva felt that art had changed his life, and he wanted to develop a collection of works that could change the lives of others. After moving from New York to San Diego in 1978, he created the Stuart Foundation and approached the university with the idea of endowing a collection of original, commissioned works that could inspire students. This collection would be led by a distinguished independent advisory committee,

and the University Chancellor would have the final say. Once the university accepted DeSilva's offer, he assembled the advisory committee and recruited Beebe, who was then directing the Portland Center for the Visual Arts. The collection's advocate with students, faculty, and donors, she has guided its selections for over 30 years with the help of the advisory committee, the University Chancellor, and project manager Matthieu Gregoire, a sculptor and former colleague from Portland.

The collection began with Niki de Saint Phalle's *Sun God*, which was selected by the first advisory committee (chaired by Newton Harrison, with Pontus Hulten and Pierre Restany) before Beebe's arrival; her first task was to oversee its fabrication and installation. The choice proved a brilliant one. Placed at a central gathering spot, the colorful iconic "bird" has become the campus mascot, adorned by the students with everything from eggs to earphones. It also inspired UCSD's annual Sun God Festival.

Because the collection began with Pop art, the advisory committee decided that it would be important, in the next commission, to move in a different direction. To establish breadth of style, they invited California native and McArthur Award recipient Robert Irwin to develop a concept. Irwin, who was exploring ideas of perception, created *Two Running Violet V Forms*, a pair of blue chain-link

planes weaving overhead through a eucalyptus grove and hovering over a parallel field of purple-blooming ice plants. Like the eucalyptus trees themselves, the planes change color in different atmospheric conditions, challenging perceptions of space and transforming the experience of light throughout the day.

All of the works in the collection have strong intellectual underpinnings rooted in the artists' interests and previous work. Choice of site and the approach to that site are determined by each artist, often with gentle nudging by Beebe and Gregoire. Although architects working on campus have asked Beebe to integrate art into their buildings, she has

Terry Allen, *Trees*, 1986. Three lead-covered eucalyptus trees, approx. 40 ft. high each; 2 with 24-hour intermittent recorded sound.

Nam June Paik, *Something Pacific*, 1986. 2 views of mixed-media installation with 6 outdoor elements (televisions, buddhas) and an indoor bank of 24 interactive televisions.

stood firm in the belief that artists are not there to "correct architects' mistakes," and, with the exception of Jackie Ferrara's quiet courtyard in Moore Rubell Yudell's Cellular and Medicine Facility, none of the Stuart Collection works have grown out of traditional artist/architect collaborations.

The individualized integration of art and site at the Stuart Collection has been profoundly mean-ingful. The UCSD campus offers a fascinating canvas, a 1,200-acre former military base that includes a few gridded groves of eucalyptus, barracks, Brutalist concrete and post-Modernist buildings, rolling hills, and breathtaking ocean views. Artists have responded to these features, as well as to the aca-demic context. For example, Michael Asher's *Untitled* granite water fountain calls attention to the site's former military function, completing a partial axis created by a military marker and a large American flag. Alexis Smith's *Snake Path* weaves its way to the entrance of the Geisel Library while creating a metaphorical reference to the biblical "fall from grace" precipitated by the acquisition of knowledge.

Many of the works are the result of an active collaboration between the artist and Gregoire, who assists them with fabrication and logistical support. For example, when Tim Hawkinson proposed a gigantic teddy bear made out of boulders for the engineering building courtyard, Gregoire located the boulders, commissioned accurate scale models of each stone for Hawkinson's use, and then worked with engineers to pull off the astounding feat of fabricating a teddy bear from 18 tons of rock. When the collection commissioned Terry Allen's sound-based, lead-wrapped *Trees*, Gregoire helped

him to find and select the dead trees to reinsert into an existing grove. He also helped Kiki Smith find and cast a dead tree as the "pedestal" of her fountain sculpture, *Standing*, situated in the courtyard of a medical building complex.

Some works, like Richard Fleishner's monumental *La Jolla Project* installed on a vast lawn or Bruce Nauman's astonishing *Virtues and Vices*, announce themselves dramatically. Nauman's work consists of seven-foot-high neon words encircling the top of a building, with the virtues and vices running clockwise and counter-clockwise, randomly overlapping as they pursue their separate ways. Other works, like William Wegman's playful and ironic *La Jolla Vista* or Nam June Paik's *Something Pacific*, are more subtle interventions. The outdoor component of Paik's two-part work, installed around the Media Center, features several semi-submerged carcasses of old televisions, each one "watched" by a bronze Buddha, or, in one case, by a replica of Rodin's *Thinker*. In contrast to this video graveyard, the Media Center lobby hosts a vibrant grid of television monitors programmed to create ever-evolving patterns controlled by communications students.

Over the years, the collection and its leadership have evolved. The advisory committee has gained and lost members. A Friends of the Stuart Collection organization was formed to support the work. Stuart himself died in 2002. Through these changes, the collection continues to grow. Beebe says that Ann Hamilton's proposal to create a sound-based work is next on her wish list. With Beebe's passion and the strength of the collection's support team, there is little doubt that this work will be realized.

Sculpture at Evergreen: Private Past Meets Public Present (2013)

by Sarah Tanguy

Sculpture at Evergreen, a biennial of temporary, site-specific, outdoor sculpture at Johns Hopkins University's Evergreen Museum & Library, may be Baltimore's best-kept secret. Though characterized by innovation and experimentation, the program takes its inspiration from the past, exploring the history of the 1858 mansion and estate and, most importantly, the two generations of Garretts who made Evergreen their country home. This outdoor show fulfills Ambassador John Work Garrett's vision "that Evergreen House be hospitably open to lovers of art, music, and beautiful things." A previous John Work Garrett, president of the Baltimore & Ohio Railroad and grandfather of the ambassador, purchased the 28-acre estate in 1878 for his son, Thomas Harrison Garrett. In thinking about improve-ments, Thomas corresponded with noted landscape architect Frederick Law Olmsted, whose recom-mendations still permeate the entrance area, the stream, and the edges of the property. The idyllic grounds also feature Italianate gardens at the back of the house, natural woods, meadows, and rare specimen plantings.

In 1920, the estate was bequeathed to Thomas's son, John Work Garrett (1872–1942), who served as U.S. Ambassador to Italy from 1929 to 1933. He and his wife, Alice Warder, transformed a wing of the house into a gallery of Asian art and installed a private theater designed by Russian émigré Léon Bakst of Ballets Russes fame. Both generations of Garretts collected avidly, amassing some 35,000 rare books and manuscripts, Tiffany glass, European and American paintings, sculpture, and works on paper, coins, and Asian applied arts, all of which have become source material for biennial participants.

The Garretts' personal touch and sense of hospitality continues to this day, making the sculpture program a kind of extended family affair in which startling juxtapositions of new and old result in a unique, in-depth approach to temporary, site-responsive interventions. As James Abbott, director since 2007, explains, "Here's a couple that had no children. They loved this house. They loved art every day of their lives. But they also recognized that the art that they loved would not necessarily be the art that people 50 years down the road would be passionate about or see as cutting edge. They really thought about Evergreen as growing beyond their lifetimes, and that's what makes [it] so special. All of the sculpture programming is born out of nurturing artists."

When John Work Garrett died in 1942, the estate and collections were donated to John Hopkins Uni-versity, with life tenancy for his wife, who died 10 years later. In 1990, the restored mansion and grounds reopened as a historic house museum. Former director Cindy Kelly initiated the sculpture biennial in 1999 under the sponsorship of the Evergreen House Foundation and other contributors. Kelly, along with curator Jackie O'Regan, oversaw the first exhibitions in 2000 and 2002; O'Regan continued with the 2004 and 2006 shows, and James Abbott shepherded the 2008, 2010, and 2012 installments.

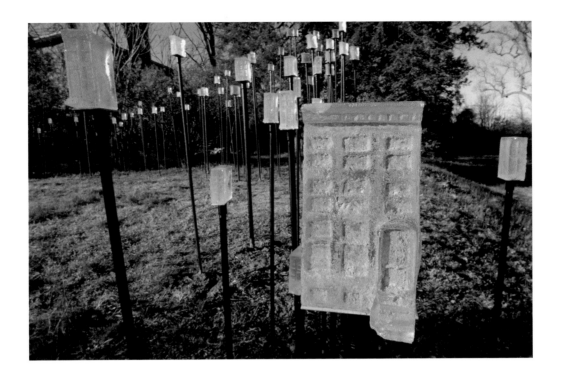

Katherine Kavanaugh, *Class*, 2006. Cast glass and steel poles, 60 x 40 ft.

Each incarnation gains an individual character from its guest curator, who is selected by an informal group of museum curators, art collectors, and art scholars. Artists are chosen from a national call shaped by the curator and Evergreen staff. On average, 10 works are commissioned for each show. Very few rules or parameters exist other than prior experience in creating sculpture and the ability to stay within the allocated budget for travel, installation, fabrication, and de-installation. Another must is a site visit or short-term residency, which allows artists to channel the zeitgeist of the property. Intellectual curiosity, unhampered imagination, and adventurous spirit go without saying.

The program's ambition is reflected in the broad range of curatorial themes. Starting with Michael Brenson's focus on materials as a reflection of artistic vision (2000), exhibitions have explored "practicing in place" (Mary Jane Jacob, 2002), a study of how gardens and homes act as sites of healing and family identity; "Illuminating a Landscape in Transition" (Jennifer McGregor, 2004), exploring the shift from private historic home to public contemporary space; "Inside/Out" (Julie Courtney, 2006), a look at how interior goings-on can be manifested outside; "Interventions" (Andrea Pollan, 2008), an investigation of our estranged relationship with nature; "Simultaneous Presence" (Jennie Fleming and Ronit Eisenbach, 2010), a consideration of Evergreen as former residence and "performed place, a destination for the production and consumption of culture"; and most recently, "Landscape as Laboratory" (Jack Sullivan, 2012), which took Evergreen's goal of nurturing artists to a new level.

Over the years, the forms of contemporary expression have kept pace with the richness of the source material. In the first show, Jann Rosen-Queralt responded to the regular chamber music

concerts sponsored by the Garretts by moving music out into nature. *Cultivus Loci: Dropa* transformed a portion of the Stony Run stream into a quasi-scientific instrument for the diffusion of sound in space. Straddling the meandering banks, shiny rings of stainless steel radiated from a central stack of steel dishes. As the stream levels fluctuated, the "satellite" collected water sounds to the beat of changing water and light patterns.

In the following biennial, Roberley Bell chose the Friendship Garden, a sanctuary conceived by the elder Mrs. Garrett, to further examine landscape as an extension of the domestic sphere. Enclosed by an ivy-covered brick wall, the intimate outdoor room sits on the far side of the stream, across from a grove of red leaf maples. Bell's mixed-media installation, *Listen*, played off the garden's manicured formalism by introducing steel urns—stand-ins for the human body—covered in Astroturf and sprouting artificial flowers. Cedar benches inscribed with text provided a restful place to enjoy a meditative environment in which memory could peacefully converse with the present.

In 2004, two artists, Brian McCutcheon and Adam Dougherty, explored the notion of a garden folly. McCutcheon's *Totus Mundus Agit Histrionem*, "all the world's a stage" in Latin and the motto of Shakespeare's theater, took the form of an over-the-top, gilded proscenium. Made from steel, fiberglass, resin, and auto paint, the work outrageously set off a modest fountain at the end of the central walk. In interpreting architectural details from the house and library, it suggested that the outdoors could also be a platform for learning, while highlighting the Garretts' book collection and theater patronage. Dougherty opted for a subtler statement, with a cardboard version of Mrs. Thomas Harrison Garrett's teahouse. Sited beyond the formal gardens, the original structure, which was covered in tree bark and shingles, had hosted informal gatherings. Dougherty retained the proportions but reduced the scale to three quarters of the original so that only the mind's eye could enter. In coating the cardboard in epoxy resin, he underscored the futility of any intervention in the landscape.

Katherine Kavanaugh's *Class* was a highlight of the 2006 biennial. Rather than focus on specific elements of the property, she took on the larger issue of social distinctions in 19th-century Baltimore. Just beyond the formal gardens, she fashioned a series of miniature row houses of differing styles and sizes, mimicking the homes of the elder Garrett's employees. Propped on poles, they also resembled birdhouses, bringing to mind the ornithological books in the collection, as well as the migratory lifestyle of railroad workers. Another kind of memorial was the subject of Bruno Laverdiere's *Sacandaga Markers*. Drawing on eroded 19th-century graveyards, his primal outcropping of gravestones nestled in the south woods honored the beloved horses and dogs once under the Garretts' care.

Eschewing traditional media such as steel and stone, the 2008 exhibition sought out artists who would remind us, in guest curator Andrea Pollan's words, of how "like it or not, we live in a wired society more comfortable with a mediated experience of nature than a direct encounter." For the wisteria vines that once grew along the west wall of the carriage house, Hyungsub Shin substituted a network of brightly hued electrical wires twisted together and anchored to the remains of the trellis. Inspired by overgrown banyan tree roots at Angkor Wat, *Rhizome* drew a surreal parallel between floral propagation and branching human nerves. Even more out of place, Sharon Engelstein's inflatable *Green Golly* lodged in the front portico of the house between two grand columns. The bulbous, 15-foot-high enfant terrible seemed poised to burst from its confines and wreak havoc on the manicured lawn beyond.

Hyungsub Shin, *Rhizome*, 2008. Electrical wire and twist wire, 18.5 x 40 ft.

Many of the works in the 2010 biennial incorporated an element of relational aesthetics. Shannon Young's *How Does Your Garden Grow?* may have started with a reference to the foundations of a former greenhouse, but it became a witty commentary on consumption and sustenance. Removed from their everyday context, nine grocery carts in three orderly rows were planted with seasonal vegetables. Later she designed and used a kitchen greenhouse to prepare meals and serve guests, underscoring our distance from food production. David Page's *Skip* was equally provocative. A mining cart, outfitted with a cage and padded suit, stood on a four-foot segment of track inside the *porte cochère*. Both performing and at rest, the work starkly recalled the harsh labor conditions of the Gilded Age and the source of the Garrett wealth.

In the spirit of "Landscape as Laboratory," the 2012 exhibition replaced professional artists with young amateurs from the University of Maryland. Students in landscape architect Jack Sullivan's fall 2011 Design Fundamentals course came up with individual ideas for projects. Then, a smaller team of graduate and undergraduate students honed and fabricated 10 of those works, pushing them through an intensive process of brainstorming, drawing, and modeling during an independent course with Sullivan in spring 2012. Abbott, himself an expert in decorative arts and architecture, encouraged this emphasis on landscape design and embraced the heightened level of risk-taking: "I think the title of the show is quite valid because one of the beauties of this particular installation is that we can see the process. We're working with students, and the visitors who come here will be able to see some of that process, some of that dialogue."

The experience no doubt left a lasting mark on the students. During the conceptual phase, they toured the estate and studied the National Park Service's Historic American Building Survey when

considering topography, seasonal change, and flora. Just as critical in decision-making were the interests and eccentricities of the Garretts themselves. It was quite a learning curve for Sullivan, too, who was curating his first show: "It was one big experiment...we had to read the existing landscape, make some minor alterations, and intervene by dropping in a whole range of objects and environments intended to make people see the landscape differently."

Mrs. Garrett's theatrical flair enlivened *The Illusion Garden*. The circular chain-link room rose out of an open meadow, its interior covered with mirrors. Inspired by her lavish private bathroom, the funhouse hybrid invited visitors to enter its *trompe l'oeil* space and watch their reflections mingle with those of the surrounding landscape. Flowering plants creeping up the walls lent seasonal color and definition. *Ghost Greenhouse* cleverly resurrected the estate's once sumptuous Victorian greenhouses by introducing a white, two-part exoskeleton. Cutting through ruins and bramble, the geometric structure also framed a multiplicity of views. The nearby woods formed the backdrop for *Vine Hut*. During the team's fall tour, they had noticed several Japanese maples still in their nursery pots, with their roots extending into the ground. An ode to the overlooked and cyclical change, this subtle installation about letting nature do its thing created a magical crawl space from a tangle of trees and vines.

Though visitors won't hear the peal of Mrs. Garrett's laughter or the lightness of her foot, they will feel the sparkle of the family's wit as they discover vestiges of the past through the lens of contemporary art. This fundamental tension between continuity and change fuels Sculpture at Evergreen. "It's rejuvenating," Abbott affirms, "I think the public gets a renewal very similar to the one

Shannon Young, *How Does Your Garden Grow?*, 2010. Greenhouse, grocery carts, dirt, vegetable seeds/seedlings, sunlight, water, and garden materials, dimensions variable.

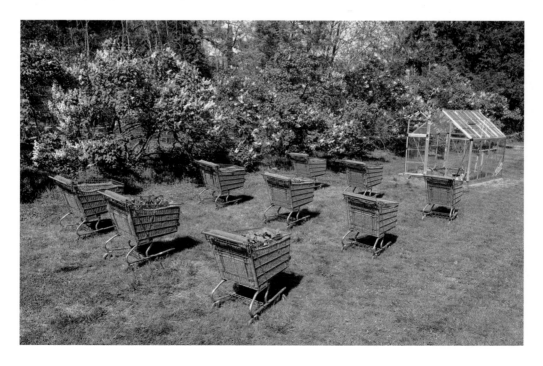

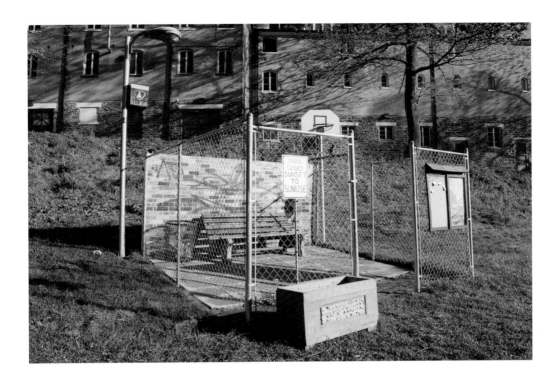

Eric Leshinsky, C. Ryan Patterson, and Fred Scharmen, *Evergreen Commons*, 2010. Mixed media.

that I get working with the artists, by walking around the grounds and seeing what is different with each installation, what is special." A *Wunderkammer* and artistic muse for over a century, the estate is also a window into nature, history, and art. With support and dedication, Evergreen and the sculpture biennial it inspires will continue to intrigue and delight for years to come.

Vita Brevis: A Public Art Initiative at Boston's Institute of Contemporary Art (2013)

by Sierra Rooney

The Latin adage, "ars longa, vita brevis," which roughly translates to "art is long, life is brief," evokes the power of art to transcend time. "Vita Brevis," then, is a playful, though fitting, name for the Boston Institute of Contemporary Art's 10-year foray into temporary public art. This partnership between two usually distinct entities allowed both to engage in a deeper exploration of site and audience than either could have done independently. Founded in 1997 by Jill Medvedow, Vita Brevis dislocated the ICA from its physical space and place in the cultural fabric of the city, giving it access to new sites and new publics beyond its usual reach. Likewise, the imprimatur of the ICA gave Vita Brevis an established visitor base and cultural cachet not normally accorded to public or temporary works in Boston. Though the program was unofficially discontinued in 2007, it made effective use of sites around the city to embed artworks in the cultural and historical context of Boston in ways that would not have been possible otherwise.

Though partnerships between public art programs and museums have become a burgeoning trend—recent examples include the Queens Museum of Art's collaboration with Creative Time for Tania Bruguera's *Immigrant Movement International* and the National Museum of Women in the Arts' public sculpture project on New York Avenue in Washington, DC—they were something quite new when Medvedow became director of the ICA in 1998 and Vita Brevis became a permanent program under the curatorial direction of Carol Anne Meehan. Museums and public art initiatives may share basic motives, but they have vastly different tools at their disposal. Teaming up with Vita Brevis, the ICA emphasized a strength that it could not claim for itself—the ability to operate in public space, a characteristic shared, not coincidentally, with many of the city's popular memorials and tourist destinations. The two were ideal candidates for the first major partnership between a public art program and a museum in the U.S.

Vita Brevis curators and artists drew strength from neighborhood groups, churches, and non-arts organizations, including the National Park Service and Boston's Parks and Recreation Department. Working actively with the community relied on an engaged citizenry willing to donate time, space, and resources, as well as flexibility on the part of organizers. The community became a co-creator in the art-making process of Vita Brevis, developing a sense of responsibility for and shared ownership in the work, which, in turn, required the ICA to relinquish a degree of creative ownership and authority.

Just as significantly, the sense of disconcerting "newness" hovering around contemporary art was not an issue with Vita Brevis, since the program frequently engaged sites that were the antithesis of "new." Site was the most crucial dimension of the program; its easily accessible (often outdoor) pieces offered its parent institution broad access to Boston itself—a city whose history teems with national significance. For tourists and lifelong Bostonians alike, popular historical sites often tend

to overshadow contemporary art in the city. Vita Brevis took that situation as its starting point and sought to correct the imbalance by presenting contemporary art that directly responded to popular sites and their implicit historical narratives. The curators of Vita Brevis used site to bridge the gap between artists and audiences, replacing the unfamiliar "newness" of a contemporary art museum with the familiarity of tourist destinations.

For "Let Freedom Ring," the inaugural Vita Brevis project in 1998, Krysztof Wodiczko, Jim Hodges, Mildred Howard, and Barbara Steinman re-contextualized the storied Freedom Trail, which consists of memorials, monuments, and historic sites linked to various episodes in Boston's history. While popular with both tourists and residents, the Freedom Trail memorials speak the same message as they did decades ago; and decades from now, they will still carry basically the same message. The temporary installations in "Let Freedom Ring" shifted that message, challenging the immutability of the traditional memorial form.

Wodiczko's *Bunker Hill Monument Projection* brought one of the Freedom Trail's most venerated

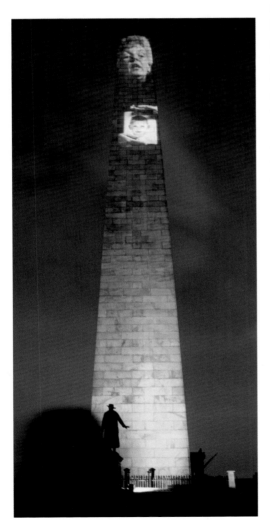

elements—the titular obelisk—from the past into the present. Though on view for only three nights, this large-scale video and sound intervention spoke to the very heart of Boston. Wodiczko spent several months working with Boston residents, specifically in the neighborhood of Charlestown, where the Bunker Hill Monument is located. He eventually chose to focus on a 20-year history of unsolved murders in the Charlestown area, where countless young men had been killed and their murderers shielded by a so-called "code of silence" prevailing among residents. For three nights, Wodiczko projected the faces and voices of three grieving mothers on the towering Bunker Hill Monument, venting the community's legacy of secrecy. A memorial to the fallen men of the Revolutionary War, Bunker Hill became reconfigured as a monument to the sons of present-day Charlestown, a connection of past and present, national and local. Most important, Wodiczko's project was not a memorial in the usual sense; the Bunker Hill obelisk offered a public space and a formidable symbol for reflection, but the projection was as much a call to action as it was a remembrance.

For the seventh annual ICA/Vita Brevis project in 2004, Jennifer Allora and Guillermo Calzadilla

Krzysztof Wodiczko, *Bunker Hill Monument Projection*, 1998. Video projection at Bunker Hill Monument, Boston.

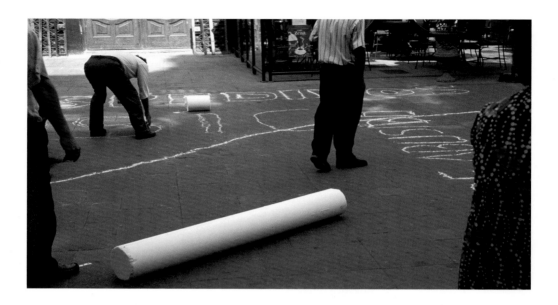

Jennifer Allora and Guillermo Calzadilla, *Chalk*, 1998–2002. 12 chalk sticks, 64 x 8 in. diameter each. View of the Lima version at the Pasaje Santa Rosa, Bienal de Lima.

turned to the activist history of Boston's parks for inspiration. *Chalk* put in motion a simple but effective concept, literalizing the view of public art as a "public creation." Allora and Calzadilla commissioned dozens of oversized logs of common classroom chalk, each one more than five feet long and thicker than a telephone pole, and placed them on the sidewalks in Boston Common over the July 4th weekend. Anyone who wanted to express their ideas could enter this democratic forum, break off a piece of chalk, and write or draw whatever they desired. The timing for the project was very deliberate, as Meehan explained: "Our strategy was to capitalize on the moment just prior to the Democratic National Convention taking place in Boston, when free speech, open democratic communication, and the right to demonstrate were very much on people's minds."[1] The location was specifically chosen for its rich history as a site of assembly and demonstration—the city established the Boston Common as a public park in 1634. With chalk in hand, residents of contemporary Boston were able to contribute to this great tradition.

The level of participation was overwhelming; the park was practically whited-out over the three days. People used the chalk for innocuous drawings and impassioned political statements, and everything in between. Statements like "We are not the world," "Lesbians against Bush," "~~Kerry beat~~ Bush 04" covered the ground. The temporary nature of the chalk medium also provided a sharp contrast to the park's historical permanence; after one rain shower, the elaborate and extensive markings disappeared. With its high level of participation, *Chalk* proved that temporary public art can be an effective way to achieve social currency. The sidewalk provided a forum for individuals to express everything from politically charged feelings to generic doodles, thus becoming a litmus test for the social climate in Boston.

The last official ICA/Vita Brevis project in 2007 continued to engage Boston's public parks, but this time, Teri Rueb, Ernesto Pujol, Anna Schuleit, and the artist group Office DA also maintained

strong ties to the museum. "Art on the Harbor Islands" was located on the series of islands just off-shore in the Boston Harbor, within sight of the ICA. *Core Sample*, Rueb's installation on Spectacle Island, developed a direct relationship with its surroundings through an "audio core sample" of what lies below the island's surface layer.[2] Spectacle Island once housed farms, a quarantine hospital, resort hotels, and a garbage dump; it wasn't until the summer of 2006 that it was opened as a public park. The audio core sample, heard over personal headsets and dictated by GPS, used natural sounds, music, and narrative oral testimony to blend historical survey into present conditions. Howling winds, lapping water, the clink and grind of construction, bird song, and human voices heightened the experience of the park. The piece formed an artificial soundtrack to accompany the island's past and present, and the headsets allowed it to be both a personal and collective journey into time. What made *Core Sample* unique, however, was its sister work inside the ICA, where Rueb installed a similar soundscape in front of the ceiling-to-floor, harbor-view windows. Spectacle Island, its voice emanating from the floor, seemed to sing like a siren, calling viewers out to sea.

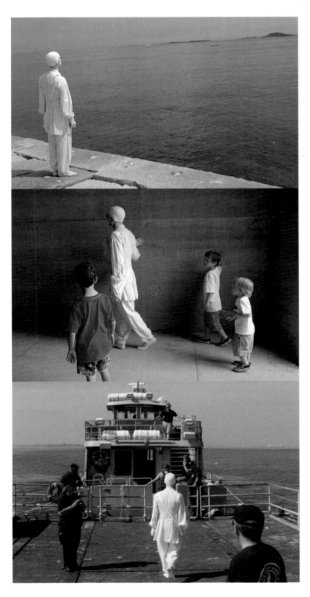

Spanning 10 years and more than 25 art installations, Vita Brevis provides a model of institutional practice that demonstrates how museums can engage more meaningfully with the culture of their cities.[3] Rueb says, "The ICA supported a much broader agenda than gallery-based art, and the way in which ICA was exceptional is tied to Vita Brevis."[4] The program demonstrated a novel approach to attracting new audiences, not through educational models or outreach programs, but through art itself — specifically, engaged public art.

By virtue of location, public art offers an inherently more populist forum than a museum space. Museums, particularly urban institutions, can use public art to re-energize their constituency by responding directly to local

Ernesto Pujol, *The Water Cycle*, 2007. 3 views of performances on Georges Island and Little Brewster Island.

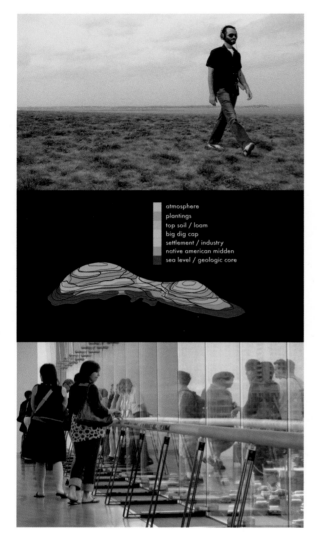

Teri Rueb, *Core Sample*, 2007. 3 views of GPS-based sound installation with components on Spectacle Island and at the ICA.

atmosphere
plantings
top soil / loam
big dig cap
settlement / industry
native american midden
sea level / geologic core

landscapes, histories, and communities, something all but impossible within the sanctity of the galleries. In addition to increased physical access, public art offers another, even more important asset: conceptual access. It can tackle timely issues that pertain to community life—as with *Bunker Hill Monument Projection*—and directly involve audiences—as with *Chalk*. Invoking the specifics of locality also helps to define the identity of the museum. Each city is distinctive, and a public art program can help a museum to express that uniqueness while maintaining the collection's general appeal. Responding to vastly different issues concerning the Boston community, the Vita Brevis installations collectively illustrate meaningful interaction between a museum and its public. Such temporary projects escaped both the physical context of the museum and the super-social aesthetic experience implied by that context. Viewers encountered these pieces in public social space, free of expectations, and therefore engaged with the work as thoroughly or as casually as any other daily encounter. No other kind of museum program can hope to reach the viewer in this manner.

Notes

1 Carole Anne Meehan, "Contemporary Art and History Museums?" lecture at the Annual Museum Computer Network Annual Meeting in Minneapolis, November 2004.

2 *Art on the Harbor Islands*, exhibition guide, June 23–October 8, 2007.

3 The first five years of the program are documented in Carole Anne Meehan and Jill Medvedow, *Vita Brevis: History, Landscape, and Art* (Boston/Göttingen: Steidl, 2004).

4 Teri Rueb, phone interview with the author, February 2, 2010.

Art on the Line (2013)

by Susan Canning

Originally part of an elevated railway viaduct built in 1934 along Manhattan's far west side and now repurposed as a city park, the High Line raises the viewing of public art to a whole new level. Initiated by artists and designed by architects in a careful balance of nature and promenade, the High Line could be seen as a large interactive installation or perhaps a contemporary earthwork, one that celebrates its urban location even as it seeks to reconnect the visitor, albeit in a carefully planned way, to the untamed environment of 1980s New York City, when the West Side was rougher and the defunct railroad tracks had given way to wildflowers and native plants. A model of the public/private partnerships that have become increasingly common in this era of belt-tightening and budget cuts, this 1.45-mile-long park shows just how mainstream public art has become.

Photographers Joel Sternfeld and Barry Munger began documenting the viaduct in the 1980s after it had been decommissioned by the railroad. They, along with others from the surrounding Chelsea neighborhood, including activist Peter Obletz, sought to preserve the structure from demolition. Their efforts, assisted by the Friends of the High Line, founded by Joshua David and Robert Hammond in 1999, led to the High Line's reconstruction and reincarnation as a public park.

A collaboration of James Corner Field Operations (project lead), Diller Scofidio + Renfro, and planting designer Piet Oudolf, the High Line's careful design orchestrates a series of vistas and experiences along a mainly north/south axis, conceptually linking New York's once vital industrial past with the present day by passing through or alongside buildings once serviced by the railroad. From the southern entrance on Gansevoort Plaza (where a High Line Visitor's Center and much-needed restrooms, as well as the new Whitney Museum, are being built), one is guided, almost as in a theme park, first through woodlands and grasslands, under the Standard Hotel, along a sundeck complete with wooden lounge chairs, and through a corridor under a former warehouse now occupied by condominiums and the Chelsea Market.

This dark passageway serves as a site for food vendors, a few artists selling work in assigned spots, and temporary art projects including performances and film projections. It is here where Steve Vitiello's sound installation and Spencer Finch's glass wall, both organized by Creative Time and the first public art pieces commissioned for the High Line, were installed. While all that is left of Vitiello's piece is a large speaker hung high above the space (to be used for future performances and film projections), Finch's *The River That Flows Both Ways* remains. Aptly demonstrating that location is everything, the floor-to-ceiling grid of colored glass panes faces the river and changes with the light and time of day. Set into existing steel mullions, each colored panel is based on documentary photographs that Finch took every minute over a day of the Hudson River's ever-changing reflections. Arranged progressively to suggest the flow of time and the river, *The River That Flows Both Ways* (a

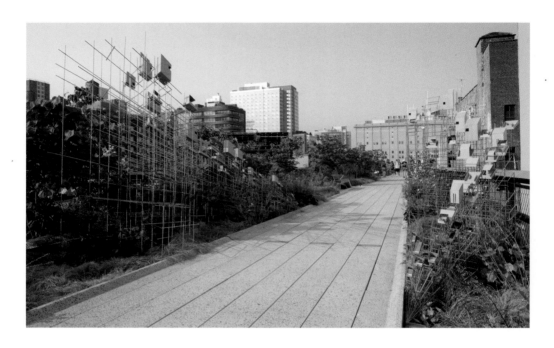

Sarah Sze, *Still Life with Landscape (Model for a Habitat)*, 2011. Stainless steel, wood, paint, and concrete, 9 x 21 x 22 ft.

translation of *Muhheakantuck*, the Native American name for the Hudson) offers a harmonic blending of color, light, and public space that even Monet would admire.

Beyond this passageway is one of the High Line's most popular spots: the Northern Spur and Tenth Avenue Square, with its mini-amphitheater and broad rectangular proscenium overlooking the traffic that ebbs and flows along 11th Avenue. One can sit here, have lunch or dinner, and watch traffic go by like a real-time movie. This framing of urban vistas is repeated again at 26th and 30th Streets, setting up a dialogue involving perspectival views of the urban grid, the water and boat traffic along the nearby Hudson, and the illusion of rambling, overgrown nature encountered along the High Line. More thickets, wildlife, and grasslands await along the planked pathway that leads, in the second section, to a metal bridge "flyover" that lifts the visitor above and through a dense terrain of shrubs, trees, and flowering plants and then descends to a low, flat field of wildflowers. Still to come (the rights were recently transferred from the CRX corporation to the City of New York) is the last half mile of Section Three, which runs from 30th Street above the still-used yards of the Long Island Railroad and along the river, terminating at the Jacob Javits Center on 34th Street. Since most of the viaduct is only 30 feet wide, with the planked path only eight to 12 feet, this new section will provide a much-needed open space for performances and installations. All along the High Line, there are places to sit, occasionally watch a movie (projected onto a wall at 23rd Street), listen to a sound piece (Julian Swartz's *Digital Empathy* was located within water fountains, elevators, and the one public restroom on the Line) or take in a performance, and here or there, discover art. But with its panoramic views of the Hudson River, the New York skyline and harbor, and the Statue of Liberty, to say nothing of the many plants, flowers, and trees, the High Line provides stiff competition for attention and numerous distractions from anything an artist might produce.

Although public art has always been part of the park's plan, with High Line Art commissioning and producing projects since 2009, the limitations imposed by the location and the need for site-specific art can prove challenging. No artwork can endanger plants, impede traffic flow, or damage structures, and the narrow pathway is often crowded. The pieces must be durable (installations are up for one year) and capable of withstanding the sometimes punishing conditions along the Hudson, including blizzards, high winds, intense heat, lightning, and hail.

Francis Cape, *The Other End of the Line*, 2010. 2 views of trailer home/art space installed on Gansevoort Plaza.

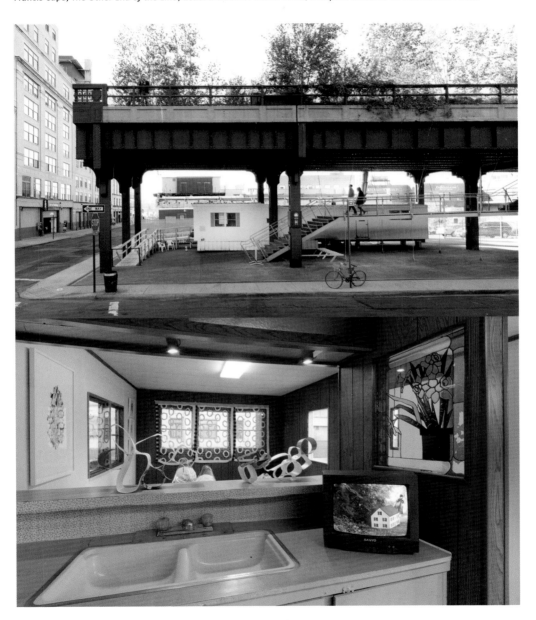

Kim Beck, *Space Available*, 2011. Plywood and steel, 3 elements, 15 x 9 x 12 ft., 18 x 15 x 12 ft., and 18.5 x 19.5 x 12 ft.

Of course, the limits and challenges of such a site can stimulate creative solutions while also expanding the parameters of public art. Responding to the shortage of large display areas as a way to move beyond the association of public art with sculpture on pedestals, Lauren Ross, who served as the first High Line Art curator, presented dance, performance, photography, and sound pieces in addition to sculptural installations. Many of these commissioned pieces encouraged public involvement. Sue de Beer's *Haunt Room*, an interactive sound environment set within a 15-foot-tall, box-like structure of smoke-colored Plexiglas panels, invited the audience to explore the aural, optical, and psychological experience of barely audible sounds. Francis Cape's trailer home tucked under the High Line's entrance stairwell examined notions of transience and mobility in collaboration with 13 artists from upstate New York whose works were displayed inside. Sarah Sze was probably more successful than some in finding a way to integrate her work into this public park. Bisecting the lateral trajectory of the High Line's planked walkway, her wire structure of architectural models set into a perspectival grid acted as an elaborate gate for visitors to pass through. This mini-metropolis and three-dimensional town plan included perches, birdbaths, and feeding stations that attracted birds and butterflies. Functioning as sculpture, urban metaphor, and interactive wildlife observatory, Sze's piece engaged the viewer in a dynamic dialogue about art, nature, science, and urban life.

The narrowness and limitations of the viaduct also led Ross to look for sites "off-line," on private property. In one of the first of these non-sites, Kim Beck's sculptural structures resembling metal billboard supports were installed on three rooftops along the High Line, where they offered a sly commentary on increased development and commercialization in the surrounding area. Complemented by a performance in which a skywriting plane trailed advertising slogans, Beck's sculptures blended in with their industrial milieu so well that they might have been mistaken for real billboards, if not for their ghostly structures and lack of purposeful message. Like Beck's installation, which encouraged viewers to take in the rooftop views, Trisha Brown's *Roof Piece* performance, a mutable, improvisational dance first presented in SoHo in 1971, also had people looking to the tops of buildings at the southern end of the High Line as 10 dancers interacted with the urban topography.

Though this performance roster (including Simon Forti's experimental dance *Huddle* and Alison Knowles's restaging of her Fluxus piece *Make a Salad*) and the film program add to the High Line's public art offerings, they could be mistaken for entertainment or public programming, not unlike the concerts that occur regularly in other city parks. But perhaps this is the goal—to create random occasions for visitors touring the park to encounter and have an art experience.

The High Line Billboard, a 75-by-25-foot sign in a parking lot near 18th Street, provides yet another way for the public to see and interact with art. Offering a large flat surface in a highly visible location viewable from the viaduct as well as from the street, the billboard invites creative intervention. One of the earliest of these projects, organized by one of the original supporters of the High Line, Joel Sternfeld, was a series of giant photographs collectively called *Landscape with a Path*. In addition to Sternfeld's own photograph of the viaduct and railroad tracks covered with native plants and flowers, the series included Robert Adams's photograph of a Nebraska highway and Darren Almond's image of China's Huangshan mountain range during a full moon. Panoramic in scale and vista, these images emulated 19th-century American landscape imagery, offering a nostalgic interlude that, while incongruous with the parking lot location, could also be confused with a gigantic travel poster.

Demetrius Oliver's mysterious photographs of props and staged activities were far more disruptive. Resembling a collection of orbs or a gathering of planets suspended in a dark void, and complimented by performances from John Coltrane's "Jupiter (Variation)" and a celebration of the autumnal equinox, Oliver's billboard invited visitors to look more carefully and align their observations with a broader cosmological outlook. Likewise, John Baldessari's image of a $100,000 bill

John Baldessari, *The First $100,000 I Ever Made*, 2011. Print on vinyl, 25 x 75 ft.

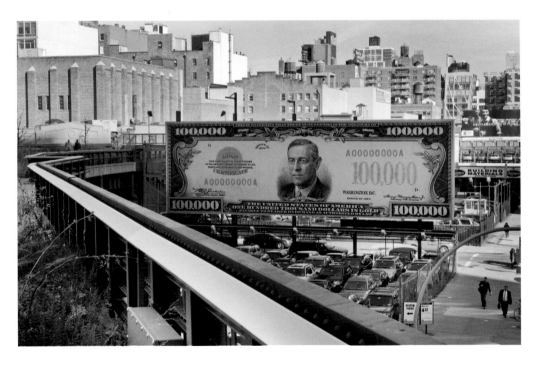

and Maurizio Cattelan and Pierpaolo Ferrari's wonderfully surreal collage of severed fingers on a blue velvet background served up savvy, staged interventions that interrupted the flow of image and commodity usually associated with billboards and the street, causing even a casual passerby to take a second look. While intriguing, even mysterious, the latest billboard—Elad Lassry's large-scale, colored photograph of two nearly identical women looking out of portholes against a green background—duplicates many contemporary advertising strategies, which hardly distinguishes it from its neighbors. As the billboard project evolves, one can hope that curators will look beyond photography as a way to make this space into an even more engaging venue for public art.

Since the first section opened in 2009, the High Line has become a popular tourist destination, with four million visitors last year. Luxury housing and hotels have been or are being built all along the route, spurring further development and higher real estate prices in an area once frequented by cruising prostitutes. Nearby Chelsea galleries, inspired by the foot traffic on the High Line, are installing sculpture on their own rooftops. Condos are marketing their proximity to the park as a selling point, and some have even commissioned artists to make installations in their common areas adjacent to the Line. Local artists have put their work on display in windows, fire escapes, and backyards in hopes of patronage, and the graffiti artist JR brought his Inside Out project to a wall adjacent to the High Line at 29th Street, where he and his crew pasted up a four-story-tall portrait of the Lakota Tribe's Brandon Many Ribs.

Indicators of the success of the High Line and its public art program, as well as of the impossibility of controlling what happens in the open spaces around the viaduct, such endeavors—in addition

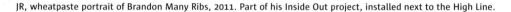

JR, wheatpaste portrait of Brandon Many Ribs, 2011. Part of his Inside Out project, installed next to the High Line.

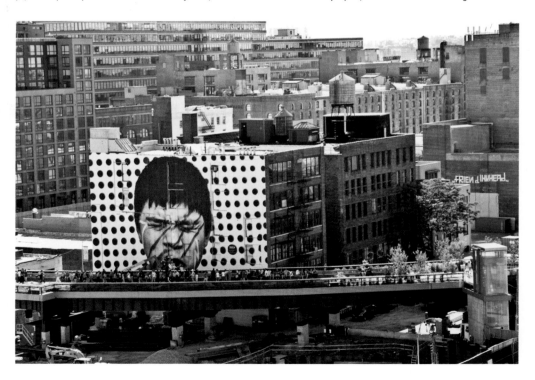

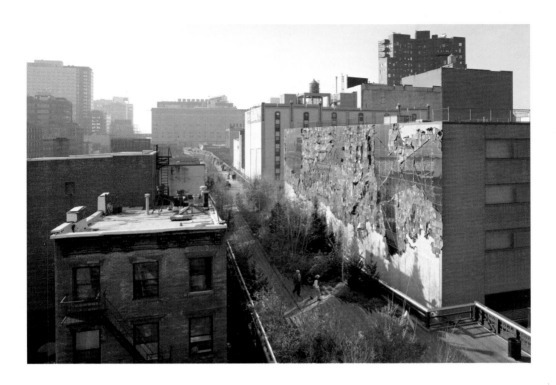

El Anatsui, *Broken Bridge II*, 2012. Pressed tin and mirrors, 37 x 157 ft.

to the changing landscape of the High Line itself—test the curator's ability to present an engaging, focused, and cohesive exhibition program. Indeed, it is a challenge to figure out new ways to expand the parameters of public art within the very carefully designed and limited platform of the High Line, while at the same time trying to avoid being viewed as a promotional tool for real estate interests. Current curator Cecilia Alemani acknowledges and welcomes the difficulty, though her exhibition "Lilliput" falls back on a more traditional approach, with small sculptures installed in a number of spots along the Line. Although the miniature scale is meant to counter the monumentality of a typical public art installation, most of the works get lost in the park's dense vegetation. The one exception is Tomoaki Suzuki's *Carson*, a mini-Michelangelo dressed in black leather who stands on the railway bed near a bench; he is so popular that he has his own Twitter feed. Juxtaposed with the many diminutive works in the show, Thomas Houseago's *Lying Figure*, a large cast bronze of a male nude, has a more visceral appeal, his reclining pose a comfortable fit for the train tracks under the Standard Hotel. More promising is the installation of El Anatsui's large-scale tapestry *Broken Bridge II* on the large western wall between 21st and 22nd Streets in October 2012. Made of mirrors and pressed tin formed into a wave pattern that reflects and projects color and light back onto the park, this piece, the artist's first outdoor work in the U.S., will, due to its scale and manner of construction, certainly bring even more visibility and patronage to this elevated park and ongoing experiment in public art called the High Line.

Bridging Art and Life: Documenta and Skulptur Projekte Münster (2013)

by Lilly Wei

When Documenta was established in 1955, it was not primarily a contemporary art exhibition, nor was it thought of as an outdoor public art project. The brainchild of artist, educator, and curator Arnold Bode, it was conceived as an act of recuperation after trauma, a strategic use of art more recently deployed at Prospect.1 in New Orleans following the devastation of Hurricane Katrina. Documenta I provided an opportunity for Germany and German artists to re-engage with the European avant-garde after the country's catastrophic recent history, showing major modern artists like Picasso, Kandinsky, and Matisse. The choice of Kassel as host location was also significant. A former munitions center with its own forced labor camp near the divide between East and West Germany, the city was nearly annihilated by Allied bombings between 1942 and 1945. Emphasizing not only art, but also a conflicted history and ravaged exhibition venue—the Fridericianum— Documenta I became a resounding, unexpected success, a symbol of Germany's cultural revival and restoration.

Over time, the focus of the exhibition, which takes place every five years for 100 days, shifted almost exclusively to contemporary production, much of it commissioned and installed throughout the city in both art and non-art venues. An avoidance of market machinations and a tradition of inquiry have been crucial to Documenta's identity, emphasizing the relationship of art and culture to the political, social, economic, and scientific spheres in which global outreach, the clamorous, problematic present, and vestiges of Germany's complicated past are inevitably and variously intertwined. The spirit of Joseph Beuys, five-time participant between 1964 and 1982 and Documenta's venerated genius loci, still hovers over the show, which is now in its 13th edition.

For Documenta V, Beuys established the Organization for Direct Democracy Through Referendum at the Fridericianum, where he was in residence, and talked with visitors for the event's entire 100 days. This project highlighted what would become both his own mission and that of Documenta: the integration of art into the social fabric. The desire to explore, expose, and reconcile the complex, problematic relationship between art and social reality pushed art into the public domain, into the streets, squares, parks, and buildings of Kassel and its life, often on a monumental scale. Beuys's celebrated *7000 Oaks*, an ambitious project that has become part of Kassel's landscape and a symbol of the city, as well as an important part of the social art and environmental sculpture canon, was inaugurated at Documenta VII in 1982. The plan called for volunteers to plant 7,000 trees around the city, each paired with a basalt marker rising approximately four feet above the ground. Transported from a nearby quarry, the stones were initially piled in front of the Fridericianum. On March 16, several months before the opening, Beuys planted the first tree with its stele. The project continued over the next five years under the supervision of the Free International University, with the dwindling heap

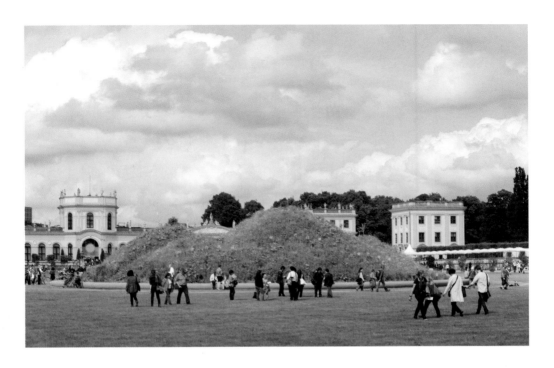

Song Dong, *Doing Nothing Garden*, 2010–12. Rubbish and building refuse, plants, and neon signs, 7 x 32.5 x 23.5 meters. View of work at Documenta XIII.

of basalt stones in front of the museum an indicator of its progress. Planting sites were proposed by residents, neighborhood councils, schools, local associations, and other organizations. At the opening of Documenta VIII in June 1987, a year and a half after Beuys's death, his son Wenzel planted the last tree.

The definition of art as socially engaged, inclusive, environmental, activist, responsive to site, dematerialized, and in the public domain has been espoused by many Documenta curators and artists over the years. Documenta XI extended the definition and the reach of the event through an 18-month, around-the-world series of symposia, a kind of dematerialized public art show held prior to the opening of the physical exhibition in Kassel (which was only considered its Fifth Platform, not necessarily the central event). Pascale Marthine Tayou, reiterating that outreach, installed a live feed from Cameroon. Documenta XIII, the 2012 show, also extended beyond Kassel to Kabul-Bamiyan, Cairo-Alexandria, and Banff, an outsourcing that further exploded the idea of a fixed (and limited) location for international exhibitions. This strategy breaches geographical limits in the same way that artists once breached the walls of museums and galleries. These additional sites point the way to a more comprehensive formulation for future Documenta projects and their accessibility, a vision of interconnection earlier exemplified by Martin Kippenberger's imaginary global subway system, *Metro-Net*, the plans for which were presented at Documenta X in 1997.

For Documenta XII, China's most prominent artist and activist, Ai Weiwei, flew in 1,001 Chinese farmers, teachers, artists, students, engineers, and ordinary people from all walks of life (chosen from an open call on his blog) to visit Kassel. He called these participants "tourists," and for many

of them, it was their first trip outside of China. *Fairy Tale* (Kassel was the home of the Grimm brothers for many years and has a museum dedicated to them) was conceived as an act of direct confrontation and exchange, another version of social sculpture (at a reported un-proletarian cost of over $4 million).

For Documenta XIII, Song Dong erected a flourishing, somewhat unkempt, six-meter-tall hummock of refuse, compost, and weeds on the pristine lawn of Karlsaue Park in front of the Orangerie. *Doing Nothing Garden* formed a comic, biodynamic version of the Chinese sublime, encircled by a low ledge (much used as public seating) to create an ad hoc social center. Pierre Huyghe's enormous crater-like excavation at the other end of the park was more enigmatic. This surreal garden featured a painted dog, a beehive-headed sculpture of a reclining nude female figure, and poisonous fruits and marijuana, among other plantings. Huyghe's notes identified a tree incorporated into his work as a toppled Beuys oak. Theaster Gates moved out of the park to renovate Kassel's crumbling Huguenot House, an 1826 building bombed during the war and abandoned since the 1970s, using salvaged and repurposed materials from his Dorchester House on Chicago's South Side. Reciprocally, remnants from the Huguenot House will be incorporated into the Dorchester dwelling. As an installation, performance site, and community center for visitors to Documenta — reprising, or perhaps extending, the Chicago project — the Hugeunot House rehab was conceived as a Beuysian *Gesamtkunstwerk*, including videos of performances and live music, Gates's sculptures and reliefs, food and conversation — and permanency. Gates hopes to purchase the Huguenot House and turn it into a site for artists' residencies connected to future installments of Documenta.

Skulptur Projekte Münster takes place every 10 years (concurrent with Kassel and Venice, the last time in 2007), and, like Documenta, it lasts for 100 days. Also like Documenta, it strives to remain free from market considerations, to be experi-

Pierre Huyghe, *Untilled* (detail), 2011–12. Living entities and inanimate things (made and not made), dimensions and duration variable. View of work at Documenta XIII.

Adrián Villar Rojas, *Return the World*, 2012. Unfired clay, wood, cement, and metal, view of work at Weinberg Terraces, Documenta XIII.

mental and experiential. That it does so, perhaps more successfully, is due in part to its refusal to overreach. Münster is the smallest and the youngest of these events, established in 1977. It is located in a conservative university town, 125 miles from Kassel, which was also destroyed during the war but more faithfully restored. Münster is noted for its dedication to one discipline, charting how sculpture has expanded over the years from an object-oriented stance to include performance, installation, sound, video, and film while moving from formal considerations to the social and participatory, from the ordered to the random — the demarcation between sculpture and other disciplines increasingly ambiguous or ignored.

Münster has always been distinguished by its commitment to site-specificity based on local political, geographical, and social narratives, more absolutely since 1987. Works appear in unfixed locations throughout the town's public spaces, forgoing museums and other art institutions. Artists are asked to select a site and then make work that responds. Although two of the previous exhibitions boasted a relatively long roster of artists, Münster has never aspired to the size of Documenta. The original show had nine artists, and the 2007 edition featured 34, a mix of the notable and the lesser known. Münster is not as polished as Documenta, the production values are not as high, and the work varies more in quality, but often it is satisfying for those very reasons. It is possible to see everything without staying the full 100 days that Documenta often seems to demand from its ideal, and also privileged, viewer — despite its populist assertions (who else would have the time and wherewithal?).

In all its iterations, Münster has been presided over in some capacity or another by curator and museum director Kasper König, with König, Brigitte Franzen, and Carina Plath acting as co-curators for 2007. Each edition of Documenta since 1972, on the other hand, has relied on the vision of a single curator. Münster sets no theme, unlike Documenta and most other exhibitions of this kind. König has said with disarming self-deprecation that audiences don't want to know the opinion of the curator, they want to see what the artists are doing. "I think that if a curator adheres to a theme, it is often the case that he or she is manipulating, controlling, trying to make the artists subordinate to that theme." He concluded, "It is much more interesting to remove the idea of the theme from the process, so that the artists themselves can be surprised by what they ultimately do." The 10-year hiatus is also instructive. König believes that interval is needed to see real changes in art, though it may be too long for today's accelerated pace.

Münster was founded in a different era than Documenta, a time much more removed from the aftermath of war, though the event also arose out of conflict. After an acrimonious debate over a donated, and refused, Henry Moore and an equally bitter fight over an accepted George Rickey, König and Klaus Bussman resolved to educate the city about contemporary sculpture and the relationship between art and public spaces. It was not an easy sell; many people had to be convinced of the merits of public sculpture—the vacillating city government, the Catholic church (a force in Münster), and the general public. The international press, however, put the show on a par with Documenta from the beginning. With this success, it, too, has become a source of civic pride, even if much of the town's interest seems to center on the decennial influx of art world visitors (and revenue), which offers its own form of spectacle that might be called social sculpture.

An artist-centered alternative to the extravagance of Documenta, Skulptur Projekte Münster makes

its own significant contribution to the discourse on contemporary outdoor art, with its own Beuysian slant (he participated here as well). Unlike most exhibitions of this kind, it retains works from previous installments as part of its mandate, for a total of 39 to date. Consequently, an ongoing dialogue between past and present demonstrates how site-specific works and public art have changed through the years. Continuity is further assured by inviting some artists to return. Michael Asher, for instance, has appeared in all four shows.

Among the sculptures still in Münster are works by Donald Judd, Siah

Ayşe Erkmen, *Sculptures on Air*, 1997. 13 stone sculptures, helicopter, safety belts, metal tighteners, carabiners, steel plates, bars, and pallet. View of work at Skulptur Projeckte Münster.

Pawel Althamer, *Pfad / Sciezka*, 2007. Path measuring approx. 1 kilometer. View of work at Skulptur Projekte Münster.

Armajani, Ian Hamilton Finlay, Dan Graham, Jorge Pardo, Herman de Vries, Martin Boyce, and Rosemarie Trockel. Judd's large double ring of concrete, weathered and etched with remnants of graffiti, is from the first show. Pardo's minimal *Pier* (1987) stretches elegantly into the Aasee, the town's large lake. Graham's *Octagon for Münster*, a signature mirrored glass pavilion, creates perceptual and psychological disruptions. de Vries's *Sanctuarium* (1997) is still a work in progress, continually altered by random additions. A traditional brick garden wall with no entrance encloses a space thickly populated with trees, plants, birds, and insects, glimpsed through four small oval windows. The exterior is scribbled over in bold, colorful graffiti — outdoor art is always an invitation for collaboration — and the whole forms an entropic dialogue between nature and culture, order and chaos.

Some artists from 2007 critiqued Münster's site-specific tradition. Dominique Gonzalez-Foerster made substantial-size models of site-specific sculptures from past and present Projekte and placed them in a park where they became objects rather than site-specific work. Pawel Althamer cut a narrow path more than a kilometer long through several fields of tall wheat, permitting only single-file passage through a simple, but lovely interpretation of sculpture and site-specificity. The use of local history as a signifier of site-specific work was, as usual, a common strategy. In the town center, Silke Wagner's overly large-headed statue of Paul Wulf (1921–99), a victim of Nazi sterilization, was cloaked in materials that documented his search for redress, claiming public space for political purposes. Hans-Peter Feldmann vastly improved the public restrooms in front of the cathedral with new sinks, tiled walls, and chandeliers — art as public service. Destruction of public space — public space itself might be a work of public art — was addressed by Annette Wehrmann, who built a construction

site for a fictitious spa on the shores of the Aasee. Andreas Siekmann made a large, unsightly ball from the fiberglass detritus of past municipal art projects, believing that the only way to resist the trivialization of public art is to make it unassimilable as décor.

Münster, rather than Documenta, might seem the obvious model for site-specific, outdoor public sculpture exhibitions, but in some ways, they are not so different. What do sculpture and site-specificity mean today, and more significantly, what will they mean in the future? What function will site-specific sculpture have? What function will art have? Documenta XIII's artistic director, Carolyn Christov-Bakargiev, said, "I am not sure that the field of art will continue to exist in the 21st century," at least as we presently categorize it.

These two exhibitions and many like them, have already given us a partial answer even as they pose questions. As ideas about what constitutes public space for art are redefined, public art becomes redefined. Contemporary art does not stand apart from the world or from life, and separation into artificial, outmoded disciplines and forms is insufficient to capture the complexities of modern existence. As Althamer's narrow pathway through Münster wheat fields and Documenta XIII's 400 postcard-sized apple drawings by Korbinian Aigner, a Bavarian pastor who developed four new strains of the fruit while imprisoned at Dachau, both demonstrate, the authenticity and audacity of the imaginative can transform everything into art. When Beuys repeatedly said that everyone is an artist, he was urgently acknowledging the primal, instinctive desire to create that is in each of us. And if everyone is an artist, then public art may indeed become truly public.

Fokus Łódź Biennale—From Liberty Square to Independence Square (2013)

by Gregory Volk

I'd like to begin with full disclosure. I was one of the selectors for the 2010 Fokus Łódź Biennale, and I've been involved with artists and exhibitions in Łódź since the early 1990s. In my opinion, the free-wheeling and exuberant Łódź Biennale is a wonderful and innovative affair that compares favorably with exhibitions of its ilk realized at far greater cost and with far more developed infrastructures. Exactly why the Łódź Biennale has proven so successful has to do, in part, with what it adamantly, even gleefully, avoids: grandiose themes and curators who serve as the focal point. Instead, the Łódź Biennale is a risk-taking exhibition with a real focus on artists, many of whom present their work in unorthodox, non-institutional sites, so that the show becomes embedded in the city, a temporary part of urban life.

Łódź restores the wonder, enthusiasm, challenge, mystery, humor, and delight that get down-played in biennials-as-usual. Risky and innovative works gather one's attention visually, intellectually,

Daniel Knorr, *Stolen History—Statue of Liberty*, 2010. Aluminum frame, polyester, and carbon fiber, 5.3 x 3 meters.

emotionally, and perhaps even soulfully. It also demonstrates what can happen when artists, and not just artworks, gather to form a free-spirited, temporary community. In Łódź, large-scale exhibitions double as just such a meeting ground, in which informal interaction between diverse artists, as well as between artists and the public, is an important and essential part of the show. What happens in the exhibition venues is important, but so, too, is what happens in the bars, restaurants, at breakfast, on the street. Enduring friendships are formed, ideas exchanged, and it is my informed guess that the human "energy" of the exhibitions continues and flourishes long beyond the closing date.

The Łódź Biennale, whose first installment in 2004 celebrated Poland's admission to the E.U., is indebted to the "Construction in Process" exhibitions begun in Łódź in 1981 by Ryszard Wasko and others, including the great Łódź-based artist Jozef Robakowski. The first show, held during the height of Solidarity (and later shut down when the government declared martial law), received a great deal of acclaim. It was an important, and crucial, event in the Polish art scene of that era—a wildly, even absurdly, improvisational event that brought together renowned artists from the West (some exhibiting in Poland for the first time) and artists from the East. What is of particular interest to me is not only this important historical event, but the scope and character of later events organized by Wasko and others, which are linked to this special history but have taken those energies and developed them, oftentimes in surprising and fruitful ways.

As near as I can determine—and I have participated in several "Construction in Process" exhibitions over the years in Poland, Israel, and Australia—the essential component was how these art events were flooded, so to speak, with *life*. They involved not only the display of finished artworks, but also the process by which the works were made, the unfettered human exchange occurring between the artists during the installation process—which could be sloppy and exalted, brilliant and ridiculous—as well as between the artists and the public at large. For many participants, these events proved memorable and cathartic, exactly the kind of thing that you might have wished for but rarely, if ever, found. The thing about exhibitions organized by Wasko (and others)—really the spectacular quality of "Construction in Process" events—is how they took this communion and pushed it to the extreme, to the point where it became an essential part of the whole event, something bound into its very character. In an often fractious art world, these transformative events proved welcome and essential.

While Wasko served as artistic director of the Fokus Łódź Biennale and was a major influence, and while some of the other principal organizers are also veterans of "Construction in Process" events (Adam Klimczak, Ewelina Chmielewska, Łucja Wasko-Mandes), this wasn't a new version of a "Construction in Process" exhibition, chiefly because it dispensed with or relaxed two longstanding tenets, namely that artists be selected by other artists, and that all artworks be developed on site during the installation period. Here, a committee of international selectors (including artists, critics, and curators) chose the participating artists, and while many of the projects were realized specifically for and in Łódź, others were not. The result was a more intact and professional, yet still experimental and improvisational, exhibition that retained a great deal of the vigor, humanity, and generosity of "Construction in Process" events.

The Fokus Łódź Biennale started from a simple, yet marvelously evocative, premise: a walk down Łódź's main avenue, Piotrkowska Street, between two landmarks—Liberty Square and Independence Square. Call it a Minimalist idea with a nod toward conceptual art: a long walk through the city, a line demarcated by art, and more lines "drawn" by visitors as they moved down the avenue from art-

work to artwork. Rather than responding to an abstract or general notion of "the street," the show engaged one specific street, Piotrkowska Street, said to be Europe's longest urban boulevard. As viewers walked from artwork to artwork, they also absorbed and responded to Łódź: its present and past; its architecture; signs of renewal and abiding decay; abundant indications of capitalism; abundant reminders of communism; many indications of the city's 19th- and early 20th-century status as a manufacturing center; and, finally, its daily, civic routines. The two landmarks also resonated, reaching back to Łódź's origins as a special free-market manufacturing center in 1815 and to the collapse of the communist government in 1989.

Most of the works were exhibited in apartments, former factories, cultural venues, and stores on or very close to Piotrkowska Street, not in museums or galleries. Some occurred on the street, for example a remarkable concert arranged by artist Zorka Wollny and composer Anna Szwajgier, both based in Krakow. The renowned composer Artur Zagajewski, who is from Łódź, emphatically conducted his *Umhum for 23 Musicians and 52 Pedestrians*. Suddenly appearing on balconies and in doorways, 20 members of the Łódź Philharmonic performed enthralling and haunting music that merged with accidental street sounds and life.

Unencumbered by an institutional framework, the resulting works inspired a considerable spirit of freedom and discovery in viewers. Surprises abounded. You could turn down an alley to encounter Daniel Knorr's (Romania/lives in Berlin) black, looming, and frankly unnerving sculptural rendition of the head of New York's Statue of Liberty, suspended in a courtyard. You could climb rickety stairs

Erika Harrsch, *United States of North America*, 2009. Interactive installation with spinning fortune wheel, give-away passports, banners, posters, 24 framed Gicleé prints, limited edition passport inside of entomological box on a pedestal, and participatory games.

to enter an abandoned apartment and discover a swirling, luscious, and quietly spectacular black wall work by Ragna Róbertsdóttir (Iceland) made of lava chips gathered at the volcanoes in her home country. You could duck into a café to view three tremendous videos by Cao Fei (China), from her *RMB City*, a virtual realm in the on-line world of Second Life. You could, if you were lucky, encounter a procession of devout Catholics parading up Piotrkowska Street, with national and religious flags held aloft, and then discover Grzegzorz Klaman's (Poland) installation of white flags: blank flags, flags of surrender, flags promoting no political party, endorsing no government, and extolling no religious creed, offering instead a visual respite from competing ideologies, values, and creeds.

Given the Łódź Biennale's comparatively low budget, many of the artists went all out with ambitious projects. In the theater of the formerly grandiloquent, and now partially ruined, Old Philharmonic building, the Irish duo Kennedy Browne (Sarah Browne and Gareth Kennedy) presented their high-definition video *How Capital Moves*, inspired by the 2009 closing of a Dell computer plant in Limerick, Ireland, and its relocation to Łódź. Using an on-line forum in which employees and former employees of Dell (not named in the video but simply, and ominously, called "The Company") anonymously discuss their worries and grievances as a source, the artists developed six different characters with fictional stories, performed by the same Polish actor (Tomasz Mandes), always wearing pajamas. The pajamas allude to an incident in the U.S. in which Dell employees were summarily fired on a "pajama day." At once absurd and hard-hitting, comical and probing, Kennedy Browne's video effec-

Ati Maier, *Event Horizon*, 2010. Video with animation and sound by Remi Pawlowsky, 3:06 min.

Via Lewandowsky, *Street Life*, 2010. Street lamps on Piotrkowska Street.

tively deals with lives shaken, disrupted, or made tenuous by corporate decisions. Erika Harrsch (Mexico/lives in New York) devised a humorous, yet politically confrontational "government office" on Piotrkowska Street dispensing convincing, although entirely bogus, passports from the fictional United States of North America.

The Old Philharmonic building was the perfect setting for Kennedy Browne's video, as well as for a number of other impressive works. In the dark and foreboding basement, Miru Kim (Korea/lives in New York) engaged in an extended performance just visible through a small hole in the wall. Naked, she wallowed about in mud like a pig, making for a peculiar mix of animal and human, eroticism and vulnerability. Tavares Strachan's (Bahamas/lives in New York) project involved a broken beer bottle on the floor. Using advanced glassmaking and laser-cutting techniques, he meticulously duplicated the shattered bottle in its exact configuration, making for a marvel of creation and destruction, accident and plan. Ati Maier (Germany/lives in New York) projected an overhead animated painting/video involving cosmic exploration. Its effect in the space was masterly: a 21st-century, digital-era version of ceiling frescoes. With works such as these, the semi-dilapidated building temporarily became an active and renovated zone.

Some artists responded to the "street" context, for instance Tacita Dean (Great Britain), who devised postcards and sent them to every address on Piotrkowska Street. Dan Perjovschi (Romania) printed his own newspaper, filled with his politically and culturally charged, doodle-like drawings,

and distributed it to passersby. Kamil Kuskowski (Poland) placed loudspeakers along Piotrkowska Street, which played music and songs concerning liberty and freedom from different countries. Via Lewandowsky (Germany) attached a second "arm" to a functioning street light, which reached into a third-floor apartment to illuminate an interior emptied of everything save for one chair. Lewandowsky's work, in particular, revealed what was truly excellent and refreshing about this exhibition. A quotidian street light, the kind you pass all the time but rarely, if ever notice, was suddenly diverted from its usual position and function and given a new role and identity. This "hacked" or "pirated," deviously misbehaving object was also an outlandish reminder of how people used to steal electricity during socialist times. It was hilarious, yet the work resonated with complex encounters between public and domestic space, mass culture and private consciousness.

In Łódź, walking up and down Piotrkowska Street is a fundamental part of daily life, and part of the street has largely been turned into a pedestrian zone. For the duration of the exhibition, this normal walk suddenly turned abnormal, eccentric, and invigorating. The street and the city as they ordinarily are, and as they were temporarily reconfigured by art, coexisted, and it was for viewers to navigate between these two contexts. The art became part of the city, part of life in the city, and served as a transformative and renovating force. You had the feeling that the organizers cared deeply about their city and were offering something very important: not merely an exhibition, but sustenance, wonderment, joy, challenge, humor, and provocation.

Public Art in India: Khoj and Its Transformative Vision (2013)

by Minhazz Majumdar

Public art in India is an often controversial arena, just coming into focus for artists, curators, art organizations, and last but not least, the public. For many years, what passed for public art in post-independence India consisted of generic representations of freedom fighters, political leaders, or religious figures, with an occasional mural or two. Commissioned by government departments as decorations with an underlying goal of perpetuating national pride and identity, these sculptures occupied high pedestals in public parks or fenced-off traffic circles, affording little interactivity. Today, in contrast, private organizations, artists, and in some cases, proactive city councils are undertaking exciting initiatives in major metropolitan centers and in smaller towns across the country.

In a country as geographically vast and culturally diverse as India, the definition of public art and its experiential elements raises numerous dilemmas. What is considered public or private in a country of a billion-plus people, where a person's life can play out on the street, where notions of space and privacy are radically different from standards in the rest of the world? What is art and what is not art in this ancient country, with its multiple cultural and artistic traditions and practices? Just

Thukral & Tagra, *Monday Market, Pehno at Pushp Vihar*, 2010. Part of *PUT-IT-ON*, an ongoing project that explores alternative ways to raise awareness of HIV and AIDS.

walking down a busy street in India can become a means of informal aesthetic engagement—the small, unintentional installation of religious statues under a tree, street hawker performances, colorful folk art on exterior walls, and vibrant posters and hand-painted signs visible everywhere including on truck bodies. What of the gigantic tableaux and floats that accompany religious festivals like the Durga Puja and the Rath Yatra, which engage thousands in interactive experience?

Even if we define public art as "art that is planned and executed by artists and curators to be staged or sited in the public domain and easily accessible," the idea is rife with potentialities and problems in the Indian context. There is tremendous debate about the accessibility of popular venues such as airports, shopping malls, and lobbies of five-star hotels given the gap between rich and poor. What is the line blurring art in public and public art? How inclusive is public art? Barriers between the art object/experience and the viewer/participant are built on elitist and exclusionist foundations. Given its strong potential as a tool for social and political critique, public art in India can serve as a call for action and change by focusing attention in a non-didactic manner on key societal problems, an idea that many public art initiatives in India have put into practice.

Khoj International Artists Association, an artist-led organization providing alternative space for experimentation and international exchange, has been spearheading public art initiatives in India since 1997. At that time, art was confined to the walls of a few galleries in major cities, and opportunities for experimental art and public art beyond the conventional were limited. Yet, ferment was growing, as artists prepared to go beyond the formulaic began to search for something new. The idea for Khoj came from Robert Loder, founder of the U.K.-based Triangle Arts Trust, who suggested that India needed a stimulating, creative space for experimental art, a place where artists could freely

Sylvia Winkler and Stephan Koeperl, *The PPR Experience (Passenger-Propelled Rickshaw)*, 2010. Modified rickshaw.

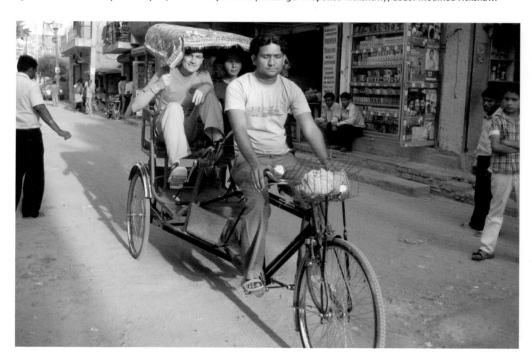

express themselves outside the confines of prescribed academic approaches and gallery interests. This concept resonated with curator/arts administrator Pooja Sood (current director of Khoj) and artists Anita Dube, Manisha Parekh, Bharti Kher, and Subodh Gupta, who together set up Khoj.

For its first three years, Khoj—in Hindi, the name means "a search"—focused its efforts on an annual two-week International Workshop held in Modinagar, a small industrial town close to Delhi. The leading business family, the Modis, offered living and working space for artists on one of its many estates. These workshops, which brought together emerging and established artists from India and around the world (with particular emphasis on artists from Asia and Africa), opened new paths of self-expression and fostered unusual partnerships for the artists. In 2000, Khoj began its program of artist residencies, both national and international, and established itself in Khirkee, one of Delhi's many urban villages, which has a rich history and a vibrant local community. Today, Khoj "plays a central role in the development of experimental, interdisciplinary, and critical contemporary art practice in India, constantly challenging the established thinking about art."

Khoj's site-specific endeavors remove art from a private sphere of consumption enjoyed by the privileged few and bring it into the public domain. Sood explains, "Given the fact that we do not have a museum-going culture in India, if artists want to communicate beyond collectors and fellow artists, it is imperative to put their art in public spaces." For Khoj, public art is not limited to show-casing a physical art object; its goals extend to creating an art experience, fostering engagement, and stirring up reaction (positive or negative), all of which are premised on the primary objective of bringing art to people who would typically not venture into a gallery. Khoj actively seeks to push the boundaries of public art in India, expanding its scope and application beyond permanent sculptures to include process-driven, ephemeral projects that focus on research and action, that incorporate causality as well as a local space and time.

Khoj's public art programs encourage multidisciplinary collaborative efforts, some quite radical and new in an Indian context, bringing hitherto unexplored facets of Indian life and culture into the ambit of art. As a result of Khoj's commitment to investigational modes of art creation, and because it is difficult to secure permission for permanent artworks, its public projects tend to be temporary, the transitory nature of the art-making and viewing itself becoming a highlight.

Khoj's forays into public art began with residencies in 2004 for Indian and international artists and small-scale projects in the public arena, including community art projects in Khirkee. Khoj now sponsors a full program of international residencies, workshops, site-specific works, temporary instal-lations, performances, and interactive events by both Indian and international artists. Recent proj-ects include *Om: Mating Season No. 11* (2010), Chinese artist Han Bin's erotically charged multimedia performance focusing on the garbage spawned by India's rising rate of conspicuous consumption, and *Bhogi/Rogi II (Consumption/Disease)* (2011), an interactive installation by Sheba Chhachhi and Thomas Eichhorn alluding to transgenic food and how we are defined by what we consume.

In 2010, Khoj initiated "In Context: public.art.ecology," a major public art/residency program. Part of Khoj's ongoing engagement with the interface of art and ecology, the first "In Context" fea-tured projects by Aliya Pabani, Andrea Polli and Chuck Varga, Namrata Mehta, Navjot Altaf, Sheba Chhachhi, Sohei Iwata, Sylvia Winkler and Stephan Koeperl, Tejas Pande, Thukral & Tagra, and Thomas Eichhorn. Their projects, which took place across New Delhi, addressed a variety of themes, including energy efficient and eco-friendly transportation, weather patterns, climate change, urban greening, water-purification, and the links between memory and identity. Winkler and Koeperl's *The*

PPR Experience (Passenger-Propelled Rickshaw) cleverly shifted the working dynamics of the rickshaw to raise a host of social and environmental issues. The rickshaw driver is counted among the poorest of the poor, earning a livelihood through exhausting physical labor — pedaling seated passengers to their destinations. By flipping the equation and making the passenger work while the rickshaw driver steers, Winkler and Koeperl change the power balance, creating a situation that requires cooperation and equal status if the rickshaw is to get anywhere. In performance, *PPR* offered a fun way of highlighting energy efficiency, healthy living, and the politics of urban transportation without being overly serious or moralistic.

Polli and Varga's *Breather,* a stark and alarming work focusing on the auto emissions that pollute Delhi and many other cities worldwide, was based on a clever conceit — a lung-like plastic bubble encasing an iconic Maruti car (which heralded the arrival of cheap cars in India, contributing to both greater mobility and worsening air quality). Their Maruti was painted with a slogan in Hindi and English proclaiming, "One person dies every day from air pollution in New Delhi." Mimicking the act of breathing, the plastic sack inhaled the ambient air, expanding in size, and then exhaled, contracting until it stretched tight across the car, apparently choking it and forcing it to exude fake exhaust gas (stage smoke). Public reaction to *Breather,* which appeared in a swanky shopping mall, was interesting — some viewers were so overwhelmed that they felt breathless and complained to the management about the fake emissions.

The 2011 edition of "In Context: public.art.ecology" examined the convergence of science and art and added a critic-in-residence, Jyoti Dhar, to the mix of participating artists. The idea was to "investigate and explore sites of science pursued through its diverse projects…[and] break down the language barrier between art and science…opening up a world of possibilities and creative ideas emerging from current developments in technology and scientific research." Works by Ackroyd-Harvey, Brandon Ballengée, Navin Thomas, and Pratik Sagar included living ecosystems for insects, an organic grass photosynthesis photograph, an interactive bird habitat, and a living wall of green barley.

This year's "In Context" focused on "food as artistic medium, incorporating performance, art installations, or interactive events that re-examine the significance and relevance of food in the social context, in its connection with the body, or as a primary ritual that fosters engagement, interaction, and collaboration." The project included a video installation on the politics of biscuits as fortified food by Frame Works Collective; a series of communal ceremonies (Fosfofagias) involving fluorescent food and drink by Spanish artist Alfonso Borragán; Indonesian artist Julian Abraham's interactive, sound-based re-creation of making cheap fermented liquor; Shweta Bhattad's interactive sculptural installation and performance addressing food waste; and a vending cart by the Italian duo Andrea Caretto and Raffaella Spagna offering items formed of cow dung, edible silver, and gold-covered supergrains.

"Negotiating Routes: Ecologies of the Byways," a recently inaugurated two-year program, offers an ironic counterpoint to an ambitious national development project initiated by India's Road Transport Ministry. Under this scheme, the rural hinterland is being carved up to build 15,000 kilometers of highways, called Golden Corridors, connecting north and south, east and west. While promising better connectivity, the construction is unleashing massive changes in the social, cultural, and ecological fabric of rural and small-town India. According to Khoj, "Negotiating Routes" will "encourage archiving of local knowledge and mythologies about various ecologies like flora, fauna, home remedies, stories, and folklore." The program invites artists to reflect on the "anxiety of 'development' embodied in the rank infrastructural development across India and its co-existence with local ecologies."

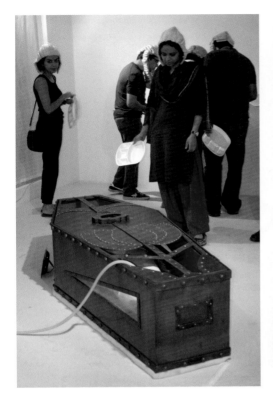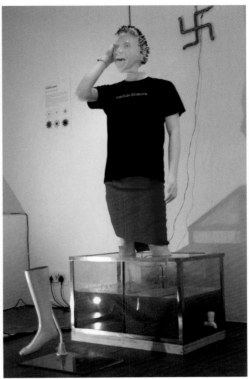

Left: Shweta Bhattad, *A Three Course Meal and a Dessert of Vomit*, 2012. Installation with sculpture, video, and performance. Right: Julian Abraham, *Karma Wine*, 2012. Mechanical installation involving an experiment in fermented alcohol production.

Initiated by artist Varsha Nair and co-curated by Pooja Sood, "Negotiating Routes" draws inspiration from Joseph Beuys's *7000 Oaks*. Spread across India, the site-specific, multidisciplinary interventions will engender collaboration between artists and local populations, between art and research, while "addressing the visible and invisible transformations currently taking place in their immediate environments." In its full scope, the project intends "to map the various project sites across the country to create an alternative road map where artists and communities have come together and have been involved in discussions on the regeneration of the local ecology of the cities or villages that they inhabit. Using the nomenclature of the National Highway or NH1, the sites, ironically named NR1, NR2, and so on, will form the nodal points of this alternative mapping as they connect to each other metaphorically, a route 'marked' by art where transfer and exchange of knowledge has taken place."

The projects conceived under "Negotiating Routes," currently in its third phase, display great diversity of form and content, incorporating physical, social, and cultural geographies as varied as a riverside village, wetlands, and a town of darners. NR 9 *Abstract Reality: A visual perspective on the organic movement in Madhya Pradesh*, by Akshay Rathore and Flora Boillot, is sited in the village of Aulinjaa in the central Indian state of Madhya Pradesh, a major agricultural region. Boillot and Rathore worked with local farmers to document flora, fauna, agricultural practices, and knowledge

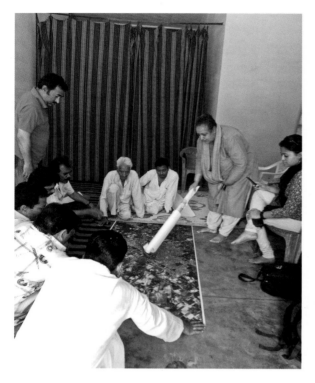

Priya Ravish Mehra, *Making the Invisible Visible*, 2012. Garments and textiles repaired by Rafoogar darners, with demonstrations, workshops, and community-outreach events.

systems related to seed-saving and biodiversity, with applications to city-based farming initiatives across India. NR 10 *Making the Invisible Visible*, by Priya Ravish Mehra, focuses on a little-known community of darners, or Rafoogars, in Najibabad, a small town in North India. The Rafoogars specialize in repairing old and new damaged textiles. In addition to documenting their life, Mehra will work with them to create a collection of contemporary works based on their darning skills.

For Khoj, "Negotiating Routes" is not just about artists addressing local issues or collaborating with local communities; it is also about giving back something of value. NR 2 *Gharelu Nuske and Muft ki Salah*, by Aastha Chauhan, was sited in the Himalayan region of Chamba, Tehri Garhwal. Chauhan collected folk wisdom related to traditional remedies and cures. She then shared her results through radio broadcasts, a blog, and social networking sites, spreading awareness of this vanishing knowledge while underscoring its fragility.

Khoj's stated intent to facilitate "change by encouraging artists and audiences to engage with vital concerns such as ecology, sustainability, and community participation" is evident in its public art projects. These programs display an amazing versatility and are embedded with multiple layers of meaning, blurring boundaries between disciplines, as well as between maker and viewer. "Negotiating Routes" takes on particular significance because it has corrected the urban bias of public art in India and moved into those unnoticed but important by-lanes of the great Indian land-mass where contemporary art is absent. "In Context," meanwhile, continues to open up new ways of seeing the familiar, be it food, transport, or the natural world, engaging critical problems of city life through art. Sood sums up, "For artists to become more relevant and to test out where art is relevant, public art serves the purpose." With their dialogic and transformative emphasis, Khoj's various initiatives have shown the way to a responsive and relevant public art.

LAND of Opportunity (2011)

by Heather Jeno

It all began by thinking outside of the institutional box. In January 2009, LAND—the Los Angeles Nomadic Division—premiered its inaugural set of curated artist activities at four sites across L.A. and emerged as the city's most ambitious public art initiative in recent history. Founded by Shamim M. Momin and Christine Y. Kim, LAND offers unconventional programming aimed at revitalizing and reconsidering site-specific public art and accompanying notions of space, scale, and monumentality, with potential for significant conceptual impact on art and cities alike.

As curators at the Whitney Museum of American Art and the Studio Museum in Harlem, respectively, Momin and Kim were deeply engaged in critical discourse surrounding contemporary art practices. Momin—a dynamic, articulate arts advocate with an impressive curatorial pedigree—found an enthusiastic and equally curious partner in Kim, a native Californian and currently an associate curator of contemporary art at LACMA. Both founders cite specific exhibitions in their careers that aided them in formulating LAND. For Kim, it was her principal role in curating "The Philosophy of Time Travel" (2007), a conceptual Studio Museum show in which five artists were invited to create large-scale installations challenging traditional sculptural boundaries and the constraints of history and time. For Momin, it was a more gradual process that developed from her research for several Whitney biennials. Through studio visits and discussions, she noticed that many artists were extending their practices from the object into multimedia, activity-based efforts, often within a collaborative framework.

Gonzalo Lebrija, *The Distance Between You and Me*, 2009. Video, installation view.

After almost 10 years of percolation and development, Momin and Kim crafted a proposal for an organization dedicated to realizing this type of process-oriented practice. Before moving forward with the bureaucratic details

of starting a nonprofit, they called salon-style gatherings of artists, curators, critics, and other colleagues to cull critical feedback about the organization's specific L.A. context and its appropriateness to the field at large. "Through these two discussions [in fall 2008 and January 2009]," says Kim, "it became clear to us that it was timely and important to move forward with a grounded, rigorous, and dynamic nonprofit for public art." After slowly transitioning to L.A. from New York, Momin officially took over the reins as director in 2009, while Kim became a member of the board of directors.

While it may be unusual for two former New Yorkers to give accolades to L.A. as an artistic center, Momin and Kim saw a spirit of collaboration and a tight-knit artist community supported by preeminent art schools—the ideal foundation for LAND. For Momin, the fractured geography of L.A.—the disparate demographics, pockets of ethnic enclaves, and ongoing urban growth—perfectly parallels LAND's ideological underpinnings in the belief that contemporary art practices no longer fit into neat, labeled genres and are rapidly expanding into messier but often more compelling areas. LAND's mission to commission and produce "site- and situation-specific projects with national and international artists, in Los Angeles and beyond" becomes an institutional infrastructure in which participants may activate the city's multifaceted web of artists communities.

Momin cites L.A. as a natural resource from which the organization can mine content, drawing on diverse populations of artists and the exploding variety of critical practices: "We really want [an individual project] to be understood as a kind of institutional activity even if it's not in one site. Our aim is that each individual project ultimately be understood both as a unique exhibition and as part of a larger institutional construct…LAND was created from the outset with an eye toward strategic, ongoing programming, but it needs to also be mutable and appropriate to the way artists are working." By embracing movement, ephemeral activities, and unfolding connections between

Artemio, *Colt Frac-Tiles* (detail), 2010. Ceramic, 9 x 35 ft.

José León Cerrillo, *Double Agents*, 2009. Iron, mirror, and enameled wood, dimensions variable.

projects over time, LAND mimics Los Angeles's constant flow of exchange both literally and conceptually.

Both Momin and Kim envision the organization's replication in other cities and have purposefully drawn from international centers that mirror L.A.'s frenetic creative activity. For its inaugural series of projects, VIA/Stage 1, LAND tapped into the vibrant art offerings of Mexico City to create the first iteration of LAND 1.0, which features large-scale, multi-artist, multi-site exhibitions. (LAND's ongoing programming also includes LAND 2.0, which produces commissioned projects by emerging or mid-career artists, and LAND 3.0, which focuses on work by lesser known artists).

LAND is a public art initiative, but its projects take a more subtle approach to the subversion of space and quietly integrate into their surroundings. For example, Mexico City-based Artemio, who participated in VIA/Stage 1, contributed *Colt Frac-Tiles*, a temporary tile pathway installed in the lobby of the Pacific Design Center during the January Art Los Angeles Contemporary Art Fair. Artemio created the piece using *talavera*, a type of Mexican ceramic characterized by a milky-white glaze, on which he painted an ornamental design. From afar, the installation presented an abstract decorative pattern, but closer inspection revealed a repeating kaleidoscope of guns—a commentary on the violence and drug culture of his home country and the proliferation of weapons in contemporary society. The placement of Artemio's work within the cool, hyper-designed Pacific Design Center was rebellious yet understated.

The restrained sensibility of the VIA/Stage 1 works is endemic to LAND's goal of presenting loosely connected projects in a covert, almost minimal fashion. As Momin explains, "Each VIA project conveys that in its own discreet way as well as, hopefully, in their totality…you can't see all of it at once, but

there is a gesture toward discovery in the larger landscape. Over the course of [time], you make a content connection between multiple pieces, much like you move through L.A. itself." The first project to be unveiled was a presentation of black and white films by Guadalajara-based Gonzalo Lebrija, shown on high-resolution LED monitors on Sunset Boulevard in West Hollywood; Artemio's tile piece came next; then, in collaboration with the MAK Center, a series of posters by José León Cerrillo inspired by a two-month residency at R.M. Schindler's Fitzpatrick-Leland House; and finally, a copy of the artist Moris's visa-denial letter installed as a large-scale graphic on the side of the Geffen Contemporary building at the Museum of Contemporary Art.

To maximize public impact and establish appropriate locations, LAND partners with organizations like MOCA, LACMA, MOLAA (the Museum of Latin American Art), the City of West Hollywood Arts and Cultural Affairs Commission, and the MAK Center.

Momin hopes for LAND "to become a sustainable process and collaborate with other institutions—to create a web-like connection...that embraces and activates that fundamental structural aspect." For Momin and Kim, the organization's viability relies on this type of nimbleness and adaptability. And when entire urban centers are potential sites for activation, site-specificity takes on a whole new meaning.

Reclaiming New Orleans: Prospect.1, Improvisation, and Grassroots Art Activism (2013)

by D. Eric Bookhardt

As a terrain for the practice of public art, New Orleans has always been difficult to define and contextualize. The city's dream-like environs, both natural and manmade, can cause the boundaries between art and life to seem unusually porous, even osmotic. Here, hard-to-categorize examples of vernacular architecture crop up as stylistic inflection points on streets where improvised performance events seem to arise out of the blue, then gradually dissipate like summer storms. Spontaneous parades, indigenous street spectacles, and socio-aesthetic happenings of all sorts have traditionally co-existed alongside the notably more conventional local art establishment, but only after the near-death experience of Hurricane Katrina in 2005 did conventional and vernacular culture begin to exhibit a degree of perceptible synergy. This was largely due to an improbable alternative public art efflorescence that refocused diverse currents of creative practice that had long simmered just below the surface.

Wangechi Mutu, *Ms. Sarah's House*, 2008. Installation for Prospect.1.

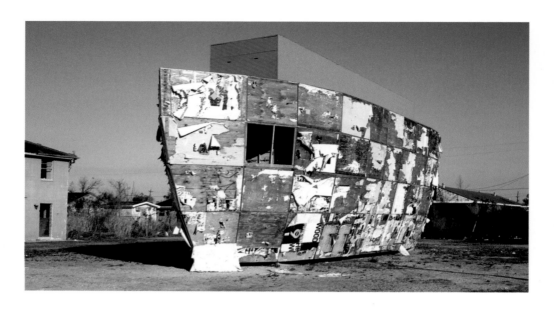

Mark Bradford, *Mithra*, 2008. Found paper on plywood and metal shipping containers, 70 x 20 x 25 ft. Installation for Prospect.1.

The most dramatic catalyst took the form of Prospect.1 New Orleans, which had its origins not in any governmental or museum office but in a panel discussion at the Arthur Roger Gallery in January 2006, during which noted curator Dan Cameron mentioned that an international art biennial would be the best way to help the city's recovery. Cameron soon found himself in charge of what would become a rambling exhibition of works by 84 artists in 24 venues across the city. Prospect.1 opened on November 1, 2008, and by the time it closed on January 18, it had attracted 70,000 visitors and glowing reviews from all over the world. It also pioneered a new paradigm for the use of public art in energizing the reclamation of urban spaces ravaged by large-scale disasters. But the real genius of Prospect.1 was that some of its high-quality components were deployed in intriguing, rarely touristed neighborhoods rich in street culture such as Treme and the Lower 9th Ward. At the same time, indigenous performance artists like the Mardi Gras Indians — secretive working-class African American societies that traditionally parade in fantastical American Indian costumes — were featured alongside leading international contemporary artists, often in conventional settings like the New Orleans Museum of Art. Like the Indians' famously unpredictable parade routes, Prospect.1 covered a broadly meandering landscape that included such unlikely venues as the Colton School. Here, a vast hive of art studios replaced the widely dispersed student population and introduced visitors to the historic if seedy St. Claude district, where the existence of numerous co-op and collaborative arts spaces along the storm-ravaged corridor probably came as a surprise.

As an exercise in community-based art, Prospect.1 forged unusual alliances between artists and distressed communities. For instance, Los Angeles painter and sculptor Mark Bradford erected a house-sized ark on a vacant lot in the Lower 9th Ward and helped raise funds for a nearby gallery, the L9 Art Center, which was struggling to rebuild. Similarly, Wangechi Mutu's *Ms. Sarah's House* — a skeletal ghost structure consisting of timber and lights on the site of a demolished home — also

included a limited-edition print series that raised money to rebuild the original residence. In her review of Prospect.1, *New York Times* art critic Roberta Smith wrote, "It proves that biennials can be just as effective when pulled off without bells, whistles, or big bucks. Maybe even more effective, if the local cultural soil is spectacularly fertile. Under these conditions something magical can happen: a merging of art and city into a shifting, healing kaleidoscope."

The Colton School has since been restored to its original purpose, but Prospect.1 also helped to inspire the fluid assortment of more than 18 collective, co-op, and pop-up galleries and visual arts organizations that now form an almost entirely artist-run arts district. And if art galleries do not ordinarily fall within the purview of "public art," their function in the St. Claude district is often more community oriented than most. For instance, by 2006, the Life is Art Foundation, based in the heavily flooded St. Roch neighborhood, was staging edgy art shows in a renovated former bakery building with experimental installations in some adjacent blighted cottages, but it also provided free yoga lessons to area children, as well as a structure used by conceptual-environmental artist Mel Chin as part of his ambitious *Operation Paydirt* project for the remediation of the city's lead-contaminated soil. Although Life is Art has since shifted its focus to Tasmania, most of the St. Claude art spaces that proliferated in its wake continue to pursue notably unorthodox and inclusive concerns.

Most of these spaces are organized along collaborative or collective lines. Those that follow the collaborative model typically have a director, often a volunteer, who works informally with artists and curators, providing space for mostly experimental work with minimal emphasis on sales. In the better-known collective or co-op model employed by leading St. Claude galleries such as The Front, Antenna, and Good Children, the members are co-equal partners who pay monthly dues and share in the unglamorous tasks of gallery maintenance. Most participants have day jobs, so the collectives are generally open only on weekends except for special events, and sales are strictly incidental,

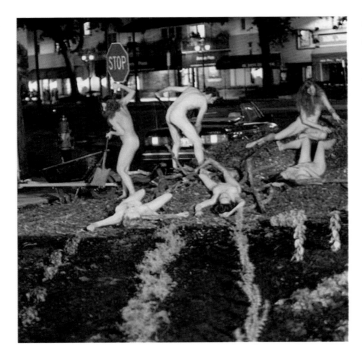

between artist and buyer. Most collectives retain no percentage of sales revenues.

If such galleries sound almost inexplicably idealistic compared to the money-obsessed contemporary art market, it's because they grew out of the practical concern to rebuild communities in what initially resembled a post-apocalyptic landscape. And while the proactive efforts of Prospect's Dan Cameron, as well as a series of workshops and events produced by artist-activist Paul Chan in 2007, were

Life is Art Collective, *Burial*, 2010.
Part of "Self Dissolution" series.

Victor Pizarro, Myrtle Von Damitz, and Jeff Shyman, Occupy Frankie & Johnny's protest, October 21, 2011.

undoubtedly inspirational, the biggest single impetus was initially situational, for it was a time when much of the city had risen up in mass protest after government agencies released maps showing how New Orleans would be rebuilt after the flood under the direction of "experts" from the Urban Land Institute, with entire neighborhoods reduced to "green space." The citizens of New Orleans, anarchic in the best of times, would have none of it, and organized into militant neighborhood groups that successfully agitated for local self-determination. It was this same DIY spirit that propelled St. Claude-area artists of all genres to create their own galleries, studios, and performance spaces, which in turn attracted a large influx of young artists from across the country.

Although the St. Claude district includes several distinct historic neighborhoods, it is largely bohemian and working class, and most residents appear determined to keep it that way. Performance art is often a weapon of choice, as was evident in the Occupy Frankie & Johnny's protest movement of 2011. Fiercely protective of St. Claude Avenue's richly blighted visual texture and adamantly opposed to non-indigenous commercial activity, area artists and anarchists (led by Victor Pizarro, Myrtle Von Damitz, and Jeff Shyman) formed a united front in opposition to an attempt by the CVS drugstore chain to acquire the site occupied by Frankie & Johnny's Furniture Store, a gloriously funky home furnishings emporium. A protest demonstration at the peak of the controversy featured costumed members of the anarchist Krewe of Eris carnival society along with artists such as Skylar Fein who appeared in a fake CVS lab coat while carrying a syringe and wads of money, as anti-CVS placards appeared everywhere. Frankie & Johnny's survived, but the placards remained, just in case.

While any grassroots synthesis of visual art and vernacular performance traditions such as Carnival may sound unusual in a North American context, it is a long-established local legacy that traces its roots to the Caribbean, the source of a majority of the city's population when Louisiana became a state in 1812, and which has set the tone ever since. This unusually holistic and multicultural sensibility pervades the local alternative art community as well, but few organizations embody those cross-cultural synergies more fully than New Orleans Airlift. Founded in 2007 by artist-curator Delaney Martin and bounce music impresario Jay Pennington, Airlift facilitates cultural exchanges

between local artists and their counterparts elsewhere in the world; it was initially known for events that introduced bounce, a local version of hip-hop famous for its transsexual star performers, to wider audiences. The organization is also known for involving local alternative artists in its Tableaux Vivants—"living pictures" or stationary theater performances—a genre that attained its peak popularity in the European culture capitals and New Orleans carnival societies of the mid-19th century.

But it was Airlift's *Music Box*, a site-specific installation of artist-designed and -built shanties crafted to double as musical instruments, that unexpectedly became a popular sensation. Often described as "a fairy tale set in a junkyard," *Music Box* attracted thousands of visitors between its opening in November 2011 and its closing in June 2012. The three official performances—conducted by musician and sound engineer Martin Quintron, whose electro-acoustic soundscapes melded hints of Stockhausen and Brian Eno with traces of bounce and funk—brought wide acclaim and media attention, including a cameo appearance on the front page of the *New York Times* Web site. Funded by small grants, donations, and volunteer labor, *Music Box* epitomized St. Claude's gumbo mix of old and new, local and global, in a 3,000-square-foot mythical village. The next phase is a permanent, three-story musical house designed by New York street artist Swoon with input from Airlift's creative community and seed funding from a successful Kickstarter campaign. A popular funding source for alternative culture projects here and elsewhere, New York-based Kickstarter is the brainchild of co-founder and CEO Perry Chen, himself a part-time St. Claude resident.

Similar grassroots, low-budget, and cross-cultural approaches are employed by the city's alternative theater and circus communities, whose activities often coalesce in the annual Fringe Festival. St. Claude is home to a vibrant alternative film and video community recognized for such works as the

Natsu, *Weaving of Fate*, 2007–08. Plastic beads, brass wire, and sequins, installation view. KK Projects—Derelict Cottage I (destroyed by Hurricane Katrina), New Orleans.

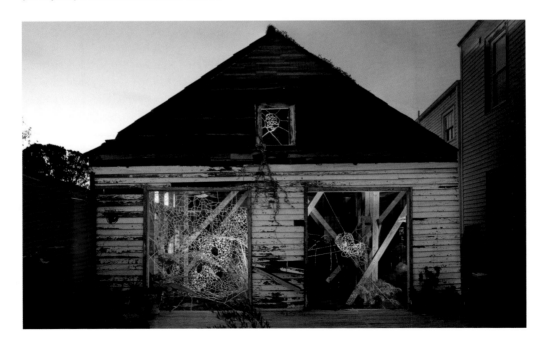

New Orleans Airlift, *Music Box*, 2011. Mixed media, installation view of shanties/musical instruments.

Court 13 collective's full-length feature film *Beasts of the Southern Wild,* which received top honors at the 2012 Sundance and Cannes film festivals. Like *Music Box*, with which it shares at least a few supporting artists, *Beasts of the Southern Wild* combines elements of local culture and universal themes—leveraged with grassroots support and ordinary people from off the streets as actors—to achieve its eerily mythopoetic, magic realist narrative.

A variation on those ad hoc approaches was seen in Sculpture for New Orleans, a nonprofit organization founded in 2006 by artists Michael Manjarris and Peter Lundberg "to reinvigorate and heal" through the deployment of monumental works by artists such as Mark di Suvero, James Surls, Louise Bourgeois, Deborah Masters, and John Clement, among others. According to Manjarris, a New Orleans native based in Texas, more than 50 monumental sculptures valued at around $20 million had been loaned and installed by 2012 at a cost of some $300,000, supplemented by volunteer labor and services. If the result was a somewhat conventional presentation of iconic contemporary sculpture, the underlying, remarkably cost-efficient effort embodies the improvisational ethos of much local alternative public arts activity. Scattered across the metro area, the works complement the city's only truly exceptional example of conventional public art, the New Orleans Museum of Art's free, generally excellent, and oddly cohesive sculpture garden.

All of which poses a contrast to the city's history of haphazardly eclectic public art, an eccentric assortment of statues and monuments to military heroes, classical muses, and Latin American liberators, as well as the usual Arts Council and percent-for-art projects. The underlying irony of all this was that it took America's worst urban natural disaster, and the outpouring of alternative public art activity that arose in its wake, to finally bring some cohesion to New Orleans' unusually complicated cultural landscape.

Gibellina: Where Art Renews Life (1997)

by Virginia Maksymowicz

To American eyes, Italy seems full of contradictions, and Sicily even more so. The crusty façades of 500-year-old buildings contrast disconcertingly with modern marble and ceramic tile interiors. A beautiful Liberty Style mosaic graces a bakery in the Capo market, set amid piles of rotting vegetables and bloody animal bones. A monumental, foul-smelling paint factory, built in the 1990s, overlooks one of the prettiest beaches on the northern coast. Sicilian-produced oranges shrivel in their orchards (the cost of harvesting and bringing them to market is greater than the price they can command), while Spanish and Israeli imports are sold in Northern Italy. Thousands march in the streets, publicly demanding an end to the Mafia, but many shop owners still pay their *pizzo* (protection money) to the local don. It is a land of deeply rooted economic poverty, but its people possess a seemingly inexhaustible wealth of generosity, courage, and historical and cultural resources. Against such a backdrop, it is no wonder that the town of Gibellina and its public sculpture embody a wide range of incongruities.

When a severe earthquake hit the Belice Valley on the western part of the island in 1968, many towns were damaged; Gibellina, situated on the side of a hill, was hit hard. Its inhabitants were moved to barracks, where they continued to live for the next 14 years. One year to the day after the tragedy, a group of artists, writers, scientists, sociologists, priests, journalists, and *contadini* (peasants) gathered at the ruins to discuss the re-creation of Gibellina and the direction that it would take. Although these foreigners must have been viewed with suspicion by the locals, a movement began that found its vision in the person of Ludovico Corrao, Gibellina's mayor. It was decided that a new town would be built 12 miles to the northwest, on level ground, and its reconstruction would somehow incorporate art into everyday life: theater, music, dance, painting, and sculpture. "Art isn't only a superstructure," Corrao was quoted as saying, "it can become a structure, an instrument for understanding reality."[1] Art would put Gibellina "on the map" and ensure that the world would remember its Phoenix-like rise from the ashes.

This belief that "art is not superfluous" resulted in the new Gibellina becoming a sort of open-air museum.[2] By 1997, it had more than 50 public sculptures (with two more in process), two museums, and a theater, as well as a performance space at the site of the destroyed town, now memorialized by a major earthwork. Internationally renowned artists such as Joseph Beuys, Philip Glass, and Robert Wilson have performed there, and major Italian sculptors, including Alberto Burri, Arnaldo Pomodoro, Pietro Consagra, and Mimmo Paladino, have contributed works. Gibellina represented Sicily in the 1993 Venice Biennale. Yet this tiny hamlet of 5,000 farmers and shepherds sits in the middle of nowhere, miles from the two major airports at Palermo and Trapani or the beaches at Taormina and Mondello.

According to Enrico Stassi, the director of the Museo Civico d'Arte Contemporanea and a member of the Fondazione Orestiadi, which oversees the artworks, the town's first museum was formed by a group of printmakers while the townspeople were still living in the barracks. From 1979 to 1981, when the move began, the sculptures were gradually installed (many of them having been donated by the artists). Over the next 15 years, both the buildings and the artworks grew organically, their placement a collaborative decision between the artists and the town administration. Stassi emphasized that the new Gibellina was a "work in progress," that it would continue to transform itself since change plays an essential role in the vision.[3]

For those interested in public sculpture, Gibellina is an experiment worth studying—for its successes, its failures, and its efforts to maintain what Stassi terms a "finestra aperta," or open window, to the world. A number of the sculptures are remarkable. Consagra's *Ingresso al Belice* (*Entrance to the Belice Valley*, 1978–81), a 26-meter-high, stainless steel star rising up out of the valley and acting as a gateway into the town is nothing less than spectacular. Burri's earthwork, *Cretto* (*Crack*, 1983–84), entombs the ruins of the old town in 120,000 square meters of white concrete. From a distance, the sculpture looks like a furrowed glacier slowly sliding down the hillside; at close range, however, it becomes evident that its crevices map the streets of the destroyed village. Walking through the stark whiteness, weeds poking through the seams, one can almost hear the voices of the dead carried on the wind that whips along the narrow corridors. Paladino's stage set—originally constructed for a performance at old Gibellina—towers over the Case di Stefano, the other museum in town. Stylized horses are engulfed in a mound of white concrete (for the performance, salt from the coast at Trapani was used), and viewers are free to scale its height. Some of the smaller sculptures scattered

Alberto Burri, *Cretto* (*Crack*), 1983–84. Concrete, detail of 20-acre site.

Mimmo Paladino, *Scenografia: La Sposa di Messina di Friedrich Schiller* (*Stage Set: The Wife of Messina by Friedrich Schiller*), 1990. Concrete and copper, detail of installation.

throughout the town, including Paolo Schiavocampo's *Doppia Spirale* (*Double Spiral*, 1973) and Fausto Melotti's *Contrappunto* (*Counterpoint*, 1983), lend linear grace to the streets. Sculptural fountains such as Andrea Cascella's contribute to pleasant gathering places. The incorporation of salvaged elements from the ruins by Nanda Vigo in *Tracce Antropomorfe* (*Anthropomorphic Traces*) and Francesco Venezia in *Giardino* (*Garden*) maintains a sense of continuity and history.

There are significant problems, however, and the artists, the townspeople, and the administrators are not unaware of them. The layout of the new Gibellina itself poses aesthetic and functional problems. While the old village was perched somewhat precariously on a slope, its winding streets and varying levels provided shelter from the weather and enhanced the feeling of community. The choice of an earthquake-safe location, along with anti-seismic building regulations requiring wider streets, gives the new site a barren, dust-blown look. The avant-garde architectural style of the theater, city hall, and church clashes with the plainness of the houses and makes it hard for the smaller outdoor sculptures to hold their spaces. Many of the artworks are mediocre, and a number of them began to deteriorate quickly—some because of faulty design and fabrication, some because of little or no money for routine maintenance. (*Contrappunto* rusted through, for example, due in part to its hollow construction.) In some cases, inferior building materials were used: the roof of Ludovico Quaroni's Chiesa Madre (the main Catholic church in town, whose large spherical dome makes it look like a planetarium) was begun in 1972 and collapsed in the summer of 1996, shortly before its scheduled completion, because of substandard concrete.

Then there are the social questions: How do these structures integrate themselves into the lives of those who live and work in Gibellina? How does this great experiment in public art extend beyond the municipal borders? What is the impact on local economies? What are the political issues involved?

Nanda Vigo, *Tracce Antropomorfe*, 1978. Installation incorporating ruins from the old city.

In June 1996, a group called SOSArte, the heirs to those who had convened at the ruins 27 years earlier, attempted to address some of these questions. They described Gibellina as "frutto ancora acerba," or "unripe fruit," admitting that "it's difficult to understand...what still remains to be done, what is provisional, and what is already defined." They also stressed that a town's formation is a *processo*, a term that in Italian means both "process" and "trial."

The paper produced by SOSArte, "...oltre la prima impressione" ("Beyond the First Impression"), outlines the group's concerns about reconciling the "scholarly and programmatic precariousness" of contemporary art with the "conservation of good taste"; about continuing the sense of Gibellina as a "permanent laboratory, a simmering of ideas and artistic and cultural elaborations"; about embarking on "interventions of restoration and maintenance" without "interrupting the evolutionary *processo*"; about safeguarding the history and soul of the town; and, ultimately, about recognizing the contradictions inherent in trying to embody the "testimony and expression" of contemporaneity while still dealing with the legacy of the past. By American standards, the document is more theoretical than practical, and it is difficult to see how such concerns will be implemented.[4]

While Gibellina's "open window" indeed looks out on an international art scene whose devotees jet from Rome and Milan, northern Europe, and America for summer performances, it is hard to say how the local populace fits in. Enrico Stassi hopes that the town's efforts might attract young people who normally drive from Palermo or Trapani for a bit of high culture. However, my own college-educated cousins, who live not more than 20 miles away, were only dimly aware of the goings-on in the rebuilt Gibellina.

Tourists in this part of Italy are still a rarity, and the few restaurants have plenty of empty tables. If anything, the sculptures seem to have been more of an economic drain than a boon to the municipal economy. Mayor Corrao was ousted from office for a time, but returned in 1995, and an unsuccessful attempt was made to evict the Fondazione Orestiadi from the Case di Stefano and move its art collection elsewhere.[5] In the labyrinthine world of Italian politics, it becomes virtually impossible to uncover the "truth" in any situation. Why the church's concrete crumbled remains a mystery. Project administration and funding came from centralized sources, and the local government was not involved. If, and to what extent, corrupt politicians and organized crime were implicated will never be known. A Palermo architect, who was involved with the post-earthquake recovery, feels that the reinvention of Gibellina was the result of political maneuvers. He insists that the destruction of the old town was not as complete as generally maintained and that reconstruction at the original site was more than possible.[6] And despite Corrao's goal to put Gibellina "on the map," as late as 1993, most of Italy's road atlases did not indicate its current location.

In some ways, however, Gibellina's commitment to contemporary art is a resounding success. Its public sculpture provides the town with a structure to "search for and recover an identity," and its myriad problems and contradictions are an all-too-accurate "revelation" of real life in contemporary Italy.[7] Furthermore, in their struggle to deal with these issues, the Fondazione Orestiadi, the artists, the government, and the townspeople are engaging each other to find solutions. In the final analysis, perhaps this type of *processo*—as inefficient and as slow-moving as it seems to an American— is turning Gibellina into a model for a truly public art, a place where "l'arte rinnova i popoli e ne rivela la vita" ("art renews the people and reveals life to them"), as inscribed on Palermo's Teatro Massimo.

Notes

1 Dominique Fernandez, "Morte e Resurrezione," in Nicola Cattedra, ed., *Gibellina* (Rome: Artemide Edizioni, 1993), p. 98. Thanks to Blaise Tobia for assistance with translations.

2 Victor Ugo and Giorgio Contino, "Dream in Progress," reprinted in a promotional brochure published by the Commune di Gibellina.

3 Interview with the author, July 1996.

4 From an unpublished document, "...oltre la prima impressione," produced by SOSArte, July 1996.

5 From an interview by the author with Giulio Ippolito, vice president of the Fondazione Orestiadi; also noted by Fulvio Abbate, "Patrimonio a rischio," 1996.

6 Interview with the author, July 1996. The discussant wished to remain anonymous.

7 "...oltre la prima impressione," op. cit.

Destination: Public Art as Pilgrimage (2013)

by Marc Pally

Spectacular landmark sculpture was perfected by the French in the 19th century with the Statue of Liberty (1886) and the Eiffel Tower (1889). Now iconic almost to the point of cliché, these works combined sheer monumental scale with deeply resonant imagery (the welcoming of immigrants to New York Harbor and the soaring elegance of the industrial age in Paris) to set high standards for future developments in public art and iconography. Perhaps Anish Kapoor and Cecil Balmond's *ArcelorMittal Orbit*, commissioned for the 2012 London Olympics, will someday join their ranks and become a must-see symbol drawing people from across the world.

The use of art as a means of engaging publics and creating identity remains as strong as ever today. In evaluating some examples of this genre, it is critical to keep in mind that quantity is not quality: one million visitors to an art event or single artwork do not connote artistic excellence—though such numbers do inspire conversation and some reflection. Kapoor's wildly popular *Cloud Gate* (2007) in Chicago's Millennium Park, where attendance approaches four million visitors a year, is a good starting point for a discussion about public art that attracts unusually large audiences.

If we were to come across *Cloud Gate* in a museum collection, it might be contextualized with works by Brancusi and Arp, two early 20th-century sculptors who also pursued a reductive purity of form. In the public arena, however, without the validation and references provided by an art institution, other, broader contextualizations become available. In the case of *Cloud Gate*, Kapoor makes connections to the site itself, to the surrounding city and the people within it. The highly polished, reflective surface bounces back the surrounding world, including the skyline of Chicago, viewers immediately in front of the work, and other people using Millennium Park. Embedded within the sculpture is a dialogue that allows viewers to interact with it by creating different reflected images as they move around its perimeter. Distortions caused by the form's curvature change as people circulate, creating another layer of engagement. Together with Jaume Plensa's *Crown Fountain* and Frank Gehry's Pritzker Bandshell, *Cloud Gate* makes Millennium Park what Fodor's calls one of Chicago's 10 "must-see" landmarks.

As *Cloud Gate* demonstrates, size matters. Contemporary artworks that quickly become iconic and "worth a detour" are always of monumental scale. For instance, Antony Gormley's *Angel of the North* (1998) stands 66 feet tall and is visible for miles around its site on the edge of Gateshead, in North East England. Placed adjacent to the A1, a major north-south highway, the sculpture is a commanding presence. Though called an "angel," the welded Cor-ten steel figure is more material than ethereal, its "wings" clearly referencing airplane design. Though not without opposition (at least at the beginning), *Angel of the North* became the first of Britain's landmark sculptural colossi, works so large, dramatic, and unexpected that people travel just to see them. (Mark Wallinger's *Horse*, winner

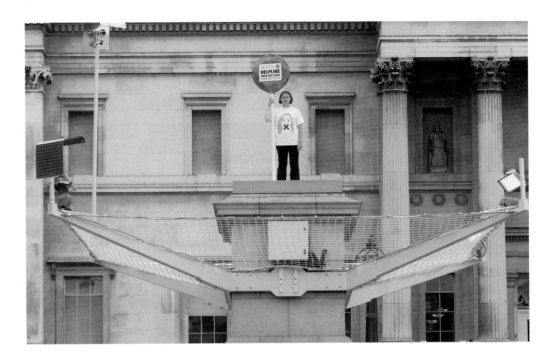

Antony Gormley, *One and Other*, 2009. Volunteer participants, performance sculpture at the Fourth Plinth, London. Commissioned by the Mayor of London and the Fourth Plinth Commissioning Group.

of the Ebbsfleet Landmark commission in 2009, is a recent heir to *Angel*'s legacy, though it will probably never be realized; the life-like, and apparently very popular, horse, would have towered over the flat, rural landscape of Essex.)

These landmark works don't always have to be permanent. Gormley also creates very successful temporary projects that draw large crowds to places as wild as the Alps (*Horizon Field*, 2010–12) and as domesticated as the courtyard of the Royal Academy of the Arts in London and Madison Square Park in New York City (*Event Horizon*, 2007) to interact with iron (and sometimes fiberglass) figures based on his own body. At the Royal Academy, he hung the figures from the roof and windows of the building. Suspended at all angles, they created a sense of distress and mayhem, the spectacle attracting thousands of visitors. *Event Horizon*'s iteration at Madison Square Park—with figures dispersed around the park grounds and positioned on nearby rooftops—likewise attracted a large audience. The disconcertingly posed rooftop figures, which added a whiff of danger, acted as a magnet for unsuspecting passersby (some of whom called the police to report suicide attempts in progress).

While these temporary art projects draw crowds to otherwise ordinary locations, Trafalgar Square's Fourth Plinth commissions benefit from the prestige of an already famous and highly visible site. Rachel Whiteread, Yinka Shonibare, Mark Quinn, Wallinger, Gormley, and Elmgreen & Dragset are among the blue-chip artists who have created site-specific projects for this empty, 19th-century plinth. Perhaps because these commissions are raised high above public heads and safely out of harm's way, they can be more aggressive and ambitious. Gormley, for instance, turned the plinth into a stage for performance, politics, and interaction, giving 2,400 people the chance to become "living

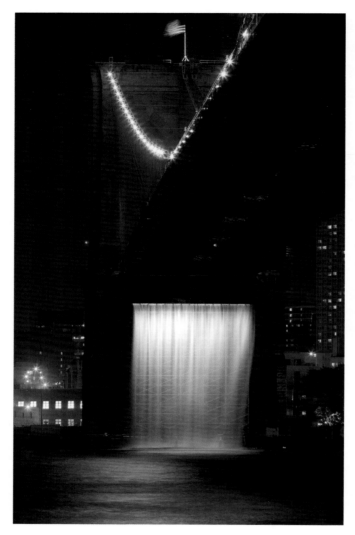

Olafur Eliasson, *New York City Water-falls*, 2008. Scaffolding, pumps, and hoses, 4 elements, 30–40 meters high each. A Public Art Fund project, in collaboration with the City of New York.

sculptures" for an hour (*One and Other*, 2009). Quinn's larger-than-life *Alison Lapper Pregnant* (2005) filled the plinth with an accurately rendered marble sculpture of a pregnant Alison Lapper, who was born with no arms and shortened legs. *Alison Lapper Pregnant* made for a disruptive, and controversial, presence in the public sphere, particularly given the male-dominated, martial emphasis of Trafalgar Square's iconography. The Fourth Plinth commissions seem to relish their potential to counter established narratives and offer alternative visions to the normative standards set by British history and traditions, as exemplified by the immediately adjacent National Gallery of Art.

Several individual sculpture projects over the past decades have distinguished themselves as major destinations. Clearly, Christo and Jeanne-Claude's unique site-specific works set the standard. From wrapping the Pont Neuf in Paris and the Reichstag in Berlin to *Running Fence*, *The Umbrellas*, and *The Gates*, their projects have attracted enormous audiences. These ambitious endeavors are also unique in that they are produced independently of any established institution. There is no validating imprimatur other than the Christo brand.

Christo and Jeanne-Claude's projects entail years and years of organization, with vast effort put into the permitting process required at local, regional, state, and sometimes federal levels. They are always self-financed through the sale of maquettes, prints, and other objects created for each project and free of sponsorship credits. Their rural projects, including an upcoming work for the Arkansas River in Colorado (set for 2015/16), act as destinations for everyone from dedicated cultural tourists to curiosity-seekers intrigued by the sheer audacity of the artwork. *The Gates* was heavily promoted as a tourist attraction by the City of New York and by businesses that could benefit from the upsurge

Christian Boltanski, *Demain le ciel sera rouge*, 2011. Performance installation, Nuit Blanche, Paris.

in out-of-town visitors. Hotel specials and other travel promotions were common. One hot dog vendor in Central Park said that his daily sales went from a typical $120 for a February afternoon to over $1,000. It's stories like these that reinforce the validity of cultural tourism as an economic engine. One headline in the *New York Times* summarized the financial benefit of *The Gates*: "Park Visitors See Saffron, and Businesses See Green" (February 14, 2005).

The most expensive and challenging of New York City's temporary art projects, and the one that created the most global attention, was Olafur Eliasson's *New York City Waterfalls* (2008). Four monumental waterfalls were created

in New York Harbor and the East River on sites along the shores of Brooklyn, Manhattan, and Governors Island. While visible from land, optimum viewing was achieved from the water. The Public Art Fund, which co-sponsored the project, coordinated with Circle Line harbor cruises to schedule regular boat tours. Though critical response was tepid, the topicality of the waterfalls could not be denied, and the project held national and international interest for many months. At a cost of over $15 million, it demonstrated the challenges, and potential rewards, of working at the scale of civic infrastructure (the Brooklyn Bridge served as a backdrop for two of the waterfalls), and the necessity of sophisticated fundraising.

Some art projects are temporary in the extreme, existing for one night only. Nuit Blanche in Paris is the most established of this genre. Founded in 2002 by Mayor Bertrand Delanöe, who was determined to restore Paris as a vital center for contemporary culture, Nuit Blanche translates literally as "white night" and colloquially as "sleepless," the exact state required to experience installations and performances spanning the city and running from seven p.m. through seven a.m. Attendance in 2002 was estimated at 500,000; in 2011, it exceeded 1.5 million. The work is highly diverse in scale, quality, and approach, from the monumental to the human. Everything is free (the vast majority of the budget is funded by the City of Paris, which employs a full-time permanent staff for Nuit Blanche), and the event enjoys the full support of all departments in the city government. The City of Toronto gives the same depth of commitment and funding to its "white night" event, Scotiabank Nuit Blanche, named for a major funder. Minneapolis/St. Paul's Northern Spark, which enjoyed its second iteration in June 2012, is a project of Northern Lights, "a roving, collaborative, interactive media-oriented, art agency from the Twin Cities for the world." Riga, Madrid, Buenos Aires, Montreal, Rome, and Tel Aviv have also produced nuit blanche events with varying degrees of success and varying levels of financial support from city government. The Paris event is without doubt the most extensive and well-funded, with Toronto a close second.

The official program of the Parisian Nuit Blanche always includes several international artists; Doug Aitken, Miroslav Balka, Christian Boltanski, Ryoji Ikeda, Anthony McCall, Tony Oursler, Patti Smith, James Turrell, and Erwin Wurm have all created major installations. These artists receive funding and technical support to realize their projects. Auxiliary projects are sponsored under the aegis of local and regional arts organizations and museums. Each year, approximately 100 projects are situated in various neighborhoods. Nuit Blanche coordinates with public transportation agencies to ensure that bus and/or metro lines run throughout the night to outlying zones. Paris is unusually rich in superb public spaces, and Nuit Blanche artists have used the Place de la Concorde, Jardin des Tuileries, Palais Royal, Gare du Nord, Champs-Élysées, Le Madeleine, and Pont Neuf to great effect.

I have attended four Nuit Blanches, and while many of the projects remain vivid in my memory, one is outstanding. In 2007, the collective of 12 artists known as La Compagnie Carabosse redefined the elegant Jardin des Tuileries as a spectacle of fire. Beginning at the Place de la Concorde with a Ferris wheel of fire (pots of paraffin occupied the "seats") and continuing to the Louvre, all manner of fire sculptures were activated, most composed of wrought-iron armatures holding flower pots filled with burning paraffin. The potted fire displays were occasionally interrupted by sculptures reminiscent of 19th-century industrial furnaces. Operated by members of Carabosse, these fire-machines generated giant blasts—impressive displays of sound, heat, and visual pyrotechnics, not without a tinge of fear. For an American public art professional, the experience of being in a large crowd adjacent to a work of fire was thrilling—and a firm reminder that not everyone in the world shares America's culture

of fear and litigation. French spectators respected the fire, no barriers were necessary, and the 12-hour show proceeded without any major problems.

In addition to reinventing outdoor spaces, artists make good use of the city's seemingly endless inventory of majestic, haunting, glorious, historic (add your adjective) interior spaces. Nuit Blanche occupies churches, medieval courtyards, building lobbies, indoor swimming pools, theaters, cinemas, and department stores—any and every kind of space. In 2011, Boltanski created a work for the Théâtre de l'Atelier in Montmartre, where he realigned the relationship between "show" and audience. Viewers entered through one of two stage doors and occupied the stage itself. A pig and a cat—human-scale and formally attired—sat in the auditorium, staring straight ahead at the viewers on the stage as though waiting for the show to begin. Then a soprano with a haunting voice cantilevered over the seats from the balcony and commanded the theater with a powerful and ethereal performance. Divorced from ordinary experience or expectation, this installation was like a dream, which seems to be a successful strategy for many of the Nuit Blanche works.

Glow, a project of the City of Santa Monica, California, was the first American nuit blanche-type program to consist entirely of newly commissioned artworks. (Full disclosure, I am the artistic director of Glow). The first installment in July 2008 included 27 site-specific works. Much to the surprise of the organizers, according to the Santa Monica Police, attendance reached approximately 250,000. Some installations required crowd control, with long lines forming until three a.m. Glow is centered on the beach, which makes for an interesting combination of nature and culture and provides unique

Usman Haque, *Primal Source*, 2008. Large-scale outdoor waterscreen/mist projection system, microphones, and crowd participation. Commissioned for Glow, Santa Monica, CA.

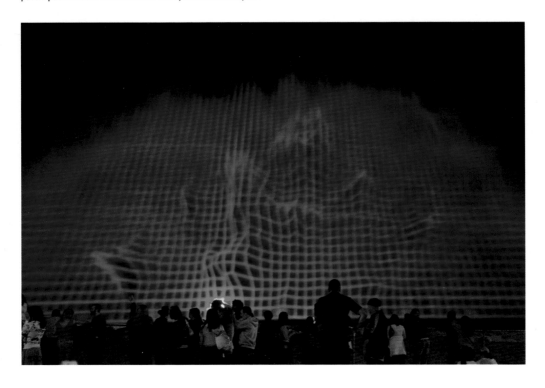

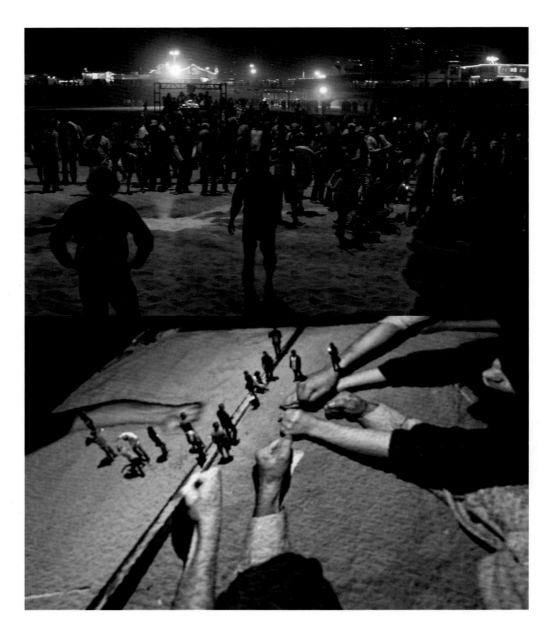

Rafael Lozano-Hemmer, *Sandbox*, 2010. Infrared surveillance cameras, infrared illuminators, 2 sandboxes, computers, DV cameras, 4 projectors, *milagros*, and plastic rakes, projection onto 8000 sq. ft. of sand, sandboxes: 69 x 92 cm. each. Commissioned for Glow, Santa Monica, CA.

opportunities and challenges for artists. The program emphasizes interactive artworks. In 2008, for instance, Usman Haque created his own software to translate audio signals into color and pattern. His project, *Primal Source*, stationed eight microphones in front of a large pond that stored water for the 40-foot-high fountain onto which images were projected. As viewers varied their audio output—

screaming, clapping, and singing—they changed the color patterns on the water wall. Rafael Lozano-Hemmer's *Sandbox* (2010), like most of his work, also depended on audience participation. Two low-rise platforms supporting small sandboxes filled with tiny *milagros* (charms or votive offerings) flanked an 8,000-square-foot projection/participant area in the sand. People were invited to reach into the sandboxes and find the charms. Cameras recorded live images of their searching hands, which were fed to two 35,000-lumen projectors (one for each sandbox) suspended 80 feet above the beach; the images were then projected straight down—at monumental scale—onto the people romping in the sand. Additional cameras tracked the beach area participants, and those images were transmitted live back to the small sandboxes, where, in another scale translation, they became Lilliputian ghosts of the buried milagros. This riveting installation, with its three scales and undertone of surveillance, kept people engaged and mesmerized from seven p.m. until three a.m.

In many of these destination projects and events, audience is an indelible component of the experience. The orthodoxy that governs the relationship between art objects and viewers is simply not relevant for artworks that depend on interaction or are embedded in public sites with large crowds. While one's individual experience with an artwork remains an internalized dynamic, that personal experience can be considered as a component of a larger social dynamic of multiple and simultaneous experiences, which is valuable for its ability to bring pleasure and social bonding. I have witnessed this at Northern Spark, Scotiabank Nuit Blanche, Nuit Blanche, and Glow. The intensity of the moment is shared through casual interactions and immediately amplified through social media. These events prompt interaction not only with the artworks, but also among members of the audience and with their networks beyond the physical site. The magnetism that brings people to *Cloud Gate*, that draws them to see the Fourth Plinth and to travel to experience a Christo project, becomes a kind of cultural currency and a measure of experience. "Pilgrimage" may be too strong a word to describe this phenomenon, but there is an element of renewal and optimism in the public hunger for dramatic, collective experiences.

A Matter of Passion: A Conversation with Christo and Jeanne-Claude (2004)

by Jan Garden Castro

The temporary outdoor projects of Christo and Jeanne-Claude (who died in 2009) figure among the most ambitious, innovative sculptures in the world. Their iconic works include *Wrapped Coast* (Australia, 1968–69); *Valley Curtain* (Rifle, Colorado, 1970–72); *Running Fence* (Sonoma and Marin Counties, California, 1972–76); *Surrounded Islands* (Biscayne Bay, Greater Miami, 1980–83); *The Pont Neuf Wrapped* (Paris, 1975–85); *The Umbrellas* (Japan—U.S., 1984–91); *Wrapped Reichstag* (Berlin, 1971–95); and *The Gates* (New York, 2004). *Over The River* (1992–present), 5.9 miles of luminous fabric panels raised above a 42-mile stretch of the Arkansas River between Salida and Cañon City in south-central Colorado, is in the final permitting phase. Christo hopes to install the work for two weeks in 2015/16. All of their multi-million-dollar projects are funded through sales of Christo's works from the '50s and '60s and of preparatory drawings. Each project's process, preparatory art, materials, photographs, and documents are carefully preserved for museum exhibitions.

In a radical departure from much public art, Christo and Jeanne-Claude's projects require up to a quarter-century to realize, yet they have a life span limited to days or weeks, after which they are deconstructed and the materials recycled. *The Mastaba*, a new proposal for Abu Dhabi, however, would give their work a permanent legacy. The colossal structure (taller than the great pyramid of Giza), which the artists first envisioned more than 30 years ago, will be constructed from 410,000 oil barrels painted in desert colors to reflect the visual effects of an Islamic mosaic.

Jan Garden Castro: *How does your work dialogue with nature and the public?*

Christo: Let's take *The Gates* first. We made other proposals for New York City between 1964 and '68, which involved buildings. Then we did a lot of projects outside of Manhattan—in Australia, in the Rocky Mountains in Colorado, in California, and Loose Park in Kansas City, Missouri. More and more, our interest in the architecture of Manhattan moved to people walking in the streets. In Manhattan, people walk so much. At one point, Jeanne-Claude and I were contemplating using the sidewalk to do a project involving people simply walking.

Jeanne-Claude: We knew we would never get the permits, so we abandoned that idea in a few seconds.

C: Of course, the only place where people walk leisurely is in the parks. There are many parks in the five boroughs of New York City. But Central Park is exceptional, not only because of the design, but also because it is isolated from any natural forms, absolutely stuck in the middle of a highly condensed urban grid. West Side Park is diluted by the Hudson River; even Prospect Park is diluted by private homes, gardens, and big trees. Vaux and Olmsted designed Central Park in a ceremonial, Victorian way. It is surrounded by a stone wall, and the only way to go in is through openings called gates. Several gates even have names, like the Gate of the Girls, the Boys, the Artists, the Strangers.

We are trying to invent a module to activate the most banal space between your feet and the first branches of the trees. You usually walk on the park's walkways, looking at trees, looking at people, but you have a space between your feet and the branches hanging over the walkways or just near the walkways. We are trying to energize that space.

For each of our projects, we do life-size tests before the project starts. Vince Davenport, our chief engineer and director of construction, and his wife Jonita Davenport, who is project director of *The Gates*, built 18 gates with different widths of walkways on their meadow in Washington state. The width varies with the width of the walkway; sometimes they are 18 feet wide; sometimes they are six feet wide. Each gate is 16 feet tall. The rectangular shape reflects the geometric grid pattern of hundreds of city blocks surrounding Central Park. This project — and every one of our projects — is designed for a specific site, to engage profoundly with the people living in that site.

JGC: *How did you decide on the saffron color?*

C: This is the color of autumn. On a very cold winter day, in a bare, gray park, you have the reminiscence of the autumn foliage.

J-C: We chose February because it is the only month of the year when we could be sure that there would be no leaves on the trees, so you can see the work from far away, through the bare branches.

C: All of our projects distinguish between urban environments and rural sites. Central Park was invented by Vaux and Olmsted. It is a manmade structure like the Pont Neuf in Paris or the Reichstag in Berlin. It is entirely an architectural, landscaped park.

JGC: *In photographs, some of your works, like* Wrapped Coast *(1968–69) in Australia, appear to be in pristine settings. But* Wrapped Coast *was nine miles from the center of Sidney on the grounds of the Prince Henry Hospital. It was used as a garbage dump.* Surrounded Islands *was in the heart of Miami.*

C: In Dade county. Over 2.5 million people live around Biscayne Bay, which is exactly like a giant water park. All of our projects take place where people live and use the space to build bridges, houses, factories, churches, post offices, and highways.

The Gates, Project for Central Park, New York City, 1997. Pencil, charcoal, pastel, wax crayon, aerial photograph, and fabric sample, 2 parts: 244 x 106.6 cm.; 244 x 38 cm.

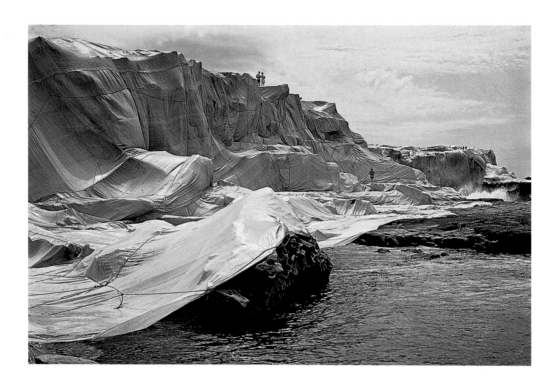

Wrapped Coast, One Million Square Feet, Little Bay, Sydney, Australia, 1968–69. 90,000 sq. meters of erosion-control fabric and 56.3 kilometers of rope.

J-C: Like *The Umbrellas* — blue in Japan, yellow in California. In both countries, the umbrellas were in front of temples, churches, gas stations, schools, highways, and bridges. *Running Fence* was installed on the property of 59 ranchers. And for *Over the River*, there are signs that the place is widely used by humans. We are in the third year of preparing an environmental impact assessment for that project, which we pay for. It is already the thickness of the New York telephone book. We have spent over $300,000, and each month we receive more bills, which we promptly pay. They have analyzed every possible situation of humans, animals, and plants. The process is part of the work, as much as a pregnancy is part of having a baby. Of course, the process is very important, but it has only one aim — to one day finally realize the project.

JGC: *Do you have a philosophy of art?*

J-C: We don't have a philosophy of art. We wish to create works of art, works of joy and of beauty. As with every true work of art, it has absolutely no purpose whatsoever: it is not a message, it is not a symbol, it is only a work of art. And like every true artist, we create those works of art for ourselves and our collaborators.

C: This is very important. The essential part of these projects is that they are decided by us. It is something we want to do, we have the urge to do it, we enjoy doing it. This is one of the reasons we will never, never do commissions. For all of the projects, we have the inexplicable urge to do it.

J-C: No commissions, no sponsors, ever.

C: Over the last 40 years, we have realized 18 projects, and we failed to get permission for 38 projects, and we lost interest.

JGC: *Woven works are important to you.*

C: All of our projects are living objects. The still photographs don't give a true understanding, because these projects are in constant motion—the wind is blowing the folds, the pleats. For 14 days, the Reichstag was like a living object, breathing, moving in the wind, and, of course, changing color and the shapes of the shadows in the folds. This project involved a tremendous dynamic quality, which is a very important part of all of our projects. They're not static, not like wood, stone, and steel. *Running Fence* was always moving—it was showing the extraordinary power of the wind. The *Surrounded Islands* were moving with the surf, with the waves of the ocean. All of these projects are very dynamic structures.

The important thing to understand is that all of our projects have a nomadic quality: things in transition, going away, gone forever. This quality is an essential part of our work. Our projects are airy—not heavy like stone, steel, or concrete blocks. They are passing through.

J-C: You understand why we say "nomadic." You see a giant empty plain. Then a nomadic tribe arrives, builds an entire town of fabric, lives there for a few weeks, and one day they fold up their fabric tents and are gone. And what remains? A vast empty plain. The nomads are gone.

C: Our projects exist for a very short time, and they disappear after a few days, two weeks.

JGC: *Is there an epiphany about exile?*

J-C: We never talk about generalities, nor about other artists. But you have a point: Christo and I are immigrants. For three years, we were illegal aliens in New York. And we will be immigrants our entire lives. Our American passports do not change anything. We are displaced persons.

C: That is a very important quality of late 20th-century and early 21st-century culture. There have never been so many people displaced for political, social, and economic reasons. Of course, thousands, millions of people around the world from different places going to different places are creating a completely different culture. And our work has a tremendous dimension of that process.

Over the River, Project for the Arkansas River, Colorado, 1999. Pencil, charcoal, and crayon, 55.9 x 71.1 cm.

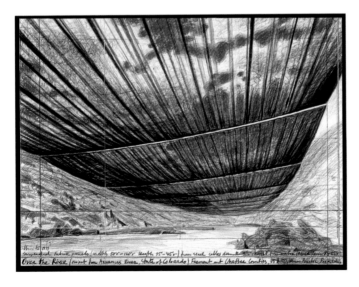

JGC: *You are careful to separate your artwork financially from the books, films, and postcards about the work.*

J-C: Yes. Do you know the difference between the name Christo and the name Christo and Jeanne-Claude?

JGC: *The two of you are responsible for outdoor work starting in '94?*

J-C: Every outdoor work since

the first one in 1961, but we changed the name in '94. All the drawings created by the hand of Christo alone are called preparatory drawings because they are created exclusively *before* the completion of the project, never afterward.

C: The ideas for projects come from both of us. For example, the islands in Florida surrounded with six million square feet of pink fabric was Jeanne-Claude's idea.

J-C: Of course, we kept our mouths shut because we wanted to get the permit. If we had said that it was my idea, forget it. Only our collaborators knew. Each of our big projects has its own documentation exhibition, which varies between 250 and 400 items; the shows travel only to museums, colleges, and universities. In the exhibition, you can see the evolution of the project long before we had the permits.

C: You can see the drawings, sketches, scale models, technical input from the engineers, the real materials — fabric, anchors, poles, cables — documents, correspondence, court drawings when we're taken to court, and photographs.

J-C: It's a complete story.

JGC: *For* The Gates, *Michael Bloomberg is on your team. For the Reichstag, I guess that you were friends with Willy Brandt.*

J-C: Yes, but the fact that we were friends with Willy Brandt did not help to get permission, because he died many years before. Do you know how we got permission for the Reichstag? They didn't invite us; it was imposed on us. Our arch-enemy was the Chancellor of Germany, Helmut Kohl. And he had told the media that as long as he was chancellor, the Reichstag would not be wrapped. He was absolutely sure that we would lose if it were to come to a roll call vote in parliament — because he had ordered his party to vote against us. After 70 minutes of debate, we defeated him by a majority of 69 votes: 292 in favor, 223 against and 9 abstentions. That is the only time in history that the creation of a work of art was decided by debate and parliamentary vote.

JGC: *There has been a shift in your aesthetic over the years. Has your work evolved from covering to revealing?*

C: With *Running Fence* and especially with *The Gates*, which started in 1979, our aesthetic moved to an important thing: exploring inner space. You can walk *inside* the gates and *under* the umbrellas. Inner space started to develop with the 1979 proposal of *The Gates*.

J-C: But you will already find it in *Store Front* (1964) — inner and outer space.

C: The curtains hanging in the storefronts were really the precursors of *Valley Curtain* and *Running Fence*.

JGC: *So,* The Gates *has taken from 1979 to 2005 to be realized.*

J-C: When they ask us how we can have so much patience, I always answer, it's not a matter of patience, it's a matter of passion.

Public Art Goes to the Mall: Larry Sultan's *People in Real Life* (1998)

by Donna Graves

The popularity of neo-traditional city planning and the much-publicized opening of Celebration, Disney's main street village in Florida, have revived debate about the nature of suburbia and the values that go along with it. For generations now, writers, filmmakers, and visual artists have depicted the suburbs as sprawling, characterless developments organized around conspicuous consumption and populated by bored teenagers and depressed housewives. Whether intentionally satirical or not, photography has played an important role in creating an image of the suburb as anti-icon. From widely published images of Levittown to the works of Robert Adams, Bill Owens, and Lewis Baltz, photographs have confirmed beliefs about the soul-destroying power of suburbia.

A more complicated and forgiving spirit informed a public art project in a suburban shopping mall created by Larry Sultan in collaboration with artists Harrell Fletcher and Jon Rubin. Sultan, whose work in both photography and public art has been widely recognized since the 1970s, had fantasized about being an "artist-in-residence" at a shopping mall for several years. Intrigued by its

Larry Sultan, Jon Rubin, and Harrell Fletcher, *People in Real Life*, 1997. Project at the Stoneridge Mall, Pleasanton, CA.

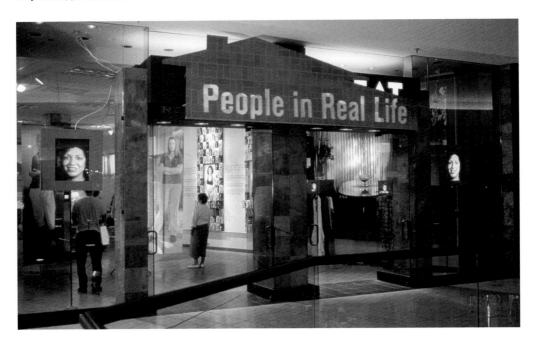

increasingly important role as a public gathering place, and the potential for a large and diverse audience, he saw the mall as "the appropriate place for public art at the end of the 20th century." He invited Fletcher and Rubin, two of his former students, to collaborate, and the team spent more than three months at the Stoneridge Mall, located an hour east of San Francisco in the affluent suburb of Pleasanton.

Employing the "hanging around" method of research, the artists talked to more than 200 shoppers, mall workers, and residents of surrounding communities. These conversations revealed an unexpected diversity of people at the mall, thereby subverting the stereotype of homogeneity that clings to suburbanites, and a surprising range of relationships between the mall and its clientele, from early morning walking clubs to teenagers hanging out after school. *People in Real Life* (1997), the six-week installation that resulted from the "residency," retold those real-life experiences with humor, sympathy, and a sophisticated use of the visual lexicon of the surrounding mall.

For postmodern theorists and those who dislike malls, these hermetically sealed spaces filled with identical chain stores reinforce feelings of placelessness. Malls literally "dislocate" us by design, emphasizing the generic and bland, rather than the quirky and complex. The *People in Real Life* storefront—squeezed between Contempo Casuals and Kinney Shoes—reflected the artists' study of the imagery and design in surrounding stores, from the Body Shop to the Gap. "We didn't really want to represent ourselves as artists with a capital A," said Rubin. "There is plenty of public art, even here in the mall. The problem is people don't look at it. We wanted to play in that in-between area, where people look and they aren't sure, so they look longer."

Racks, shelves, and boxes of carefully arranged clothing were distributed throughout the space, as were the "real people" selected from the artists' interviews. Window-mounted video monitors

Larry Sultan, Jon Rubin, and Harrell Fletcher, *People in Real Life* (detail), 1997.

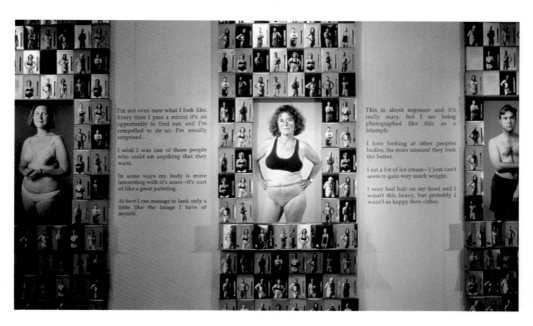

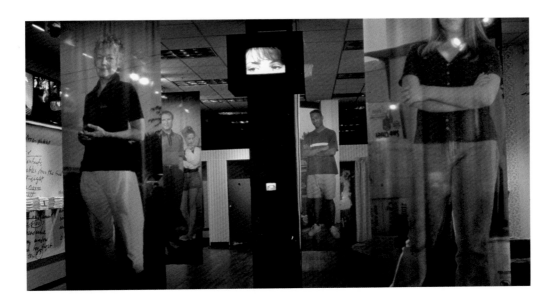

Larry Sultan, Jon Rubin, and Harrell Fletcher, *People in Real Life* (detail), 1997.

faced the mall's "boulevard" with 20- to 40-second portraits of dozens of local people—their facial expressions caught in the transition from public persona to a less self-conscious visage. Behind these hung full-length portraits printed on silk banners that turned other suburbanites into quasi-heroic figures.

While advertising-style strategies were used to draw viewers into the installation, the intent was to allow people to question the conveyed messages. "Advertising makes us feel like we should be someone else," Sultan explained. The powerful ambivalence inspired by shopping (think of going to buy a bathing suit) and advertising informed many of the artists' conversations with mall-goers. Descriptions of people's desires and worries were inscribed on tall stacks of crisply folded white t-shirts. The statements are, tellingly, not always easy to categorize: "Getting drunk at the wedding," "The kids get in bed with us," "The way you look at me."

Articles from the wardrobes of real people hung below five video monitors positioned near the store entrance. Footage of the wearers describing their clothes and their lives revealed individual complexity, along with rich and troubling connections between image, clothing, values, and relationships. A father and teenage daughter play out family anxieties over autonomy and identity through clothes shopping. A handsome young African American man speaks at length about how wardrobe reveals the social contradictions in his life; as manager of a store catering to skateboarders and "urban youth," he needs to adopt their look in order to "be credible with the customers," yet his personal taste runs to stereotype-flouting Brooks Brothers shirts and penny loafers. An older woman speaks of costumes as important tools for fantasy and, in the case of business attire, as oppressive constraints.

The installation also explored "public," "private," and the gray areas in between through its spatial organization. As viewers moved through the store, design elements changed from formal and commercial to domestic and intimate. A rear corner of the space held a dais encircled by patterned wall-

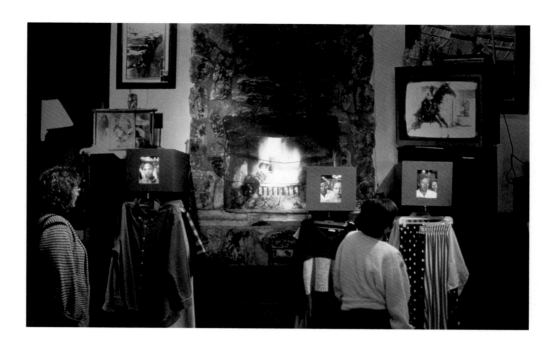

Larry Sultan, Jon Rubin, and Harrell Fletcher, *People in Real Life* (detail), 1997.

paper and outfitted as a typical suburban living room where local people serving as "hosts" invited visitors to talk about their thoughts and responses to the work. Nearby, two dressing-room doors offered the pleasure of eavesdropping on taped conversations between young women and between a husband and wife about sex, body image, clothes, work, and daily chores.

The strongest public response was inspired by dozens of custom-made underwear boxes arranged in the kind of plentiful display grid favored by marketers for its message of abundance. Though the packaging was designed à la Calvin Klein, the box fronts were printed with photographs of everyday people posing in their own underwear. The reverse side held their thoughts about bodies and identities: "I once had hair on my head and wasn't this heavy, but probably wasn't this happy then either," "This is what a real woman of 60 looks like."

Irony and satire might have been easier tactics for artists approaching this site and this subject, yet Fletcher, Rubin, and Sultan pointedly avoided those strategies without diluting the intelligence of their work. As Rubin described the team's methods, "One life told in relation to itself is always extraordinary." The individual voices and personal narratives of *People in Real Life* were yet another subversion of advertising techniques. "We realized how much advertising for clothing relies on narrative to sell its product. Clothes don't have a life, so ads need to endow them with attractive stories," Sultan said. In place of the romance or travel narratives encountered in nearby stores, *People in Real Life* created a space for individuals to narrate their own clothing with all of the experience and identity attached to it. The "real life" introduced by Sultan, Rubin, and Fletcher into the controlled predictability of one shopping center demonstrated that the resonance of the particular, the local, and the individual can speak powerfully when given a chance.

Starting Over From the Ruins: Simparch at Wendover Air Force Base (2004)

by Polly Ullrich

Wendover — 120 dusty miles west of Salt Lake City on Highway I-80 — hangs on the border of Utah and Nevada. The town, a collision of Mormon and gambling cultures, abuts the barren, pristine 30,000-acre Bonneville Salt Flats, a natural straight-away that has produced multiple world land-speed records. But Wendover's apocalyptic roots spring not from its extraordinary landscape but from its military history. During World War II, the 509th Composite Group led by Col. Paul Tibbets, Jr., secretly trained at the Wendover Air Force Base, eventually delivering Little Boy and Fat Man, the atomic bombs that obliterated Hiroshima and Nagasaki in 1945.

Wendover's relation to the cataclysmic and its location on the edge of a landscape void make it a perfect site to explore the boundaries of art and environmental action — as is evident in *Clean Livin'*, a self-sustaining structure developed by the collaborative group Simparch. The project, which navigates the realms of architecture, sculpture, ecology, and ethics, exemplifies the critic Homi Bhabha's definition of culture as "borderline work," as an attempt to devise an "in between space" that allows new hybrid art forms to escape the elitism of contemporary art by annexing new concepts and practices.

Supported by the New York arts fund Creative Capital and the Los Angeles-based Center for Land Use Interpretation (CLUI), *Clean Livin'* started as a rusted Quonset hut riddled with stray gunfire. The project is located in the deserted South Base. Miles of pockmarked proving grounds and bombing ranges littered with decaying hangars, twisted chunks of rusted metal, and abandoned barracks still stretch over the area. Although the Air Force deeded part of the Wendover base to the city in 1977 for civilian development, law enforcement training groups still engage in target practice and special operations maneuvers.

During the summer of 2003, CLUI commissioned Simparch, which includes artist/designers Matt Lynch, Steven Badgett, Chris Vorhees, and Pat Finlay, to rebuild the Quonset as an "off the grid" living space (using energy not derived from petrochemicals), so that visitors could experience and study the stark landscape and controversial military past of Wendover. Richard Saxton and Amy Horst of the artists' group Municipal/WORKSHOP in York, Alabama, developed the "Rover," a four-wheel, pedal-powered bicycle outfitted with a 55-gallon water tank and solar panel, to transport water from other parts of the base to *Clean Livin'*. Architecture students from the Illinois Institute of Technology (IIT) in Chicago also worked with Badgett to design sustainable components for *Clean Livin'*.

"The project enables a broad audience to go to South Base and experience one of the most interesting and stark landscapes in America," said Matt Coolidge, CLUI director. "The project is also about autonomy, isolation, making do with a bare minimum, making something from next to nothing, and exploring the basement of one's will...I see it as about starting over from the ruins of the military, about the birth of the atomic age, and the possibility of global Armageddon."

Simparch constructed *Clean Livin'* with two photovoltaic solar-powered battery systems from Intermountain Solar Technologies. During the construction, the artists camped in tents within a 5,000-square-foot shed: "Living and sleeping in the large open warehouse began to take its toll," said one entry in the group's work journal. "The nights with hot wind gusts up to at least 50 mph. The so-called doors swinging and rattling. Mouse droppings on you as you slept in an open hammock (bad idea), blowing sand, bats flying around in the space…a new set of life rules must be described and lived by."

Simparch decided on a minimal and reversible aesthetic to preserve the Quonset's historic character—they patched bullet and rust holes with roofing materials and sheet metal, insulating the structure and making it watertight. They documented the Quonset's north and south ends, and then, invoking the area's past, they installed small windows salvaged from pick-up truck toppers to imitate the pattern of bullet holes. They also installed a composting toilet, a water pump, and a student-designed water tower with an elevated 110-gallon storage tank for the kitchen and gravity showers. A prefabricated quarter-geodesic dome covers the garden.

As an aesthetic project, *Clean Livin'* is unlike other Western land art, with its imposition of human will; but then, *Clean Livin'* was not created to be a work of art. Instead, it represents an art form that intertwines with and comments on the social context and function of a specific locality. It represents groundedness—an aesthetic reaction to the direct experience of a place and the ethical values articulated in the transformation of that place.

Clean Livin' also converts the traditional idea of land as aesthetic scenery into the notion of landscape as a contested area of political, ecological action. With its emphasis on the social power of art, *Clean Livin'* descends directly from Joseph Beuys's definition of art as "social sculpture," that is, art as a process of compressing action, thought, and discussion into aesthetic material in order to reshape the world. The immersiveness, the daily functionality, of the *Clean Livin'* visitor space intensifies its poetic qualities. Its meaning—its conceptual base—emerges clearly from the "viewer's" experience of its practical and useful sustainability.

Clean Livin' is Simparch's second Wendover project for the CLUI, which has developed other buildings there, including an exhibition hall and studio space for visiting artists. In 1999, Simparch produced *The Unit*, converting a beat-up mobile home used at a Los Angeles construction site, which

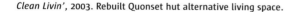

Clean Livin', 2003. Rebuilt Quonset hut alternative living space.

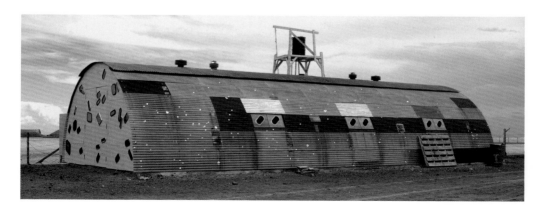

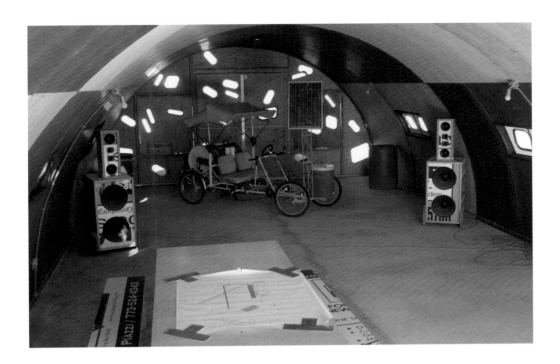

Clean Livin', 2003. Rebuilt Quonset hut alternative living space. Interior view.

CLUI had shipped to the edge of a rundown airfield across from the Enola Gay hangar. These Wendover projects are part of a larger body of hybrid architectural structures developed since 1996, when the group coalesced in Las Cruces, New Mexico, cobbling together a name from two words: "simple architecture."

The artists now live across the U.S., but they reunite periodically, working out a jury-rigged aesthetic called "transarchitecture," based on populist structures. These constructions incorporate what the group calls "shack elements" to locate metaphor and poetry in low-tech, cheaply constructed environments often built from kits, neatly skewering the strident designs featured in architecture magazines. The resulting structures—some functional, others not—create an ironic blend of sculpture, architecture, and social commentary, using odd materials including plastic sheeting, twine, twigs, steel cable, grommets, and cinder blocks.

With projects such as *Free Basin*, an enormous wooden skate bowl inspired by Southern California swimming pools, and *Spec*, a Quonset hut built from U.S. Gypsum ceiling tiles incorporating music by Kevin Drumm, Simparch has pushed the humble and the everyday into the realm of the iconic. *Clean Livin'*, with its socio-critical design, takes the effort one step further, integrating aesthetic metaphor, social change, and functional use. Locating the utilitarian structure of *Clean Livin'* within the context of art transforms its use into a kind of poetic action. Simparch has built a vehicle, a medium, that allows visitors to negotiate peculiarly traumatic ecological and military themes in a supremely rare environment.

The Barnstormers' Pilgrimage Down South (2005)

by David J. Brown

The town of Cameron, North Carolina, is a small community approximately one hour south of Raleigh. Its population of less than 250, spread among 50 or so families, supports a countrified economy of large farming tracts, small family-run hotels, and antique shops. Cameron was known for its turpentine industry until a pine bark beetle infestation decimated the source of the turpentine resin, the longleaf pine. Tobacco replaced the trees, and barns for curing the tobacco leaf soon cropped up in fields and along roadsides. In the 1960s, bulk barns made of metal, named for the more efficient mechanized system that they used, replaced the traditional wood- or gas-fired flue barns. Today, littered along the roads that pass through the town, you can find any number of glorious old tobacco barns and other outbuildings in various states of repair and verticality, each adorned with a rich weathered patina, some sprouting vines like wigs of wild hair.

Nobody knows for sure, but estimates place the number of remaining tobacco barns in the state somewhere between several thousand and 50,000. More certain is the state's 300-year history of producing this contested crop and its gradual demise. According to the North Carolina State Historic Preservation office, traditional tobacco cultivation peaked in the mid-20th century, when the state counted almost half a million air- and flue-curing barns. Along with recent losses in the textile and furniture industries, the dwindling of the tobacco farms makes the rural south a microcosm for the disappearance of the U.S. manufacturing industry in general—a disappearance that hits small communities very hard.

Cameron is an unlikely place for a social/community public art project, especially one that would forever change the participants and result in a groundbreaking museum exhibition. But that's what happened when the large-scale collective known as the Barnstormers came to town. The Barnstormers are a unique group of artists, designers, and friends, headed by former North Carolinian David Ellis, who attended the North Carolina School of the Arts high school program before moving to Brooklyn in 1989. After viewing the seminal film *Style Wars*, which celebrated the subway graffiti and street culture of New York, Ellis began to paint the sides of old barns and outbuildings on his parents' farm. Every year since his first Barnstorming visit back home with Tokyo-based artist Kami in 1999, Ellis has led as many as 30 people to Cameron to create large-scale, collective murals on old barns, tractor-trailers, shacks, and farm equipment.

The citizens of Cameron welcomed this multi-talented, creative group of artists, providing food, shelter, supplies, barns, and, during late-night outdoor painting sessions, light. Urban, hip-hop, hard-nosed, hit-and-run graffiti collided with honest-working, down-home, Southern-style hospitality, and the interaction profoundly affected both the group and the community at large. Jane Rogers, who was the school librarian while Ellis was growing up, played a key role in making the

Cameron project happen. She shared humorous stories about some of the Barnstormers being scared at night by the "monstrous and horrible sounds" of what turned out to be roosters crowing.

The Barnstormers return to Cameron every year to spend time with their extended family (to date they have painted more than 40 structures). Their repeated journeys have had a major impact on their work, as they continue to interpret and communicate the visual, cultural, and spiritual awakenings from their projects there. As Ellis observes, "Looking back on the first trip, it was overwhelming. I don't know what I thought would happen, but what did was an awakening. The two communities in my life, that in my head had nothing to do with one another, sat down at the table together, held hands, and became one."

After the group's yearly pilgrimage began to attract attention, the artists were invited to tackle the architecture of the cavernous main gallery at the Southeastern Center for Contemporary Art in Winston-Salem, where I serve as senior curator. In my initial discussion with Ellis, I suggested that the group might consider relocating one of the Cameron barns to our space to begin a time-based painting project that would alter and change as various members of the group visited the area. The Barnstormers took the bait and worked with SECCA in developing a series of works that, together, resulted in a retrospective of their work and pointed the unit in a new direction: a hybrid of sculpture, sound, film, and paint.

Barn, 2004. Two views of installation in process at the Southeastern Center for Contemporary Art.

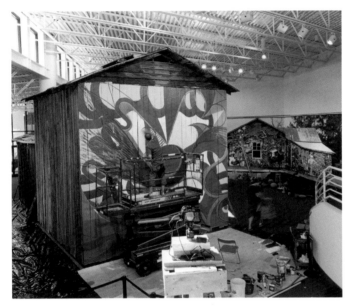

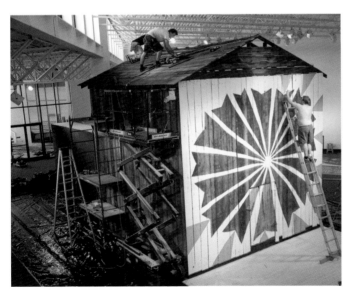

The commanding *Barn* (2004) was painstakingly dismantled from a property owned by Earl and Juanita Harbour in Cameron and rebuilt, piece by piece, by Ellis, Mike Houston, Martin Mazorra, and several others from the group. Covered in paper and poison ivy out in the field, the structure was smartly redesigned (several additional features were added, and the shape was altered to fit the space). A fading monument to the labor infrastructure that once supported its upkeep, the barn now received almost continuous renewal on its south side. Each stroke of activity, including the dismantling in the field, rebuilding in the museum, the painting, the de-installation, and the reconstruction back at the original site, was digitally recorded for a time-lapse film, with images snapped every seven seconds.

Four other films, *No Condition is Permanent* (2001), *Apostrophe* (2002), *Letter to the President* (2003) (the group's only political statement to date), and Joey Garfield's *The Barnstormers* (2004), were shown continuously on old TV monitors or, in one case, projected from the ceiling inside the barn. Except for Garfield's work, these 15-minute motion paintings were recorded in time-lapse sequence, with a ceiling-mounted camera shooting down over room-size canvases as members of the group, scurrying around like bees, produced a range of images from lush calligraphic line-work to pigs and chickens, abstract shapes, and cryptic wordplay.

A road-tested 18-wheeler was parked outside the museum. Several of the artists had emblazoned it with everything from commingling patterns inspired by the fluid lines made by a skateboarder in motion to large multifaceted diamonds. The rolling work, lent to the museum by Midway Truck Rentals, a local company headed by Zeno Marshall and his son, will travel around the country after the show closes.

Hive Mind Sound System, 2004. Found objects and 3 wooden platforms.

House (2004) and *Truck* (2004), two billboard-size banners that also received the never-ending group painting, mimicked the actual structures. Both explode with a constantly changing array of bold pop culture icons, delicate graphic images, and futuristic calligraphy, all somehow working together.

Imitating the inventive make-do aesthetic of the poor, the Barnstormers fabricated *Hive Mind Sound System* (2004), a 150-speaker cabinet ghetto-blaster of absurd proportions made from cast-off refrigerators, washing machines, automobile tires, dining room tables, and other debris. This hillbilly wall-of-sound perched on three, hand-built, wheeled wooden platforms pulled across the gallery floor by a refurbished International Harvester tractor. Musical selections, chosen by the group, pumped out hundreds of hours of sound via iPod. This work juxtaposed rapid advances in technology in certain parts of the world with comparative stagnation in other areas. It also helped to support the Barnstorming process itself. Ellis says, "I conjure much of my content by turning up the music and just flowing. I collect a vast quantity of reference material and consult it like an oracle but my biggest influence is my crew."

In homage to his father, a retired minister who has maintained a life-long admiration for the purple martin, Ellis created *Gourd Tree* (2004) and *Gourd Line* (2004), which feature 30 of the hard-shelled fruits painted by the Barnstormers. High-hanging groups of white-painted gourds are used throughout the South as nesting places for the migratory purple martin and several other species of birds. Because of their crisp resonating qualities, gourds have also been used for centuries as musical instruments. Drawing on the legacy of the African kalimba or thumb-piano, the enterprising Ellis has begun manufacturing a Gourd Speaker.

With the advent of a four-lane expansion of U.S. Highway 1, Cameron will soon be a turn-off, a destination site between Raleigh to the north and the golfing community of Pinehurst to the south. As the culture of the town continues to evolve, as the slowed-down lifestyle begins to disappear, we can only hope that the community remains curious and open to groups like the Barnstormers.

Reclamation Artists and Grassroots Public Art in Boston (2006)

by Christina Lanzl

Reclamation Artists, a loosely connected group of Boston-area artists and architects, has addressed environmental and urban planning concerns since 1980. Over the years, member artists have created major installations at neglected urban sites, many of which have since experienced revivals. The mission is to "call attention to the urban landscape and question how we shape, inhabit, neglect, or enhance it." Reclamation Artists is an elusive group that often works guerrilla-style, quietly scoping out neglected spaces and seemingly appearing out of nowhere with temporary, often large-scale public art.

In one of its most prominent projects, Reclamation Artists addressed the environmental, political, and social impact of development at Nun's Field on Mission Hill and offered an urban wild as a counter-proposal. In 2003, a developer bought Nun's Field as part of a 22-acre real estate transaction involving former church properties. The field offers views of a dramatic 30-foot-high Puddingstone rock ledge — the last cliff on Mission Hill of this rare, agglomerate rock unique to the Boston area. Invited by a neighborhood association opposed to development on the site, participating artists — including myself — worked individually and in teams. In conversation with neighbors and after researching land use in the area, 14 artists (Sarah Ashodian and Terry Bastian, Lisa Jeanne Graf, Jane Hans, Phil Manker, Vivienne Metcalf, AE Ryan, William Turville, Leslie Wilcox, Ellen Young, Rusty [Walter] Crump, and SMFA students of Mags Harries) developed an urban wild concept.

Vandalism is a serious threat for any outdoor art initiative, but low-budget initiatives are especially vulnerable. Over the years, several Reclamation Artists sites have been vandalized, including Nun's Field. Since the projects are self-financed and created with shoestring budgets, it is difficult to face these challenges. At times, it becomes more important to document a work of art than to try to protect it.

Fort Point artists pursued an equally laudable goal for the Public Art Series of 2001 and 2002, namely their own survival. The Fort Point Cultural Coalition's Public Art Series was a small grassroots initiative created to raise awareness of a community of 350-plus artists threatened with displacement due to development. In 1999, the Fort Point Cultural Coalition (FPCC) was formed as an independent nonprofit. After securing funding from the Boston Foundation, FPCC launched a campaign to increase visibility of Fort Point's artist community. The resident artists did what they do best, using individual creative skills to bring their cause to a larger audience and build support at all levels of public opinion, as well as in city and state government. Sixty-plus artists created 35 projects over three years. Jeff Smith organized Beret Day, for which he ordered hundreds of black berets and distributed them across Fort Point for a photo op and as proof of the artists' presence (many had been living in their studios illegally). My own project, in partnership with Ricardo Barreto of UrbanArts and Jed Speare

of Mobius, took place as a four-day, community-driven think tank with more than 100 participants from Fort Point and Greater Boston, including artists, arts administrators, city planners, architects, and corporate representatives. Ten temporary public art projects complemented the think tank in multiple locations in the Fort Point district, at South Station, and at Mobius. Installations were created by Caroline Bagenal, Terry Bastian, Yani Batteau, Alison Canfield, Leslie Clark, Lisa Roth and Shauna Gillies-Smith, Danielle Krcmar, Melora Kuhn, Ruth Mordecai, Jessica Poser, John Powell, and Reclamation Artists.

The South Bay Harbor Trail Public Art Initiative exemplifies a grassroots effort turned permanent public art endeavor. The project is a laudable effort to humanize major traffic arteries and to improve the quality of life. In Boston, its integrated design team approach (most common in states with percent-for-art statutes) is innovative. The South Bay Harbor Trail (SBHT) is a 3.5-mile, multi-use trail that, when completed, will re-connect five communities to each other and to the Boston Harbor. The trail effort was begun by a small group of Boston residents led by urban planner Michael Tyrrell, who formed the South Bay Harbor Trail Coalition in 1997. The Coalition formed a partnership with the environmental advocacy organization Save the Harbor/Save the Bay, which provides organizational, fundraising, and technical assistance. During the next phase, a public art initiative was launched and the UrbanArts Institute at Massachusetts College of Art was brought on board as consultant. Fundraising for two public art components is underway to finance sculptor A.M. Lilly's 30-foot-high kinetic *Watercross* proposal and a Wayfinding masterplan by Selbert Perkins Design Collaborative (SPDC).

SPDC creates art, communication, and environmental designs. Its approach will be to look at the "big picture," to establish an environmental communication plan that unifies the South Bay Harbor Trail as a significant landmark for the entire city. SPDC will use retired U.S. Coast Guard buoys as markers to engage visitors and effectively tell the story of each neighborhood and site along the trail. Lilly's *Watercross* will establish a major landmark on the site. The work consists of large stainless steel hoops activated by the wind. These rotating and overlapping rings, reminiscent of bicycle wheels, reflect the industrial nature of the proposed Fort Point Channel terminus site and suggest the joining of neighborhoods, of water and land.

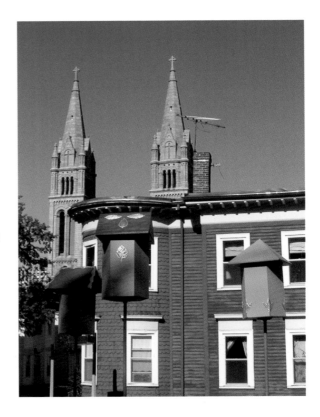

Christina Lanzl, *Nest Boxes for Screech Owls*, 2003. A Reclamation Artists project at Nun's Field.

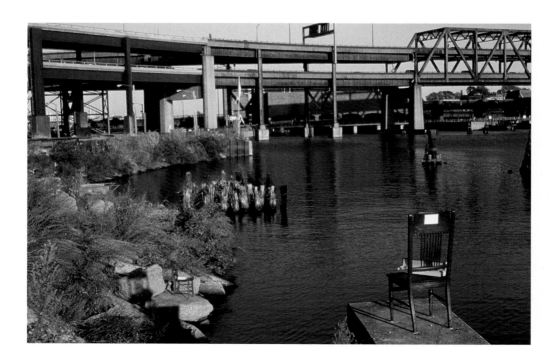

Laura Baring-Gould, *Five Places, Five Chairs, Five Boxes*, 1991. Found chairs, boxes, and objects, a Reclamation Artists project along the waterfront.

In Boston, public art is understood as a valuable quality-of-life factor. The city benefits from close-knit communities in which individuals and organizations collaborate and build alliances. In addition, its influential educational sector attracts highly trained and creative professionals willing to engage with local concerns. "Unofficial" grassroots projects like these, together with temporary and permanent initiatives launched by the Institute of Contemporary Art, the New England Foundation for the Arts, and the Forest Hills Educational Trust, strike a balance with large-scale works sponsored by the Boston Art Commission. Given a chance to thrive in Boston, these projects have fostered dialogue, brought communities together, and improved neighborhoods and public spaces—all while stimulating new expressions of contemporary art.

Temporary Services: Constructing Los Angeles

(2006)

by Amy Pederson

It has become commonplace to describe Los Angeles as an anti-city and to decry its physical and social fragmentation. Periodic fits of boosterism have done little to change the city's reputation as a segregated Babylon, and "I Hate L.A." is the most boring and frequently occurring conversation I can think of among my fellow residents.

From April 17 through May 1, 2005, the Chicago collective Temporary Services created a project called "Construction Site" on Sunset Boulevard in Echo Park, organized by the curatorial nonprofit group Outpost for Contemporary Art. Founded to assist artists in developing speculative and interdisciplinary projects, Outpost "challenges insularity and promotes cross-cultural exchange" and seeks to build relationships among diverse communities at local, national, and international levels.

Echo Park, a mixed area, is a fitting site for cross- and counter-cultural exchange. For several years beginning in 2000, the neighborhood was the farthest frontier of the gradual migration of white Los Angeles from west to east, led by an avant-garde of artists and followed by a parade of bourgeois bohemians trailed by slavering realtors. But its core of Latino families has remained, caught in a process of gentrification much slower (if not more gentle) than that of San Francisco's Mission district during the late 1990s. In "Construction Site," the artists of Temporary Services—Bret Cook, Salem Collo-Julin, and Marc Fischer—were joined by fellow artists BFE (Biggest Fags Ever), friends, students, neighborhood kids, homeless people, and random passersby as they worked to transform a vacant lot on the corner of Sunset and Alvarado into a fantastic landscape.

Neither monuments nor "installations," the resulting structures made up a massive DIY village. Discarded and reclaimed items were transformed into a swing set, movie theater, bar, jungle gym, and playground with toys of Oldenburg-esque proportions, the empty space filled with a giant Rube Goldberg contraption. Less about spectacle and more about negotiation, less about conceptual parameters and more about chance and open-endedness, the project progressed as both a factory and a community center. Screenings, workshops, and presentations took place as people ate, slept, and worked.

By their very nature, "Construction Site" and the other projects sponsored by Outpost may claim an affinity with Nicolas Bourriaud's relational aesthetics, which seeks intersubjective encounters in which meaning is collaboratively produced. Depending on audience and environment, such work is open-ended, grounded art within the larger social order, often produced by multiple authors.

"Construction Site" closed without its participants taking stock of the success, failure, or even true meaning of the work, but the success of this model of art-making within the specific context of Los Angeles remains to be seen. The art of relational aesthetics has been deplored for its blurring of art and life and, more particularly, art and entertainment. But while art need not be synonymous

Construction Site, 2005. Temporary, participatory project in progress.

with amusement, must it be hostile? Outpost and Temporary Services produced a heartening and positive project, one that might form a model for a new kind of "community art" in Los Angeles. In their next project, "Fair Trade," artists' videos will be screened on trucks traveling around the city. Finally, Angelenos stuck in traffic will have something to look at that, unlike the bumper stickers on the cars in front of them, will quell murderous rage, not inspire it.

Caoimhghin Ó Fraithile: Ritualizing Place (2011)

by Jonathan Goodman

The Irish artist Caoimhghin Ó Fraithile (Quee-veen O Fra-ha-la) makes sculptures and drawings all over the globe—in Asia, Europe, and America. A reticent, monk-like personality, he maintains his peripatetic lifestyle by taking on residencies in different parts of the world. Despite his wanderings and the temporary nature and sometimes remote locations of his large-scale work, a geographically diverse group of critics is bringing his wooden structures and exquisite drawings to the attention of the international art world. A strong will and sharp formal intelligence inform his wood, bamboo, and stone structures. Often highlighted by fire and moored on bodies of water, these ritualized sculptures exist essentially as pagan memorials. The drawings, done on unique sheets of handmade paper, look like ancient maps of places now beyond our reach.

Ó Fraithile lives on the Dingle peninsula in southwest Ireland, but he travels extensively; currently, he is spending considerable amounts of time in New York and in northern Japan, where his most recent architectural work has won the support of the small town of Fukui. Ó Fraithile possesses an unusual degree of technical skill, but his projects often require help from the local communities where they are built. In a sense, his works partake of the social consciousness that Joseph Beuys considered a sculptural phenomenon. Ó Fraithile sees the social harmony needed to complete his larger projects as a metaphor for supporting art in general. His invitations to other artists to participate in his environments—for example, the Butoh dancer who performed on the walkway and in the large construction *Fifteen Degrees South* (2009) in Fukui, Niigata City—look to collaboration as a way of investing in the artistic currency of the community. In more than a few ways, Ó Fraithile is a consummate artist of his time, looking back to an ancient past of ceremonial efficacy and a more recent past of post-Modernist art while forging new cooperative forms and methods.

Ó Fraithile's international path speaks to the wandering presence of many contemporary artists. Interactions with local communities deepen his connection with his work and its place in the world. For example, Ó Fraithile ensured that residents of An Daingean (the Irish name for Dingle) attended the initiation of his construction there by having a priest bless the event and talk about the history and people of the place. When the sculpture was outlined by fire, its local context became clear: it remembered those who had died at sea. As a result, the elegy for the dead took on a specific, as opposed to a generic, meaning. In addition to particularizing the context for his work, Ó Fraithile contemporizes his methods. Generally speaking, he uses the simplest of materials: inexpensive wood, simple colored cloth, and thatching. His three-dimensional work tends toward the ephemeral, which magically becomes ritualized through staged actions. Ó Fraithile's communal events and ad hoc buildings possess a remarkable poetry to which unknown assistants and laborers make a visible contribution—even after a project has been fulfilled and

disassembled. Interestingly, the existential precariousness of his installations underscores a particularly agrarian, cross-cultural notion of the frailty and delicate beauty of nature's continuous change.

It may well be that our sense of beauty, no matter the culture, depends on our inability to stop the decay that transforms nature. *Rag Tower* (2004, Taipei), an early work, was constructed next to a multistory building and rose to nearly the same height. Most of the construction consisted of bamboo supports, and the tower's crown was made up of dangling strips of cloth, layered over each other to create a striking visual effect. Additional lines of cloth cascaded from the top of the tower and descended through its interior. In contrast to the sturdy brown stone of the adjacent building, *Rag Tower* looked improvised and even a bit vulnerable in its frailty. Yet those same qualities, representing the antithesis of the built world and its desire for permanence, enacted a remarkably subtle poetry essentially rooted in architecture.

One of Ó Fraithile's most lyrical pieces is *Tig Donal Rua* (*Red Donal's House*, 2007), located at Mt. Brenden, some 10 miles from his home. The deserted house, really a small stone cottage, was occupied until the mid-19th century. With the help of local residents, Ó Fraithile cleaned it and set it right. He added an open wooden roof, tied cloth strips to the underside, and thatched it with rushes, which enhanced the quiet beauty of the tiny home. During the renovation, Ó Fraithile and fellow workers found the hearthstone; it is said that the last family to live in the small space included some 16 children. The project reached completion when community members trekked across the bog to a nighttime event lit by fires and candles. With no electricity in the valley and people speaking Gaelic, the gathering took on the aura of an ancient wake.

Fifteen Degrees South, 2009. View of Butoh dance performance, project in Fukui, Niigata City, Japan.

Tochar (Causeway), 2005. Wood, cloth, fire, and water, dimensions variable. View of work installed in Dingle, Ireland.

Drawing on his rural upbringing, Ó Fraithile celebrates places that emphasize the presence of nature. His visionary network of scaffolding and walkways in *Fifteen Degrees South* is set in a pond created by the residents of Fukui. Part of the structure is permanent, making a lasting contribution to the welfare of the village. Ó Fraithile is an artist of genuine and hopeful achievement; he resurrects sites and gives them life within the context of their surroundings. As such, he is architect and archaeologist as well as artist. He looks back to the past but also ahead to the future, where it is hoped that at least his longer lasting projects will maintain their lyrical effectiveness.

Public Space and Private Investigation:
A Conversation with Bradley McCallum
and Jacqueline Tarry (2002)

by Ana Finel Honigman

Bradley McCallum and Jacqueline Tarry's public installations merge aesthetic achievement, civic discourse, and social advocacy. Their work directs an empathetic focus on "difficult" issues, highlighting the effects of political or social injustice. *Witness: Perspectives on Police Violence*, conceived in 1997 following the much-publicized violence endured by Abner Louima while in police custody in New York City, was initially installed in the sanctuary of New York's Cathedral of Saint John the Divine (November–December 1999). *Witness Call Boxes* were installed citywide in October 2000; the project culminated at the Bronx Museum of the Arts (February–April 2001). The heated reactions provoked by their work testifies to its strength and ability to expand the dialogue surrounding vital social concerns.

Ana Finel Honigman: *In* Silence, *do you intend to draw parallels between slavery and current attitudes?*

Bradley McCallum: *Silence* investigates the role of silence as a conscious, active, civic decision within the period of slavery as well as today. This type of active silence, in its most toxic form, was as much an element of slavery as it is an element of contemporary racism. *Silence* represents a body of work that will engage historic sites, as well as traditional art world venues. As with *Witness*, *Silence* is a form of performative sculpture that encompasses multiple sites and installations.

Jacqueline Tarry: "Performative" in the sense that the sculpture organically adapts from the circumstances in which it was created. The civic- or issue-based nature of our work, combined with its public placement, allows for aesthetic variations on the same theme. So, after the first installation of a particular project, the public response or the changing social climate dictates that another work be created.

BM: *Silence* was first installed in the sanctuary of Center Church on the Green in New Haven, Connecticut. It focused on congregation members of African descent who petitioned the leadership of Center Church in 1820 for permission to sit in the ground-floor pews. After their petition was denied, and they were required to remain seated in the balcony, several left to establish the nation's first black Congregationalist church. The installation consisted of three elements: a reading of an address given by Rev. James Wright to the Anti-Slavery Society in 1834, a series of 19 photographs intended to establish the presence of African Americans in the central pews, and a series of granite "memorial plaques" that acknowledged the African Americans who were members of Center Church in the 1820s.

JT: The photographs are portraits of present-day Dixwell Avenue Congregational Church members, descendants of those original black parishioners. Dixwell Avenue Church is the current incarnation of the first black Congregationalist church. We installed the images in the areas where their ancestors were not permitted to sit. The photographs themselves were printed on delicate, translucent rice

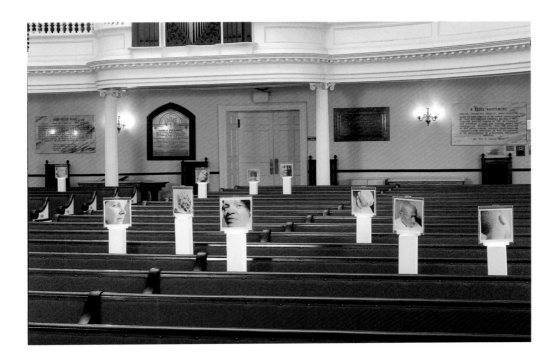

Silence (detail), 2001. Installation at Center Church on the Green, New Haven, CT.

paper, which appears very much like skin. They were presented in a manner integral to the interior architecture, so that the images merged with the space and could be seen from all sides. As a historic landmark, the sanctuary combines tourist interests with responsibilities to the congregation. It was important that we integrate the work so that the experience would unfold gradually for viewers as they explored the church or participated in worship.

The granite markers were installed in the balcony area in such a way that viewers reading the text gained an empathetic understanding of the experience of segregated seating. Center Church was built over an existing cemetery, so the basement is a crypt with gravestones from the 1700s and 1800s, preserved in near-perfect condition. By researching church records, we discovered parishioners' names, marital status, membership numbers, and the racial indicator "colored." We integrated information about the black parishioners into fictional narratives, "sampled" from the available texts commemorating the church's acknowledged members. We combined the phrases taken from the plaques with rubbings of the decorative motifs that mark the gravestones. These hybrid granite markers serve as a means of reintegrating the excluded parishioners into the church's history.

BM: A commemorative plaque given to an early pastor included the phrase "Devoted in the Service to his Lord and Master." When this text is applied to a black parishioner, it highlights the complex interweaving between the church's history and slave history. Part of our concern is how to take the existing language and ascribe it to these unknown individuals so that we create a sense of identity and personal narrative. The installation changed on the morning of November 9, when the Board of Stewards, the governing body responsible for the maintenance and use of the church, elected to remove the photographs from the central seating area and place them in the balcony, because of

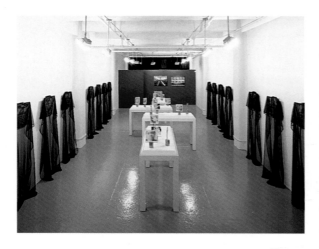

Silence (detail), 2002. View of installation at the Rush Arts Gallery, NY.

parishioners' lobbying. They did not notify the pastors, the congregation, the sponsoring arts organization, or Jacqueline and myself. It is a startling example of history repeating itself.

JT: The reason for removing the photographs (two weeks into a five-week installation) was that some of the parishioners "felt uncomfortable with the images in front of them" and could not "enjoy their worship experience." We want to have a dialogue that could contribute to our communal understanding of what informs feelings of discomfort on issues involving race.

AFH: *How do* Silence *and* Witness, *both having been installed in houses of worship, relate to "sacred spaces" and the discourse of faith?*

JT: I think our work relates strongly to the dichotomy between these being public spaces and sites of private, spiritual investigation.

AFH: *Saint John the Divine is known as politically progressive. It is a site with a strong history of social protest. How did that history inform* Witness?

JT: They don't shy away from the "tough work." When we installed *Witness*, it was during the height of media attention to police brutality. Cathedral officials were very welcoming and supportive of the work's controversial nature.

BM: Obtaining permits for *Witness* as a temporary public artwork was not possible at that time. The offer of the sanctuary, a safe space, was instrumental in providing a "public" venue for this work. Their support validated the work in a way that a museum wouldn't or couldn't at that time.

AFH: *Is there something particularly American about your work in the way you address current issues or in the way you confront contemporary relationships to the past?*

BM: Our work addresses issues and histories that are specific to America yet represent universal dynamics. The most radical social aspect lies in the possibility of sparking discourse that shapes public policy. How can we create a public conversation that goes beyond media sound-bites? How can we create a situation in which people can speak for themselves? I hope that the work creates a sense of intimacy that shapes the experience for the viewer — a moment where public spaces are experienced as sites of private listening.

AFH: *You do not avoid making beautiful sculpture. There is a reverence for something beautiful, adding attention, awe, and respect for the issues that you address. Are aesthetic concerns secondary when making art dealing with civic issues?*

BM: When I listen to the critical discourse regarding civic-based, social/political art, I rarely hear critics speak about ideas of beauty and reverence. For me, the seduction factor is very important as a means of engaging an audience with differing points of view in the experience of the work. It is through aesthetic concerns that the political is activated. Pure aesthetics captures the attention of communities beyond the like-minded, the choir. Through the objects, their materials, the acoustic

Witness Call Boxes, 2000. One stop on the citywide Call Box Tour, New York City; installation at Gowanas Houses, where a 14-year-old was killed.

space, a soft-spoken voice, we hook people who would normally avoid conversations of police misconduct or race into an extended experience of the work. By creating environments of discovery and eavesdropping, the civic issues resonate. What value systems for community art go beyond the degree to which it gives back to the community? There needs to be an aesthetic standard applied to the work. The civic focus is not self-justifying.

JT: We are seeking the experience of a conversation that takes place across the kitchen table, but while standing on the sidewalk—to capture the experience of private, intimate space in public.

Revolutionizing History: A Conversation with Olivia Robinson, Josh MacPhee, and Dara Greenwald (2010)

by Jesse Ball

Artists Olivia Robinson, Josh MacPhee, and Dara Greenwald make the invisible visible, from daily routines to entire cultural moments. Passing through the streets of Troy, New York, the trio felt a mounting sense of dismay at the changing cityscape and the loss of visible history. So, they hatched a project to re-create the façade of a missing building and thereby trigger its psycho-physical space in the land-scape as well as its historical context. An examination of possible sites led them to a two-fold prize — a vanished building and a revolutionary abolitionist.

Liberty Street Church was located at the corner of Liberty and Franklin; in 1840, it housed a black congregation and a whirlwind of a pastor, Henry Highland Garnet. That year, his leg was ampu-tated, which only seemed to spur him on. He fired blistering sermons from the pulpit, preparing the way for his famous 1843 speech, "Call to Rebellion: An Address to the Slaves of the United States of America." This was not mere rhetoric: "You act as though your daughters were born to pamper the lusts of your masters and overseers...you tamely submit while your lords tear your wives from your embraces...we ask you, are you men? Where is the blood of your fathers? Has it all run out of your veins? Awake, awake; millions of voices are calling you! Your dead fathers speak to you from their graves. Heaven, as with a voice of thunder, calls on you to arise from the dust."

For the artists, finding the spirit of Garnet — grandson of an African warrior prince captured in battle, amputee, ferocious orator — in the blank space of the parking lot laid over the holy ground of Liberty Street Church was a call to arms. It is hardly surprising that Robinson, who teaches at the Maryland Institute College of Art, would answer that call. Her countless projects, including initiatives in federal prisons, manage this exact blend of recall and revolution. Her work continually makes the point that communities must preserve themselves through action and memory. On May 30, 2008, Robinson, MacPhee, Greenwald, and a coterie of assistants set in motion a large-scale remembrance.

At the corner of Liberty and Franklin, a ghost rose from the pavement, trembling and expanding. Liberty Street Church, a symbol of African American liberty and the center of Garnet's struggle, long con-signed to dust, was clearly visible against the night sky. Passersby stopped in droves, and cars slowed to note the powerful phenomenon — on the sides of the inflated structure, images and text, part and parcel of the pastor's battle, played for all to see: "Let our motto be resistance! Resistance! Resistance! No oppressed people have ever secured their liberty without resistance." At night's end, the ghost church subsided, and morning came to an empty lot. As Robinson says, "Art is in the bodies of those who experi-ence it. At least this church, disappeared from living memory, exists again as long as those who saw it."

Jesse Ball: *Did you choose materials based on the needs of the structure, or did the structure evolve out of your expertise with particular materials?*

Dara Greenwald, Josh MacPhee, and Olivia Robinson: Seems like a pretty synergistic combination of both. Olivia wanted to make inflatables related to Troy architecture, and our combined brainstorming led to the church, which led to the ghost church idea, which fit perfectly with a clear plastic inflatable, and our budget (which was zero).

JB: *Were there particular materials that you especially liked?*

DG, JM, and OR: We especially wanted social interaction—talking with people about the project, inviting them to come—the physical materials were given meaning by the social context that the project both highlighted and created.

JB: *Do the materials add to the metaphorical content?*

DG, JM, and OR: The plastic creates an amazing ghostly quality. We call this project *Ghost of Liberty Street Church*, and it's part of the "Spectres of Liberty" series. It seems both solid and permeable, opaque and transparent. The ropes holding the church seemed metaphorical as well—as if it needed to be held down because of the power of Garnet's words. The video/animation of words spilling out of Garnet's mouth and dispersing into the atmosphere was a metaphor for his thoughts dispersing across the social fabric.

JB: *The project combined physical structure, community event, and video installation, molding them into a single whole-cloth experience. Were planning and coordinating a big part of the process? Did you have to leave room for last-minute epiphanies?*

DG, JM, and OR: Planning and coordinating were as important as working with the physical materials. We see organizing as part of our artistic process. We worked closely with a number of people and had an immense amount of help in preparing the structure, doing test inflations, working on the animations,

Spectres of Liberty: Ghost of Liberty Street Church, 2008. Plastic, clear tape, fan, video projectors, speakers, and animation, 35 x 25 x 35 ft.

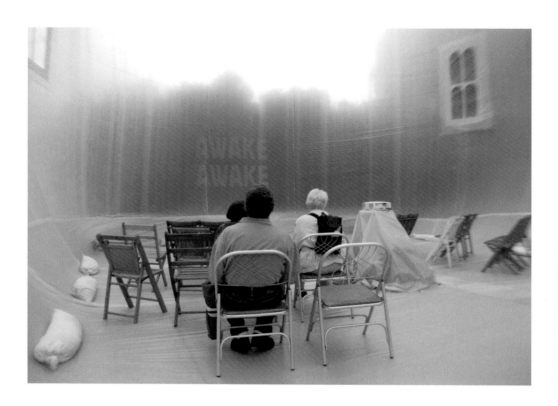

Spectres of Liberty: Ghost of Liberty Street Church, 2008. Interior view.

acquiring the location, and promoting the event. With each interaction, each test run, ideas evolved and changed for the final installation. We were making decisions up until the night of the event. Even then, we did not realize how much room we had left for epiphanies from the audience. Steven Tyson, who erected the historical marker at the same site, gave an unprepared but extremely moving speech about the site and the event.

JB: *Did the public cause the work to change?*

DG, JM, and OR: Yes, at the event, people asked us to speak and answer questions, which we had not planned on, and Tyson's participation was also unplanned.

JB: *How did you negotiate the space of collaboration?*

DG, JM, and OR: We each have different skill sets, and we ended up working that out in different ways. By the installation, very little was solely the sphere of one person, but we each took on heavier workloads for different kinds of labor. In the process, we learned a significant amount from each other and about all of the expertise involved, including video, animation, documentation, graphics production, promotion, outreach, inflatable construction, printmaking, text editing, and labor organization.

JB: *Did the controversial material create any friction within your collaboration?*

DG, JM, and OR: Luckily we tended to agree about the interpretation and understanding of the material. With this project, we were trying to inject historical specificity into a location from which it had been stripped, but we did not want to circumscribe the audience to only a single possible reading. So, we

had to agree less on interpretations of history and more on the importance of how to share that history, letting the audience take from it what they could and would. We had long conversations about how much to explain and how much to leave up to interpretation.

JB: *Did you expect the physicality of the church to accomplish as much as it did?*

DG, JM, and OR: The physicality of the church was really impressive. Even after three or four test runs, we were still in awe of the size and form that this simple pile of plastic was able to take. It was amazing to see people interact with it. It is so simple yet so hard to wrap your head around how plastic sheeting and a fan can fill a parking lot three stories high.

JB: *How long did everything take, from start to finish on the day in question, including the preparation and clean-up?*

DG, JM, and OR: Fourteen hours or so.

JB: *What is at the heart of your upcoming project?*

DG, JM, and OR: All of our projects have been about the challenge of re-animating history, pulling ideas, images, and lives from the past and reframing them so that they resonate in the present. Malcolm X once said, "Only by knowing where we've been can we know where we are and look to where we want to go." In the upcoming Syracuse project, we are working with Jermain Loguen's idea of the Open City from the 1850s. Syracuse has a rich, though not well-known history as a radical city in the 19th century. Today, it is full of social justice groups, such as the Peace Council, the oldest peace organization in the nation. The current groups and activities are less celebrated than those of the past. The past lends a certain legitimacy to ideas, especially ideas about change. Through a series of cultural events and a visceral artistic experience, we hope to celebrate and acknowledge the connections between past and present social justice work in Syracuse, while envisioning even more ways for the city to be Open.

JB: *How is the Syracuse project linked to* Ghost of Liberty Street Church?

DG, JM, and OR: Both projects are built around the idea that the past of a location means something to the present. Some of these meanings tend to be over-determined and well represented, while others may be suppressed or misrepresented. We have found that the more strident, outspoken, and militant parts of abolitionist history are downplayed today, even though they might be the very aspects that speak most to current social conditions.

JB: *What did you learn from Troy that you are bringing to Syracuse?*

DG, JM, and OR: One of the tools wielded by art and culture is the ability to create a sense of wonder and inquisitiveness in an audience. Traditional history telling or political organizing can rarely do this. In Troy, we were able to create that sense of wonder, and we hope to do the same in Syracuse. We are turning everyday materials like plywood, car parts, and bicycles into giant analog animation machines.

JB: *What is the relationship between the form you have chosen — a workshop and large-scale zoetropes — and abolitionism?*

DG, JM, and OR: Abolitionism in upstate New York was not simply an idea, but an embodied set of interlocking communities and institutions that aided slaves in their escape to freedom and kept them out of the hands of those who wished to return them to their "masters." In Syracuse, this took the metaphorical form of the Open City, which was the call of abolitionist preacher Jermain Loguen. In the Open City, abolitionists would not have to live in fear for their beliefs, and former slaves would not have to fear being captured and returned to the South in chains. Our workshop is an attempt to

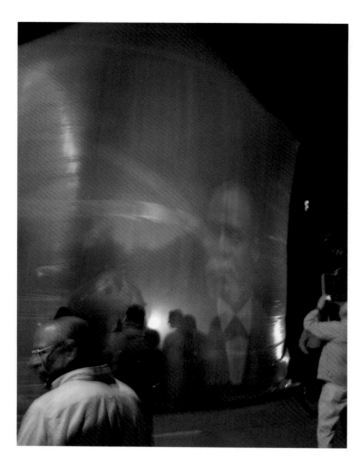

*Spectres of Liberty: Ghost of Liberty
Street Church*, 2008. Exterior detail.

parallel this sense of community; we hope to use it as a platform to connect to others who are interested in the idea of the Open City, both as a historical concept and as an arrow that points to possibilities for the Syracuse of the present and the future. The zoetropes are a tool to animate this process, to visualize the Open City with a series of technologies developed in the mid-19th century, at the same time as the struggle to end slavery in the U.S.

Removed Monuments and Shifted Narratives in Eastern Europe (2006)

by Aniko Erdosi

In 1979 Michael Asher removed a statue of George Washington from the Art Institute of Chicago entrance and placed it in Gallery 219 as part of an installation. His act posed questions regarding our relationship to history and raised one of the most relevant issues of art theory and practice of the time: the criticism of institutionalized art. But what factors inspire artists to remove public monuments today? And how can these impulses toward removal be interpreted in a global and local, a social and artistic context?

The removal of a public monument is always a forceful act. It brings together not only opposing states of remembrance and oblivion, but also sometimes conflicting interests of the individual and the public. A public statue represents the political and cultural identity of a community at a given historical place and time. At the moment of its erection, it has a powerful and clear message. As the story and context surrounding the statue shift, so does its interpretation within society at large. Time can corrode the power and meaning of a public statue, rendering it incomprehensible or insignificant, but only until it regains its radical social and cultural function. This can be restored by a simple act, for instance through a context-changing artistic intervention.

In 2003, Stefan Nikolaev temporarily transferred a 19th-century public monument of the Bulgarian poet and national hero Hristo Botev to the Swiss town of Chur, to "visit" the statue of his local counterpart Benedict Fontana. Absurd and funny, Nikolaev's project also showed an interest in historical narratives and pointed out how public monuments are at the mercy of time.

Even more provocative was the removal project *Monument Contra Cathedral (Instauratio)*. Staged by the Hungarian artist group Little Warsaw (András Gálik and Bálint Havas) in 2004, this action involved the removal of a monument to a 19th-century local hero, erected in the '60s in the small agricultural town of Hódemezôvásárhely. The artists repositioned the monument at the Stedelijk Museum in Amsterdam, where it was included in a group show examining the relationship of Central and Eastern European artists to history and tradition.[1]

Little Warsaw's action focused on a public monument from the Communist era. The statue of János Szántó Kovács (the leader of an agrarian riot) inspired intense reactions, not only on the part of local people, but also within Hungarian artistic and intellectual circles. Its incendiary history began in 1965, when the town government decided to erect a monument to Kovács and the local community reacted with unexpected repugnance. The issue was so significant that Hungarian television made a documentary.[2] The archival footage, which Little Warsaw used in a video installation, demonstrates the degree of discontent among residents — including Kovács's descendants — and includes responses from the mayor and József Somogyi, the sculptor. At that time, the debate mostly concerned the balance of abstraction and realism in the statue, an issue that remains controversial today. After the

debate calmed down, the statue fell into oblivion. It stood in the town's main square, inhabitants passing by without noticing it at all, day after day.

Little Warsaw's artistic act of removing the statue generated intense debate in professional forums and the columns of daily papers. Somogyi's daughter and heir accused the artists of trespassing on the work's copyright and brought a suit against them. The organizers of the project, in fact, had forgotten about copyright issues, and the case provides a telling example of the contradictory relations between artistic freedom and legal limitations. Town residents felt confused when they confronted the void left by the missing statue. Many of them assumed the removal to be politically motivated, while others articulated their discontent about the long-time neglect of the public square.

Some of the loudest opposition came from the Hungarian Art Academy, which published an official protest against Little Warsaw, with almost 100 signatures.[3] Academy members called on the artists to account for their "anti-sculpture" activity, for the "misinterpretation" of an artwork, and for "dishonoring" Somogyi's memory. The interesting point in this resistance is that among the opponents were artists with various political and artistic orientations, which not only makes clear the complexity of context for monumental art, but also points out the essence and the importance of Little Warsaw's project.

This importance lies in the role of the artist group and the statue in Hungarian society, which is marked by a lack of updated political, societal, and cultural narratives. The removal project and its repercussions highlighted how Hungarian society—including its intellectual and political leaders—has efficiently avoided cultural and historical assimilation of the past, especially the 40 years of

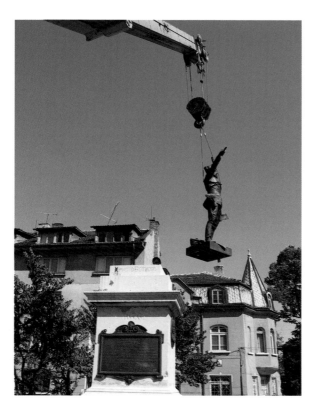

Communism. More than a decade and a half later, there is still no relevant discourse on this collective experience in its different spatial and temporal perspectives, on the professional or general social level. The fact that oblivion is more popular than remembrance is certainly a general characteristic of post-Communist countries, but the lack of intellectual discourse inhibits significant experiments of re-interpretation and the chance to draft new contemporary narratives.[4]

Little Warsaw responds to this situation by trying to dismantle a seemingly stagnant context with a conceptual mentality, by using appropriation and provocation to burst the institutional and societal boundaries of art. Their

Stefan Nikolaev, *Monument to Monument*, 2003. Temporary re-siting of a 19th-century monument.

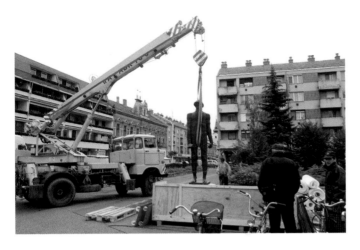

Little Warsaw (András Gálik and Bálint Havas), *Monument Contra Cathedral (Instauratio)*, 2004. Statue being removed from the public plaza in Hódemezôvásárhely, Hungary.

radical attitude is meant to provoke the cultural and societal subconscious as well as collective memory. They have carved out a very particular role for themselves in Hungary's contemporary art scene: to reveal unresolved social issues and the absence of current consensus, without judgment. The artists raise provocative questions, which in turn open up new approaches and make possible new historical and cultural interpretations and perspectives.

Beyond the timely and necessary aspect of these issues in Central and Eastern Europe, Little Warsaw addresses a more universal issue—the role of public space. Though the redefinition of public space is a global phenomenon, it is not an accident that Little Warsaw's conceptual project resonated so strongly in a historically loaded country like Hungary, where a sculpture park was created for public statues from the Communist era. Memento Park, which is located in a suburb of Budapest and serves as a tourist destination and point of reference for history classes, and the projects of Little Warsaw signal diverse approaches to the assimilation of the recent past.[5]

Notes

1 "Who if not we...? Episode 2: Time and Again," October 23, 2004–January 30, 2005. The project was later replicated in the U.S. for "Re_dis_trans: Voltage of Relocation and Displacement," April 12–May 20, 2006, a show that I curated at Apexart in New York.

2 *Lelepleztek egy szobrot (The Uncovered Statue)*, directed by Boris Zsigmondi, 1965.

3 The Hungarian Art Academy, formerly the Szechenyi Art Academy, is an art organization founded in 1992. Its members are artists, architects, filmmakers, photographers, art historians, and composers. Most of them are committed to conservative, nationalist values. At the time of this book's publication, the Academy has become the official "cultural representative" of the right-leaning, populist-nationalist administration of Hungary, with influence even over the Kunsthalle, which had been committed to a progressive, international artistic program.

4 See Edit Andras, "Little Warsaw in and out of Budapest—The projects of the Hungarian artist duo Little Warsaw," *Springerin*, 2006/5.

5 More information on Memento Park can be found at <http://www.szoborpark.hu/index.php?Lang=en>.

Artists Placement Group: Context is (Not) Everything (2013)

by Maureen Connor

Almost every account of the Artists Placement Group begins with an evocative portrayal of its co-founder, Barbara Steveni, sorting through piles of rubbish outside a London factory to collect materials for a Fluxus installation. Peering into the factory window, she experienced an aha moment, realizing that engaging with the workers inside might be a more authentically Fluxus activity, creating a direct rapprochement between art and life. Since then, much has been made of the timing of Steveni's insight—the mid-'60s, with the developed world on the cusp of an economic transformation from manufacturing to service industries—which led her to develop the Artists Placement Group (APG) and, through it, propose that artists could play a unique role in this changing workplace.

As the name implies, the goal of the Artists Placement Group was to "place" artists in non-art venues, giving them the opportunity to engage with circumstances beyond studio and gallery. The earliest placements, which were in factories and other businesses, took place in the '60s; possibilities expanded in the '70s to include healthcare facilities, especially mental health, the commercial shipping industry, and government offices. Steveni, whose work at the time was identified mostly in relation to Fluxus, joined forces with her husband, conceptualist John Latham, to develop these placements. "Incidental Person," was the term Latham coined for artists in placement sites to indicate that they were free agents, able to make constructive contributions in real-world situations. By virtue of their creative intelligence, as well as their freedom from the conventions inherent to a particular workplace (e.g., bureaucratic routine, commercial self-interest), they would be able to imagine other possibilities.

While APG remained active into the '90s (after 1989 under the name Organization + Imagination), its work largely fell from sight in the '80s and remained so until recently. Despite the fact that the group represents one of the most groundbreaking and radical of '60s conceptual-based practices, its rediscovery, which began about 10 years ago, has been gradual and controversial, in some ways paralleling both the growth of and resistance to social practice art for which it serves as precursor and model.

When APG artists began work at a placement location, their initial contact, identified by Latham and Steveni as the "open brief," allowed them a short time (a month or less) on site to observe, listen, and gather data about the particular set of circumstances at a given workplace or organization. Artists would then use this information to create the next phase of the project, a "feasibility study." The first declaration of the APG manifesto, "Context is half the work," defined the framework. Seeming to offer a playful challenge to received wisdom, its actual register lay somewhere between caution and provocation.

How did APG artists interpret this twist on the importance of context? Once Duchamp made evident that the exhibition venue is the context that produces art and also bestows its value, artists

157 BRANDLINGS WAY PETERLEE
1976

PETERLEE

Stuart Brisley, *Brandlings Way Peterlee*, 1976. Black and white print on board.

began to explore alternative sites and sources of content and form that had previously been consid-
ered off limits. There were a few other commonly held influences among conceptual artists of the
'60s, the earliest and most radical of which was the Situationist International, a European-based
group of writers, artists, and theorists who advocated for an economic and political alternative
to capitalism. The Situationists experimented with the construction of "situations" or "the dérive"
(drift). Meant to lead pedestrians away from their usual route and defamiliarize the city, a dérive
provoked critical analysis of the urban experience.

Fluxus was an equally influential movement that established its own social and political positions,
rejecting cultural and aesthetic norms and bypassing the museum and gallery system to bring life
and art closer together. Prominent Fluxus member George Brecht considered the concept of event in
relation to new developments in quantum physics. Finally, although best known for his Happenings
("events" predating and overlapping Fluxus in almost every way), Allan Kaprow should be included in
this list of influences for his entire body of work. Not only did he impact APG and its contemporaries,
he has and probably will continue to inspire future generations of students to become, in his term,
"un-artists."

In addition to the open brief, alternative context, and feasibility study, APG work involved another
important component, the "event structure," a method devised for measuring the effect of ideas and
actions. Although Latham has been criticized for his complex (some say impenetrable) explanation

168 VIEW FROM YODEN WAY PETERLEE
1976

PETERLEE

Stuart Brisley, *View from Yoden Way Peterlee*, 1976. Black and white print on board.

of the event structure, it becomes much clearer when discussed in relation to both the Situationist dérive and the Fluxus event. The basic unit of measure in Latham's system is the "least-event," connected, like Brecht's event, to the relationship between energy and matter in quantum physics, but in this case serving as point zero, a beginning from which things move forward. According to Latham, industry and government measure time and productivity short-sightedly. Implicitly challenging the early 20th-century time and motion studies of Taylor and Galbraith (Taylorism/Fordism), by which humans were measured based on their short-term economic productivity, Latham wanted to employ a much longer time frame, thus fundamentally changing the standards used to determine value. Like Debord and Brecht, APG artists would present opportunities for participants to consider their subjective experiences of the workplace and engage in dérive-like defamiliarizations to encourage critique and re-evaluation of everyday surroundings and daily procedures. Since Latham believed artists already perceive and use time differently, he considered them ideally suited to lead others in an exploration of new situations and social relations in the workplace. While Latham's ideas may seem idealistic, it helps to recall that this was a time before artists became the small business entrepreneurs they are today. There was still a strong belief that art could be a means to change the world.

As graduates of any MBA program know, feasibility studies are used to uncover the strengths and weaknesses of a proposed venture in order to determine its potential for success. APG's use of this mundane-sounding exercise turned the tables on business analysis by directly addressing

the practical concerns of the artist. The question was not how successful the artist's project would be, but how cooperative the host would be in carrying out the proposal. Although APG may seem exaggerated in its claims about art, group members were very serious about creating new roles for artists in non-art contexts that they believed could offer opportunities to confront the status quo.

It is not surprising that during the '60s other fields were reconsidering "the everyday" as an important area of investigation and interpretation, particularly the social sciences. Alfred Schutz, an Austrian philosopher and sociologist who worked across disciplines, combined sociology and phenomenology to develop an influential mode of inquiry that sought to explicate the everyday aspects of human experience. To better understand a context at the subjective level, phenomenological sociologists look beneath obvious interpretations of behavior and actions to observe how meaning is built among what were called "consociates" or people who share a community of space over time. Another sociologist, Harold Garfinkel, developed this research further and defined a new area of inquiry, ethnomethodology, which focuses on understanding social order, how it arises, and how it is maintained.

Although there is no evidence that either of these areas influenced APG directly, the fact that similar experiments existed simultaneously in two very different fields could lend authority to both. And while there were vast differences in method and intention between the two fields, one could compare the results of such social science research to an APG feasibility study. Conceptual artist Stuart Brisley's study for Peterlee, a new town in Dunham County in North East England is exemplary in this regard. Built in 1950 to improve living conditions for the inhabitants of overcrowded mining villages, Peterlee, like many "new towns" constructed after World War II, was erected quickly, with generic design and shoddy construction. By 1976, when Brisley's project was undertaken, its inhabitants had been permitted such negligible input into the town's planning and administration that many felt alienated, even after living there for more than 25 years. Realizing that residents needed to become more aware of the social and economic history of the area to better comprehend their current circumstances, Brisley laid out a plan titled "History Within Living Memory." For part one, which involved collecting historical materials, he employed six local people to gather all available photographs and make and transcribe tape recordings that documented the events and changes between 1900 and the 1970s, when the original villages in the area of Peterlee were transformed from rural farming communities to industrial mining sites. Brisley demonstrated his sensitivity to the British exigencies of class and social hierarchy in his introduction when he implicitly countered any idealization of the past that might occur as a result of the project: "(T)he form and character of the physical and social environment of the pit villages resulted largely from the outcome of the development of interests concerned with the creation and acquisition of excess wealth. In the process of the realization of excess wealth, mines were sunk, wage labor was bought (pit sinkers, miners) and housing built. The miner sold his labor power to temporarily alleviate the basic needs…This…produced to a large extent the shape and character of the environment." While interviews with some of the communities' elders recount an ethos of support and solidarity among miners and their families, Lewis Bunt, grandson of Thomas Bunt, the first local miner elected to Parliament, quoted his grandfather's description of the degraded quality of the miners' houses as "reflecting what coal owners thought of miners."

Although the U.K.'s prewar mining towns, notorious for their blighted working and living conditions, might seem obvious choices for possible placement locations, Steveni's social and political antennae were finely tuned. Keeping abreast of regional controversies, debates, and sources of

discontent, she carefully sought out communities with the potential to benefit from a placement while also considering which artists would make significant and meaningful contributions. Thanks to Steveni, APG's placements were never random, nor was their approach ever one-size-fits-all.

APG's lack of a comprehensive publication contributed to its virtual disappearance in the '80s. Although many magazine articles appeared during the group's active years, most of its projects were developed for small, non-art audiences, and documentation was rarely exhibited within an art context, making it difficult for even the strongest art world supporters to keep track of APG's work. When such a book is finally compiled, the letters of inquiry sent by Steveni to potential placement locations will be among its most outstanding and useful revelations. Meanwhile, although negative press began to undermine APG as early as 1971, following an exhibition at the Hayward Gallery, it continued to receive support from the Arts Council of Great Britain (in declining amounts) for several more years. Ironically this was the period of its most successful projects, including Ian Breakwell's work with the U.K. Department of Health and Social Security, which facilitated his placement at two notorious high-security psychiatric hospitals, Broadmoor and Rampton. His feasibility study report, co-written with a group of architects, which recommended a total restructuring of each institution's practices at all levels, had a positive impact on conditions in both hospitals.

In fact, some of APG's work was deemed so effective that a private U.K. foundation joined forces with the Arts Council to create their own iteration of artist placements. APG spent years challenging the legality of the Arts Council's actions and eventually sued them, but to no avail—the court had no power over an official agency. In addition, the Arts Council was able to suppress information about APG's work, saying that they had lost materials or never received correspondence and even that certain projects had never existed at all. Although APG kept its own records and documentation, at that time and for a number of subsequent years, it became very difficult to challenge the Arts Council's authority. For the most part, the Arts Council placements followed what is now a conventional artist-in-residence model rather than APG's carefully developed protocols.

While some of APG's processes seem similar to those used in the social sciences, their overall relationship to the area has been misunderstood. Early on, the Arts Council contended that APG was "more concerned with social engineering than 'straight' art." From the perspective of political science, social engineering connotes an effort to influence popular attitudes on a broad scale, usually to produce conformity to particular behaviors. APG's aim, however, was to encourage people at their placement sites to question received information and popular beliefs in ways that might encourage them to act more independently. In his essay "Context is Half the Work," curator Peter Eleey noted APG's early interest in the new "systems" of social science and recognized the group's prescience in forecasting the growth of the service industry and the increasing value of intellectual property.[1] Although better able, with 20/20 hindsight, to re-evaluate certain aspects of APG's contribution, Eleey seems to interpret its placements as experiments in behaviorism rather than allowing that they might truly function as the art/life mediations they were intended to be.

Most of APG's critics place the group among differently problematic but not necessarily opposing positions. From one perspective, it is blamed for the instrumentalization of artists (working to serve an idea or agenda) and held responsible for creating a prototype for today's precarious worker (part-time and project-based employment). Other critics go further, indicting APG for the so-called corporate takeover of "creativity" on the one hand, while reproaching it for indiscriminately idealizing the "creativity" of artists, on the other.

Exploiting artists or other workers was never part of APG's plan. Another artist/institutional relationship that APG's philosophy and methodology both anticipated and calls into question is the area of artists' "services," first identified by Andrea Fraser in the '90s. Noting that these "services" include a broad range of practices that had evolved from the '60s and early '70s, she classified such projects within an expanded set of terms that include community-based art, public art, context art, project art, and cultural production.[2] Calling attention to the proliferation of such "services," Fraser aimed to explore some of their functions in and for institutions. Making clear that these projects were not thematically similar and the artists not part of a new movement, she proposes that the call for such initiatives was driven by extra-aesthetic needs — often those of publicly subsidized institutions in their attempt to satisfy "educational" or "community" activities required by their funders. The primary issue here is the old saw of artistic autonomy, but with a twist. Fraser believes that artists were giving up their freedom not by performing services with and for others but by doing them within the museum itself. When such projects were brought into the institution to be managed and then presented as "art," their social component was instrumentalized and thus neutralized by the art institution while their identity as artistic production became forced and over-determined.

In terms of precarious part-time workers, a subject that has been much discussed, Latham's critique of the Taylorist/Fordist system advocated for measuring productivity and the value of labor over a much longer term. Instead, our current system has taken us in the opposite direction. To help explain this development, Andrew Ross was among the first to point out that what were traditionally considered the privileged components of artistic production — creativity, autonomy, flexibility — had been adopted by business as tools to increase productivity and decrease labor costs.[3] In the "new economy," bosses offer creative satisfaction and cultural capital instead of living wages. Theorist Brian Holmes's essay, "The Flexible Personality" (2001), draws even more insidious connections between business and art.[4] Noting

that the anti-hierarchical approach to economic organization developed from the '60s revolt against authority, he explains how neo-liberal social policy experts of the '90s capitalized on these values to exploit the "immaterial laborer" (knowledge worker) of the newly developing technological industries. Since then, the idea of "creative" work has become a nearly ubiquitous aspect of job descriptions. While it can have many connotations (some of which might actually include innovation, although always in the service of the bottom line), "creative" is often a code word for what is now the ideal applicant: someone willing to devote her/himself 24/7 to their work (which in this case means the success of their employer), just as artists have traditionally done, often at the expense of their personal lives.

William Furlong and Ian Breakwell working on the APG "Reminiscence Aids Project," c. 1978.

The renewed interest in social practice and socially engaged art that has led to the rediscovery of APG also determines its reception. Many artists, reacting for some time to the effects of deregulation and destructive globalization, are desperate for new models of art production with the potential to produce change. If APG is to provide such an example, its work must also, sometimes unfairly, be held up for scrutiny in relation to present-day concerns. While it is understandable that current art discourse would find aspects of APG's work problematic, it seems more useful to consider what the group accomplished.

Initially very much a part of '60s counterculture, APG set out to bring its anti-authoritarian values into placement sites. (In another frequently cited exchange, an IBM director responded to one of Steveni's placement requests with the following: "If you are doing what I think you are doing, I wouldn't advise my company to have anything to do with you.") Today, not only have these values been co-opted by neo-liberalism to exploit workers, as Ross and Holmes have shown, they have also been used to dismantle "bureaucratic" social welfare systems in the name of the free market and individual empowerment. Building on these ideas, performance historian and theorist Shannon Jackson has lamented that we are now experiencing the consequences of this retreat to "individual-ization," produced by both government and industry, in the form of growing economic and social instability.[5] While not claiming that art has the capacity to restore balance to an increasingly uneven field, she proposes that it can set an example, bridging the gap (and deconstructing the difference) between self-construction (autonomy) and interdependence, citing Duchamp, the Situationists, Fluxus, and Kaprow, among many others, as pioneers in the breakdown of this duality. Although she does not mention APG, it certainly belongs among this group. Moving outside art institutions to take art-making in a radically new direction, APG reached out to a very different audience—one that could potentially receive its work as part of everyday experience. If APG artists seemed to place an exagger-ated importance on the creative process, they also demystified it, taking its systems and principles out of rarefied art confines and into the workaday world, testing what could happen if they placed value on the everyday, within the everyday. By bringing their "services" to industries, transportation companies, businesses, development corporations, hospital boards, new towns—what Peter Eleey calls the "infrastructure that serves [communities]"—APG acknowledged them as equal partners in the production of culture. Pursuing a collective and collaborative approach to society at a time when autonomy held sway, APG offers a unique example of art's capacity to be constructive as well as resistant, especially in our present moment of chaos and decline. Having convinced us that context isn't everything, APG's legacy challenges us to seek out circumstances and create "events" in which art can continue to do "half the work."

Notes

1 Peter Eleey, "Context is Half the Work," *Frieze*, November–December 2007.

2 Andrea Fraser, *Museum Highlights: The Writings of Andrea Fraser* (Cambridge, Massachusetts: MIT Press, 2007).

3 Andrew Ross, "The Mental Labor Problem," *Social Text*, Summer 2000: pp. 1–31.

4 Available at <http://eipcp.net/transversal/1106/holmes/en>.

5 Shannon Jackson, *Social Works: Performing Art, Supporting Politics* (New York: Routledge, 2011).

Defying Categories in Southern California (2013)

by Marlena Doktorczyk-Donohue

The late 1960s and 1970s brought the earliest community-based art to Southern California, a movement emanating not surprisingly from the disenfranchised—women and other so-called minorities. Distinguished by collaborative attitudes, this form of art-making presented non-normative (at the time), artist-to-artist creative exchanges and co-productions. Because academies and museums were closed to them, feminist, lesbian, and Latino community art provocateurs enacted funny, shocking, and incisive critiques in stridently non-interior, open zones—the desert, museum façades, civic centers, the airwaves—intended to expose, confront, and equalize entrenched interests in supposedly "public," but tightly controlled spheres. Often misunderstood as absurdist by their own as well as the dominant culture, conceptually astute art collectives, including Asco, Feminist Art Workers, and Sisters of Survival, used art to enact, or translate into accessible live actions, questions regarding power, class, race, and the media distribution of grand narratives.

Asco, *Spray Paint LACMA (East Bridge)*, 1972 (printed 2011). Color photograph by Harry Gamboa, Jr., 16 x 20 in.

From Asco's inception in 1968, there was nothing simply activist, purely socially engaged, or clearly issue-driven about it, which reaffirms how hard it is to pinpoint categorically a field of art in which critique occurs contextually and on so many simultaneous and nuanced levels. To start with, before the Asco members became community artists, they called themselves "Jetters," which denoted a camp, stylish, glam, cool, and hardly transgressive vibe; but glaring inequities politicized Harry Gamboa, Jr. Along with other Latino teens, he decided to stage a walk-out beginning on March 1, 1968. Three disadvantaged high schools participated in simultaneous "secessions" to protest economic disparity (many were already aligned with the César Chavez cause), war disparity (disproportionate numbers dying in Vietnam were non-whites), and, of course, an educational system that collected government funds based on "daily attendance" but showed no daily duty to educate in the barrios. Along the way, Gamboa invited his Garfield High School friends to participate in a variety of increasingly conceptual community actions, such as *Caca-Roaches Have No Friends* (1969), ironizing white culture's view of the Latino home as overrun with roaches; *caca* means "shit" in street Spanish, a double reference to the status of the non-white and the bullshit of the stereotypes. By 1972, the Asco collective crystallized to include Gamboa, Willie Herrón, Gronk, and Patssi Valdez. The act of appropriating the forceful Spanish word for disgust and nausea as their name signaled their message to East Los Angeles and to the larger world. Viewed until recently as extemporaneous, wild, and naive, early community art like Asco's was anti-establishment but conceptually precocious in its notions of alterity.

However counterculturally we summarize the '70s for ease of argument, the times were not clear-cut. Many authors suggest that in the wake of escalating war efforts, repression of free speech, and assassinations, disillusionment with the possibility of change and not activism sent the first public artists into more nuanced conceptual interventions.[1] Much current alternative art practice builds connections rather than rebutting power—an attitude that may have its roots in collectives like Asco, who acknowledged entrenched power and couched revolution as a Situationist invitation for the margins to re-imagine ways of seeing and being.

It is hard, however, not to read radical activism into *Action Project Pie in Deface* (also known as *Spray Paint LACMA*). In 1972, Gamboa, Herrón, and Gronk tagged the façade of the Los Angeles County Museum of Art with the names of Asco's four members, supposedly reacting to a comment by a museum curator who quipped, "Oh, Chicanos don't do art; they're in gangs." I cannot imagine such a statement even then, but it has become the stuff of art lore. This community art action holds so many inversions of symbols and publics and engaged so many diverse communities that it becomes hard to track them all. The act announces what Lucy Lippard called the ephemeral art object—an "artwork" with no commodifiable cultural product. It "marks" an ostensibly public space that is, in fact, not public and renders it communally coded, for civic use. It repositions tagging as intervention not vandalism; and finally, it interrogates the wall murals that all Latino artists were expected to make as a way to voice some overarching, race-defining Chicano/a identity—here was the mural parodied, personalized, and reclaimed by a real community in order to replace the art historical trope of Rivera and "social" art.

Quickly whitewashed, the act became the quintessential open work, continuing to take shape as it was used in negations of meanings at psycho-cultural edges. "Deface" is a funny play on words: gangs deface, a pie in the face of the system. Once removed from the wall, this community art existed only as a photo of Valdez casually standing before the tag; the intervention transformed into inordinate press hype and the dialogue generated by it.

By the '90s, when discourse caught up with the earliest alternative community art, many authors noted Asco's collusive/collaborative countermanding of mass media apparatuses. This strategy, which was specifically taught by public artists such as Suzanne Lacy in the '70s (see her public artwork, *In Mourning and Rage)*, links Asco to similar "friendly" (project-serving) deployments of institutional systems by new genre work today.

These tactics were most evident and complex in Asco's "No Movies." Pastiched, collaged, and easily assembled, these multimedia "ads" were artfully designed for community display, hawking non-existent, evocatively titled films in which the purported "stars" were Asco members co-opting certain roles or "types" drawn from lily-white cinema. Aided by curious text, the "No Movies" stills circulated as if they were evidence of actual Chicano films. The images borrowed famous tropes from European/American classics but inserted Chicano faces and mores in funny and discordant ways.

This was a clear comment on the absence of Latino faces and experiences in a spectatorial social system that (still today) projects and produces a generalized, abstracted reality built primarily by and for dominant culture. The images used in the "No Movies" were frequently staged as seamless insertions into the daily routines of diverse social sectors.[2] Content for the "No Movie" *Á La Mode* was produced at a well-known Los Angeles eatery that served middle America, Chinatown, and the barrio. Performing the Hollywood vixen Chicana style, Valdez was visually "served up" alongside dinner on a restaurant table. One can imagine the shock, confusion, and/or insouciance of the customers. The community action continued to engage as a public ad for a non-existent movie featuring a fictitious Latina "temptress."

Asco, *Á La Mode*, 1976. Black and white photography by Harry Gamboa, Jr., 11 x 14 in.

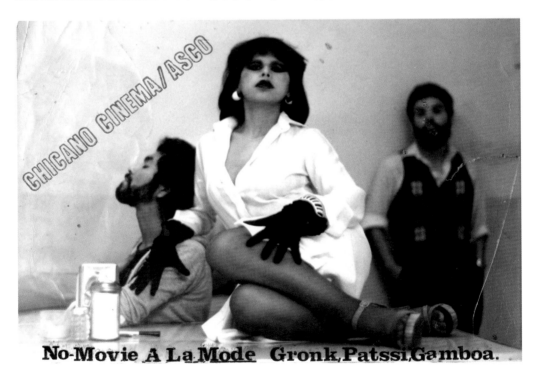

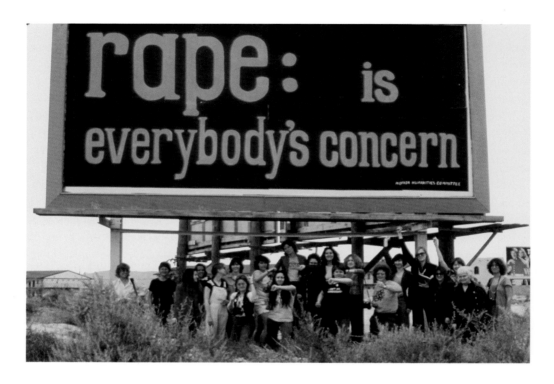

Nancy Angelo, Cheri Gaulke, Laurel Klick, and Vanalyne Green (Feminist Art Workers), *Traffic in Women: A Feminist Vehicle*, 1978. Bus tour/performance from Los Angeles to Las Vegas.

Feminist Art Workers (FAW) was formed in 1976, remained active into the early '80s, and included Nancy Angelo, Candace Compton, Cheri Gaulke, Laurel Klick, and Vanalyne Green. Green stresses that FAW members did not view themselves as a "performance art group," with all the high art theory and conceptual overtones such labels imply. As she emphasized, "We never called ourselves a performance collective. This term is from today's world. 'Collaborative performance art' and 'feminist art education group' would probably be more accurate." Her distinction is not minor. "Feminist performance" does not adequately describe the pioneering, "beyond aesthetics" ethos or capture the broad range of FAW's art in community. In the "bus performance," an educational art action/tour given the intentionally funny/not-so-funny title *Traffic in Women*, women packed into a large bus for a bonding, redemptive, and interventive road trip, reclaiming the macho, "on-the-road," Kerouac mystique and re-inscribing it as feminist, as well as socially rather than narcissistically purposed. As Gaulke recalls, "Suzanne Lacy and Leslie Labowitz were working with women at the University of Las Vegas and had invited FAW to bring women from L.A. to participate. FAW decided to design the journey as a participatory performance structure."[3] The bus traveled the desert route from Los Angeles in a pilgrimage-like retracing of the road to Las Vegas, hub of female sex work. The idea was to re-mark ritually and thereby repossess the space via the actions and the agency of alternative use. Commercial billboards selling all manner of products using the objectified bodies of women line the route; into the sea of billboards selling pleasure, FAW inserted a collectively made sign with the flat-footed, distinctly alternative, and uniquely public message: "Rape: is everybody's concern."[4]

Sisters Of Survival (S.O.S.) originated as an anti-war, community performance collaborative that included Nancy Angelo, Jerri Allyn, Anne Gauldin, Cheri Gaulke, and Sue Maberry, most of whom were practicing L.A. feminist artists who'd formed strong ties learning and then teaching politically engaged community art out of the Woman's Building.

Totally self-funded, S.O.S. artists dressed in signature nun's habits that they'd sewn by hand in vivid colors such as green, yellow, and blue. Collective members left studio practice to design a variety of community-based interventions conceived specifically to encourage public awareness and dialogue during the nuclear arms buildup of the 1980s and Reagan's escalating Star Wars program. Their public actions informed and mobilized artists and citizens around the non-sectarian issue of world sustainability in a nuclear age.

The acronym "S.O.S." referred to the group's signature use of hand-held flags communicating distress at sea. The name and the marine props re-oriented the quintessentially male, militaristic call-to-arms; the playful nun's garb re-positioned traditional female gender roles in equally interesting ways and turned "Save Our Ship" into a non-sectarian call for human sustainability. The S.O.S. art action *At Home in the Nuclear Age?* was part art, part theater, part information distribution. Against a backdrop of appropriated and pastiched, visually beautiful images of deserts—some engulfed in the awesome mushroom atmospheres associated with nuclear tests—costumed members distributed published scientific data on fallout and toxicity rates, while others furiously swept up billowing "toxic dust" (actually flour) installed as found art throughout the public venue.

Sisters of Survival (S.O.S.), in collaboration with Marguerite Elliot, *Shovel Defense*, 1982. Performance based on drawings of Hiroshima survivors. Los Angeles City Hall, May 10, 1982.

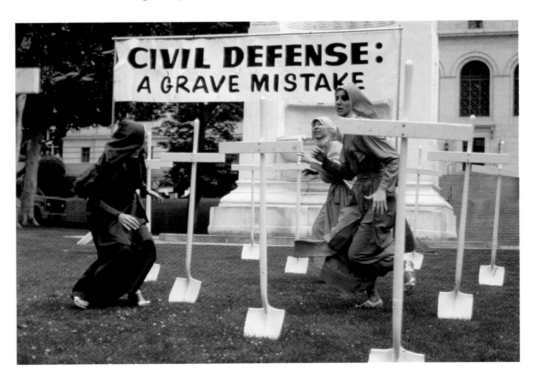

Iñigo Manglano-Ovalle, *Search (En Busquedad)*, 2001. Radio telescope installation at the Plaza de Toros Monumental, Playas de Tijuana, Mexico. From "inSite 2000–01."

inSite (1992–2005), a repeating international exhibition of site-specific, commissioned projects, installations, lectures, contemporary art programs, film screenings, and performances that addressed the margins where cultures interface and psycho-social-political spaces are fluidly made and remade, comes quite close to current theory and practice in new genre public art. Its pro-gramming evolution mirrors the arc of the genre as a whole. inSite began with agitprop art actions by the performance collective Border Arts Workshop, founded by Guillermo Gómez-Peña and David Avalos, which focused on border politics and the injustices done to Mexican immigrants at the literal border between the U.S. and Tijuana. Border Arts, along with Las Comadres, a similarly engaged Latina artist group, planned events and exhibitions that focused exclusively on Chicano cultural production and issues at the Centro Cultural de la Raza in San Diego's Balboa Park. From here, in 1992, the nonprofit Installation Gallery enlisted/ organized citywide public art programming in various San Diego institutions committed to bringing art to a broader arena. In 1994, the program grew to include not only U.S. border venues, but also Mexican institutions showcasing/sponsoring site-specific works across the border in Tijuana. By 1997, inSite had become a well-recognized international event, with curatorial board members and a host of participants from San Diego and Tijuana.[5]

In 2000, reflecting changes in how public art was imagined, internationally based guest curators Susan Buck-Morss, Sally Yard, Ivo Mesquita, and Osvaldo Sánchez expressed inSite's revised mission as a desire to move away from static outdoor works that rehearsed clichéd notions of the victimized Mexican and toward in-community arts programming, art commissions, artist residencies, and inter-disciplinary panels situated in and reflective of the geographical boundary, but exploring the broader implications of personal and group experiences in an urban borderland where cultural identities are dynamically constructed.[6]

The balance between aesthetic sensitivity and activism, as well as the means of audience address demonstrated in citywide, bi-border projects, varied widely. Some projects looked like Dada freeform shock, others seemed thinly imagined versions of "can't we all just get along." Jeffrey Vallance's com-munity connection took the form of a close collaboration with the famous Mexico City-based sculptor Victor Hugo Yanez, creator of figures for Tijuana's beloved populist wax museum. Conflating high and low art, heady conceptualism and minority kitsch, Vallance made three figures of culturally

loaded icons—the Virgin of Guadalupe, Dante, and Richard Nixon—and placed them seamlessly into the Tijuana Wax Museum permanent display. Mauricio Dias and Walter Riedweg hit a very high conceptual standard in their two-channel video *MAMA*, which was installed so that anyone "crossing over" from one nation to the other had to pass through two sets of looped images running side by side. On one side, border guards/customs officers spoke lovingly about the dogs that they trained to track illegal crossings and contraband, then answered tender questions about their mothers; on the other screen, Mexicans sat furtively around a fire waiting to cross, then jumped and scurried suddenly at the sound of guards advancing.

Iñigo Manglano-Ovalle's absolutely stunning installation covered the popular bullfight ring at Playas de Tijuana with stark white tarps that turned the ring into minimal art—a quiet, otherworldly, almost sacred space repurposing the architecture of violence into a huge round satellite dish. A radio antenna suspended from the building transmitted sounds to the Tijuana community and further transformed the space into a radio telescope for bi-border or "alien" signals.

By 2005, inSite had undertaken a far more proactive definition of community practice. Public interviews, personal archives, and extended in-community artist residencies—occurring simultaneously on both sides and at the actual border—built more closely on Lacy's model of new genre, issue-driven, co-collaborative public art. Visitors/ viewers were actively, not passively, embedded in the experience, traveling by bus and guided by map to manage the terrain in a way that echoed the concept of diasporic spaces underpinning the inSite endeavor. Artistic director Osvaldo Sánchez gathered organizers/curators (Adriano Pedrosa, Carmen Cuenca, Michael Krichman) from an array of counties, and partnering "white cube" institutions grew to include the San Diego

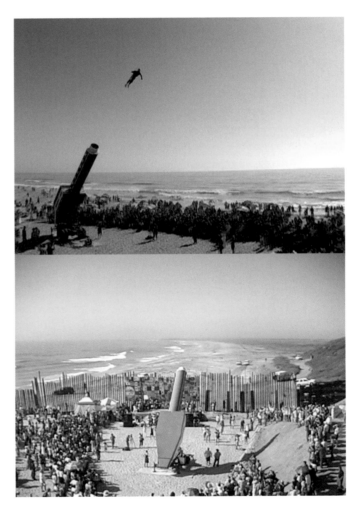

Javier Tellez, *One Flew Over the Void (Bala perdida)*, 2005. 2 stills from single-channel video projection, color, sound, 11:30 min. Documentation of performance at "inSite 2005."

Museum of Art, San Diego State University, the Andy Warhol Foundation for the Visual Arts, and the National Endowment for the Arts. Much more ambitious and critically informed, "inSite05" had four levels/modes of community outreach. Interventions were funded by an umbrella organization supported by American and Mexican individuals, foundations, government agencies, and corporations. Twenty-two commissioned artists from 15 countries created "encounters" in the public domain that evolved over a two-year period and began with artist-in-community residencies lasting up to three months. Scenarios occurred between August and November 2005 and involved ephemeral digital archives and cyber cross-border projects, such as an on-line curatorial project of community art/artifacts, an "inSite05" Web site designed as an interactive multi-player game, social networks, and commerce sites. Conversations involved ongoing, in-the-street, non-ivory tower panels and talks with artists, thinkers, and citizens. Finally, "FarSites: Urban Crises and Domestic Symptoms in Recent Contemporary Art," a bi-cultural exhibition hosted simultaneously at the San Diego Museum of Art and the Centro Cultural de Tijuana, featured 52 artists from five countries exploring the urban crises particular to their own environments and borders. But "inSite05" could have demonstrated greater accessibility; curators and artists wrote in dangerously arcane (non-populist) theoretical lingo regarding the desire to avoid the spectatorial and deconstruct the paternalistic. The action on the ground consisted of a truly dizzying, almost circus-like array of projects. The most successful was perhaps also the silliest. Javier Tellez worked in close connection with patients from a Tijuana mental hospital. He queried addicts and other patients about their illnesses, hopes, and views of reality (invoking another more nuanced view of "borders" based on normalcy and difference). Out of this came a patient's design for a work that catapulted "an alien" via canon across the highly guarded border. In *One Flew Over the Void (Bala perdida)* — or "lost bullet" — a professional human cannonball was shot across the contentious border, as crowds, media, border patrol, and communities on both sides gathered in awe. In its radical interpretation of alternative public art's avowed focus on the needs of a special marginalized public (the mentally ill), in its conception of an art project made with, but not for, a disenfranchised sector (patients designed costumes), in its careful understanding of the power of spectacle and of dominant mass media systems to teach/practice difference, this was Southern Californian public art at its quirky, category-defying best.

Notes

1 Kirsten Fleur Olds, "Networked Collectivities: North American Artists' Groups, 1968–1978," dissertation, University of Michigan, 2009. See especially Chapter 2.

2 The feminist collective The Waitresses engaged in similar actions. See Jerri Allyn and Anne Gauldin, eds., *The Waitresses Unpeeled: Performance Art and Life* (Los Angeles: Otis College of Art and Design, 2011).

3 Conversation with the author, 2011.

4 For a full description of the alterative community art projects undertaken by FAW, see Cheri Gaulke and Laurel Klick, eds., *Feminist Art Workers: A History* (Los Angeles: Otis College of Art and Design, 2012).

5 For a program overview, see Susan Buck-Morss, "What is Public Art?" in Sally Yard, ed., *inSite97: Private Time in Public Space* (San Diego: Installation Gallery, 1998).

6 Lauri Firstenberg, "West Coast Reviews: San Diego Tijuana," *ART PAPERS*, January 2006.

Revolution is Sneakier: A Conversation with Vito Acconci (2002)

by Anne Barclay Morgan

The godfather of transgression, Vito Acconci has been setting up controversial public art encounters for more than 40 years. From confrontations with passersby on the streets to furniture that mocks or indulges private obsessions and taboos, to interventions that tease pedestrians with a jolt of fear and panic, his work has consistently forced us to rethink the relationship of the human body to public space. Whether architecture, landscape architecture, furniture, or public art, the designs produced by his collaborative think tank, Acconci Studio, challenge the functional and conceptual status quo of public space—streets and plazas, gardens and parks, building lobbies and transportation centers. Yet, as experimental as its approach might be, the studio still seeks viable, if unusual, solutions to real problems of the public realm. *Garbage City* (1999), a theoretical project for the Hiriya Garbage

Acconci Studio (Vito Acconci, Luis Vera, Dario Nunez, Sergio Prego, Azarakhsh Damood, and Peter Dorsey), *Waterfallout-in*, 1997–2011. Visitor's Center, Newtown Creek Water Pollution Control Plant, NY.

Dump in Tel-Aviv, combined solar panels, crops, and gas-processing equipment with more typical building materials in an effort to put waste to use. *Waterfallout-in* (1997–2011) for the Visitor's Center of the Newtown Creek Water Pollution Control Plant in New York blurs boundaries between interior and exterior, land and water, plant facility and the natural world in a topsy-turvy educational thrill ride. Posing questions few others ask and providing highly innovative answers, Acconci Studio envisions the public realm as a zone of change, adaptability, and new encounters.

Anne Barclay Morgan: *What propelled your trajectory from video to furniture to public art and architecture?*

Vito Acconci: My background was in fiction and poetry. What interested me was the space of a page, how you move from left margin to right, how you turn from one page to the next. I treated the page as a kind of field over which I, as writer, traveled, just like you, as reader. It then seemed unnecessary to restrict that movement to an 8.5-by-11 piece of paper. There is a whole world out there or at least a street. So, stuff entered a so-called "art context" at the end of the '60s. Art seemed to have no inherent characteristics of its own, except for the fact that it was called "art." In other words, art was a field into which you could import from psychology, sociology, and politics. I used to know what my ground was—this piece of paper in front of me. Now, I was in real space.

I started by trying to tie myself into a system that already existed in the world. If someone was walking on the street, I would follow them. Decisions of time and space were out of my hands; I was dragged along by another person. It became obvious that if I was to go on using my own person, the pieces had to be about person-ness, about the self, the development of the self, maybe the destruction of the self. The pieces started to become somewhat circular: I start an action, I end this action. Many were done in film, with me as the target of the camera. In turn, I can do what the camera is doing: I can use myself as a target, I can focus in on myself, I can do something to myself, apply some physical stress to my body. That set up a self-reliance. I only had myself to work with. Maybe I needed a match to burn myself, but I didn't need much else. I didn't need other people, and that became a problem. I thought that if I applied some stress to my body, if I made myself vulnerable, maybe the viewer would have more of an approach toward me. But the opposite happened. If I start an action, that action is in me, I am setting myself up in a closed circle. The viewer is outside.

I wanted some occasion in which my space and the viewer's coincided. The performance piece *Claim* (1971) made me think of art as an exchange, an occasion of meeting, a place where the person in the role of artist comes face to face with the person in the role of viewer. But it bothered me that viewers had to come toward me. This confirmed an art world hierarchy: viewers have to struggle in order to get to the art. It seemed that everything I disliked about art—art as religion, artwork as altar, artist as priest—was confirmed by my work. There had to be a way out. My problem was one of focus: as soon as viewers entered a space, the focus was on me. What if I tried to disappear into the space? Rather than being a point in the room, I could be a part of the architecture. *Seedbed* (1972) raised the question: If I am not seen in a space, do I have to be there at all?

By the mid-'70s, stuff became installations trying to fit out the already given exhibition space. They involved audio and some kind of furniture, certainly places where people could come in and sit down. In 1976–78, I was using gallery and museum spaces as if they were plazas or town squares, places where people are together anyway. Now that they are here, could a piece be used to form a community? I had nagging doubts about pretending. If I really wanted a town square so badly,

I couldn't pretend all my life. I also worried that my viewers weren't doing much beyond sitting. I started thinking that if I made them listen to something, maybe I was also making them neurotic, in the sense that there was nothing on which they could vent their anger and frustration. I wanted people to be more a part of the piece. In the early '80s, I designed a number of pieces as self-erecting architecture: a person sits in a swing, it turns into a house; a person sits on a bicycle, it forms a kind of house. It started to occur to me that I didn't like the field I was in.

ABM: *Why was that?*

VA: I started doing art because I hated art, because I resented the "do not touch" signs in museums. In every other field of life, when you come across something for the first time, you pick it up, you touch it, you taste it. In art, the viewer stands here and the art is there. You are always in a position of desire and hence a position of frustration. With those pieces from the early '80s, it became clear that I was trying to re-invent architecture, to discover for myself what it could be. Could human use, human instrumentation, make a building? I was obsessed with the notion that four people standing in a square could become the living columns of a house. By the mid-'80s, I was more interested in the space that remained. Such a space shouldn't be in a gallery/museum, which is already a house. If you want to make a house or something like a house, it should be on the street or in the park.

I realized that my stuff wasn't art anymore and didn't depend on art conventions. It seemed to want function. I am not sure if art is ever happy with function. Also, I don't know that I like the idea of a viewer. I prefer the idea of a passerby, someone who hasn't come specifically for art. You happen to be walking on a street where many things are happening and, for some reason, you happen to go through this one. If I was going to do something in a public space, I had to come to terms with the

Vito Acconci, *Bicycle Parking Lot and Guardhouse*, 2000. Steel, polycarbonate, and light, 18 x 52 x 52 ft. Project created for The Hague.

fact that architecture and landscape already dealt with public spaces. I had to start working the way that architects work. I needed people to work with, because I didn't have any particular skills. Luckily, the year before my stuff appeared, words such as "conceptual art" began being used. Suddenly, there was a place for me. If you work on something private, it ends private. If you want to work on something public, it has to begin at least quasi-public.

ABM: *You needed a crowd.*

VA: By the end of the '80s, I thought the work shouldn't come from Vito Acconci anymore. Acconci Studio has been in existence since 1988, with a number of people, four of them architects, plus me. We work very much together. I might start a project with a general idea, a vague theory. I might be asked to see a space. I come home with slides and some thoughts, and then we start to talk and work together. I don't think the projects would have been the same if they had come just from me. For me, the studio works best when it is a mix of thinkers, with a mix of genders, nationalities, and ages to mess things up.

We mostly get so-called "public art" projects, rather than architecture projects. You are asked to do the piece in front of the architecture or to the side of the architecture. Sometimes that position gives you an advantage because your work isn't taken as seriously as the architecture and you can get away with more. At the same time, you are always adding the extra — the function has already been addressed. We try to be semi-architectural, but often we can't give people more than a place to sit down. I don't know if that is enough. You have to get up sooner or later. Lately things are changing. We have been asked to do some projects, mostly in Europe and Asia, that seem more like real architecture projects.

ABM: *Your proposal for Mur Island in Graz, Austria, doubles as island and circulation route — the dome morphs into a bowl, morphs into a theater, morphs into a plaza. It's an ever-changing playground and backdrop for encounters.*

Vito Acconci, *Island on the Mur II*, 2001. Steel, polycarbonate, water, and light, 5.5 x 75 x 75 meters. Project for Graz, Austria.

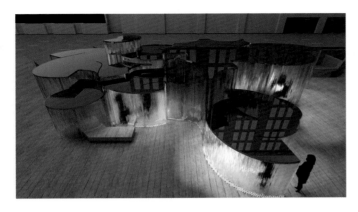

Acconci Studio (Vito Acconci, Frank Bitonti, Brad Rothenberg, Pablo Kohan, and Loke Chan), *WATERINWATER—INWATERIN* (working title), 2011. Project for the Millennium Library courtyard, Winnipeg, Canada.

VA: It is meant to function as a theater, a café, and a playground. We have also been asked to design the shop for the Museum of Applied Art in Vienna, and we're looking at a store of rotating rings, products on the move.

ABM: *For architectural interventions, do you select predominantly historical sites or modern spaces?*

VA: Probably modern spaces, only because I feel that I have a kinship with them. The spaces that I love to be in are modern—not that I ignore old spaces, but I always feel like this is a different time. I feel much more comfortable if I am in a place where culture and place coincide. I am a city person. I like to walk through cities, which few people do in the U.S. Our first goal is to come up with an idea or theory of the space. These places are occasions for people, their interactions and activities—some shape, some form, must exist that presents the potential for some relation, some interrelation, that might not have existed before.

ABM: *Is the humor in your work a way to link private and public spheres?*

VA: Possibly. Humor has been part of my work for a long time, because I hate things in which the viewer or experiencer is meant to be drawn in and numbed, has to believe. Going to Catholic schools from kindergarten to college convinced me that I don't want awe anymore. Humor gives me a chance to have second thoughts, to reconsider. It allows subordinate clauses and parentheses, allows you to see things in two or three different ways. Is there a public or private? There is a mix, a fluidity, a blending, and the humor allows you to have both sides.

ABM: *How do you see public space evolving in the new millennium?*

VA: I have no idea what public space is or what public space should be at the beginning of the 21st century. The most I can say is that increasingly it is a composite of privates. When Peter Schjeldahl wrote for the *Village Voice*, he commented that I make spaces where large groups of people gather to be totally alone. I don't think he was so far off. Public space isn't a piazza anymore. I don't think public activity exists. I was grounded in the '60s notion of public space—where discussion occurs, argument occurs, and then the revolution happens. I don't really believe that anymore. The revolution is sneakier than that, and it probably happens with billions of people, each withdrawing to a home computer and cell phone. I have a feeling that "public" has become a mix of capsules.

Unconventional Public Art in Europe:
Three Case Studies (2013)

by Herve-Armand Bechy, translated by Françoise Yohalem

The three projects presented here are very different, but they all engage the public in some way or another while querying site and entering into a wider dialogue with society. In each one, the public, whether residents or visitors, has a role to play. Individual life experience is essential; every response is valuable and contributes to the growth and life of the project. The meaning of the work stems from the organic creative process, not the art object itself. These projects illustrate the depth and breadth of public art as it reaches beyond its traditional definition and role.

Raoul Marek, *La salle du monde*

Since 1993, the historic Château d'Oiron, located in Western France, has served as an important international venue for contemporary art. Its contemporary cabinet of curiosities, "Curios and Mirabilia,"

Raoul Marek, *La salle du monde Oiron*, 1993. 150 participants dine on personalized table services once a year at the Château d'Oiron in Oiron, France.

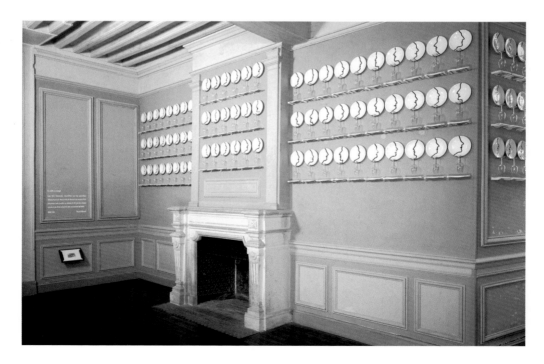

Raoul Marek, *La salle du monde Berne*, 2005. 150 participants dine on personalized table services once a year in Bern, Switzerland.

features site-specific works by more than 60 artists, including Swiss artist Raoul Marek's *La salle du monde Oiron*.[1] This permanent work consists of a unique ensemble of 150 personalized place settings used only once a year during a formal dinner at the castle. One hundred and fifty villagers (the number was set in Marek's original proposal) accepted his invitation to participate in the project back in 1993. Marek calls the group a "communauté de hasard" since the participants were chosen randomly and only met because of the project. Each villager owns his or her place setting, which consists of a Sèvres porcelain plate decorated with a Marek sketch of the owner's profile, a crystal glass bearing the owner's initials, and a napkin with a handprint. The tableware is displayed portrait-gallery style, in one of the large rooms of the château. It is only used for the reunion dinner attended by the owners and the artist.

Through this annual ritual, *La salle du monde* has brought together the citizens of Oiron and their château. In this unusual setting, the villagers have the opportunity to meet and socialize as they become performers in a "living" artwork. The dinner, which is organized by the citizens' group 30 Juin R.M. Oiron, takes place every June. Though the original commission was funded through the French Ministry of Culture, the citizens' association has now assumed full sponsorship.

Several of the original "guests" have died since the beginning of the project. Their place settings are still displayed in the portrait gallery, which has also become a memorial, and, one day, only the

gallery and the sets will be left. Though active participation will eventually disappear, Marek intends for the memory of the event to live on, unless the villagers themselves decide otherwise. Recently, members of the association have been discussing whether relatives of the original participants should be allowed to succeed them in the annual gathering. Many other questions are being thoughtfully considered and discussed by the villagers, who have now become both the directors of and actors in this important artistic event.

In 2004, Marek created another *salle du monde* in Bern, Switzerland, where the annual dinner takes place on the third of September.[2] This version of the project, financed through foundations and private donations, emphasizes mobility. The table settings are kept in four movable storage containers, which can be opened and displayed to the public at different locations. They have been exhibited in a bank, a school, a business, and a museum. They have also traveled to the Hermitage Museum in St. Petersburg and to Lieu Unique in Nantes, and Marek is considering additional requests to show the work. In Bern, the dinner is always held in a public space, though not always the same one, since the idea of a "moving feast" is important. Sometimes the huge table is set in the city's central plaza, sometimes under the arcades. Over the years, ties of friendship have been woven between Oiron and Bern, with citizens of the two towns attending each other's dinners.

Through a ritual of sharing and exchange, Marek brings together people from different socioeconomic backgrounds and cultures. In both Oiron and Bern, *La salle du monde* has become a living work of art capable of generating and sustaining its own network.

Cécile Pitois, "Sculptures à Souhaits"

Cécile Pitois has spent the last 10 years creating "Sculptures à Souhaits," a series of urban sculptural installations. Each one of her "Wish Sculptures," which relate

to the idea of the "wishing well," begins with a tale that Pitois weaves together from a combination of real and invented elements. The story, typically concise and uncomplicated, enables her to tell people about a particular place. Each tale develops like a fable or legend and can start with "Once upon a time" or "Some day." Her sculptural elements visually anchor the tales and serve as focal points for the rituals that they are intended to initiate. Stimulating the imagination while encouraging new appreciation for and new interpretations of particular sites, these participatory sculptures create unique opportunities for social interaction within the urban environment.

In 2006, Pitois requested permission to install a work in the Place Beaune-Semblançay in Tours. She obtained approval and funding from the city's Office of Parks and Gardens, which was planning a complete rehabilitation of the square. *La Fontaine des Amoureux* (*Lovers' Fountain*) was inspired by Pitois's apocryphal legend of the fountain's origin. She tells the story of a very

Cécile Pitois, *La Fontaine des Amoureux*, 2004. Work installed in the Place Beaune-Semblançay, Tours, France.

wealthy man who had a fountain built in the public square to satisfy the wish of his beloved wife. On the day that the fountain was dedicated, the two of them threw a gold coin into its basin. When the coin reached its destination, two beautiful pillows magically appeared on the ground. Since then, the legend says, the space has been visited by people who want to make a wish.

In *La Fontaine des Amoureux*, the two colorful polyurethane pillows anchored to the ground by the edge of the fountain can be seen as precious jewels within the space, and they also work as seats or pedestals for viewers who become actors in a sculptural tableau. The text of the story is engraved on a plaque set into the ground near the fountain. Together, sculpture and story create a special social interaction and ritual.

The Place Beaune-Semblançay is surrounded by a mix of Renaissance buildings and contemporary architecture, with some physical coherence, but not much harmony or memorable history. Pitois's mythical fountain, and the story behind it, gives the space a new context, a new life and soul. Because of *La Fontaine des Amoureux*, the square, set apart from the more commercial side of the neighborhood, has become a quiet place for people to partake in a thoughtful celebration.

Olga Kisseleva, *It's Time*

In 2010, Olga Kisseleva created *It's Time* in conjunction with the Contemporary Art Biennale of Ekaterinburg, an industrial center in Russia's Ural region. The city is home to the Uralmash factory, which manufactured the T-34 Soviet tank and intercontinental missiles. Though Ekaterinburg is slowly moving toward a more diversified economy, it still relies heavily on its industrial legacy, and most of the town's residents work at the factory.

Olga Kisseleva, *It's Time*, 2010. Clock and plethysmometer. Installation at the Uralmash factory, Ekaterinburg, Russia.

Olga Kisseleva, *It's Time*, 2010. Employee at the Uralmash factory clocks in using the work.

Kisseleva purposely located her temporary installation at the main entrance to the factory, where it served as a reminder that, during the Soviet regime and especially during wartime, discipline there was merciless. Life was implacably ruled by the sound of the siren activated by the factory clock, and a tardy workman could be severely punished, meals taken away and worse. The daily rhythms at the factory were regimented by this clock, which employees feared as the "dictator of time." *It's Time* also spoke more generally about perceptions of time and contemporary notions of its passing.

During the biennial, Kisseleva's clock gave workers the ability and power to regulate time according to their individual biological rhythms, thereby reversing the standard situation: the mechanical clock no longer dictated time. The turnstiles that allow workers into the factory were equipped with electrocardiographs. As workers entered, they placed a hand on a special sensor that picked up cardiac pulsations from their fingertips. A computer processed that reading and directed the historic clock to record and display a new "real time," an organic time as transmitted through the body's rhythm.

Stress translated into an acceleration of time; when a worker was tired, the computer slowed down the clock. There were about 50 variations. With constant activity and interactions, the clock kept going forward and back.

In order to make this happen, the clock—the same one in use during the period of the "time dictator"—had to be modified to receive the data transmitted by the body-activated sensor. Kisseleva also added a light panel that juxtaposed "real" time with the biological time transmitted by each entering worker. To upend the regimen of time in this manner, she enlisted the help of several scientists, including Sylvain Reynal, a quantum physicist at the Cergy Pontoise laboratory in France.

Kisseleva has pursued a similar theme in other works. She believes that people should not allow themselves to become victims of the normative rhythms that rule over the passage of time in our society; they should fight instead. She also champions the right of individuals against collective and corporate oppression.

Notes

1 The "Curios and Mirabilia" project was curated by Jean-Hubert Martin. Participating artists include Marina Abramović, Lothar Baumgarten, Daniel Spoerri, Ian Hamilton Finlay, Felice Varini, Christian Boltanski, Wim Delvoye, Ilya Kabakov, Wolfgang Laib, Annette Messager, Guillaume Bijl, Linares, Panamarenko, Giuseppe Penone, Niele Toroni, Markus Raetz, and Fischli & Weiss. <www.oiron.fr/collection-art-contemporain-visite-chateau.html>.

2 Marek won the Prix de l'Art de la Ville de Berne in 2002; *La salle du monde Berne* was the result of the award.

Patrick Killoran: Exploring Conundrums (2004)

by Judith Hoos Fox

The territory that Patrick Killoran explores in his work parallels the premise of the acclaimed book *Philosophy in the Flesh* by George Lakoff and Mark Johnson, which appeared in 1999, when Killoran wasn't long out of art school. Lakoff and Johnson offer a conception of the self that entails the metaphor of the body as container. They argue that to be an integrated, unified being, one must be totally enclosed: to have self-knowledge and awareness, paradoxically, one must be able to see oneself from the outside. This conundrum forms the basis of the explorations that Killoran has undertaken over the last six years in a series of succinct, provocative works of art.

Killoran's projects take place in the public arena and involve common urban props, such as portable toilets, sandwich boards, t-shirts, and cars. They require the participation and interaction of the public. For the 1997 re-opening of P.S.1 in Queens, Killoran invited visitors to lie down on his *Observation Deck*, a platform that slid out through the third-story window of an office space. The participant would mount wooden steps to reach the platform and lie down on it, belly up. Slowly, as one pushed oneself out the open window, the sky reached upward, seemingly forever, and the New York skyline appeared at the bottom of an inverted field of vision. Here, as opposed to the claustrophobic experience of an MRI device, boundless space became disconcerting. Why is the experience of propelling oneself only 18 inches out from the interior of a wall so frightening? Consciously we know we are completely safe. Only our heads extend into open space. But, as Killoran explains, when on the *Observation Deck*, it is the experience of the head, not the body, that dictates our perceptions and emotions. I found the experience of sliding myself out exhilarating — but when I thought to try it a second time, the memory was too terrifying.

Autobody 02 (Jose Centeno), 2000. Vehicle adhesive print on taxi.

In 2000, Killoran continued his exploration of the body as container with *Autobody*, this time in a more public way. Working with a fleet of taxicabs in Hartford, Connecticut, he

Self-Promotion, 2001. Ink-jet prints on sandwich boards. Project in Old Town Square, Prague.

sought drivers willing to have their nude torsos photographically transferred to the car body. Exploiting the dual meaning of "autobody," he transformed the car into a second skin, the literal container of the driver. The feeling of sanctuary that comes from being alone with one's thoughts while driving was here expressed literally and visually. This experiment in portraiture continued in Sweden when Marika Wachmeister, director of the Wanås Foundation, her husband, and grown sons participated. Most recently, Scott White, a baker at Wellesley College in Massachusetts, volunteered for the version featured in the exhibition "Surrounding Interiors: Views Inside the Car" at the college's Davis Museum and Cultural Center. White left the image on the car that he uses for special occasions—to deliver wedding cakes, for instance.

In 2001, as part of the Jeleni Studio Program in Prague, Killoran was provided with a studio and invited to create a project. He chose Old Town Square as his site, a place where young people congregate, often clad with sandwich boards carrying advertisements. Enlisting their cooperation, Killoran personalized the boards with photographic images of the bearers' bodies—their fronts for the front and their backs for the back. His collaborators on the piece, called *Self-Promotion*, emphatically announced themselves as individuals protesting the commercial, capitalist world of advertising.

Killoran's *Glass Outhouse* was first sited in the courtyard of the SculptureCenter in Queens (2002) and later appeared at Mills College in Oakland, California. Continuing in the tradition of Duchamp's *Fountain* (1917), Killoran transformed a port-a-potty. Two-way mirrored surfaces form the walls of his outhouse, creating a reflective exterior skin and a transparent inner face. Conflating public space with private behaviors in a very disconcerting way, Killoran has constructed the container described by Lakoff and Johnson. This carapace for the body and its most basic functions invites a positive affirmation of the public persona as reflected on its external surfaces.

In *Insight* (1997), an unlimited edition t-shirt, Killoran inverts the function of a body covering by placing a grommet in the center of the chest area. The shirt, under normal conditions an outer shell that protects the private self from the gaze of the world, is now a camera obscura, and our skin, instead of coating our innards, becomes a screen for the activity of the world. Peering down the stretched neck hole and directing the grommet toward a source of light, the image of the outside world appears on the wearer's torso.

Killoran entered a new arena with *Lost & Found*, which began in June 2003 in the city center of Birmingham, U.K., where he deliberately set out to "lose" 500 wallets. Their contents were identical: a health certificate, shopping list, key, restaurant receipt, and identification card belonging to Thomas Swallow, a fictional resident of Tierra del Mar. The wallets were planted in places such as telephone

Glass Outhouse, 2002. Modified portable toilet, exterior and interior views.

booths and benches. When several were turned in to the Birmingham Police, they stopped the project, though Killoran continued to stage it in other cities across the world. Who is Thomas Swallow? We have traces, but no corpus delicti. Like *Glass Outhouse* and *Autobody*, *Lost & Found* explores the aura of the persona.

Killoran has projects sited in swimming pools, theaters, and open plazas in the planning stages. These works involve mirrors, projections, and inflatables. His studio is his fertile mind, which views the world from a fresh and startling angle, kind of like looking at Manhattan from the third floor of a building in Queens with our bodies at a 90-degree angle. We know the view but have never experienced it in quite this way.

Amy Young: The Art of Giving (2012)

by Jan Riley

Inspired by the Street Art movement, social media, and the photographs of Walker Evans, Amy Young's tiny sculptural works engage in the art of giving and sharing. Since June 2010, she has placed hundreds of tiny street-art works in New York, London, and Paris. Each work is part of an edition signed and dated by the artist, who identifies herself by printing her Web site and a QR code on each piece. A complete list of the works, along with the comments of those who find them, is posted on her blog at <www.seemetellme.blogspot.com>.

Three recent series illustrate different aspects of Young's large and still-growing project. *Subway Saints III (mini)* (2011) was inspired by Young's daily commute and by Evans's *Many are Called*. In 1938, Evans hid his camera in his overcoat and surreptitiously photographed subway riders. Following his example, Young shot 250 clandestine images, assembled them into tiny, accordion-style books, and placed each book into a clear plastic box decorated with beads, gold paint, and sequins. She

then glued a magnet to the back of each box. To place them in the subway (to "bomb the subway," in Street Art parlance), she searches for anything that will hold the magnet. Once a collector has found a Saint, Young gives the additional gift of participation: open the little box, pull out the tiny accordion book, and then post a comment on the blog.

Little Monsters III (2011) is built using the same plastic boxes and the same magnetic attachments. This time, though, the images are taken from the Greek, Roman, Romanesque, and Gothic Revival sculptural motifs that decorate buildings all over New York. Each Monster comes equipped with a tiny

Little Monsters, 2011. Photography, plastic labels, plastic boxes, silver beads, magnets, and LEDs, 2 x 1 x 1 in. each. Project in New York.

173

Devil at the Crossroads, 2012. Images Xeroxed onto rice paper, primed canvas, and clay. Project in New York.

LED light and a cluster of silver beads. When you find one, you can open the box, pull the tab that protects the LED leads, and illuminate the Monster with red, green, blue, or yellow light. When Young bombs the subway with *Little Monsters*, she sometimes illuminates them and sometimes leaves the LED dark for the collector to discover.

In the *See Me Tell Me Shifts* (2011), which were built differently and created in two different editions, each piece consists of a tiny sleeveless dress hung on a miniscule hanger. In the first edition of 25, Young decorated the front of each dress with an image found in a New York art exhibition. For the second edition of 25, she used images created by street artists working in New York, London, and Paris. In both series, the backs of the dresses are created from shopping bags. The participation aspect of the *See Me Tell Me Shifts* exists within the joy of play and play-acting.

Visitors to Young's 2011 exhibition at the Kedar Studio of Art / Index Art Center in Newark, New Jersey, were encouraged to take two of her pieces with them. The instructions asked each participant to keep one piece and to give the other to a friend or to place it out in the world. In exchange, each new collector filled out a label with his or her name and e-mail address and placed the label on the wall where the collected piece once hung.

Young has successfully married two formally distant arenas: fine art and contemporary social media. She gives her collector/participants a way back into the history of art and a way forward into exploring their own art-making and critical faculties. The "See Me Tell Me" project was not created in a passive voice. It is admirably universal and generous, and all of its aspects create movement and growth. It is both an echo of and a bellwether for the burgeoning wealth of creativity inspired by new technologies.

Outside the Institution: Seattle's New In (2013)

by Suzanne Beal

From the earliest Northwest pioneers marching to the beat of their own drum along the Oregon Trail to the trailblazers of grunge, the defining music of the Northwest, Seattle residents have long personified a unique do-it-yourself-ness. The city has been brewing its own concoction of artist-inspired, take-it-to-the streets projects for years, beginning in the 1960s with artists like Buster Simpson, Lawrence James Beck, and then art critic, now novelist, Tom Robbins. In recent years, thinking outside the box has become more the norm than not: outside traditional institutions, as it turns out, might very well be the new in, making it possible for the visual arts to not just survive but thrive.

In 2005, the trio of John Sutton, Ben Beres, and Zac Culler—collectively known as SuttonBeresCuller—created *The Island*, a performance installation set afloat on Lake Union. Attired in tattered business suits, Sutton, Beres, and Culler set off with a four-day supply of water, food, and tequila. When their anchor got away from them, the "crew" called it a day, but not before they were spotted by thousands of confused onlookers driving across the 520 bridge, which links the city of Seattle to the affluent

SuttonBeresCuller, *The Island*, 2005. Mixed-media performance, 20-ft.-diameter floating desert island on Lake Union.

Vital 5 Productions, Lundgren Monuments, 2012. Handmade cast glass, dimensions variable.

Eastside suburbs, and instigated a barrage of media coverage. Was this art? Theater? Pranksterism? *The Island* ushered in a series of Seattle-based art-escapades, many of them likewise collaborative and categorically slippery.

The Island was conceived in collaboration with Vital 5 Productions, the brainchild of arts entre-preneur Greg Lundgren—the brilliant mind behind a number of arts-cum-social meeting grounds, including The Hideout, a bar/art gallery; Lundgren Monuments, a headstone manufacturer with an eye on changing the stony cemetery landscape to glimmering glass; Vitos, a restaurant and longtime Seattle institution known primarily for its alleged connections to the mafia; and of course Vital 5 Productions, an arts-instigating workhorse founded in 1998 that has facilitated any number of oddball, socially driven events incorporating cell phones, public confessionals, fashion shows, arbitrary art grants, and even a cookbook of art recipes designed to "get people to write their thoughts, paint their dreams, and perform their fears."

Lundgren is in good company. Filling the gaps left by contemporary arts institutions that have shut their doors or moved to other cities in the last few years, idea-driven exhibition spaces, self-published zines and catalogues, residential and fly-by-night art galleries, and collaborations that extend beyond the reach of the visual art world have sprung up like so many Northwest mushrooms following a thundershower.

The Project Room, a nonprofit founded by Jess Van Nostrand in 2011, takes an alternative approach to standard gallery practice by concentrating on process rather than product. Operating from a small Capitol Hill storefront with wide-open windows, it entices passersby to join community knit-ins,

potlucks, open studios, and interviews. In 2012, Susie Lee and Decode.com co-founder Hsu Ken Ooi used The Project Room for a speed-dating event designed to break down language barriers between artists and techies. Ten artists and 10 technologists investigated the nature of problem-solving across different fields, while 10 "chaperones" listened in and tweeted about the event in real time. World peace might not have ensued, but this initial meeting of disparate minds inspired two follow-ups: "Dinner and a Movie," in which groups of former speed-dating participants discussed and presented observations on topics teased out during the previous event, and "Getting It On," in which multiple groups prototyped and brainstormed prior to presenting proof-of-concepts to the public.

Unlike The Project Room, Sea-Cat (short for Seattle Catalog), an art project and for-profit company started in 2010, offers goods for sale. Seattle-based artists Gretchen Bennett, Wynne Greenwood, and Matt Offenbacher began Sea-Cat as a series of conversations about value, art, space, and success. They publish a tri-annual sales catalogue featuring artwork from local artists, but their collaborative efforts also produce compelling ideas — ideas with potentially more selling power than their collections of smart physical objects.

In the summer of 2012, Sea-Cat's founding members presented a three-act play detailing the benefits of collectively purchasing artwork. With minimal costumes, simple language, and a stand-in work of art that purportedly "spoke to its viewers," their enacted fable raised important questions about the value of art and what we expect from it. As a follow-up, Sea-Cat offers concrete solutions to problems facing would-be buyers, proposing alternative purchasing plans that accommodate all financial brackets. The Sea-Cat Web site allows viewers to download the script and a sample contract for collection purchases that outlines issues such as who houses the object and when, what to do if the piece breaks, and how to decide who gets it and when. Simple and streamlined, this new model could make art ownership accessible for a broad audience.

Vignettes, situated in the front room of Seattle artist Sierra Stinson's 1925 studio apartment, makes the act of showing art seem almost effortless. But it comes with a price. Twice a month since December 2010, artist and curator Stinson has had to move her bed into her closet to make way for

PDL (Jason Puccinelli, Jed Dunkerley, Arne Pihl, and Greg Lundgren), *The Portable Confessional Unit*, 2007. Sponsored by Vital 5 Productions.

Mike Pham, *L'apres-midi d'un Pham*, 2011. Performance on a pink '50s Chrysler. From NEPO 5K Don't Run.

one-night-only shows in which up-and-coming artists, poets, and performers do their thing in tight proximity to curators, critics, and gallery owners. In the same year, Robert Yoder began to operate a gallery out of his postwar house in the Ravenna neighborhood, offering visitors a suburban counterpoint to Stinson's urban nexus. Whereas Stinson's stripped-down, white-walled apartment could pass for a gallery, Yoder makes no pretense about the fact that guests enter his home to visit his seasonal shows (four a year). In the recent "Squeeze Hard, Hold That Thought," embroidered works by Seattle fabric artist Allison Manch rubbed shoulders with paintings by New York's Sharon Butler throughout the living and dining rooms with their '50s-era furnishings.

NEPO House, the home of Czech ex-pat Klara Glosova, not only invites guests in, it also drives them out again. NEPO 5K Don't Run, a wildly inventive, curated walking tour, is now sauntering into its second year. In 2011, Glosova curated exterior performances and installations that led participants on a five-kilometer trek from Seattle's downtown Pioneer Square to the home/art gallery on Beacon Hill that she shares with her husband and two children. A plethora of interactive artworks by more than 80 artists strung sports to culture, with a pinch of politics thrown in for good measure: when organizers failed to get a city permit designating the event as a run, they fluidly shape-shifted the name, changing it from NEPO 5K Run to NEPO 5K Don't Run. In doing so, they prompted participants to slow down and take a lingering look at the contemporary art along the way. What did the approximately 500 participants see en route? Among other things, a fold-up elephant, an insect mating ritual, live poetry, and myriad madcap performances. Those who made it all the way to Glosova's house watched art critics conducting interviews from an upstairs bathtub, live music in a nearby garage,

A K Mimi Alin, *The Not So Easy Chair*, 2012. Performance inviting people to sit and engage in a not-so-easy conversation. From NEPO 5K Don't Run.

and DJ'ed dance parties. Art appeared in virtually every corner of the house, making personal and private, household and work, indistinguishable.

The second NEPO 5K Don't Run was co-curated with artists Zack Bent and Sierra Stinson. Instead of ending up at Glosova's house for a final shindig, the 2012 walk worked in reverse: participants began at NEPO House before meandering downhill to a block party in Seattle's International District Kobe Terrace Park, complete with bands, Butoh, food trucks, and still more art. But NEPO 5K Don't Run is really about the road rather than the finish line: the 2012 line-up showcased work by everyone from seasoned professionals to upstarts who haven't even graduated from art school (if they went at all).

Artist-initiated projects outside traditional art infrastructures have also affected local training grounds. For instance, the collaborative team of Max Kraushaar and Graham Downing—neither of them students at Cornish College of the Arts—recently installed a nondescript newspaper dispenser just outside the visual and performing arts school. *Dispensor* listed two short but sweet instructions: the first to insert $75,000, the second to receive one of the diplomas held inside. It took school administrators two weeks to recognize *Dispensor* as a wolf in sheep's clothing and to remove it from the premises. Though they claimed that the work insulted students at the school, Cornish college attendees flocked to virtually every media outlet that allowed comments to support the work, whether or not they agreed with the price of tuition (which by all accounts was dramatically low-balled).

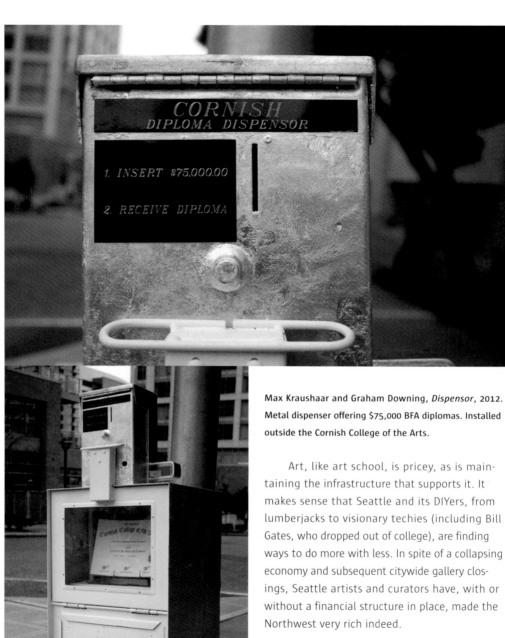

Max Kraushaar and Graham Downing, *Dispensor*, 2012. Metal dispenser offering $75,000 BFA diplomas. Installed outside the Cornish College of the Arts.

Art, like art school, is pricey, as is maintaining the infrastructure that supports it. It makes sense that Seattle and its DIYers, from lumberjacks to visionary techies (including Bill Gates, who dropped out of college), are finding ways to do more with less. In spite of a collapsing economy and subsequent citywide gallery closings, Seattle artists and curators have, with or without a financial structure in place, made the Northwest very rich indeed.

A Shared Research (2013)

by Mary Jane Jacob

This is not a narrative of a project or series of them. It is a text that takes up the subject of time: the time of a project, the stream of time that flows through the process of a project, especially when one is *in the flow*, and then as one process flows into the next, over time. There's constancy, yet, like a river, it is never straight by nature. This is also an essay about art — not so much about theory as about practice. It is about the understandings gleaned from art-making as a research practice — research manifested so that you can see for yourself and so others can partake or contribute. This practice constitutes a life's research for artists; it can also be so for curators.

I will start this story in 1991, in Charleston, South Carolina, with the invitation from the Spoleto Festival USA to curate a sculpture show at Middleton Place plantation, which became "Places with a Past" downriver, in the heart of this colonial capital. Here, the use of public, non-gallery locations was not so much a critique of the museum-as-institution as a critique of the institution of slavery. On the streets of Charleston, artists could play out theories of post-colonialism *for real*, vitalizing rich and troubled discourses of place, history, and memory. Here, artists experienced an unmistakable, though long silenced, presence of the past, and they deployed the temporary venue of an arts festival to push meanings forward. This exhibition occasioned experimentation for some artists, who extended their practice through installation (Lorna Simpson and Alva Rogers's *Five Rooms*), community collaboration (Antony Gormley's *Field* and David Hammons's *House of the Future*), large-scale outdoor work (Joyce Scott's *Believe I've Been Sanctified*), and the engagement of an entire building (Ann Hamilton's *Indigo Blue*).

"Places with a Past" has been cited as an incidence of alternative curatorial practice, but, for me, it was not so much a conceptual trope as an embodied practice in tune with the processes of art. Curators care for process, as well as objects, creating situations so that art-making can happen fully and deeply. Curators also take care that experiences can happen for others, believing that experience in art and life will connect.

One critique of this show stung — and stuck. At least one critic called the artists' processes "parachuting."[1] Yet the critics were flying in and out, too, and often made their assessments long-distance, with little care for local responses.[2] This debate was at the crux of my subsequent program, "Culture in Action." In dialogue with the board of Sculpture Chicago and potential funders, we asked: Is it possible to speculate together on what public art can be, to follow artists' practices instead of the institution's way of doing things, to invest in their work and see if members of the public would become invested, too?[3] This meant suspending judgment for a time to see what might be spawned. While I hoped that "Culture in Action" might expand the policy parameters of public art procedures, my primary curatorial ambition was to reinforce connections between viewers and the art experience that I felt had been eroded in museums, as well in the street presence of art.

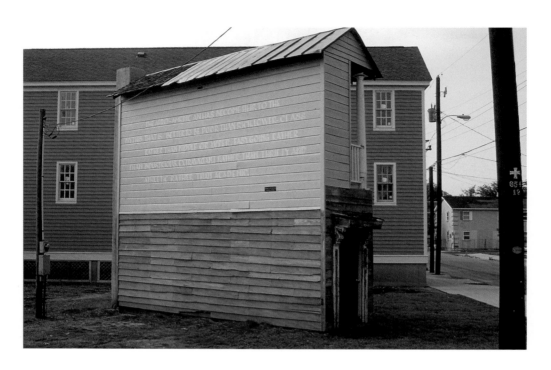

David Hammons, *House of the Future*, 1991. 2-story structure of found building materials. From "Places With a Past: New Site-Specific Art in Charleston," 1991. Spoleto Festival USA, Charleston, SC.

The artists worked in Chicago for over three years (1991–94). Each of the eight projects took several forms (not just installations), had multiple audiences depending on venue and activity, occurred at different moments, and engaged the public for long periods—the vast majority of participants close to the process had never been an art audience. Though the artists' time on the ground ballooned, this program sparked other criticisms. Why is it art and not pedagogy (Mark Dion's *The Chicago Urban Ecology Action Group*)? Why is a candy bar art, particularly when its form is co-determined with a constituency of non-artists (Grennan and Sperandio's *We Got It! The Workforce Makes the Candy of Their Dreams*)? Why is the role of the artist to provide self-esteem and skill-building for youth (Iñigo Manglano-Ovalle's *Televecindario*)? Is a project effective enough if it only teaches 15 students (Dion) or only involves 12 factory workers (Grennan and Sperandio); if it doesn't fix public housing (Ericson and Ziegler's *Eminent Domain*) or stop urban renewal (Daniel J. Martinez's *Consequences of a Gesture* and *1000 Victories/10,000 Tears*); and if it only heals a concerned population rather than someone with HIV or AIDS (Haha's *Flood*)? Is it effective artwork or ineffective social work?

Critics and detractors couldn't afford to wait and see what would happen over time, while I couldn't tell them, "Wait, artists' practices will develop from here and communities will change." No one could know that the alliance between Community Television Network staff and high school students in *Televecindario* would lead them to start their own organization, Street-Level Youth Media, which probably would not have happened if it had been part of the curatorial plan, the funder's mandate, or even the artist's design. We had to let the process unfold and *listen to the process* as it went to the heart of the issue. Moreover, if *Televecindario* had not been art, the theoretical questions and

social dilemmas it embodied would not have gone straight to the hearts of those involved and been transformed into an educational organization now going into its 20th year and serving 1,000 youth annually. This is the product of time. This is the positive side of "an unclear beginning and end."[4] This is how a work can be a locus for "the macro socio-political-economic context," and through which "the micro forces that come together to do a project can create individual community experiences and constitute artists' practices."[5]

The biggest lesson of "Culture in Action" was process. All of the works grew out of conversations between artists and members of various publics. By throwing a curatorial net around these projects to support them, bringing them into conversation with each other and with the field, bringing some clarity to what was at stake, they served as motivation for other efforts, including Claire Doherty's Situations in Bristol, Micaela Martegna's More Art in New York, and Luiz Guilherme Vergara and Jessica Gogan's MESA (Mediation, Encounters, Society and Art) in Rio.

As process undergone in Charleston flowed into Chicago, we arrived at what might be called a "best practice": devote time to the community tied to the subject and location of a public project, be open and responsive, and listen while bringing all of your critical and aesthetic awareness to bear. This may or may not be the criterion for artists today; there are lots of different strategies and intents that come under the currently favored label "socially engaged art." But for some projects, this is a good and essential practice.

Still, there is more than one way. Even though the artists' time in Charleston was shorter, and the works existed for only a summer (though, unexpectedly, two remain permanently), much of what the work embodied went to the heart of the place—a place whose heart had been kept closed. Charleston was a global capital as early as the 17th century, and we still live the story set in motion

Haha, *Flood*, 1992–96. Visitors in storefront garden on Greenleaf Street, Chicago. From "Culture in Action."

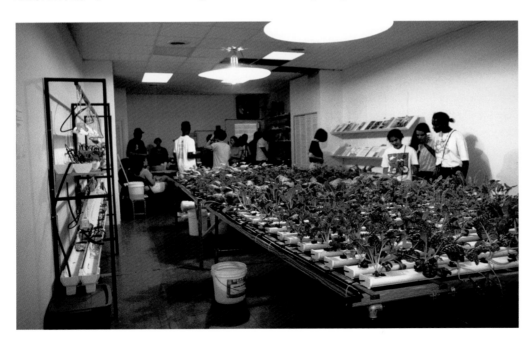

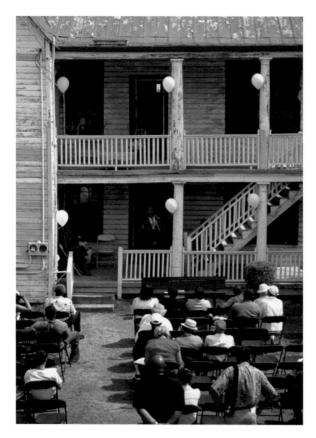

Suzanne Lacy, Rob Miller, and Rick Lowe, *The Borough Project*, 2002. Archival effort, installation, and performance. From "Evoking History," Spoleto Festival USA, Charleston, SC.

there. These installations, in all their artifice, rang true as lived experience, not because every detail was historically accurate but because they evoked a shared experience. Art can convey this, not as a resolution or celebration, but with complexity and consternation, in pain and with empathy. But you need time to be with the art — not in person with the work, but the work within you.

It was a blessing in hindsight that the works in Charleston were able to do their job over time — without an annual or biennial effort, without more art squeezing out life. The effects of art are not always overt or specific; they happen in their own time. We aren't always ready for art when it confronts us, and this can be especially true of public art. First reactions do not tell the whole story. In this case, what was revealed, maybe reaffirmed, over time was that the experience remained deep in memory long after the work was gone from view. Perhaps the works' transitory nature sparked greater awareness. The experience was aided by viewers being able to step physically into these imagined, articulated worlds, while walking through the city between projects and seeing at each turn art in life. The work lived in respect to its resonance with life. Experience flows as it will, over time, and we were lucky that Charleston is one of those places where time is long, and is felt, and life is lived with a sense beyond one's own lifetime.

"Conversations at the Castle," during the 1996 Atlanta Olympic Games, was another chance to probe the debate around community practice or new genre public art as this work was gaining greater traction.[6] For me, the concern was to broaden ideas about the possible audience for contemporary art and the nature of art experience. Critics of community-based practice had pitted a primary audience of collaborators with a vested interest against unspecified members of the public as a secondary audience. "Conversations" tested that assumption through work in three modalities. Some artists worked in neighborhoods not accessible to visitors during the constricted and controlled time of the games; I also asked them to create another experience for viewers at a central location, an old mansion close to the High Museum of Art known as "The Castle," which became the program center. Other artists working at The Castle created what we would now call "relational" pieces, asking the public to complete their work through interaction. Finally, the Venetian collective artway of thinking

created a massive relational project with food, facilitating a dialogue between issues and ideas, among persons from various walks of life, from near and far. For two weeks, *Chow for "Conversations on Culture"* brought together diners and a group of author/collaborators selected in consultation with project co-producer Michael Brenson.[7]

Process requires clear aims that clarify why we are doing something. This is not the same as what a work will be—that will come if we trust the process, remembering why are we doing a project. We might conjecture a goal, imagining what the project will look like, having concepts to test or inspire others, but to enter the process openly, with what Buddhists would call "beginner's mind" or "the mind of don't know," is to work without expectations and preconceptions. We need to be willing to shift what a project is in order to realize the true aim. Most of all, we need to be fully present, listening to the process itself. Insight comes from inhabiting those invested moments, from being in the flow, in a place and in particular circumstances, as the project develops over time and through one's practice.

When I returned to work in Charleston, 10 years after "Places with a Past," I found people who remembered those works in great detail and still lived their experiences of them. Instead of taking up the offer to do a show, I suggested that the artists and I just work in the community in an open-ended way, with no goals (projects) defined until aims arose through a process of listening and shared understanding of what was then at stake in the city. Being outsiders was important to the process: you sometimes tell things to strangers that you do not tell to your friends or those inside; outsiders are at a safe distance, and their presence offers the chance to tell a story again to someone new.

This new endeavor, which unfolded over the next decade, came to be known as "Places with a Future." It responded to anxieties over rapid redevelopment in some of Charleston's neighborhoods. Everybody felt it. It touched everything that was "home." This was a learning process for both insiders and outsiders, who came together to co-evolve an understanding of the moment. The propositional projects and created artworks followed no single strategy, but they all touched on a story of change: the push to develop and grow, fast, in the American name of progress, then to consume and consume more. Our activities centered on three places out of step with this dynamic, so they were vulnerable. Over time, however, they have proved to be in step with where we all need to go in the future.

Albert Alston, *Al's Door*, 2001. Found door and bricks, sited in an empty lot across from David Hammons's *House of the Future*, on which Alston, a Charleston contractor, served as collaborator.

Ernesto Pujol and Walter Hood, *Untitled*, 2004. Temporary site-specific installation mapping changes to Gullah-Geechee heritage lands. Charleston County, SC. From "Places with a Future," Spoleto Festival USA, Charleston, SC.

Pedagogy in formal and informal ways is always part of the process, so it may not come as a surprise that my curatorial practice is now located at the School of the Art Institute of Chicago, where exhibitions are a shared research. I recently did a studio-seminar class in social practice. Reading through a sizeable literature from the past 20 years, I found that a lot was different, a lot the same. Conflating diverse practices under the rubric of "socially engaged art practice" isn't working. Work that aims to elicit participation in museums or reactions in the street and work that once would have stood as "political art" are now lumped together with work created through a co-evolutionary process of artists and communities. There is a schism between projects that seek to do good and those that point out the bad, leading to the sincerity-versus-irony paradigm, with the former suffering from the problem of positive outcome, or what has been called the embarrassment of the feel-good.[8] So we find the social work versus art dynamic recast as a crisis of moral obligation versus artistic freedom, without the possibility of their coexistence.[9] Meanwhile questions of quality seem of little concern, and there is little assessment of the effectiveness of either the art-as-political-stance or the art-for-community-change paradigm. The perceived conspiracy of art and money is also significant, as critical questions from the 1990s addressing how to make this work well and to what end have been replaced by an economic and political critique of culture. With this, the earlier position that funds could be put to better use through social means than through art (the result of the American public art funding debate of the late-'80s Culture Wars and 1990s new genre public art) has been supplanted by fears of U.K. and E.U. artists being co-opted by governments, with their projects seen as quick fixes and replacements for social welfare programs.[10] Morality (use) versus freedom (aesthetics) is at a standoff. As for claims to evaluation, researchers, foundations, and others who had the final word for the past decade are being challenged by theoretically based critics. Vying for reinstatement

of their authority, they claim that this story has been told for too long by artists and curators who, they feel, can only be uncritical and biased (rather than informed).[11]

The conversation continues among those coming into the field and those long committed to it as their life's research; students everywhere are part of this. The past echoes in today's arguments, as circles of conversation keep growing, with voices from more than one "art world." I find intensity and value in this, because at the core of this story, there is a sense that art matters. It's a shared research through which we can all think more deeply about our own experience and that of others.

Notes

1 See Lucy Lippard, *The Lure of the Local: Senses of Place in a Multicentered Society* (New York: W.W. Norton & Company, 1997), pp. 280–81. Lippard wrote: "The now time-honored practice of importing artists for place-oriented exhibitions is increasingly questionable…["Places with a Past"] did so from the outside: both curator and all but one of the artists (a transplanted French team living in Charleston) were from elsewhere, although some had connections to the region." This essentializing paradigm overrides more complex questions of who is the insider and who the outsider in today's global world, but it can also be seen as a device to withhold resources from communities for which the status quo seems good enough.

2 Ibid. Lippard claimed that "it was hard to impress the locals, who usually knew more (or different information)…" Yet it must be noted that she neither saw "Places with a Past," nor did she survey or evaluate the projects through direct discussion with "locals." Of course, no one could have known how this exhibition would motivate change in the city and national legislature over the next decade. Lippard's assessment in the 1990s, that the show was "strong in form and weak in connectedness," didn't leave an option open for what might unfold over time.

3 The Sculpture Chicago board had direct experience with reaching non-museum-goers. Enabling the making of sculptures on the street and in public view, what impressed them most were the experiences of the workmen who assisted the artists; their participation built bonds of ownership and appreciation that they shared with family and friends. So we asked, what if we widened the means of participation, aligning them to newer artistic practices?

4 See Claire Bishop, *Artificial Hells: Participatory Art and the Politics of Spectatorship* (London, New York: Verso, 2012), p. 2.

5 Ailbhe Murphy, artist, researcher, and co-founder of Vagabond Reviews, speaking at the North 55 "Connect" seminar in Inishowen, Ireland, September 2011.

6 Since this program of the Arts Festival of Atlanta complemented the Olympics' visual arts component devoted to southeastern U.S. artists, all of the participating artists came from other countries. The show asked whether it was possible to have a conversation across cultures.

7 These conversations and the projects are the subject of *Conversations at the Castle* (MIT Press, 1998), which I co-edited with Michael Brenson. "Points of Entry," at Pittsburgh's Three Rivers Arts Festival (see *Points of Entry*, Ram Publications, 1997), offered another chance to take up these debates. For the book, we asked artists at the conclusion of their projects to respond to several questions: Can art have a social motivation and still be art? What happens when artists share the artistic process with participants? And why is there so much mistrust of your processes and rush to imagine that the public is being exploited?

8 See Shannon Jackson, *Social Work: Performing Art, Supporting Publics* (New York: Routledge, 2011), pp. 45–59. See also Mick Wilson, "Autonomy, Agonism, and Activist Art: Interview with Grant Kester," in *Art Journal*, Fall 2007: pp. 106–18.

9 Claire Bishop, "Participation and Spectacle: Where We Are Now?" in *Living as Form*, Nato Thompson, ed., (Cambridge, MA: MIT Press and Creative Time Books, 2012), pp. 38–41.

10 Bishop, *Artificial Hells*, op. cit.

11 Ibid., p. 6.

Serendipitous Curatorial Practice: Connecting Artists and Sites (2013)

by Julie Courtney

Twenty years ago, not many people were thinking, "I want to be an independent curator." It was not something that could be learned in school, although there are many excellent programs now doing just that. My expertise came from working at various types of institutions, from Marian Locks Gallery, the most well-regarded for-profit gallery in Philadelphia at the time, to the funky, multidisciplinary nonprofit The Painted Bride Art Center. I was the founding director of The Temple Gallery for Tyler School of Art and a consulting curator for the University of Pennsylvania's Institute of Contemporary Art. All of these experiences enhanced my enthusiasm for collaborating with artists. Working independently has allowed me to bring this passion to extraordinary places outside traditional art spaces.

I am inspired by sites and artists, in no particular order. I have been incredibly lucky to have had support from people willing to engage with me in dreams and adventures. The word "independent" may not be exactly right. I'm always collaborating with artists and institutions. Usually, I come up with a proposal for a nonprofit, convince them of its value, and write the grants. This approach allows my creativity to grow and flow. Over the years, I've found that I am my favorite institution. Working this way gives me the ultimate freedom to take on projects that would be impossible from within an organization.

In 1990, my life and curatorial vision changed forever when an artist friend invited me to visit Eastern State Penitentiary, an abandoned 19th-century prison in Philadelphia. At the time, Eastern State was an unstable ruin with crumbling lead paint, pigeons everywhere, feral cats, and plants growing

Susie Brandt, *Glint*, 1998. Plywood, paint, mirrored acrylic disks, screws, grommets, and plastic tubing, 600 x 900 x 900 in. From "Points of Departure: Art on the Line," Merion Station, PA.

Virgil Marti, *Couch*, 1999. Cotton brocade, linen and cotton velvet, digitally printed dye, wood, and foam, 36 x 30 x 400 in. From "Points of Departure: Art on the Line," Ardmore, PA.

out of cracks in the thick stone walls, but it had extraordinary light and vaulted ceilings. It was breathtaking. We were there to help the Philadelphia Historical Commission decide what could be done with this mammoth structure sitting on 11 acres of prime real estate. The solution, I thought, was simple: invite artists in and let them do what they do best—interpreting the social, architectural, and cultural history of this decrepit, scary, heartbreaking place. Co-curator and artist Todd Gilens and I spent five years conducting tours of the prison for artists and potential funders. It took that long to raise the money for "Prison Sentences: The Prison as Site/The Prison as Subject," which opened to the public in 1995. On view for six months, "Prison Sentences" consisted of 14 installations and interventions by 21 artists, and it forever derailed my ability to imagine and think creatively in more traditional venues.

I have been back to Eastern State twice, experimenting with new media both times: an immense sound installation by Janet Cardiff and George Bures Miller (*Pandemonium*, 2005) and, more recently, a collaboration with filmmaker Bill Morrison and composer/musician Vijay Iyer (*Release*, 2010). My practice has expanded into other historic sites and abandoned buildings. "Points of Departure: Art on the Line" brought nine projects to commuter train stations along Philadelphia's Main Line, assured of a daily audience of thousands. Mark Dion developed an interactive project for Bartram's Garden that culminated in an installation in Bartram's historic house in Philadelphia (*Travels of William Bartram—Reconsidered*). For *The Lost Meeting* (2005), J. Morgan Puett enlivened an abandoned one-room Quaker meetinghouse on the edge of a park (so named because it was buried under a tangled mess of overgrown weeds and developed one block away from the Main Jenkintown Meeting). Many of these encounters were serendipitous: hearing Vijay Iyer on "Studio 360," meeting him after a midnight show at Iridium in New York City eight months later, and then proposing a collaboration with Bill Morrison, whom I had never met. Iyer said that they'd always wanted to collaborate. Captivated by Puett's *Cottage Industry* in Charleston, South Carolina, I knew we had to work together. When I found out that we could have access to the Little Abington Meeting, I knew it was meant to be. This type of practice continuously introduces new and different audiences to contemporary art. Each project has its own specifically selected artist(s) and venue, its own participants and interactions, and each one results in a completely unique experience.

In fall 2010, Jennie Shanker, Philadelphia artist, educator, and the head of the installation crew at Eastern State during "Prison Sentences," came to me with a proposition. She had recently learned of an abandoned bungalow colony in the Catskills that could be made available for creative re-purposing.

J. Morgan Puett, *The Lost Meeting*, 2005. Collaborative installation in an abandoned Quaker meetinghouse, with composer David Lang, the greater Quaker community, and other participants.

I was eager to learn more. It was just the kind of project that inspires me, with its cultural history, the natural beauty of the surrounding region, interesting architecture, and an audience looking for stimulation. We went to the Catskills immediately and looked over other sites on Christmas Eve.

As we got to know the area, we found amazing examples of vernacular architecture of great character and integrity, which had been left to deteriorate and cried out for creative interventions. Often, artists are the ones willing to commit to the revival of the inherent potential of a place, allowing it to express itself anew, transforming something seen as a scar, a burden, or an embarrassment into something distinctive and inspiring.

CENTERpieces, our curatorial initiative in the Catskills, embodies this spirit. The intent is to recognize the cultural history embedded in these derelict structures and to offer artists the opportunity to convert buildings and empty lots into artworks and gathering places. The transformed sites will fascinate, educate, and create community, vitality, and tourism in this underserved region. Our plans focused on artists who could address the rebuilding of communities, with a specific plan to work with the history and architecture in the area. Hurleyville is a hamlet within Fallsburg (Sullivan County), New York, a former star in a constellation of Borsht Belt towns. We found a nonprofit (The Center) that owned a number of the sites and was willing to host us. The organization wanted us to enhance the lives of their community, people with mental and physical frailties, through public artworks. We were shown and considered a number of buildings and sites in the area: a salt shed with amazing acoustics, a geodesic dome building with two domes, the bungalows, and Main Street itself. The relationship with our host offered a broad audience, and it made the proper selection of artists more critical. Though I'd been working outside of the art world for some time, it pushed my practice in the real world beyond anything I'd done before. If we did this right, we could create regional attractions that would help to stimulate tourism and economic development. We could enhance the lives and experiences of people who don't often have the chance to experience the magic of art created for a particular site. Thus CENTERpieces was born.

With the intent to commission several multi-year projects over time, we saw CENTERpieces as a kind of open-access sculpture park. Instead of presenting works on a single plot of land, we would dot projects throughout the region. The potential benefits would be not only artistic and social, but also economic. This new string of sites could stream visitor traffic and connect various destinations in the region. Dia:Beacon, Storm King, Art Omi, and Opus 40 are all within an hour's drive. One of the sites that we considered was a geodesic dome building originally constructed from a kit in 1984. The moment we saw it, we knew that Richard Torchia was the artist for that site. Though the building is scheduled for demolition, it still embodies the commitment to green architecture that remains one of The Center's hallmarks and furthers its commitment to improving life in the community.

Torchia first visited the geodesic dome in March 2011 and turned the space into a laboratory for his work, which has long involved highly poetic camera obscura projections. The observatory-like structure lent itself to this approach, and we knew he would create something magical. Torchia and Shanker worked on the logistics and constructed an immersive light installation powered solely by the sun. Viewers walking into the dome found themselves beneath a canopy of thousands of holes drilled into the ceiling, making a pattern that attempted to chart the stars present behind the daytime sky. Lenses placed in the dome's lower windows threw camera obscura projections onto hand-held screens. The large open space, which appeared entirely empty at first, became dense with live, inverted images of clouds, trees, and wildlife. The natural environment — possibly the region's most precious asset — was thus brought into the building, where its beauty can be seen with magnificent clarity.

Richard Torchia, *The Harris Observatory*, 2012. Camera obsura projections, lenses mounted onto 8 existing windows, skylight of disused geodesic dome, circular hand-held screens, holes in ceiling based on the location of stars at midday, and bird feeders, geodesic dome: 20 ft. x 40 ft. diameter. From CENTERpieces, Catskills, NY.

The Harris Observatory opened in February 2012. This inaugural CENTERpieces show embodies the possibilities that surround us when we revalue what we see. Future CENTERpieces projects might include Ann Hamilton in the salt shed. This acoustically rich and architecturally grand building could offer Hamilton the challenge of creating a piece for people with no language and often compromised hearing. Allan Wexler is considering the bungalow colony, a group of five buildings and a swimming pool, and is challenged with the task of creating a path through the hilly colony that will allow the disabled to experience the installations in and around the houses. Shay Church is interested in building a community bread oven on Main Street that would be available to all—a huge rock slab would accommodate both people in wheelchairs and people who would bring their own chairs to pull up to the "table." We also have plans to create an artist-designed, accessible miniature golf course—the quintessential Catskills activity.

My hometown, Philadelphia, prospers from culture, which the mayor has recognized by dedicating an office in city hall to Arts, Culture, and the Creative Economy. Likewise, in the Catskills, local businesses, government, foundations, and organizations can follow the CENTERpieces model by working with cultural partners to create transformative sites and form opportunities for art that can be of benefit to everyone in the community.

Hinterland: Public Art at the Back of Beyond

(2013)

by Jennie Syson

The word "hinterland" specifically describes an uncharted area beyond a coastal or river district, or the outlying land surrounding (and serving) a market or port. In more common usage, the word has come to mean somewhere on the fringe or outskirts of an urban or industrial center, an area lying beyond what is visible or known. It evokes the backwoods, the sticks, the middle of nowhere, the back of beyond—a fictional kingdom ripe for re-creation and new definition.

"Hinterland," as a series of art exhibitions, began in 2006 and continued through 2010. Following the example of the Center for Land Use Interpretation in the U.S. and the *Land, Art* anthology compiled by the Barcelona-based curatorial office Latitudes, I decided to take the River Trent as a motif or geographical starting point. I was also inspired by Skulptur Projekte Münster and intrigued by the context in which Grizedale Arts in Cumbria was presenting a "new idea for an art institution which exists as a growing network of projects and ideas."

I wanted to create a kind of *Gesamtkunstwerk*, a synthesis of artists' projects, many parts contained in one all-embracing art form, similar to a museum collection but in the context of the public realm. I began to think of how commissioned works could take on the characteristics of a river tributary—quite literally "paying tribute" to speculative areas of interest that happened to catch the artists' eye or imagination. The Trent, as it flows through Nottingham, provides many picturesque platforms for revelation and contemplation. In consultation with a number of artists and curators, "Hinterland" developed into a unique way of working with temporary events and installations.

Jonathan Willett, in his essay for the second "Hinterland" publication, quotes Pascal Nicolas-Le Strat's argument in favor of this neglected, but vital, in-between zone: "Hinterlands are often portrayed as portmanteau places, their boundaries formed out of their chance proximity to more distinct locations. The residual place of the hinter-

Rob Sweere, *Styx*, 2007. Artist-made machine, interactive performances at the National Watersports Centre, Holme Pierrepont, Nottingham.

Via Vaudeville!, *Via Vaudeville!'s Folly*, 2008. Constructed ruin, soil, and plants; 1:10 scale model with plinth and case; guided tours and presentations; and limited edition fold-out. Collaboration with designer Guy Brown, Wilford Village, Nottingham.

land is an index for the changing state of modern urban ecologies, the complex territory at the borders of major rivers or ports, in geographic mixtures of common land, flood plains, public parks and footpaths, allotments, hedgerows, brown field industrial sites, small commercial holdings, depots, pylons and electricity sub stations; a diverse urban network of everyday life that comprises 'the ground floor of the city.'"[1]

This staking out of aesthetic territory has an early precedent in the literary ecology of Gilbert White's *Natural History of Selborne* (1789). White documented a local natural history in fine detail, highlighting complex relationships between wildlife and natural habitats, his narrative infused with the aesthetic conventions of the picturesque tradition. White's natural history was significant for its tendency to endow species with a vitality and independence in no way anthropomorphic: nature had a life of its own. Culture, from this perspective, is not distinct from nature, but part of a material continuum in which natures and cultures are composed and assembled in the process of life. At the ground floor of Selborne, we are introduced to the open-source ecology of a thousand tiny networks, an expressive nature in formation.

"Hinterland" traced many of those networks, facilitating the investigation of local folk history, Nottinghamshire communities, science and nature, and perhaps most importantly, the use and disuse of peripheral spaces on the edge of the city—an ancient church and its village hall, an artificial lake, industrial estates, bird sanctuaries, football clubs, city canal paths, and underpasses. The artists engaged in "Hinterland" have provided unique insights into these often overlooked areas of Nottingham.

"Hinterland" installations have navigated a way along the riverside through the social, the sublime, the poetic, and the political. Although the project began with fairly rigorous and traditional curatorial goals—taking the concept of a geographical and intellectual hinterland as a liminal space for making what could be termed an ongoing outdoor exhibition—it is often described as artist-led. This is not totally untrue, because the invited artists have naturally led each commission, but it might be better to consider "Hinterland" as a collaborative enterprise. Some artists were selected for aesthetic reasons; others were chosen because they were working in the Nottingham area and shared similar interests and research methodologies. Like a contemporary Gilbert White, I always intended to present the demarcated geographical area of the River Trent as it traverses Nottingham as a

species quadrant for artists to study intently, essentially under their own direction and for their own artistic ends.

Revisiting the project two years after its completion, it's refreshing to see more work in the public realm being created in the spirit of "Hinterland," particularly in Nottingham. Artists involved in the project continue to work with its ecological concerns and geographical constructs. For instance, artist Rebecca Beinart (a "Hinterland" alumna), producer Mathew Trivett, and writer David Bell are participating in the *Wasteland Twinning* project, which hijacks the concept of "City Twinning" and applies it to urban wastelands in order to generate a network for parallel research and action.[2] They are investigating a site situated between the inner-city area of Sneinton and Nottingham city center, next to One Thoresby Street artists studios, in order to connect it with other disused spaces all over the globe. In 2010, Neville Gabie planted community apple trees in Nottingham's revamped Sneinton Market; in the second phase of *Orchard*, he donated more than 100 varieties of apple trees to local residents, schools, and organizations in order to create a diverse urban orchard on the east side of the city.[3] Further afield, similar initiatives gained attention in the lead-up to the Olympics. London's award-winning *Folly for a Flyover* (2011), created by Assemble, a nonprofit collective of architects, artists, and designers, followed some of "Hinterland"'s seminal works with its nod to architectural follies and a cycle-powered cinema located below an industrial concrete flyover adjacent to a river.

One of "Hinterland"'s most memorable works was Rob Sweere's *Styx* (2007), which appeared on a manmade lake used by the national rowing team. An installation artist from the Netherlands, Sweere develops participatory instruments (artist-made machines) to be used along meticulously staged paths. Viewers following the trajectory of his carefully delineated tracks undergo a translated sensory experience beyond the ordinary. In Nottingham, using locally sourced, recycled materials and with assistance from boat builders at the National Watersports Centre and local artists, Sweere created the means for a memorable journey across the lake. Evoking Charon the ferryman, Sweere transported two people at a time in his moving structure. Each traveler, like the dead entering the underworld, paid the artist a penny for passage, then climbed up to a bier, lay down facing the sky, and placed the coin on his or her forehead, where it had to remain for the duration of the trip. This made it impossible to move one's head, forcing attention to concentrate on the sky while enhancing the feeling of floating or maybe even flying.

In 2006–08, "Hinterland" invited artist duo Tomas Chaffe and Blue Firth, known collectively as Via Vaudeville!, to take part in a residency. Ongoing collaboration and discussion led to the sharing of studio space in Nottingham and the founding of The Reading Room,

Unwetter, *Discursive Picnic*, 2007. Interactive event along the River Trent.

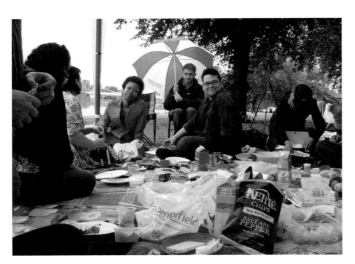

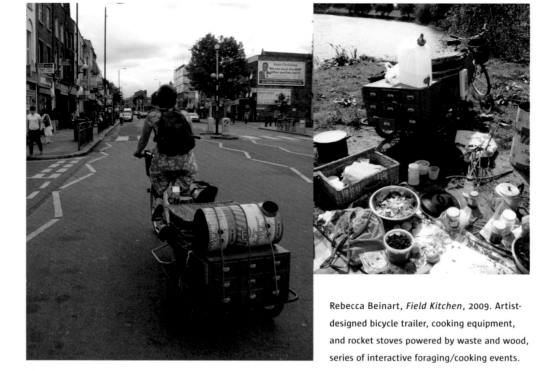

Rebecca Beinart, *Field Kitchen*, 2009. Artist-designed bicycle trailer, cooking equipment, and rocket stoves powered by waste and wood, series of interactive foraging/cooking events.

a library facility that hosted regular talks and events for local artists. For the culmination of their residency in the picturesque Nottinghamshire village of Wilford, Via Vaudeville! presented a new work among the tangles of wildflowers and shrubbery overlooking the River Trent behind St. Wilfrid's Church. Like many follies, *Via Vaudeville!'s Folly* (2008), which opened on a warm August afternoon, took the form of a "fake ruin" deliberately crafted to posses an air of charged memory. Via Vaudeville! invited the public to embrace a mythical narrative for the artificial kingdom of "Hinterland." The project included guided tours, complete with double-decker bus, and talks with Andrew Plumridge, founder and trustee of The English Folly Fellowship, and Christopher Woodward, director of the Museum of Garden History. This 21st-century folly reflects the artists' interest in the intersections of public sculpture and vernacular architecture and the relationship between the River Trent and contemporary Nottingham.

Unwetter, an international group of artists, curators, theoreticians, and activists based in Berlin, is interested in radical changes within an environment and how new spaces can be opened up for exploration (the name means stormy and turbulent weather). "The collective stages temporary events—so-called discursive picnics—with open invitations to participate in an exchange of ideas and a discussion on the parameters of contemporary art. During the course of the picnics, rigid designations of curator, artist, audience, producer, and consumer are broken down."[4] As part of Architecture Week 2007, Unwetter joined "Hinterland" for a discursive picnic along the banks of the River Trent. Nottingham residents were invited to join a discussion about changes to the landscape of Nottingham and what a new arts center might bring, methods of creating art outside a gallery environment, and the regeneration of the city (especially the riverside area). The picnic also investigated the geo-

graphical site where ancient ferry crossings meet modern structures and buildings. It concluded with an exploratory walk along the river to a look at the physical manifestations of some of the afternoon's discussions.

In 2009, Rebecca Beinart, a Nottingham-based artist, activist, educator, gardener, and cook whose work invites you to taste your surroundings, sniff out stories, and listen to other inhabitants of a place, led a series of foraging trips into the local landscape. On foot or by bike, participants learned foraging techniques and made a series of meals from ingredients found in Nottingham's trees and hedgerows. *Field Kitchen*, commissioned for "Hinterland," consists of an artist-designed, self-sufficient bicycle trailer incorporating all the equipment necessary to cook meals with plants found on expeditions in urban wilds — including rocket stoves powered by waste and wood. *Field Kitchen* continues to make physical and social interventions in the public realm; the temporary spaces that it creates can be stowed away and carried off without leaving a trace. The project examines what we can find in our immediate surroundings for sustenance, pleasure, and well-being, raising questions about our relationship with food, our reliance on imported goods, and lost fields of knowledge. Throughout the development of the project, Beinart collaborated with specialists on wild food, fungi, herbal medicine, folklore, pickling, and preserving. In addition to foraging trips on land, Beinart invited the public to join her on the water for a two-day event called "The Floating Kitchen." Participants took part in medicine making, foraging, pickling, preserving, and preparing food while sailing down the canals that intersect Nottingham's periphery. The event ended with a foraged feast along the Trent at which guests were invited to sample experimental culinary delights cooked outside on the rocket stove.

Annexinema is a peripatetic and autonomous events-based group committed to programming visionary and experimental work in sound, moving image, and performance. For the launch of "Hinterland 2009," founders Emily Wilzcek and Ian Nesbitt constructed a cycle-powered cinema and curated a program of artists' films that combined works by local emerging artists with historical and influential pieces by John Cage, Margaret Tait, Fernando Sanchez, John Smith, Mischa Leinkauf & Matthias Wermke, Chris Marker, John Chapman & Frank Simeone, Ben Rivers, George Barber, Emily Richardson, and Matt Hulse & Joost van Veen. Created with assistance from the nonprofit collective The Magnificent Revolution, a group made up of artists, musicians, designers, eco-builders, ecologists, and engineers, the pedal-powered cinema system used six bikes and 12 legs to power the screening. The event attracted nearly 400 people who were fed with locally sourced ale, food, and cycle-powered smoothies provided by Nottingham Brewery and the Harvest Café. This popular Nottingham viral cinema project has continued to present a varied program of live performances, installations, musical scores, and 16mm films. Its ad-hoc nights have been run on a shoestring budget, with enthusiasm for the content providing the main impetus. More than 70 international artists have shown work, and the screenings now regularly attract 100–150 people.

Notes

1 Pascal Nicolas-Le Strat, "Interstitial Multiplicity," in *Urban Act: A Handbook for Alternative Practice* (France: Atelier d'Architecture Autogérée, 2007).

2 For more information, visit <http://wasteland-twinning.net >.

3 For more information, visit <www.orchardsneinton.co.uk>.

4 See *Institutional Critique and After* (SoCCAS Symposium Vol. II), edited by John C. Welchman, (Zurich: JRP|Ringier, 2006).

No More Art For Art's Sake: A Conversation with Lance Fung (2013)

by Marc Pally

San Francisco and New York-based curator Lance Fung began his career with stints at the Marian Goodman and Holly Solomon galleries. Frustrated by the superficial "veneer" of the art world, he opened his own space in 1996 in order to pursue more personal and ambitious projects, but he only discovered his true voice as a facilitator/creative catalyst when he broke away from conventional moorings altogether and began to work closely with artists and architects out in the larger world. Whether realized in remote locations or major urban centers, Fung's endeavors evolve from a synergistic interaction of process, experimentation, collaboration, experience, and community: in these unique conjunctions of art, people, and place, the journey is as important as the result. From "The Snow Show" (2003 and 2004, in Lapland) to "Lucky Number Seven" (2008, SITE Santa Fe) and "Wonderland" (San Francisco, 2009), to a new, five-year public art series in Atlantic City, Fung's installations and exhibitions give shape to passionate vision and excite genuine engagement. His exploratory approach demands risk-taking on the part of every participant—curator, artists, and residents/viewers all have to step out of their normal comfort zones, enter new territories, and confront new ideas. For him, the best art extends its energy outward to embrace, involve, and even change surrounding communities. The aesthetic experiences themselves may be of short duration, but they have the potential to inspire lasting dreams and transformations.

Marc Pally: *You've had a long and varied career in the art world. Can you describe what brought you to your current work with Fung Collaboratives?*

Lance Fung: After two decades in the art world, looking back at what I have done and where I am heading, all I can think of is the word "process." I am most thankful that I did not get swallowed up by the machinery or have a personality or value change without even noticing it. Somehow, I have managed to remain true to my personal goals.

When I first moved to New York for graduate school, I began as an intern at Marian Goodman Gallery, which lasted a week. I then became a gallery assistant there while going to school. Two years later, in 1989, Holly Solomon hired me as gallery director. In 1996, I opened Lance Fung Gallery in SoHo with a Shigeko Kuboto exhibition. The gallery program was heavily focused on installation art. It was much less about selling art and more about starting a dialogue, about hosting happenings and poetry readings. I was caught up in the romanticism of the late '60s and '70s. In addition to solo shows of Gordon Matta-Clark, Robert Morris, and Peter Hutchinson, established and emerging artists could experiment at the gallery. Our attitude was let's work together and create an interesting experience for you and me and the audience—that was my foundation for being a good facilitator and that seems to be my role as a curator.

MP: *You're operating as a freelance agent across many platforms. Can you describe what you do and what you want to see happen with your projects?*

LF: My process is very organic. It is first about a project that excites me, and then it becomes about how I can immerse myself in a local community through the curatorial process. We can look at it from an art perspective or from a perspective that serves the general public. I truly hope my projects bridge and unite these different audiences. The range is vast, but that is the unique challenge that I set for myself. How can an art exhibition attract and "speak to" such varied visitors—from the art world to the general public to local governments? Can great art speak on multiple levels and to all age ranges, from elementary school children to their parents? I believe so, but this is rarely done under the umbrella of public art.

Now that I have curated a number of fairly unconventional outdoor exhibitions, I am pushing my comfort zone to create experiences for people that have a social message and purpose. No more art for art's sake for me, but rather, art for people's sake. That seems to be where my focus is headed. After all, we are in a field where the communication is (or should be) purely visual. Great master-pieces transcend time, geography, social demographics. I am trying to create exhibitions that do that or at least strive to. I do not think that great art and art for the masses are mutually exclusive, nor do I believe that the art is more important than how it affects people through the creative and exhi-bition process. I have worked with artists whose end result was only O.K., but it rallied people and had a true impact on a community. I have also worked with artists who knocked the project out of the park, but people did not fully appreciate or experience it at all. Which is better? I am not sure, but I try to facilitate artists to do both simultaneously.

MP: *Can you give an example or two?*

Nick Mangan, *A1 Southwest Stone*, 2008. Dirt, stone, shed, archaeological tools, and found objects, dimensions variable. From "Lucky Number Seven," SITE Santa Fe.

LF: I'll give you examples of both. In one case, I mentored a team of MFA students from the San Francisco Art Institute to create a community-based installation. They integrated themselves into the community and got everyone there involved. In the end, they created a mobile sculpture that could be seen throughout the neighborhood for the entire exhibition period. At night, it faced San Francisco's city hall. It received a lot of attention, with masses of people taking photos in front of it. I was delighted that the artists engaged everyone on the street with art that was inspiring and worthwhile, even though the sculpture itself was not nearly as delightful and playful as the initial rendering.

As an example of the other situation, I invited an emerging artist from Mexico named Erick Beltran to participate in "Lucky Number Seven," SITE Santa Fe's Seventh International Biennial. His project was one of the smartest things that I have ever supported, and we worked extremely hard to realize what became one of the most profound and meaningful works in the biennial. It was a marvelous series of unmarked mosaic tombs, dispersed throughout the town; but without signage, most people never really saw or understood the piece.

Eliza Naranjo Morse, Nora Naranjo Morse, and Rose B. Simpson, *Story Line*, 2008. Clay willows, waddle, linseed oil, rice, nylon, and thread, dimensions variable. From "Lucky Number Seven," SITE Santa Fe.

MP: *Is there a common thread across your various projects that characterizes your passion and interests?*

LF: Process. Process + experimentation + collaboration > experience = community: that was my mantra for "Lucky Number Seven." It felt so right that I incorporated the phrase as the mission statement of Fung Collaboratives. I approach all of my projects through visceral, spiritual, and cognitive threads. I have no rulebook about how other people should curate, but I know how I must. Sometimes I feel as if I am an island in a network of other islands.

I want to help make multifunctional art that provides a multi-layered experience. I aspire to do more than create another exhibition. When I am

Piero Golia, *Manifest Destiny*, 2008. Three stunt mattresses; 16-foot jump off a Tod Williams and Billie Tsien ramp onto a 2-x-12-x-12-ft. polyurethane foam landing pad. From "Lucky Number Seven," SITE Santa Fe.

fully engaged, I am in a moment of Zen. I lose perspective and any linear thought. I sink into my work and into the community. Sometimes the process is euphoric, other times I am in quicksand. I hope to work on projects that cannot be easily labeled and are more about experience. My aim is to do something that truly can alter a person's reality. Is it art? A playground? A park?

In my early days, I curated solo exhibitions and indoor shows, but it became more interesting for me to work outside of the white cube. My recent exhibitions share several consistent aspects: they are large-scale group shows, public in nature and free to the public, consisting primarily of newly commissioned, site-inspired installations highly intertwined with the local community. After I start on a project, I have to remind myself that I have created the terms, because working this way can give rise to many problems.

MP: *Can you talk more about the skills you bring to the projects you initiate? Once you select the artists, what is your role?*

LF: The most important curatorial skill is less about skill and more about personal qualities. Passion and sincerity are what I value most in others as well as in myself. For instance, I am currently working on an exhibition series in Atlantic City, where people are counting on me to create something special for a very thirsty audience. Local residents are not expecting an art exhibition but an action that can mobilize and inspire their town. In a way, they are hoping for art to change how they see their city as well as those who visit it. They want something meaningful. Isn't that what we hope to do in the art world? I began this project by listening to the organizers and the people on the street talk about what would truly impact their daily lives. They repeatedly mentioned a place of respite. So for my curatorial premise, I decided to make a living exhibition both in spirit and in the physical realm.

People can be profoundly affected by contemporary art even without any knowledge of what we do. I've seen this happen in my exhibitions, and I find it incredibly rewarding when someone who has no art history knowledge "gets a work of art." Sometimes I feel that they gain more from the experience because they come without the art filter and don't have preconceived ideas of good versus bad.

I often believe that what I do, what I hope for, is a bit out there. And my approach makes me vulnerable. People have seen me cry on location because something has gone wrong and I feel responsible for letting them down or because an artwork has moved me. I carry a heavy sense of responsibility for my projects because they are so connected to the local community, connected to people who've become friends. I hope that the experience of seeing an exhibition in which I've participated is special—not necessarily controversial, but at the very least, unique and personal.

MP: *How do you determine which projects to take on?*

LF: I believe a project finds you. The right projects may take years to materialize, but then you realize their preciousness. I have a long list of exhibitions that I would kill to realize, but other people see them as too expensive or complicated. Some of them are time-sensitive and sadly may miss their need and moment.

MP: *"The Snow Show" was an extremely important project for you, a game changer in terms of what you've subsequently done. Could you talk about it?*

LF: The first "Snow Show" was a self-starter project. I can see now that it took a lot of chutzpa because it went against the grain of the time, but I clearly had no clue about that when I began on what became a decade-long adventure. Even now when I speak with the artists from those days, they reminisce about the unique experiences we shared working in the Arctic Circle. I was surprised and thought it was a prank when the director of the Cultural Olympiad for the Torino Winter Olympics expressed interest in a new version of "The Snow Show" for the games. My team and I accepted, and we moved to Italy without even knowing how to speak the language.

In 2006, I received word from the director of SITE Santa Fe that I had been selected to curate the 2008 biennial. This was completely out of the blue, and as with "The Snow Show," I was a bit clueless about the stakes involved. I believe that I came up with a unique process in which I could break down, or at least challenge, the expectations of the biennial format. When I invited only emerging artists, colleagues said publicly that I was crazy, but in the end, those artists—along with a huge number of local volunteers—created ambitious temporary installations throughout the SITE building and the city. The number of visitors to the biennial also more than doubled.

MP: *Working with the Olympics or even SITE Santa Fe, you must have access to impressive resources. How do you work in settings with fewer financial assets?*

LF: "Wonderland" began as a framework to give my MFA students experience in the real world beyond academia. The exhibition had zero funding, so everything was based on in-kind donations and volunteering. We had no media outreach, so only people in the San Francisco Bay Area learned about the exhibition. It took us two years to realize, but it was my most rewarding experience to date.

The exhibition was set in the Tenderloin neighborhood of San Francisco. This is the poorest and most violent part of town, but it flanks the posh area of Union Square. The residents knew little about contemporary art, so they were cautious about partnering with me. I began by formulating teams of artists. They partnered with local nonprofits to conceive their public artworks with, about, and for their constituency. We worked with homeless shelters, anti-human-trafficking organizations,

Roman Cesario, Mitsu Overstreet, and Robert Gonzalez, *Fear Head*, 2009. Latex paint, aerosol paint, wood, concrete, metal, and glass. From "Wonderland," San Francisco.

soup kitchens, runaway shelters, and the Boys & Girls Clubs, to name a few. City officials did not necessarily appreciate us highlighting some of San Francisco's darker aspects, but since the city didn't provide any funding they could not edit our work.

The result was powerful works about a range of social and political issues affecting this area. More importantly, these works were created by the residents and the artists together. A very unique bond occurred. And most importantly, there was no judgment. At first residents saw a stranger, a Prada-clad, Chinese curator driving into the Tenderloin in a Mercedes convertible, but they soon saw a friend visiting. I was advised by everyone, including locals, to act and dress differently, but I felt they needed to accept me as I was, just as I had to accept them as they were.

We did not want to come into a disenfranchised neighborhood to gentrify or exploit it. It took a while to prove that we were sincere. This is what tipped the scales in our favor. We wanted a sincere dialogue, which eventually took place. This kind of dialogue is not often achieved. I'm talking about a dialogue that sheds all bias and is at the most guttural level. One of the artists was on welfare and living in an SRO. We set up a temporary studio for her, where she could also hold workshops for children. I still remember when she told me that our self-funded art show restored her dignity. She had been severely depressed, but after a tiny bit of support from us, she felt positive again. She eventually sold enough of her work to rent an apartment and leave the Tenderloin. This is one way that art can truly change people's lives. We also had local artists drop off their work for us to include in an exhibition at the community center. Some wanted to remain anonymous but still felt it important to be part of this community project.

We were all so committed to this project that the artists paid for their travel and materials, and I worked exclusively on "Wonderland" for two years without compensation. It was truly a gift for all of us, "outsiders" as well as those living and working in the Tenderloin. And the kicker was that the mayor came to the opening and said it was the best thing to happen there. Art collectors came down from the hill. Impromptu docents led tours using the free guide printed in the newspaper. Most of these self-taught docents were residents from the street. They didn't ask for money, they wanted to be heard and to share what they felt was special. People would come up to me on the street and tell me how they felt human again. I'm planning to return and work with the residents again on "Wonderland Two."

MP: *Can you tell me more about your current project?*

LF: It started just like the "The Snow Show: Torino" and "Lucky Number Seven." I received an unexpected call from Liza Cartmell, the director of the Atlantic City Alliance, and I accepted. I am happily working in Atlantic City with the Fung Collaboratives team to use vacant land as sites for newly commissioned art projects. We'll do one exhibition a year for the next five years, resulting in art playgrounds designed by artists, architects, landscape architects, and designers. Each project will be distinct, but they all will have three elements: water, sand, and boardwalk planking materials.

The first two playgrounds are now being designed, with the first opening in November 2012 and the second in May 2013; and John Roloff is doing another, separate outdoor project. I envision an experience of groundedness and exoticism for the first art playground, which is about seven acres. It will be an open, grassy, landscaped communal meeting space, with two facing mounds (17 and 14 feet high) that will interact with one another. Robert Barry is doing a text piece on the outside of the two huge forms. Kiki Smith and Ilya and Emilia Kabakov are designing works for the two interior chambers.

The second art playground will be designed by architects Todd Williams and Billie Tsien working with earth artist Peter Hutchinson. There, I envision an arid, sandy landscape with the main play-

"Artlantic: wonder," with works by (foreground) Robert Barry and (background) Ilya and Emilia Kabakov; site design by Balmori Associates. 7-acre art playground/park in Atlantic City.

Detail of "Artlantic: wonder," with Kiki Smith, *Her*; garden design by Balmori Associates.

ground elevated so that visitors experience an ascent into nature. This airy space will allow people to look out over the Atlantic City boardwalk and past it to the awe-inspiring Atlantic Ocean. Hopefully this will allow people to unplug from worldly activities like gaming, shopping, and eating and inspire moments of contemplation, relaxation, and dreaming.

We hosted a mixer so we could meet the local arts community and hear from them about what they found interesting in the art playgrounds and what was lacking. It was a moving experience; I met many residents who grew up in Atlantic City and wanted to better life for their community, as well as to enhance and diversify the experience for visitors. That meeting reminded me of my first presentations in Santa Fe and the Tenderloin. The level of support in Atlantic City has blown us away. I left the meeting feeling invigorated and inspired. I hope that with their help, we can create an exhibition in a holistic way, with spaces that everyone can enjoy, where people can find rest and nourishment. Fingers crossed, this may be my best work to date.

Space, Political Action, and the Production of Radicalized Subjectivity: A Conversation with Nato Thompson (2013)

by Sylvie Fortin

Nato Thompson's curatorial practice mobilizes art, theory, media, and politics to pose a number of questions: Where can art erupt to test the limits of existing social conditions, pressure political appa- rati, and sketch the contours of emerging aesthetic relations? How does space operate strategically and tactically? His projects have often set the stage for collaborative, self-organizing forms of research and production as test sites for models of radicalized community. Thompson is chief curator of Creative Time, a New York-based nonprofit that commissions, produces, and presents art that infil- trates the public realm and fosters social progress. Since January 2007, he has organized the annual Creative Time Summit (2009, 2010, 2011, 2012), "Democracy in America: The National Campaign" (2008), the exhibition "Living as Form" (2011), Paul Ramírez Jonas's *Key to the City* (2010), Jeremy Deller's *It Is What It Is* (with New Museum curators Laura Hoptman and Amy Mackie, 2009), and Paul Chan's acclaimed *Waiting for Godot* in New Orleans (2007). He previously worked at MASS MoCA, where he curated numerous large-scale exhibitions, including "The Interventionists: Art in the Social Sphere" (2004). He recently edited *Living as Form*, a survey of socially engaged art from 1991 to 2011, co-published by Creative Time and MIT Press. His new book, *Seeing Power: Art and Activism in the Age of Cultural Production* (2013) is published by Melville House.

Sylvie Fortin: *Space plays a special role in your work, but your conception of space has shifted, most recently through your engagement with the Occupy movement. You've said that the defining dimension of Occupy is its occupation of physical space*

Nato Thompson: It's funny, I meet with the Occupy people a lot now. I can't make the point about the need for space enough, but they hate it. "Easier said than done" is the reply. New York City has basically made the occupation of space illegal at this point. If you can't get space, then what?

SF: *Or if you can't hold on to it. Let's talk about the shifting role of physical space. How do you understand the history of physical space after the WTO Ministerial Conference in Seattle and the kinds of conditions that it creates?*

NT: Activist art, over the last 12 years or so, reflects an interesting transition in our attitudes about space. I don't know all the reasons for it, but the work demonstrates that our attitudes have shifted radically—that's important to note. With the anti-globalization movement, different art movements traced different historiographies. Nevertheless, the language of tactical media was really pronounced at the time, and the writings of Critical Art Ensemble influenced thinking about ways to engage.

The language of tactical media produced a specific kind of culture—prankster-ish, Abbie Hoffman- ish, tempered with a little *October* magazine criticality—whose antics were deployed in space. That was reflected in social movements—the Carnival Against Capitalism, the Yes Men, Billionaires for

Bush, a kind of "waka waka, ain't we funny?" kind of thing. Stunts that would capture media attention were part of the attitude toward space.

It sounds corny, but I think that the Internet has played a profound role in shifting how space is understood. Consumption happens at a different pace on the Internet than on television. With the media stunts, you were desperately trying to have a moment of your 15 minutes of fame. If you were lucky, you'd get on a news report.

The Internet used to be a place to advertise what happened in the public sphere—the age of the Web site. Now, the public sphere has become a place to advertise what's happening on the Internet. Consider the role of social media in the current social movement—it almost didn't feel real until it was grounded in a place; it needed longevity, in the media machine, too. Occupy's corollary was the BP oil spill, which was a problem that wouldn't go away. The media kept having to report on it; the news was "still spilling...still spilling." As long as it spilled, you couldn't stop talking about it; but as soon as they closed that pipe—which took forever—it disappeared. It was no longer a story. Somehow prolonged engagement in the physical world allows the media and public interest to engage. I feel like the "real" is still constituted in space. Things need to happen in space in order to get our attention. As soon as they turn discursive, they float away.

SF: *Could there be a tipping point when an eruption—like the BP crisis or Occupy—becomes normalized in the media circus? A moment when its status shifts from event to saga, which means that viewers expect the next episode? The fact that it is still news is somehow reassuring because it has not been displaced by another crisis or catastrophe of greater consequence.*

Paul Chan, *Waiting for Godot*, 2007. Site-specific outdoor performances of the Samuel Beckett play in two New Orleans neighborhoods.

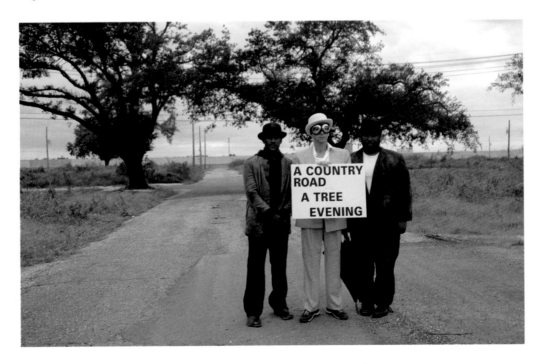

NT: Yes, it's also like that. If Occupy had lasted just one day, or even a week, there wouldn't have been much of a story. The news media didn't even report on it for quite some time. This delay is significant. Many protests don't last that long. The news media are very paranoid of getting left behind by Twitter and social media. And so, there came a point when Occupy was getting so many hits in social media that they had to recognize, "O.K., it's real." That's fascinating because social media also played a huge part in the Arab Spring and in movements across Europe. Incredible stuff is going on, and it's social media-oriented—it isn't just because the social movements got better.

SF: *This relates to two other recurring questions in your work: the legacy of 1968 and the legibility of new political formations. On one hand, you're saying that the news media are afraid of being left behind; on the other, here in Montreal at least, many of the people who are now leading media organizations would identify themselves as agents or supporters of the '60s movements. They understand political action in a certain way and can be blind to other legitimate actions and strategies. There's a real disconnect. This brings us back to questions of space, because in the '60s, activists understood the potential of space in a specific way. Space had not yet been thoroughly privatized, which means that one's position in space had a different political dimension. Coming into visibility by occupying space meant something radically different.*

NT: It's true, and you can generalize, but the geopolitical specificity of our relationships to these actions cannot be underestimated—the situation in Canada is different than the situation in New York City, just as it's different in Egypt. So, there's the overall notion of spectacle and relationships to the '60s, which have been teased out in different ways—particularly in terms of political legacies. Over the last decade, the U.S. has become much more privatized—it's a police state. Even in the '60s, you would never see this kind of straight-up assault on the basic right of assembly. They are waging war on the rights of public space.

SF: *You also propose a more immaterial space as an antidote to the foreclosure of public space: sites of transversality. I understand these sites as constituted through alliance and exchange. They are both transitive and transformational—sites of becoming that require and produce change (affective, political, or intellectual). Could you explain how these sites operate?*

NT: Often during movements like Occupy, people become "radicalized." The reason why '68 had such a profound effect on culture at large is because it was an experience that radically changed subjectivity. You connect yourself to the world very differently, you see yourself in historical terms radically differently, and you think of your community in different ways. Your relationship to power changes. There are very intimate ways in which transversality can happen, and there are very grand, gestural ways. You can have big, hypnotic social movements with great affect that allow you to join into the group; but pedagogy could also be called transversality. People like Augusto Boal or Paulo Freire were talking about similar things on a more intimate scale: how to think of education as transversality, how to give someone a sense of agency and make real the conditions around them. That, in essence, is the radical project at all times, though it's a hopeless endeavor in the Foucauldian sense—it's always erasable, it's always wanting to dominate, it's an endless game. But I guess the Emma Goldman project of freedom would be the transversality project.

SF: *So, as you understand your place in the world differently, your relationship to power changes. But there seems to be another dimension of transversality—call it its transitiveness—that hinges on recognition. It calls on affect and is also a form of empathy, the moment when you see somebody else's struggle as close to your own. Looking sideways, all of a sudden, you understand this person*

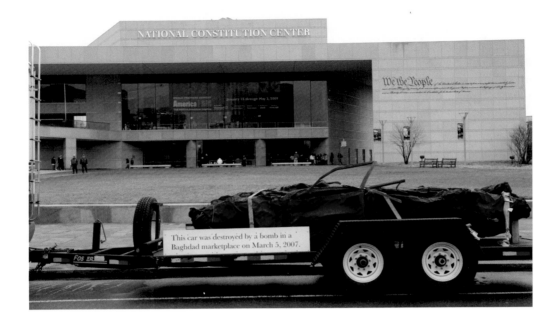

Jeremy Deller, *It Is What It Is: Conversations about Iraq*, 2009. RV and car detroyed by a suicide bomb in Iraq, U.S. tour.

whose quest and political views are very different from yours. That dimension of transversality is really important.

NT: That makes sense. These ideas are extremely relevant, but what I've read about affect is very jargony and specific. I think that it could be talked about in a much broader sense. It seems to me that affect is a great point to think about — what culture does, and what art can do, as opposed to the problematic dichotomies of the Enlightenment.

SF: *I also think it's important because the media play on affect. We haven't chosen this battlefield, but it's been imposed.*

NT: I agree. We're making a video for a foundation to present what Creative Time does, and I want to say, "Hey, this thing we think of as art isn't art. And what we think of as politics isn't politics." At this point, politics is the production of affect — just like advertising. Karl Rove doesn't give you all these good facts so you can vote; he molds a product toward which you can feel a relationship. This means, in the old system of the Enlightenment, that politics has become art. It's very hard to get the Lefties to understand this, because they're very empirical.

The gap between the '68ers and Occupy stems from the fact that this generation has no faith in meaning. Their level of reasonable cynicism is so much higher that it's hard to understand them. In '68, people hadn't experienced the erosion of meaning to the extent that we have. They still believed that if you said this, this is what it meant. That's why it's funny to watch Occupy's skepticism of everything: "We won't make claims," "We won't say what we want." That seems strange to many. I don't think this is necessarily a good thing, it's just an inevitable result. How does one make a movement without making claims? It's really difficult.

SF: *Let's move to two related notions: duration and the difference between tactic and strategy. These concerns relate to both space and legibility. Duration is central to the kind of works that interest you most—projects like Occupy and* Project Row Houses, *for instance. Can you speak about duration, slowing down, and the commitment required by strategic projects?*

NT: There are many such durational works—I call them "infrastructure projects." *Project Row Houses* is a great example because it raises so many complicated questions. It's a nonprofit, it's a kind of real-estate development company, it's pedagogy, it's social work, and it's a residency. It's many things that exist outside the art world just fine. You could ask, "Well, would that make the Department of Education a project?" This is a reasonable question, but it seems to me that the artists who are doing this kind of work do it because they have a drive to make things matter.

I've done many socially engaged art projects. Every time, I face the same accusations, so I'm familiar with a certain logic. There's a belief—which I think is normal—that the project isn't really doing what it claims. It's really difficult to prove that things matter. But with someone like Rick Lowe, who's been doing it for 16 years, there's consensus: "That guy really did it." If we follow the logic to its end, then 16 years *proves* that you care. That's a pretty tall order. Does every project have to last 16 years to get everyone's approval? The urge to matter also comes out of a suspicion, and reasonably so, that your works are just consumed, that you might be doing what you are accused of—using the gesture to advance your career or exploiting things for spectacle value.

In a weird Baudrillardian sense, there is a desire for the real, or a desire to make actual change. But it's difficult to say what that is. For example, when does the small gesture become the ephemeral, quick gesture? The language used to talk about something that actually has impact is a very difficult thing to figure out. And I think that's because it's really difficult to know when something's being exploited and when something has transversal or pedagogic value. When does that place open up? How would one know?

SF: *In addition, there's no allowance for the possibility that a project can have a desired social outcome despite the artist. There's no accounting for the value produced by delegation. Somehow, no matter how many people collaborate on a project, it always circles back to the individual artist. If you do it for 10 years, the fact that you've worked with others, who have taken it on and made it what they want, is denied. How do we begin to understand a distributed, delegated model?*

NT: That's a good point, and it applies to many artists involved in this kind of work. The phrase "keepin' it real" means a lot to them. They don't want to seem like opportunists who just take advantage of trends. They struggle to make things matter in their own lives, and these struggles produce interesting forms. At the same time, there are operators who parachute in to do these good-for-people gestures and are convinced their name has to be at the top of the press release. We should begin to talk about what people get out of projects, to bring this materialism into our assessments—not in an accusatory way, but as a matter of fact. It's not bad for someone famous to get involved in a project. Let's just put all this complicated social/cultural capital stuff into the mix of how we read, or make legible, social work.

SF: *This brings us back to the production of radical subjectivities. Does the fact that an artist just parachutes in necessarily rule out the possibility that a project can lead to a radical shift in others? Are we talking about what the work produced or who produced the work?*

NT: I'm convinced that both are possible—that you can have your cake and eat it. I think it's many people's dream to both be famous and a good person. I don't have a problem with that.

SF: *So, what really matters, if we're going to "keep it real?"*

NT: In terms of producing radical subjectivity, here's an example. I went out to *Project Row Houses* and talked to the single mothers who completed the school reintegration program. They were so radicalized and so profoundly glad that this occurred. And they stayed in the neighborhoods. So, even though there's no metrics for measuring success, I could feel, I could tell, that it was working. I want to say, "We can do this, everybody." We can come up with another way to talk about what culture does. I'm known for "political art," but that's not really my goal. My goal is to do things that matter to people, relevant things. Projects are interesting when they venture into the space of the unexpected, which is where things open up. The Iraqi man who went with us on the road trip for Jeremy Deller's *It Is What It Is: Conversations About Iraq* made an awesome observation. He said, "In America, people have heard so much that they've got a file in their head for everything. If you say, 'I'm against the war,' they open up the file in their head and they already know what you're going to say. And if you say, 'I'm for the war,' they open up that file. But if you don't fit into the files in their head, they get confused, and then they become open." That's exactly what many art projects try to do: to find a way into that overly filled head by coming up with strategies that don't fit another category. And this, I guess, is the technique for radical subjectivity. So is education. Art projects ask a lot from a limited engagement, but with education, every day you get radicalized in a very different way. What is radical subjectivity? It's renegotiating one's condition or relationships to power in a myriad of forms, not just class or capital, but gender, race, and space.

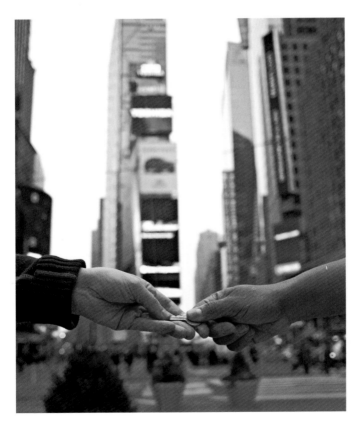

SF: *You mentioned race and gender, but strangely the body and biopolitics remain as yet untheorized in your work. With Occupy, the convergence of bodies in space made the difference. Biopower is the new battleground. Could you speak about how bodies operate in public space?*

NT: As a curator, your projects in some ways motivate your thinking. My next project is about how race is produced through space, which is about bodies and how subjectivities are produced within the urban sphere. So far, shows about African Americans are very much about skin. They are two-dimensional: they tackle representation, but

Paul Ramírez Jonas, *Key to the City*, 2010.

Tania Bruguera, *Immigrant Movement International*, 2011. Artist-initiated sociopolitical movement headquartered in Queens, NY.

not space. They don't ask, how is the body produced in space, how is space racialized? Plantations, prisons, and ghettos are obvious examples of this intersection of race and space. I've always been obsessed with the production of race in the city.

Public art allows this kind of thinking to become much more tangible. After doing lots of public projects, I also realized that public art is disproportionately a male realm. This makes me want to do something about the construction of gender and sexuality in space. Things are shifting for us at Creative Time; we're not only thinking about space now, but also about infrastructures of space, which is opening up a lot more territories.

Justice and Punishment: Human Rights Performance and Protest in Argentina (2013)

by Marisa Lerer

In the 20th century, "disappeared" evolved into a noun to describe those people who were kidnapped, tortured, and killed under the military dictatorships of Latin America.[1] When the Argentine dictatorship (1976–83) finally lost power, the people of Argentina democratically elected Raul Alfonsín (in office 1983–89), who soon passed a series of laws that put an end to the investigations and prosecutions against those accused of state-sponsored terrorism under dictatorial rule.[2] In 1989, president Carlos Saúl Menem (in office 1989–99) pardoned members of the military who had already been convicted, leaving Argentina as a nation in which ex-detainees and family members of the disappeared had to interact with murderers and torturers living among them as fellow citizens. This legacy of an estimated 30,000 disappeared persons, whose existence was denied in the military junta's official history and whose family members were denied justice by democratic governments, raises questions about memory, history, and representation not only in the private, but also in the public realm.

Multiple visions for and conflicting ideas about how to represent the missing developed during and after the military dictatorship, evolving into a competition for the material memory of the disappeared.

Grupo de Arte Callejero (GAC), *Aqui Viven Genocidas (Here Live People Who Committed Genocide)*, 2002–04/2006. Maps, video, and address book with phone numbers of human rights violators (and *escrache* targets) in Argentina.

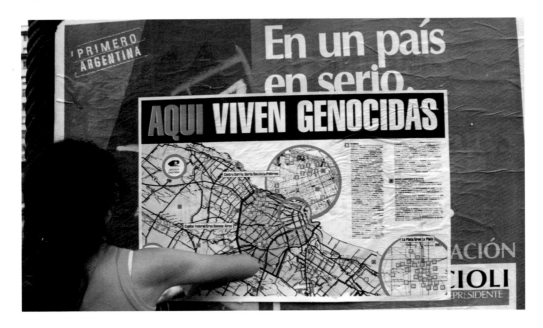

An important arbiter of these representations, the human rights group H.I.J.O.S. (Hijos y hijas por la Identidad y la Justicia contra el Olvido y el Silencio, Children for Identity and Justice Against Forgetting and Silence), which was formed in 1995 by children of disappeared parents, had partnered with neighborhood organizations, family members of the disappeared, and various artist collectives since its inception, working together to stage collective memorial protests.[3] In 1998, the organization partnered with the art collective Grupo de Arte Callejero (GAC), a group formed in 1997 by art teachers who use public space as a place for artistic expression, in order to create performances in the public realm that drew attention to the history of the dictatorship and the impunity granted to the perpetrators of human rights abuses.[4] Their actions not only functioned as didactic tools for understanding the military dictatorship and its legacy of disappearance, they also highlighted art's potential to further the cause of human rights through cathartic, educational, and condemning performances known as *escraches*.

Escrache is a type of guerrilla public performance art that reveals and marks the atrocities committed under the military dictatorship. The term comes from *lunfardo* (Argentine slang) and has its origins in the Italian word *schiacciare*, which means to crush, to squelch, and to crack. It had fallen out of use until H.I.J.O.S. reclaimed it in 1996 for an avant-garde form of commemorative aesthetic protest. *Escraches* "reveal in public, [make] the face of a person appear who tries to pass unnoticed," by furnishing photographs and information on the identity of those responsible for the disappearances and publicly indicating their whereabouts.[5] The disappeared were linked to those responsible for their disappearance; thus *escraches* fought the pardons and impunity laws signed by Presidents Alfonsín and Menem by convicting the perpetrators—if not in a legal court—at least in the public eye.

Classics scholar Gail Holst-Warhaft has asserted, "If care is not taken, if grief is artificially inflamed or prolonged, or if the expected conclusion is never satisfactorily achieved, the temporary chaos of death and mourning can spill over into the society at large and threaten its stability."[6] H.I.J.O.S. and

Grupo de Arte Callejero (GAC), *Carteles Viales* (*Street Signs*), 1998–present. Signs to identify the homes of human rights abusers and clandestine detention centers.

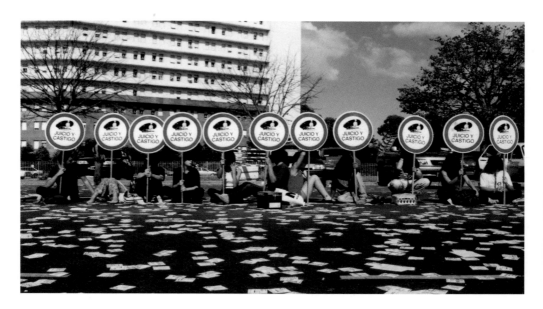

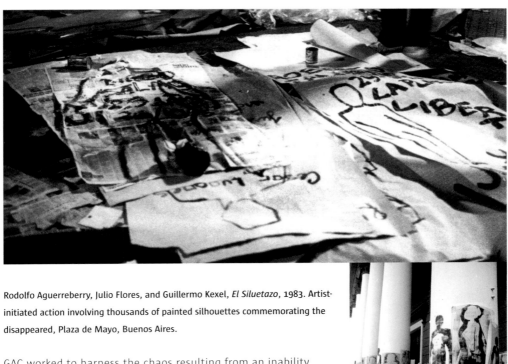

Rodolfo Aguerreberry, Julio Flores, and Guillermo Kexel, *El Siluetazo*, 1983. Artist-initiated action involving thousands of painted silhouettes commemorating the disappeared, Plaza de Mayo, Buenos Aires.

GAC worked to harness the chaos resulting from an inability to mourn by creating a carnivalesque atmosphere during the *escraches*. The first *escrache* was directed at Admiral Emilio Eduardo Massera, who, along with Jorge Rafael Videla and Orlando Ramón Agosti, was part of the 1976 military junta that deposed President Isabel Martinéz de Perón (in office 1974–76). The *escrache* took place in front of Massera's apartment, where participants donned theater masks and held up a sign reading "Free or Imprisoned." *Escraches* were frequently filled with movement and noise; in this case, close to 500 participants sang, chanted, jumped, and danced. Loudspeakers announced the crimes, *murga* bands played, and giant puppets paraded down the street alongside placards of photo IDs of the disappeared.[7] The performances ranged in theme and subject, re-creating torture scenes, the kidnapping of a disappeared person's recently born child, the confession of a military official with a Catholic priest, and a staged soccer game with the two opposing teams as Argentina vs. Argentina.

After H.I.J.O.S. researched its targets, participants distributed announcements, including a photo of the *escrache* subject, along with his biography, address, and the location of the action. The subjects included notorious intelligence officer Alfredo Ignacio Astiz, military leaders, physicians who cooperated in torture, and U.S.-based organizations like the CIA and the School of the Americas, which functioned as a training ground in torture tactics for many of the Argentine officers involved in the disappearances. Before the date of the collective gathering, H.I.J.O.S. would canvas the target's neighborhood, distributing flyers with questions such as: "Did you know that your neighbor was a torturer?" "How do you feel about working with him? Or serving him lunch? Or selling him cigarettes?"[8] These flyers, published by H.I.J.O.S. and GAC, established that individuals—identified by their photo-

graphs—were responsible for the crimes against humanity and emphasized that the perpetrators of disappearance had not been brought to justice.

During the transition to democracy in the 1980s, individual actions such as yelling insults at perpetrators in public and, in some instances, acts of physical aggression (mostly from family members of the disappeared or ex-detainees) also served as examples of *escraches*. GAC specifically looked to Fercho Czarny for performative direction on how to fight. In the 1980s, while Chile was still under military rule (1973–90), Czarny organized a group of friends and colleagues to throw paint at the Chilean embassy; the strategy of using paint as a weapon to leave a public stain of guilt was picked up in the *escraches*.[9] GAC co-opted this visually jarring, unsanctioned action by hurling red paint against the houses of military criminals to symbolize their bloodied hands. H.I.J.O.S. contrasted its exercise of freedom in the public realm with the repressive and prohibition-filled public space that existed under dictatorial rule. The disruption of the borders between private and public space echoed the home invasions conducted by military police during abduction operations under the dictatorship.

H.I.J.O.S. also looked to the public works of other human rights groups, including the Asociación Madres de Plaza de Mayo (formed in 1986), which held popular trials in Buenos Aires' Plaza de Mayo, where participants dictated punishments for the perpetrators.[10] Though H.I.J.O.S. embraced some earlier strategies, it vehemently rejected others. The depiction of the body of the disappeared became a significant point of divergence in pictorial strategy.

H.I.J.O.S. and GAC shared in the spirit of collective action that emerged from the open-air workshop space of the temporary, conceptual memorial dedicated to the disappeared, the *Siluetazo* (*Body Tracing*), which was initiated by artists Guillermo Kexel (b. 1955), Julio Flores (b. 1950), and Rodolfo Aguerreberry (1942–97) in conjunction with the Madres de Plaza de Mayo, the Abuelas de Plaza de Mayo (Grandmothers of the Plaza de Mayo), and the Frente por los Derechos Humanos (Front for Human Rights, FPDH) during the last months of military rule.[11] Despite a large military presence, on September 21, 1983, these artists and organizations, along with students and passersby, created thousands of human silhouettes and posted them all over the Plaza de Mayo and the streets, sidewalks, walls, monuments, and trees of Buenos Aires.[12] Hundreds of protestors painted silhouettes, using their own bodies as outlines. This was a dangerous activity because a meeting of more than five people was already reason to arouse the military's suspicion, and the fact that this urban intervention was produced without the dictatorship's spies uncovering the artists' plans provoked the military's ire.[13] Despite police repression, the production and dissemination of the silhouettes lasted until the middle of the night. The project's trajectory included creating a lasting trace of the disappeared. A member of Madres exclaimed, "They [the military] are also going to have to disappear the posters."[14]

Though the *Siluetazo* made for powerful public imagery, H.I.J.O.S. opposed it as a representation of the disappeared. Carlos Rice, a member of H.I.J.O.S. and the son of an ex-detained, disappeared prisoner, explained that children of the disappeared did not want their mothers and fathers represented as abstractions. He emphasized that the *Siluetazo* revealed nothing about individual lives or beliefs.[15] Instead, H.I.J.O.S. and GAC sought a distinct relationship between visual memorials of the disappeared and their connection to public space.

Their strategy drew on what geographer Derek H. Alderman calls the "scaling of public memory," which he defines as "the way an incident's recollection is prompted as people physically move through cities, regions, and nations."[16] H.I.J.O.S. and GAC scaled the memory of the dictatorship and the disappeared by inserting physical mnemonic triggers of Argentina's buried history throughout

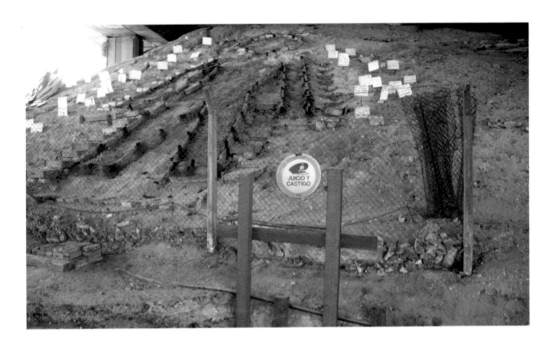

Grupo de Arte Callejero (GAC), *Carteles Viales* (*Street Signs*), 2009. Street sign marking an ex-clandestine detention center, Buenos Aires.

Buenos Aires. They mapped a cityscape of unpunished atrocities, reminding viewers/passersby that "you are here," walking amid torture centers and the homes of murderers. GAC, which emerged from a complex environment of strained tensions between memory and history, was already working through the city in this way. In 1998, the collective began installing its "Street Signs" in front of former clandestine detention centers to indicate their function under the dictatorship. This subversion of the road sign could easily be confused with official government-installed signage. GAC stated, "The road signs use institutional codes to denounce those that these same institutions tried to hide."[17] The collective's other public works included papering the walls of the city with maps indicating perpetrators' residences. They also stenciled the streets with phrases like "Justice and Punishment," creating unsanctioned art that brought to light the unlawful detention of the disappeared under the dictatorship. These counter-monuments made the space of the disappeared's captivity visible in the city. They urged pedestrians into a new awareness of urban space and encouraged people to understand their place in the city outside of their normal routines. Popular areas and spaces acquired a historical resonance and presence in an effort to come to terms with the past. The quotidian spaces that we occupy serve as places of remembrance, and GAC's memorial project emphasized the importance of place. Simply stated, the place where we remember matters.

In a victory for human rights, Argentina's Supreme Court overturned the amnesty laws in 2005, paving the way for prosecutions against the perpetrators of disappearance. Once the trials began in 2009, GAC and H.I.J.O.S. ceased performing *escraches* because their efforts had finally moved from the unsanctioned space of the street into the courts.[18] In 2012, Videla was sentenced to 50 years in prison. H.I.J.O.S. and GAC's call for justice and castigation was finally realized.

Before the prosecutions, the *escraches* emphasized the state's refusal to act; in lieu of institutional justice, H.I.J.O.S. and GAC "outed" the violators of human rights abuses through non-violent actions, thereby restricting their liberty and putting their lives on display as they walked freely among their neighbors. The collective participants chanted slogans such as "May the country be your prison" and "If there is no justice, there is *escrache*." The *escraches* brought public awareness and, in some cases, directly affected the lives of their targets. Several perpetrators lost their jobs after being publicly denounced through artistic actions. H.I.J.O.S. and GAC saw truth in Robert Musil's claim that there is nothing as invisible as a monument.[19] They therefore turned to ephemeral public performance art to make the invisible visible and to fight the injustices inflicted on the disappeared by targeting their torturers.

Notes

[1] Laurel Reuter, ed., *Los Desaparecidos = The Disappeared* (New York and Grand Forks: Charta; North Dakota Museum of Art, 2006).

[2] The Full Stop Law (1986) gave a final date for filing a suit against the military, and under the Due Obedience Law (1987), members of the armed services and police force could not be legally punished for their actions during the dictatorship if they were following orders.

[3] Etcétera, founded by Federico Zukerfeld (b. 1979), began working with H.I.J.O.S. in 1996.

[4] GAC was formed in 1997 and contacted H.I.J.O.S. in 1998 in order to add their creative voices to the human rights cause. GAC worked within the tradition of aesthetic memory actions undertaken by human rights groups in the 1970s and 1980s under the dictatorship and added its own form of commemorative protest to memorialize the disappeared.

[5] For more information, see H.I.J.O.S.'s Web site <www.hijoscapital.org.ar>. The *escrache* board is made up of the following groups: H.I.J.O.S., neighborhood organizations, Comisión Techo y Trabajo, Socialism Lebertario, GAC, Taller Popular de Serigrafía (Popular Graphics Workshop, TPS), Etcétera, Centro Social y Cultural Flores Sur, Colectivo de Ciencia Política, La Tribu, Intimo Teatroitinerante, Cooperativa Chilavert Artes Gráficas, and private individuals. The Asociación Madres de Plaza de Mayo (Association of the Mothers of the Plaza de Mayo) and the Madres de Plaza de Mayo-Línea Fundadora (Mothers of the Plaza de Mayo-Founding Line) were part of the first generation of human rights organizations that protested the dictatorship's forced disappearances; both groups supported the *escraches*, but rarely participated in them.

[6] Gail Holst-Warhaft, *The Cue for Passion: Grief and Its Political Uses* (Cambridge, Massachusetts: Harvard University Press, 2000), p. 6.

[7] Carlos Rice, interview with author, August 6, 2009. Murga bands, a popular form of musical performance from Argentina and Uruguay, were banned under the dictatorship, so their presence in public space and as a tool for retaliation against members of the military government holds a particular resonance.

[8] Diana Taylor, "'You Are Here': The DNA of Performance," *TDR* 46, no. 1 (2002): p. 151.

[9] See Ana Longoni, "Entrevista a Fercho Czarny: Un *Woodstock* de Protesta," in Ana Longoni and Gustavo A. Bruzzone, eds., *El Siluetazo* (Buenos Aires: Adriana Hidalgo Editora, 2008), p. 125.

[10] Ludmila da Silva Catela, *No Habrá Flores En La Tumba Del Pasado: La Experiencia De Reconstrucción Del Mundo De Los Familiares De Desaparecidos* (La Plata: Ediciones Al Margen, 2001), p. 266. The members of the Asociación Madres de Plaza de Mayo were originally part of the Madres de Plaza de Mayo, which was founded by mothers of disappeared children in 1977.

[11] The left-wing political group Intransegencia y Movilización (Intransigence and Mobilization), of which Aguerreberry was a member, also collaborated on the creation of the *Siluetazo*.

[12] "30,000 Figuras 'Evocativas,'" *Cronica*, Buenos Aires, September 22, 1983. For a full history and analysis of the *Siluetazo*, see Longoni, et al., *El Siluetazo*, op. cit.

[13] Julio Flores, in an interview with the author, 2009.

[14] "Finaliza La Marcha De La Resistencia Contra La Ley De Amnistía," *El Clarín* (Buenos Aires, September 22, 1983), sec. Politica.

[15] Rice, op. cit.

[16] Derek H. Alderman, "Street Names and the Scaling of Memory: The Politics of Commemorating Martin Luther King, Jr. Within the African American Community," *Area* 35.2 (2002): pp. 163–73. Paul Williams later borrowed the term in *Memorial Museums: The Global Rush to Commemorate Atrocities* (Oxford; New York: Berg, 2007), p. 79.

[17] Grupo de Arte Callejero, "Parque de la Memoria: polémica," *Ramona* 13 (June 2001): p. 44.

[18] Although H.I.J.O.S. and GAC no longer target the military, they continue to produce *escraches* in order to denounce current crimes against humanity.

[19] Robert Musil, "Denkmale," in *Gesammelte Werke* (Hamburg: Rowohlt, 1957), pp. 480–83.

São Paulo: Public Art as Lifejacket (2013)

by Marina Mantoan

At the international seminar "Public Art: Tradition and Translation" (1996), sponsored by the Serviço Social do Comércio São Paulo, American critic Michael Brenson, when asked to describe what intrigued him about Brazil, replied with an opposition between the Amazon and Brasilia: "The relationship between something prehistorical and something almost futuristic, that's the kind of collision that attracts me."[1] It wouldn't be wrong to complete his thought by saying that Brazil is both Amazon and Brasilia, an infinite diversity in the process of constant re-creation, extremes permeating each other and intermixing. Structures that appear to be contradictory co-exist in Brazil and tend to fuse into something unique.

It was from this perspective that Brazilian curator Cauê Alves approached contemporary Brazil with the exhibition "Quase Líquido" ("Almost Liquid," at Itau Cultural, 2010), comparing it to the polluted Tiete river that bisects the city of São Paulo: "A river that has a gelatinous consistency and in which organic matter accumulated on its bottom disrupts its flow. The river's current density may be a way of characterizing part of the contemporary world...A contradictory modernity, which is not entirely liquid, that doesn't engage and hardly is achieved."

"Almost Liquid" was part of a larger program devoted to questions of the environment and urban life, a recurring discussion in Brazilian public art. Invited

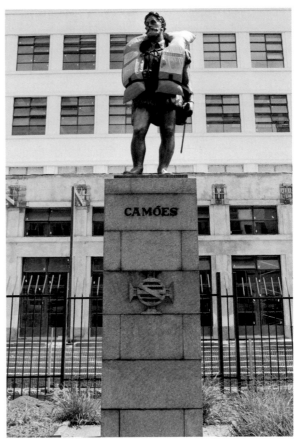

Eduardo Srur, *Sobrevivência* (*Survival*), 2008. Polyurethane foam, aluminum, reflective tape, polypropylene tape, acrylic, polystyrene, and steel cables, 25 altered public monuments in São Paulo.

artists Hector Zamora, Lúcia Koch, Ricardo Basbaum, and Rosângela Rennó presented works that went beyond the visual, not only demonstrating the slippery aspect of Brazilian sculpture, but also incorporating viewers inside the works.

Numerous public art initiatives fall into this quite particular Brazilian (de)context of a contradictory, "almost liquid" modernity.[2] Out on the streets, artworks end up permeating other sectors, including environment, education, health, and the economy (which despite improvements in recent years, still demand attention)—and having to negotiate with them. For instance, summer in most of Brazil is the period of highest rainfall, accompanied by flooding and landslides. Although not the only factor, this fact goes a long way toward explaining why, in 2008, a number of monuments in São Paulo began to wear lifejackets.

Eduardo Srur's *Sobrevivência (Survival)*, which altered monuments of so-called national heroes from the 20th century, was intended to "visually reactivate elements of history, architecture, and social life—territories abandoned by the urban imagination."[3] Having started his career as a painter, Srur develops urban interventions that promote direct dialogue with the general public, not a specialized art audience. The locations of his projects—squares, parks, and even the polluted Tiete river where he installed *Pets* for "Quase Líquido"—and their accessible aesthetic promote a discussion directed at questions of public interest such as heritage and environment.

The new clothing made it impossible not to notice these frequently unseen monuments. Even if their identity and historical significance remained obscure at first—for example, the *bandeirantes* Borba Gato and Anhanguera—they soon "started" to exist as "survivors" of the flood in present-day space-time.[4] Srur defined one of the project's goals as public provocation, luring people to take the

Denise Milan, *Cortejo de Vidas Preciosas (Parade of Precious Lives)*, 2010. Part of *Espetáculo da Terra (Spectacle of Earth)*. Independence Park, São Paulo.

Thiago Rocha Pitta, *Pintura com temporal 6,* 2010. Iron oxide paint, work will "rust" over its 2-year life span.

lifejackets off the sculptures and try them on themselves. The forgotten hero becomes a real hero once more, giving up a jacket in order to rescue someone else from the conditions of daily life. Srur's idea of spotlighting national heritage is not limited to symbolic reactivation with minimal critique, as he demonstrated in another project—*Âncora (Anchor),* an unauthorized initiative enacted at the Monumento às Bandeiras (Monument for the Bandeiras).

Built by Italian Modernist Victor Brecheret (1894–1955) and completed in 1953, the monument, which is located at the entrance to São Paulo's Ibirapuera Park, portrays the progress of Brazil through a *bandeirante* expedition. Srur added an anchor proportional to the great boat pulled by Indians, *caboclos,* and Portuguese. By interfering with the monument, Srur questioned a national mythology in which the *bandeirantes* are portrayed as heroes and builders of Brazil, as opposed to bloodthirsty marauders of Indian villages. The most curious response to this intervention occurred during the de-installation of the anchor. Police officers would not allow the removal of the added element, saying that it was public property. This behavior not only shows the rapid incorporation of the intervention into the collective imagination, it also demonstrates how much Brazil needs an approach to public art that reanimates, or at least rethinks, traditional assumptions.

Today, many Brazilian artists working in the public sphere follow this strategy, making temporary interventions that reanimate nearly dead spaces of the city and stimulate new ways of thinking. Appropriating already existing elements, their works inhabit these spaces for the time necessary to make them noticeable and not forgotten.

Since 2010, Denise Milan has been working with peripheral communities in São Paulo to develop a project called *Espetáculo da Terra (Spectacle of Earth).* With the support of the SESC São Paulo and collaboration from a team of art educators, the event's third edition in 2012 brought together more than 1,000 participants from six different peripheral communities. Milan is now considering extending the project to other countries, including the U.S., Denmark, and Italy. Her idea is to "form a crystalline network in the city of São Paulo," referring to her desire to offer new understanding through urban redesign. Her metaphor draws on the process of quartz formation, a fundamental element in her work.

Laura Vinci, *Clara-Clara*, 2012. Electrical wire and lamps, installed in the old center of São Paulo.

For this project, Milan adapted the process behind her stone sculptures and photo collages to the goals of art education. Workshops, educational materials, and a children's book called *A Pedra Azul* (*The Blue Stone*) laid the foundations for additional activities that, through artistic creation, raised themes such as sustainability and the environment within the impoverished communities of Heliopolis, Grajau, Osasco, Santana, Pinheiros, Interlagos, and Itaquera.[5]

At the end of these activities, which lasted several months, area children and adolescents gathered at Ipiranga Park to march on the Monumento da Independência (Monument of Independence) by Italian sculptor Ettore Ximenes (1855–1926). Milan said that the act suggested the reinvention of Brazilian history by making visible, at the site of a symbolic icon, lives that are often ignored and held at a distance due to political decisions. *Espetáculo da Terra* doesn't install any public artwork, but proposes that each child — seen by Milan as a formative atom within a quartz — creates ways of making him- or herself part of the crystalline structure that wraps up the world.

Showing some interest in Milan's achievements, the São Paulo Department of Culture launched, with an investment of $1.2 million ($200,000 maximum per project), the Arte na Cidade (Art in the City) contest, aiming to transform the understanding and meaning of public spaces through art. Out on the streets, projects were supposed to take freer forms. From the opening of the contest in 2010 to the installation in 2011–12, two years passed. Participating artists include Eduardo Coimbra, José Spaniol, Laura Vinci, Mauro Sergio Neri, Paulo Camillo Penna, and Thiago Rocha Pitta. The duration of each installation varies; some will remain on view through 2013 while some lasted only a few months.

Thiago Rocha Pitta, who was born in Minas Gerais and lives and works mostly in Rio de Janeiro, chose the Isnard building, on São Joao Avenue, for his *Pintura com temporal 6*. Resembling mountains or inverted clouds, this "atmospheric painting" consists of iron oxide paint applied to the building. Over the course of two years, rain, sunlight, and other elements will weather and transform colors and surfaces. Highlighting time and the mutable nature of things, Pitta creates a structural version of flux and quasi-liquefaction.

Laura Vinci's *Clara-Clara*, located in the old center of São Paulo, consists of a net made of electrical wire suspended high between buildings. Within its center, it holds illuminated street lights. The installa-

tion modifies the environment simply through light. It reveals its surroundings from new perspectives, literally casting a new light on objects and passersby. Vinci's installation starts with a ubiquitous piece of urban street furniture and transforms it from something taken for granted (unless it doesn't work) into an element noticed for its own sake.[6]

Other popular public art initiatives in recent years have attempted to reoccupy the streets through performances, shows, theater, and dance. The BaixoCentro (DownCenter) project, for example, promotes cultural events intending to revitalize and reoccupy central São Paulo, particularly the neighborhood around the Minhocao—an elevated highway used as a shelter by dozens of people. BaixoCentro's Web site describes the principles that guide the "festival." The initiative prizes urban appropriation through cultural development that's organized but, most of all, free and spontaneous. Despite a tendency toward idealism, the proposals made by artists, producers, and residents transcend the utopian in their capacity to encourage simple actions and to transform and produce positive results, leading people into the streets.

The first actions, between March 23 and April 1, 2012, followed the theme of "streets are for dancing" and offered a vast variety of events (the schedule is still available on-line), with musical shows, theater workshops, and various performances encouraging public participation.[7] Even artificial grass and a pool made an appearance within this center of concrete. On July 1, it was Festa Junina's turn.[8] The BaixoCentro is not connected to any institution or NGO, nor does it receive financial support from the government. It's maintained through raffles, auctions, and crowdfunding Web sites.

The majority of recent projects devoted to public space in Brazil share a common element—the desire to reclaim the city as a social place, where life can be lived. This simple desire is threatened by deterioration and the alienation of city dwellers. The emotional need to redefine and reoccupy urban space has become urgent: this manmade environment has assumed a level of unpredictability once associated only with the natural world. Brazil is neither the Amazon nor Brasilia; Brazil is the coexistent contradiction.

Notes

1 Flyer from "Public Art: Tradition and Translation," 1996.

2 Being aware of the rich and contradictory Brazils, I have focused this discussion on the city of São Paulo.

3 See Srur's Web site <eduardosrur.tumblr.com>.

4 The *bandeirantes* ("followers of the banner") were composed of Indians (slaves and allies), *caboclos* (descendents of Indians mixed with whites), and whites who were the captains of the *bandeiras*, expeditions that took place from the 16th to the 18th centuries. These expeditions were initially devoted to capturing Indians and forcing them into slavery; later they set out to find gold, silver, and diamond mines.

5 *A Pedra Azul* (São Paulo: Caramelo, 2011) uses the development of an amethyst to tell the story of life on earth, "a planet under mutation," just like its human occupants.

6 *Clara-Clara* was not Vinci's first intervention in the city. She also participated in the third edition of Arte Cidade (Art City), which was first held in 1994. Coordinated by Brazilian philosopher Nelson Brissac, Arte Cidade was intended to restructure deteriorated spaces in São Paulo through artistic and architectonic interventions. The project is an important touchstone for Brazilian public art.

7 See <www.baixocentro.org>.

8 Festa Junina (so called for being held in June) is a typical Brazilian celebration that pays homage to various saints, including John and Anthony, with traditional (corn-based) foods and dances such as *quadrilha*.

Beyond Utopias: A Conversation with Michelangelo Pistoletto (2013)

by Andrea Bellini

Michelangelo Pistoletto, an Italian artist and theorist, is typically associated with the Arte Povera movement. From the beginning, he has sought to break down barriers between art and everyday life, making viewers part of the work. In 1967, his studio became a meeting place for poets, actors, and film people. The heterogeneous Zoo group (1968–71) emerged out of these interactions. This "creative collaborative," according to Pistoletto, "was perhaps one of the first experiments in the passage from the object to an aesthetic of relation." In fact, the group shed new light on his classic mirror works, whose interaction with the viewer suddenly acquired a new participatory dimension. Cittadellarte—Fondazione Pistoletto was founded in 1998 as a concrete action of the Progetto Arte Manifesto in which Pistoletto proposed a new role for the artist: placing art in direct interaction with all of the areas of human activity that form society. The name "Cittadellarte" incorporates two meanings: that of the citadel—an area where art is protected and defended—and that of the city, which corresponds to the idea of openness and interrelational complexities with the world. Cittadellarte is a laboratory, a source of creative energy that generates unedited processes of development in diverse fields of culture, production, economics, and politics.

Andrea Bellini: *On June 25, 2012, you announced a "Rebirth-day," the first worldwide day of rebirth. Could you explain what this is all about?*

Michelangelo Pistoletto: In my book *The Third Paradise* (2010, distributed in the U.S. by Rizzoli), I said that when Bush and Blair, with the support of a number of other governments, declared "preventive" war on Iraq in 2003, people all around the world took to the streets to say, "That's enough!" It was a profound, desperate "No!" expressed at the planetary level, which I saw as a spontaneous democratic vote of global proportions. Every population on earth demonstrated that they were defenseless but united in their need to show their desire for decisive change.

Personally, I felt this was a call that could not be ignored—a commitment that I could not shirk. So, I decided to make *The Third Paradise* project public. I'd been thinking about it for a long time, and I realized that, even more than politics, economics, or religion, art could investigate the realm of the "possible" in order to bring out the power that was needed to change the course of history. I traced out a new infinity sign and made it the banner of this great change. With great resolve and conscientiousness, I made an emblematic drawing, adopting the fundamentally symbolic nature of art as its guarantee.

In the symbol, the first (natural) paradise and the second (artificial) paradise are separately identified in two opposing circles, while the convergence and unity of the two appear in the central circle. The humanity of *The Third Paradise* emerges from this alliance. This humanity is capable of making

nature and artifice coexist, just like any conflicting forces, to create an energy that can lead to a new era in our history.

The message was launched in 2003. At Cittadellarte in 2012, I announced Rebirth-day, December 21, 2012, the First Universal Rebirth Day. That particular day is the subject of fantastical legends of *finis mundi*, the end of the world, and it is certainly burdened by an irreversible crisis of the system. It's the prelude to a global rebirth that extends out from art to all areas of life.

All those taking part in the Rebirth Festival certify their entry into the Third Paradise. And, of course, they become an active part of it. The announcement of this celebration, which has ancient roots (the winter solstice in the northern hemisphere, the summer solstice in the south), invites us all to come together to create a global work. This Rebirth is not an event confined to a single day of celebration, for it extends out in time, offering an extraordinary opportunity to forge our own common destiny in the future, all together, with joy and enthusiasm.

AB: *A secular project,* The Third Paradise *expresses a positive and optimistic civic message that is revolutionary, too: it's an idea for a radical transformation of the world, or at least of how our species interacts with it.*

MP: The term "paradise" comes from the ancient Persian term for "enclosed garden." The way that the idea has been used by the monotheistic religions goes beyond the terrestrial meaning of the term, taking it beyond life, except in the case of the "first paradise," which biblical scriptures already used to describe the earth. The "second paradise," which follows the symbolic bite into the apple, is branded by original sin. In my interpretation, this could be understood as the origin of the artificial

"Art at the Centre of a Responsible Transformation of Society. Turning Point Architecture," 2008. Cittadellarte— Fondazione Pistoletto, Biella.

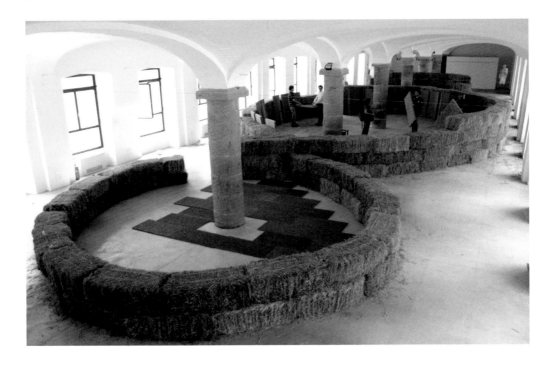

life that has led humans to cause today's devastation of nature. This ancestral pre-vision is pertinent today.

A comprehensive transformation of normal life is needed right now because the surge in artificial progress has lifted mankind so far off the ground that we are at the point where a fall is inevitable. The crisis sweeping through the world shows that this fall has begun and must be stopped at all costs. *The Third Paradise* is not the result of personal reveries, but an acknowledgement of real facts. It's a positive response to a request—a "commission," one would say in art terms—from the entire world.

AB: *Bearing in mind the complexities of the contemporary world, don't you think that this project runs the risk of being branded as yet another belated 1960s-style utopian dream? In other words, might it be considered as a poetic gesture and nothing more?*

MP: I lived through the 1960s, and I can tell you that they were very different from 2012. Even so, yesterday's intuitions helped us to foresee today's reality. In my work, I've developed a path based on these intuitions. When I publicly presented Progetto Arte in the early 1990s, people said that though the ideas were great, it was pure utopia. I used to respond that "utopia" means "non-place," but there already was "a place," called Cittadellarte, and so we were already moving beyond the utopian stage. Nobody uses this word any more when talking about Cittadellarte, which is less and less isolated in its development of initiatives designed to achieve a responsible transformation of society.

My work has a phenomenological basis, but this does not exclude the imaginative and poetic side, which can never be excluded from art. Certain past dreams and poetic actions already contained visions that have acquired great significance today, acting on the history of art as milestones of an expressive sensitivity that addresses social issues. The risk of artists being misunderstood and hindered in their search for an ethical, as well as aesthetic, transformation of society is rapidly declining because the crisis is now affecting every area of our lives, from practical aspects to moral issues, and now society itself is turning to art for help.

Opposition forces shouldn't be underestimated, though, and we need to remember that we're living in an age of massive cultural, economic, and political imbalance. We're still far from a transition toward a "real," universally applicable democracy that's capable of keeping in check the aberrations into which much of human society is being dragged. Even so, I think that art can come up with excellent prospects for the development and refinement of democracy in the world.

AB: *How did* The Third Paradise *come about, and how does it relate to your previous work?*

MP: This project has gradually taken shape over the course of my artistic development, starting with my first mirror paintings of 1961–62. These were already unlimited-liability works, because images of the individual and of every other person or thing around entered the painting-mirror. The next task was to transpose the participation of the virtual world of the mirror to the actual physical reality of the life that lay in front of the mirror. *The Third Paradise* is a clear consequence of that process.

AB: *Cittadellarte is like a model, a sort of operational arm, of this project of yours to transform the world. Is that right?*

MP: Yes, that's absolutely right, I couldn't put it better myself.

AB: *Tell me briefly how it's organized. How does Cittadellarte work?*

MP: Cittadellarte isn't a gallery, nor is it a museum or personal studio. It's one big laboratory, a generator of creative energy that develops processes of responsible transformation in various areas of society. Cittadellarte is structured organically, with a cellular system. It consists of a primary nucleus,

Il ragno tessitore del Terzo Paradiso, 2009. "Cittadellarte Fashion—Bio Ethical Sustainable Trend."

which is then divided into sub-units. These units are known as *uffizi*. Each "office" runs its own activities for a particular area of the social system. The EducationOffice, EcologyOffice, EconomicsOffice, PoliticsOffice, SpiritualityOffice, ProductionOffice, WorkOffice, CommunicationOffice, Architecture-Office, FashionOffice, and FoodOffice are currently up and running. The ArtOffice is the common denominator of all these activities.

AB: *In your opinion, what can art add to the more strictly political debate over the destiny of the world? How can it help imagine a better future for all of us?*

MP: A broad-based, artistic substratum is being created, overcoming the standard representation of financial and economic/consumerist power, extending out to form the intellectual lifeblood required for regenerating our common civic life. The avant-garde trends that were so much a part of the 20th century are being surpassed, and there is also a move away from protest art infused with the glamour of the media system. As well as nourishing this lifeblood, Cittadellarte is committed to illustrating its significance and giving it an active role in the practical process of transforming politics, in the Greek sense of the polis.

The real potential for cultural and political transformation is to be found where artists manage to combine the greatest creative freedom with a high degree of responsibility toward the world. This is Rebirth-day, when artists can extend creative inspiration, individual awareness, and collective commitment beyond the defenses that protect the garden of art, to help create a new garden of human society.

AB: *How should today's dramatic economic crisis be tackled? How are you funding Cittadellarte — Fondazione Pistoletto now that the political classes have drastically slashed funds for culture in Italy?*

(Foreground) *Love Difference — Mediterranean Tables*, 2003–05; (background) *Woollen — The Reinstated Apple*, 2007.

MP: Cittadellarte has become a place that extends far beyond its local area. Ironically, we could say that it's already a part of both history and geography. Through UNIDEE — the University of Ideas — the DNA of Cittadellarte has now entered the very fabric of civic life. And I'm not saying this out of presumption — it's a fact.

I am sure that this institution will continue to receive support as long as it is considered necessary by a part of society. This all depends on how well individuals and private and public institutions are able to draw resources from the cultural and social capital made available by Cittadellarte. This place owes its origins to the willpower of the artist, and it extends out into that of others. The Renaissance propounded the Ideal City — today Cittadellarte, which means both the city and the citadel of art, has been established. It is an enclosed place where art is protected and defended, but also an open place that reaches out to the complexities of the world. In practical terms, the assets of the foundation that administers Cittadellarte consist of my works, but this isn't enough for the size and number of tasks that are being undertaken. Public support is very limited, so the economy of Cittadellarte is parceled out to different projects devoted to sustainability in various areas of society, including cooperation in various branches of production.

The Prophet's Prosthesis: A Conversation with Krzysztof Wodiczko (1999)

by Christiane Paul

Krzysztof Wodiczko is best known for his large-scale projections on public buildings, monuments, and corporate headquarters. From Australia and Austria to Switzerland and the U.S., he has used these highly visible (and sometimes unauthorized) spectacles to bring issues of conflict, oppression, and communication into the public sphere. Born in Warsaw, where he graduated from the Academy of Fine Arts in 1968, Wodiczko immigrated to Canada in 1977 and now lives in the U.S. The former director of the Interrogative Design Group at MIT's Center for Advanced Visual Studies, he is currently Professor in Residence of Art, Design and the Public Domain at the Harvard Graduate School of Design. He received the 1999 Hiroshima Art Prize for his achievements in contemporary art and his contribution to world peace.

"Nomadic instruments," as Wodiczko calls them — including vehicles for veterans and the homeless — complement the goals of the projections, combining art and technology to empower marginal communities and critique social injustice. The "speech act equipment" works in his "Xenology series" consist of portable communication devices designed for those who don't have public voices or who have been silenced. *Alien Staff*, *Porte-parole*, and *Ægis*, for instance, combine high-tech innovation and traditional storytelling to ease alienation and displacement. *Alien Staff*, a walking stick equipped with a monitor and small loudspeaker, pairs pre-recorded personal narratives with "relics" relating to the operator's history. *Porte-parole*, with loudspeakers and a small video monitor that covers the mouth, replaces the "real" act of speech with pre-recorded and edited statements and stories. *Ægis* consists of two wing-like screens enclosed in a backpack that unfold in response to designated cues and display a pre-recorded video showing the different "faces" of the wearer, speaking and arguing in response.

Wodiczko's recent projects, beginning with a public audio visual airing of domestic abuse that sent shockwaves through Krakow and an indictment of Tijuana's *maquiladora* industry for "inSite 2000–01," merge the personal testimonials of the equipment works with the scope and affective power of the projections. Whether intimate or grand in scale, these hybrids of the personal and the public maintain their commitment to resistance and truth-telling, actively attempting to forge ethical, cultural, and political change.

Christiane Paul: Alien Staff *and* Porte-parole *continue your focus on the alien, the immigrant, the stranger. In the age of the "global village," did you consider the effects of global communications, or did you concentrate on the experience of being an alien or stranger?*

Krysztof Wodiczko: There appear to be two disconnected worlds, the explosion of communications technologies and the explosion of cultural miscommunication. There are technology enthusiasts who

City Hall Tower Projection, 1998. Public video projection at the City Hall Tower, Krakow, Poland.

advocate the liberation of the world through digital technologies, and there are crisis zones, such as Yugoslavia, where people need these technologies, especially in the most difficult moments of the crisis. Instead, people were sending blankets. People have to learn how to open up and communicate before they become manipulated by psychologists/ideologists and politicians and are molded into opposing camps to kill each other. The equipment was needed before the conflict exploded.

Alien Staff was my response to rising xenophobia in France, and Europe in general, in 1991–92: Le Pen in France, the xenophobes in Belgium, and the hostile feelings toward foreigners in Germany and Italy. My response to this climate was informed by my earlier projects—a mobile communications network and vehicles designed for the homeless in New York. Unlike the previous homeless vehicles, the new ones were equipped with a vast array of communications tools. There's a relatively large group among the homeless population with background, education, and experience in media. I was hoping that they could provide an alternative image of the city from the point of view of the wounded.

The idea was that they would create programs that could be heard and seen: programs necessary for their own survival, for resistance, for communication, necessary for self-protection against the police and hostile groups; but also cultural programs that facilitated an exchange among various alienated groups. The project strives to establish a complicated constituency, based on the recognition of its unstable character and all the antagonisms involved. The next step could be that the homeless would form constituencies and have representation in city councils, for example. The most important parts of the project were the alarm system, the use of the Internet and telephone system, as well as walkie-talkies or beepers, and sometimes satellites, Xerox machines, and CB radios.

CP: *While devices such as* Alien Staff *and* Porte-parole *bridge psychological gaps and offer new possibilities of communication, the communication is ready-made. Is it a problem that the operator has a possibility to speak out but probably can't communicate what he or she wants to say because the speech is pre-recorded?*

KW: My experiences in New York helped me to design *Alien Staff*, which will become more performance-oriented in the future. I abandoned the idea of heavy-duty equipment in favor of something very simple that can be operated and used by a single person and that facilitates the development of virtuosity, performance, and storytelling. At that point, the process of alienation becomes interesting because whatever is pre-recorded can be questioned in direct communication. I'm working on another project directed toward other groups, because there is no single category of "stranger" or "homeless person." There are so many different kinds of people with diverse beliefs, abilities, psychological conditions, and histories that contribute to their way of living — no single piece of equipment can respond to this. The walking stick was designed for people who are somewhere between speechless-

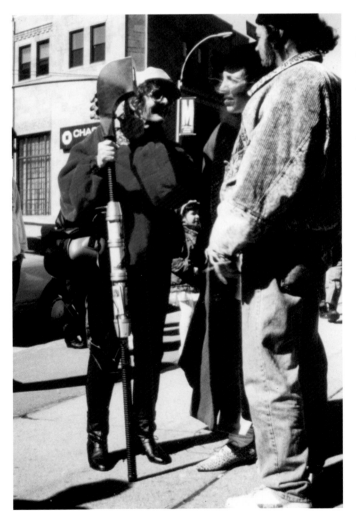

ness and virtuosity of communication. They know languages and gestures, but they need an artifice to fully realize their abilities, because they are afraid to do so otherwise. They have important things to say, but they never really try to say them because they can't find words. The process of de-alienation needed here has something to do with the preparation that has to be done before the equipment can be used in public — the gathering of memories, the recalling of events that might have been repressed or maybe expelled or replaced by half-truths and intermediate stories. *Alien Staff* users have to examine all of these aspects in the process of recording in front of the video camera.

Ideally, the strangers who go through this process are armed with a new confidence and distance from their misery.

Alien Staff (Xenobàcul), 1993. Operator: Jagoda Przybylak (New York).

The operators have created doubles of themselves that contain the things that no one wants to hear and that couldn't be expressed before, so they are relieved of an incredible load. Once it is externalized, the operator is ready to open up to others, in any place. Suddenly, the operator becomes a mediator between the speaking stick and anybody who will approach, not necessarily in order to speak to the operator but in order to listen to and investigate the object.

CP: *This process entails another alienation.*

KW: The new alienation is needed. The performer must also become alienated from the staff—alien of the alien, a kind of double alienation: "Don't listen to this, it wasn't really like this, I now realize it was different." Or someone might ask about the contents of the Plexiglas containers in the central part of the staff, and the operator might just reply, "It's none of your business." There is a connection between the relics and what was videotaped. The process of finding the object to be exhibited in the staff is a process of exploring things that are hidden. Exhibited, these relics are exposed and brought to light. Sometimes it takes a long time to find the relics because they are so precious. Immigrants bury them or leave them with friends. There is a process of construction at work here, a recollection of events and a reconstruction of ties with the past from a new, healthier point of view that transcends shame or disappointment. Immigrants who use the staff are often resentful at first—it forces them to reveal awful secrets—but by going through the process step by step, they sometimes realize a new awareness.

CP: *You've made some changes in the new generation of* Alien Staff. *Are the objects in the containers now more closely connected to their respective histories?*

KW: In the new version, the containers can be taken out for closer examination and discussion; in the old version, people had to bend down to look at the relics. Now, there are electric sensors between the containers, so that when a hand approaches, it triggers a response. This kind of interactivity requires a fairly complex computer program because a certain type of gesture has to be assigned to a certain type of manipulation of the story's content, both acoustic and visual.

There is a tradition of migrants, wanderers, gypsies, aliens, and even magicians whose survival depended on their talent in using gestures and performance. The performative aspect often guarantees survival, without it, they might die. Some storytellers might want to have a more performative instrument, so this new version allows for a story to evolve according to the choice of container, which requires a complicated development process. You have to select and organize the content, connect an object with a particular story, and decide on the relationship between the gesture, the sound, and the visual effect shown on the monitor. It requires different levels of development, as well as technological literacy. This has something to do with a larger dilemma: How can artists develop an experimental project in tune with a scientific and technological experiment? The agendas overlap, but they often don't match.

I learned a lot from the most recent model, which comes with a built-in transmission system and an antenna, a symbol of hope for the possibility that singular units might speak with each other across the city and maybe the world, that each operator could communicate with a base that could store an enormous amount of information. The user of the instrument would be a performer disseminating information, opening up a world of displacement and complexity, and undoing preconceived notions of identity and community.

CP: *Agendas—political, psychological, and ethical—constantly overlap in your works. Do you see them predominantly as artworks? To what extent would you like to see them integrated into the non-artistic, socioeconomic world? Would you want* Alien Staff *to be mass-produced?*

The Mouthpiece (Porte-parole), 1993. Operators: Boubacar Diallo and Vu-Thi-Hau (Helsinki).

KW: Public art should be understood as a possibility for financing all kinds of projects, including media projects. Of course, these media projects are often "temporary," but that could mean years. *Alien Staff*, for example, has been operating off and on for years in various parts of the world. A project like this could be more systematically developed, maybe in cooperation with institutes such as the Institute for Psychology and Crosscultural Communication in Stockholm or the Centre Françoise Minkowsky in Paris, which provides assistance to immigrants and refugees. Support could also be provided by a public art organization, like Public Art Fund in New York or Artangel in London. It could be a combination of all these institutions. I don't see why this approach should be unrealistic. Not all of the funding institutions and audiences completely understand what I'm doing. The French Ministry of Culture, which helped to develop and pay for the *Alien Staff* and *Porte-parole* prototypes, understood maybe half of it. At the V2 organization in Rotterdam, two or three of the instruments were used for four or five days, and there were about two weeks of preparation. The director of a clinic for immigrants in Rotterdam, who is an immigrant herself, evaluated the project and said that I had done in two weeks something they couldn't achieve in a year, because I had turned the immigrants into "both doctors and patients."

I was invited to explain the project on a television talk show, which makes a lot of sense since I think that the mainstream media should become an extension of my "small" media. I had asked the operators to come with their equipment, so you had both the speakers and their small screens and the show's host on the television screen. Because of a number of coincidences—festivals, events, problems with immigrants and skinheads—it made national news, and everything connected.

Homeless Vehicle, 1988–89. View of work in New York.

Without this little piece of equipment, none of this would have happened. Mass media picked it up because it was already media.

CP: *Technology is the enabling factor rather than the focus of your communication devices. These tools address a specific need while exploring the very nature of communications technology. How would you describe the role of technology in your work?*

KW: We assume that design should offer solutions to problems, but modern design often becomes a façade that hides the problem and offers only a superficial answer. There is a similar expectation with technology: each new gadget, each new system, is supposed to resolve some problem and improve the existing world. But technology and design can reveal and clarify needs that should not exist. Technology, new media, and design could articulate and expose the problematic world in which we live and, at the same time, provide emergency service and help to people who really need it. With media and technology, we can do cultural work and provide access to the circulation of power for those who are least likely to have it. This way, we provide emergency assistance and transform awareness of the world at the same time. The marginalized, displaced, and misfortunate could become agents of this new and prophetic way of understanding the world. There are a lot of things we could achieve by undertaking technological design and artistic research in the same place at the same time. Of course, I don't want to advocate a monstrous new institution that will bury all of these possibilities in bureaucratic machinery.

CP: *The realms that you mentioned won't be able to survive by themselves, an interdisciplinary approach is needed more than ever.*

KW: And not in the name of the arts, but in the name of life.

Building New Topias: A Conversation with Pedro Reyes (2009)

by Carolee Thea

The methods employed by an artist in producing a body of work are often made up of intricate and personal associations that may confound the way a viewer assimilates knowledge. Pedro Reyes, architect, cultural agent, and artist, employs simple means: objects and casual scenarios that blend the realms of utopia, psychology, function, individual fantasies, and collective aspirations. His works take the form of meaningful participatory events and social renewals, a strategy that aligns them with the theories of Nicolas Bourriaud. For Bourriaud, "the role of artworks is no longer to form imaginary and utopian realities, but to actually be ways of living and to produce models of action within the existing reality, whatever the scale." Reyes's work is conceptually based and visually unpredictable. His project *Palas por Pistolas*, presented at a talk at the Storefront for Architecture in New York City in October 2007, inspired this interview.

Carolee Thea: *How did* Palas por Pistolas *come about?*

Pedro Reyes: I was invited to do *Palas por Pistolas* for the botanical garden in Culiacán, a city in western Mexico with the highest number of gun deaths in the country. The gardens are beautiful and bucolic, considered the best collection of tropical plants in the Americas, but outside the walls, violence prevails. My project tried to bridge the two worlds. My initial step was to organize a campaign in cooperation with the city government—collecting weapons and melting the metal into shovels that would later be used to plant trees in the city and beyond. It's like a transmutation of metal motivated by the social design embedded in the process of removing the weapons from circulation—like agents of death turned into agents of life. I want to believe that by taking 1,500 arms out of circulation we might save a few lives, but the real purpose of the piece is to add a story to the world, so that in other cities they will say, "In Culiacán, they did that."

CT: *Who instigated the project?*

PR: I was invited by the curator Patrick Charpenel and the patron of the botanical garden, Agustin Coppel, a visionary philanthropist. I quickly understood that Culiacán is like a gun-slinging town in an American Western. In my research, I spoke with many people who knew of someone, in their own family or another one, who had been shot. My ensuing deliberations connected the guns and the garden to produce a social metamorphosis.

CT: *Instead of a traditional approach to making sculpture for a specific site, you negotiated several environments, seizing the opportunity to collaborate with an institution to transform its surroundings. This is a very different approach than that used by artists in the '60s and '70s, when enlisting the help of institutions was not desirable.*

PR: The point you make is very interesting. Often the idea of resisting the institution is a bit like

Still from *Palas por Pistolas* (video), 2008.

renouncing your responsibility, because the people working within the institutions may want to dialogue, and furthermore, they may be willing to be called into the project. For me, the idea of going against the institution is childish.

CT: *Back then, we were idealistic—foolhardy, maybe—but it was, after all, the times.*

PR: I'm not necessarily against it—voices of dissent are always necessary. There will never be enough dissent, because it helps to increase the critical mass that leads to change. On the other hand, I think that there are few initiatives in which you're willing to do the slow work of trying to change things from the inside.

CT: *What was the apparatus in the community that made* Palas por Pistolas *possible?*

PR: In this case, the project involved working with state authorities, with private companies, and with the military. Some of the private money came from Enrique Coppel Luken, the chairman and chief executive officer of Coppel, S.A., a retail chain of 210 department stores in 125 Mexican cities. He also serves on the board of the economic development council for the Mexican state of Sinaloa. Civilians who gave up weapons received a store coupon in exchange. If you gave up a high-powered weapon, you received a more significant reward, a computer, for example.

CT: *Was this exchange the axiom that you presented to your funders?*

PR: Yes. It was very well received because they're committed to improving the quality of life in their city. For the gun owners, the incentive was economic, activating a mechanism within their family where a wife or mother would say something like, "We need a new fridge, so why don't we give up that weapon stashed in the closet?" But the operation had to be carried out by qualified people, in this case, the military, because only they can handle the weapons.

Above: Still from *Palas por Pistolas* (video), 2008. Left: *Palas por Pistolas*, 2007. Wood and cast metal from recovered guns, 48 x 12 x 5 in.

CT: *It's a kind of spiritual barter, a collectively solved, complete equation.*

PR: Yes. The number of destroyed weapons is equivalent to the number of shovels that were made and to the number of trees being planted — involving 1,527 people willing to plant one tree each. It ends up as a very collaborative project. The piece will be complete only when we finish the process of the plantings. I liked having this kind of holistic approach to solve a social problem.

CT: *Félix Guattari talks about "art not purely as an agency for communication but as a catalyst for change with the potential for collective and social reinvention."*

PR: I agree. *Palas por Pistolas* has a real degree of effectiveness beyond purely aesthetic terms: by destroying 1,500 weapons you save lives — by planting 1,500 trees you do something for the environment. However, I don't think that all art has to be held accountable for improving the world. It is quite the opposite — it is the space where you induce reflexivity. For instance, in *Leverage*, a see-saw is a symbol, with social, political, and economic connotations, illustrating an asymmetrical relationship in which one player is equal in power to a group of nine, but there are a number of possible interpretations. When I first did

that piece, I was thinking of oppressor against the oppressed. It's really diagrammatic of the inequities or hierarchies present in all human organizations.

CT: *Do you see a problem or a solution?*

PR: If you see a problem, you are telling yourself, "This is wrong, someone is to blame, someone should fix it." If you see solutions, you're saying to yourself, "This problem may be an opportunity. How can I fix it? How can I help?" The fundamental factor is that, in the second scenario, you are posing a question. As long as you're busy answering the question, you become responsible for it, your mind is active. The "problem mode" is the lazy way—you reach an end point by making a judgment, and you set yourself outside the situation.

Going back to the concept of leverage, I started thinking that it was the single player who was taking advantage of the group. What he is really doing is propelling the group upwards and vice versa. Finally, I associated this with the notion of agency: to induce change, you need to work collectively.

CT: *It's a way of seeing an action differently, and so, the see-saw became a catalyst for an impromptu (non-scripted) happening.*

PR: Yes, this idea is not a representation, but a physical interplay experienced physically. When you enter the exhibition space, you need to induce another nine (or more) people to work with you on the see-saw, and surprisingly it happens—it's an example of a spontaneous activity.

CT: Capula XVI (obolo a) *and* Capula XVII (obolo b), *giant basket-like structures, and* Evolving City, *an adjustable wall mural, were executed for the Seattle Art Museum's Olympic Sculpture Park. The "Capula" series, which has examples installed around the world, is consistent with your desire to include communities. The sculptures, which translate Mexican basketry traditions into an architectural scale, employ local craftspeople in their manufacture.*

PR: The mural, which will be moved to the museum's downtown venue, is composed of 300 separate pieces—all independent silhouettes depicting buildings, events, and characters. The exciting part is that the museum has invited a team of local architects to rearrange the 300 pieces in a new way. I don't have any input into the new installation. And I have no idea what it's going to look like.

CT: *In creating new geometric forms that respond to changing visual systems, your architectural background often comes into play.*

PR: I definitely nurture myself from architecture. I want to make actual buildings that do not exist in the world. With the "Capula" works, I wanted to make something round, translucent, and movable— an environment that you enter and that constructs an experience that changes your psycho-dynamic. The weavers who worked on the sculptures were excited and encouraged by the idea of making something that didn't exist in the world yet.

CT: *An early example of your projects inspired by architecture,* La Torre de los Vientos, *was also a catalyst for change in your hometown of Mexico City. You've said that the structure "looks like a bunker, a cenotaph, a missile silo, a chimney, a granary, a lighthouse, an oven, a mosque, an observatory, a water tank, a ziggurat."*

PR: This abandoned tower was originally constructed in 1968; it sat squarely in the middle of the highway for 25 years. I lived south of the city and would see its conical structure all the time. However, it wasn't until I broke the lock that I saw what an extraordinary and dramatic space it was. From 1996 to 2002, I took it over, and it became my studio. With the tower serving as an art laboratory, I invited artists to submit proposals that subsequently arose autonomously. The projects fed off this futuristic/ ancient entity, giving forth artistic processes never imagined before or even after.

Leverage, 2006. Mixed media, installation view.

The tower's significance can also be measured by the fact that it cultivated works whose primary audience consisted of immediate friends/artists, which was a departure from the previous generation. The activities also inspired those artists who were running independent spaces. Since many of the works happened outside, on the street, it was a move against the white cube. Public spaces in Mexico are not controlled, so even if you disturb someone, it is not a problem as it might be in the U.S.

CT: *In this sense, your project of creating new worlds, new habitable spaces apart from ordinary ones, is very much related to utopian architecture and avant-garde constructions.*

PR: I think that we need other topias to play with. We should talk about psychotopia, a mental place; neotopia, a new place; prototopia, almost a place; ecotopia, a sustainable place; hypnotopia, the place of our dreams; teotopia, a sacred place; and infratopia, less than a place.

Chicago: Burn the Pedestal (2012)

by Jason Foumberg

There was a time when all of Chicago's important contributions to sculpture could be plotted on a tourist's street map. These totems of high art—by Picasso, Miró, and Calder—still adorn the city's plazas like cemetery statuary, but their idea of civic myth fails to iterate current self-identities. Even works that passed for vital populism just a decade ago—by Dan Peterman, Anish Kapoor, and Jaume Plensa—may succeed at getting people to assemble, but what exactly should be bringing them together? While Chicago officials are revamping a 25-year-old Cultural Plan, which has been on the table for many months, artists are envisioning their own place-making strategies. Recently we've seen entire houses, skyscrapers, and streetscapes transformed into eloquent expressions of community.

Today, sculpture wedges into the gap between the common and the creative. Its materials are everything that grows and dies here—families and workers, urban byproducts and discards. The project *Temporary Allegiance* initiated a turn toward the activation of new, creative rituals. A 25-foot-

Jessica Stockholder, *Color Jam*, 2012. Vinyl, work at the corner of State and Adams Streets, Chicago.

Theaster Gates, *Dorchester Projects*, 2010. Transformation of an abandoned property into a library and archive.

high flagpole sited near the Eisenhower Expressway and the UIC Halsted blue line stop is available to any Chicagoan who wants to erect a personal, hand-made flag for one week. The ongoing project is coordinated by artist and curator Philip von Zweck and UIC's Gallery 400. Since 2005, more than 200 flags have flown.

Temporary Allegiance triumphs because it honors a simple premise: free access for all. But that ideal is a contested one. When, in 2008, the city fenced its highway underpasses to bar the homeless from their provisional shelters during the subzero winter, Mike Bancroft drew attention to the vicious eviction with piñatas. Bancroft runs Co-op Image, an extracurricular arts program for students with limited resources. Together, they built 200 piñatas and dropped them behind the chain-link enclosures, where they remained safe from beating.

Focusing on hyper-local communities is important for contemporary artists in Chicago, and many become sculptors by default in their handling of the city's resources. (Some term this tactic "post-material," but it is actually a re-evaluation of the readymade as an instrument of ethics). Throughout the summer of 2012, Jessica Stockholder's *Color Jam* partially covered the streets and buildings of a downtown shopping corridor with brightly colored vinyl wrap for the largest public work ever installed in Chicago. The real artwork, however, only revealed itself when the colored vinyl framed beggars and strangers like actors on a stage—they became impossible to ignore—while the city's gray grit crusted up like an Expressionist painting.

More directly, Theaster Gates pinpoints impoverished neighborhoods on Chicago's South Side and rehabilitates their derelict buildings. He has said, "Activism, like art, may just be the byproduct of doing what you believe in." Following Dan Peterman's creative re-use methods, and with a background in urban planning, Gates first turned a house in the Grand Crossing neighborhood into a community center and archive and shipped another piecemeal this past summer to Kassel, Germany, in exchange for one of their ruins, to be rehabbed here.

One of Gates's lessons is to build neighborhood strongholds, and many projects already do. Often, it begins in the home. Artists, collectors, and curators run cottage exhibition industries from domestic properties on the city's peripheries. These venues encourage creative architectural adaptations and

artists who favor experiential exhibition formats. Current leaders of this practice include The Franklin, in Humboldt Park; Slow, in Pilsen; the "Home Knowledge Spectacular," co-curated by Alberto Aguilar and Jorge Lucero, at North Branch Projects; New Capital, in Garfield Park; Iceberg Projects, in Rogers Park; 6018 North, in Edgewater; Terrain, in Oak Park; and the recently shuttered Southside Hub of Production.

In 1900, engineers reversed the flow of the Chicago River, and the city grew up and hardened into divisions. Now the city sprawls, providing fertile ground for questioning the fortresses of regionalism. On the South Side, the DuSable Museum celebrates the city's black culture. To counter the displacement of important local histories, Jeremiah Hulsebos-Spofford and Faheem Majeed are proposing to float a replica of the museum and its exhibits, constructed of scavenged materials, up the river and to dock it downtown. Given Spofford's recently staged "immigrant landings" — makeshift vessels landing on the Gold Coast from Lake Michigan — the radical new proposal seems feasible and poignant.

A similar redistribution of material histories lies at the heart of "Two Histories of the World," a two-part exhibition whose curator, Kartsen Lund, enlisted four artists to create ready-made, site-specific sculptures from the detritus of freshly dead industries housed in a cavernous and derelict warehouse. Later the sculptures were reassembled at the Hyde Park Art Center as critiques of social use-value. The surplus of material fallout from the Midwest's post-industrial and post-agrarian economies is ripe for appropriation. Barn wood has been transformed into immersive spectacles by Laurie Palmer for threewalls gallery and by Juan Angel Chávez for the New Harmony Gallery of Contemporary Art. Chávez used fire to symbolically regenerate his barn wood, as did Daniel Shea,

Jeremiah Hulsebos-Spofford, *Give me a place to stand and I will move the world*, 2011. Students from ChiArts staging an immigrant landing in Gary, IN.

Mara Baker, *Untitled*, 2011. From "Two Histories of the World," William H. Cooper Manufacturing, Chicago.

who collected oral histories and lumber ruins from the downstate Illinois rustbelt. Shea presents the chars in tidy piles, retouched with black spray paint to seal the myth of rebirth.

Many of these projects use an underlying strategy of destabilizing the conditions that produce exclusivity while circulating alternatives. Rubble and debris are conveniently narrative-rich materials, but not all artists are scrap-pickers, and the objects need not be ephemeral. threewalls gallery has co-opted community-shared agriculture subscriptions to distribute mini-collections of specially commissioned multiples, thereby broadening the art community. Tom Burtonwood embraces 3D scanning and printing technology to manufacture uncomfortable objects, as does Mariano Chavez, who uses plastic-casting techniques. Even the city's former giant of industry, the Inland Steel Company, has opened its downtown lobby for temporary sculpture exhibitions, the antiseptic Modernist structure incubating fledgling forms.

In June 2012, comedian Conan O'Brien had some fun at the expense of Chicago's beloved art clichés. After attaching wheels to decoys of the Picasso sculpture, Kapoor's "Bean," and a fiberglass cow, he shot them over the partially opened State Street drawbridge to see if they would survive. (The Bean and the cow made it over, scathed; the Picasso crashed into the Chicago River). The iconoclastic act was met by approving cheers from the audience.

Three-Headed, Nine-Legged Publicness:
A Conversation with Pope.L (2013)

by Lisa Dorin

Pope.L is a maker of texts, paintings, objects, fictions, and situations, but he is best known for the provocative urban interventions and performances that he has been staging since the 1970s. Over the last decade, his heightened institutional recognition—coinciding with a tendency across the museum field for espousing performative and public-based practices—has fostered ever more fluid shifts in his work. While Pope.L's gallery practice is inextricably linked to his public work, the two do not always appear proportionate. His inclusion in a museum or gallery exhibition very well may, by his own design, involve having none of his work on view within the institution's walls. Such absences necessarily beg the question of institutional benefits. For Pope.L, the newly welcoming walls of the gallery or museum are a permeable membrane: because what occurs outside is just as, if not more, important as what's inside, he treats institutions as conduits to public space, making a subject of the increasingly soft distinction between private and public space. Pope.L's constructions occupy a space that cannot be divided neatly, only negotiated with a strong sense of precariousness. He mounts a particular challenge to art institutions' voguish assertions of "audience engagement": again and again, his projects take viewers beyond their comfort zone, beyond institutionally controlled parameters. In this way, he continues to assess the social dynamics that organize public space, drawing into focus that which typically remains unseen until an extraordinary event dramatizes it.

Lisa Dorin: *What does public art mean to you?*
Pope.L: It's an opportunity to create a duration with a community for something to happen, something that doesn't usually occur, a porous event that recognizes the reality on the ground but moves beyond.
LD: *What comes most readily to mind when thinking about your public work is the series of crawls that you began in the '70s in New York. How did they develop?*
PL: For me, the crawls were always public works, even when I was the only one doing them. I recruited myself first because that was the most efficient thing to do. I needed to lay the groundwork to make a "living" rhetoric before others would participate. In much of my public work, there's a lot of convincing going on.
LD: *I've heard you talk about the bystander in the* Tompkins Square Crawl—*in which you crawled through the neighborhood wearing a business suit—as having "changed the rules" for you. He made you speak to him, which you previously chose not to do. How did he do that?*
PL: I don't know if he changed the rules or if he understood them better than I did. He would probably say, "I didn't understand anything. I felt something." He was a great teacher. Also physically threatening, but he was a heartfelt guy to take time out of his day to help me because he thought I was in need. And

Black Factory, 2005. Performance, a protest.

I was. I needed someone to give me a crit. I don't know how long it would have taken me to understand what he unintentionally brought up in the work. I could have rejected his contribution as misreading my intent but luckily I didn't. He saw, as a subtext of the work, that black people should not be doing what I was doing, that I shouldn't be doing what black people used to do. I think he also felt that homeless people shouldn't wallow in their own lack. But on the other hand, my collaborator was suffering from a "bootstrap" philosophy of upward mobility and self-improvement. I was saying, suit or no suit, we still crawl, not just black people, not just the homeless. People with suits crawl. But if that's true, then who is there to aspire to?

LD: *So you took that critique and turned it into a learning experience as you moved forward into works such as* Black Factory, *in which conversation becomes not only possible, but necessary.*

PL: A learning experience—I like the sound of that, but I'm not sure. *Black Factory* made talking an action, but you have to go back to crawling again because conversation is *very* slow. Perhaps slower than crawling. For every word you give, you hold two words back. That's what conversation is. Silence is a necessary part of the collaboration. Disagreement is also necessary, but we did not rely only on conversation. It was also important to do action-based activities to give the project more bottom. If someone asked, "Why should I be interested in *Black Factory*? Why should I believe? Why should I take the leap?" Well, this is what we do. We leap. We talk to people to share the idea of change. We know that change is multifaceted, we know it doesn't always work, we know change for its own sake is bankrupt. Here are some things that *we're* doing. At every stop on tour, we raise money for people who have less. The whole crew works small jobs for soup kitchens and the like in the community. *Black Factory* was always a mix of approaches, tones, images, and points of view.

LD: *Once you determined that getting out and working was integral to the project, was it the host institution's role to identify how the* Black Factory *crew could be put to the best use?*

PL: We'd discuss it—but we had our own agenda. With institutions, there were usually two major issues: what was going to be in the gallery and parking the truck near the museum. My answer was always, "We're not about being in the gallery. The idea is to be in the community." I understood their concerns, and most were very supportive. Bottom line: I was asking them to bring this project to their city, but they might not get much out of it. Whatever their reasons, it was very cool that they did it. Besides the institution-dependent situations, we also did guerrilla stops. We'd stop anywhere, get out, and explore. In guerrilla stops, the truck wasn't always visible. I realized at one point that being anchored to the truck could become a kind of justification for what we were doing. We found that as we got more confident with the project we didn't need the truck as much.

LD: *What, for you, determined if it worked? How did you measure success?*

PL: I measure success several ways. It's cowardly to avoid the success question just because the work is so-called "social" or "open-ended." We grew every year. We built and manifested almost every idea we came up with. We got better at what we did, so much so that we had to stop. We annoyed people. Some thought we were simplistic, ineffectual, and didn't know our asses from a hole in the ground. Probably true. Some thought we were a ray of sunshine in their community. Also probably true. *BF* was in some ways a sweet, funny, clumsy, corny idea; it definitely had a bit of tilting at windmills in it. You see, I want people to be good, but I myself am no good at it—arrghhhh.

LD: *In these awkward instances, do you use humor as a way to connect with people?*

PL: Awkward, yes, a favorite formal feature. Humor connects but also splinters. Take someone like Richard Pryor, who was able to keep audiences in their seats while delivering very uncomfortable

Freedmans Town to Enron City, 2003. Group crawl performance, Houston, TX.

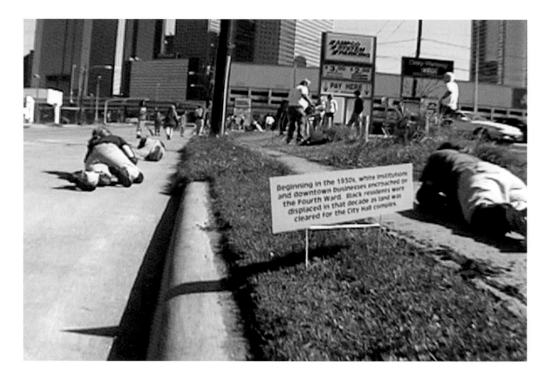

material. He wasn't simply funny; he was charming, self-deprecating, manipulative, smart, and sometimes brutally and intimately honest about what humans do to themselves and others. For example, in the "sunset strip" monologue, he set himself on fire free-basing crack cocaine. He is the phoenix, dressed in red leather, rising from the ashes of addiction to dump shit on his head as he describes his stupidity in detail. We cringe and applaud. Pryor's performance was a space of ritual questioning of the economies of negative intimacy and self-care. In creating this space, he constructed a really dense knot of failure particles. And we laugh.

LD: *You just used the word "failure," a notion we've discussed at length, particularly in regard to the "Failure Drawings" that you showed at the Art Institute of Chicago a few years ago. Can you talk about the role of failure in your public projects?*

PL: Failure can be productive as a technique, not a lifestyle. I grew up with people who could not avoid it as a lifestyle. I don't believe that we are fated to fail, but I know about feeling that way. I don't believe that celebrating failure or making it into candy is a good thing. If a project does not confront and contain its own failure, it is not interesting.

LD: *Moving on to your most recent projects, what is* Blink? *How did it come about?*

PL: *Blink* was a *Black Factory* project commissioned by Prospect.2 New Orleans. I wanted to do something community-based and participatory with the people of New Orleans. I wanted to give *Black Factory* new life by doing a spin-off. *Black Factory* had always been larger than life, unwieldy, with so many parts, so much caretaking, particularly the eight-ton, 25-year-old truck. The whole thing was a beautiful mess and a weight on my neck, beautiful but an albatross. For *Blink*, I re-imagined the truck as a weight, a darkness, a lack that we pull behind us like a shadow — all the regrets, the "should have but didn'ts," the fears, anxieties, real-world ghosts, and monsters. But how do you make that concrete? Well, what if we literally pulled our collective darkness together into the form of the *BF* truck? And what if the interior of the truck had a brighter, more positive value? What if we reconfigured the interior as a magic lantern projecting a film made up of images created by New Orleanians? The images were based on two questions: When you dream of New Orleans, what do you see? When you wake up in New Orleans, what do you see?

LD: *You've used the words "struggle," "community," and "celebration" to describe what is at the crux of this project. Is that still how you read it?*

PL: I would add other words as well — "doubt," "willfulness," "impishness," and "grace." The payoff in this work is not clear. For example, when it comes to pulling the truck, I'm asking people to do hard and, on the surface, thankless work. Like the man who accosted me during my *Tompkins Square Crawl* said, "We're done with that. We don't have to do that anymore." But all work, even the most high-end, is platformed on the physicality of the body: "There's no shame in hard work." I am asking people to show the fragility of their bodies as a collective and then go for a walk with others who are dragging the same ole dreams down the same ole corridors and to take time out to wonder about that.

LD: *Let's talk about the transition from* Blink *to* Pull, *so from New Orleans to Cleveland.*

PL: I'm working with Spaces in Cleveland, which is a whole new city but with similar darknesses. I gave them a basic outline, similar to *Blink* — a three-day endurance work in which rotating groups of citizens continuously pull an eight-ton truck that rear-projects images of their hopes, fears, and facts through the streets of the city. *Pull* is different from *Blink* in several respects: a three-day duration; the reconfiguration of physical labor as the bedrock of all work; allowing the darkness underneath

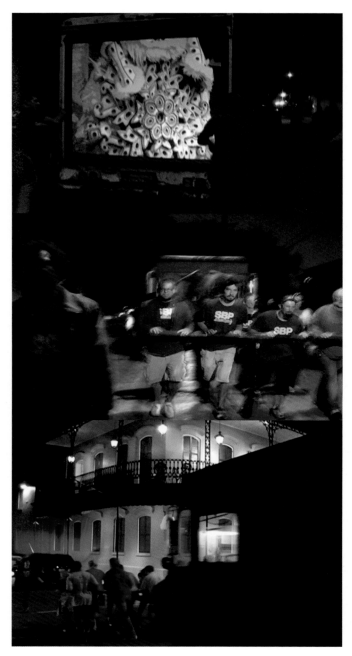

Blink, 2011. 3 views of performance at Prospect.2 New Orleans.

the theme to shine a little more; increased time spent in the neighborhoods the vehicle will pass through; budgeting funds to pay people who might be out of work and want to participate.

LD: *In New Orleans, it was important that it be done from sun up to sun down because of the lantern, but this is not the case in Cleveland. Why?*

PL: Dusk to dawn is also a poetic of *Pull*, and I am upping the ante duration-wise by insisting on a continuous 72 hours, with folks pulling and the projector projecting whether the image is visible or not. Very stubborn, very willful, very American. In *Pull*, the tone of the visual world is more consciously coordinated than in *Blink*. From the images of work donated by the people of Cleveland to the performers' dress, to how the truck is painted—the visual elements create a tone and inform the ideas behind this tone: ideas like it's not a glorious past that America harks after but a ghostly image of a past that possibly never was.

LD: *What you are offering is an opportunity to do work that may be more physically intense than the work people already do. Why are they going to do it?*

PL: They should do it because it's good for them. Langston Hughes, playwright and theater innovator, once said, "If you want folks to participate in the arts, it's got to be for them, near them, and by them." *Pull* is a unique experience combining the beauty of doing physical work with an opportunity to join others to re-think history and our place in it as people who have jobs. *Pull* offers a slow-down

time in which participants can join with others in work whose focus is themselves and their group, not the boss, the clock, or the product.

LD: *You are describing a sense of loss in terms of our value as workers. That myth or fantasy being dispelled makes me think about your film* Reenactor, *which you've referred to as your Civil War movie. What is the idea of the film, and how does it relate to your public art practice?*

PL: It is my Civil War documentary, my ghost documentary, experimental documentary, that is. Taking the ghosts of the past and shadowing them in the present via costume, location, performance intervention, digital fuzz, and flutter to create a non-linear series of images—some direct cinema, some staged—all shot in a southern city seemingly invaded by Civil War re-enactors ranging from a family of three to couples, to bands of wandering troops, to a single character dressed in red, all wandering through the city of Nashville with no specific intention except to occupy and re-occupy. The film is 3.5 hours long. Last fall, *Reenactor* premiered in a rough cut at Lafayette College in a specially built room and screened continuously for 24 hours. Sleeping was encouraged.

LD: *We've discussed how hard it is to convince people to get out of their routines and do something different with a group of strangers. What is the payoff with* Reenactor?

PL: *Reenactor*'s payoff is dispersed yet also individualized. On the surface, the experience of viewing a film is grossly different than a hands-on event, yet the eye, posture, image organization, interaction with other audience members, and individual choice regarding what, when, and where to attend can render viewing alive and active. *Reenactor*'s non-linearity, repetition, puzzle construction, painterly crossfades, and "stutterings" aim to encourage an active, poetic attention; it is an opportunity to behave differently within what has become a very formalized tradition of viewing a film screened for a group in a certain space. At Lafayette, access was 24 hours, making the frame of choice more porous and playful and, at the same time, more conscious and part of the viewing experience. How do I choose to attend? When do I choose? How long do I stay with my choice? When do I leave my seat and turn my back on the flow that's happening right in front of me and why?

LD: *You mentioned interaction, which brings to mind the idea of audience participation. As with your use of humor, these projects are never just a one-way street.*

PL: Audience participation is naturally humorous because it can be like herding cats and imminently dramatic. Along the continuum of action, film viewing is a small action. However, the size of the action belies the complexity of the movement happening inside the viewer. *Reenactor* encourages movement inside the viewer via its playful, off-kilter montage. For example, sometimes the film will speed forward or backward like microfiche. Sometimes a scene is inverted or held for long periods, and time is allowed to simply occupy the screen. These strategies may move some viewers out the door. So much for choice. At future venues, I'm asking local filmmakers to supply the cartoon or coming attractions to precede the feature to increase community participation in the happening.

LD: *There is also a public aspect to how the film was made, the idea of releasing these characters, these "General Lees," out into the world. They encounter people who just happen to be there and who become, perhaps like the Tompkins Square man, unknowing collaborators. Can you talk about that?*

PL: Staging documentary with obvious theatrical tropes dresses up the moment—history—as intentionally clumsy and comic. With performance intervention, you don't know what will happen when you insert a prepared reality into an unprepared situation. Many times, the reactions are small, as if the unprepared experience the intervention as a film. What is the inner screen that turns reality into

a movie of the week? History is how we dress it up. But time has a mind of its own, a haunting. It's always about the shadow on the page or stage. I'm after a less reliable public-ness, how we costume the uncertainty of time. I am after a three-headed, nine-legged publicness.

Fight-Specificity: A Conversation with Oliver Ressler (2013)

by Sylvie Fortin

Vienna-based artist/filmmaker/curator Oliver Ressler creates "fight-specific" exhibitions, installations, projects in public spaces, and films that address economics, democracy, racism, forms of resistance, and social alternatives. His work has been featured in more than 200 group shows around the world, as well as in solo exhibitions at the Berkeley Art Museum and Pacific Film Archive, California; Platform Garanti Contemporary Art Center, Istanbul; Museum of Contemporary Art, Belgrade; Kunstraum der Universität Lüneburg, Germany; Centro Cultural Conde Duque, Madrid; Alexandria Contemporary Arts Forum, Egypt; and the Bunkier Sztuki Contemporary Art Gallery, Krakow. For the 2008 Taipei Biennale, Ressler curated "A World Where Many Worlds Fit," an exhibition about the anti-globalization movement. "It's the Political Economy, Stupid," curated with Gregory Sholette, was recently on view at the Austrian Cultural Forum in New York and the Center of Contemporary Art in Thessaloniki.

Sylvie Fortin: *In the late 1990s, you were working with Martin Krenn on projects that tackled racism, borders, and immigration. You used three means to intervene in public space — billboards, posters, and direct mailings. How did you think of public space at the time, and what was its potential? What could these interventions do?*

Oliver Ressler: I started to work in public space shortly after I finished my studies. In the mid-'90s, the Austrian far right was gaining power. Public sentiment was shifting. A very ugly climate of conservative backlash was spreading, and social gains were being threatened. In reaction to the politics of the far-right FPÖ (Freedom Party) and its leader Jörg Haider, the other parties also moved to the right. In this context, I thought that public space could offer the possibility to react to certain reactionary tendencies. I collaborated with Martin on a number of billboard projects. *The New Right — Materials for the Dismantling* (Vienna, 1995), a series of four large-scale billboards, focused on right-wing ideology — its definition of nationalism, its take on the role of women in society, and its narrow, self-serving use of the notion of homeland. Only one referred directly to the FPÖ, because the project responded primarily to the publication *Die selbstbewußte Nation* (*The Self Confident Nation*), a conservative, nationalistic, and highly influential book aimed at spreading the New Right school of thought.

SF: *What kind of visual language did you use for the billboards?*

OR: The visual language was very sober and text-based. It did not include any images or color, just black and white text. Each billboard consisted of two statements: a crossed-out excerpt from a statement by the New Right was confronted with a statement that analyzed or criticized it. These texts were entangled with each other; if you wanted to read the critical argument, for example, you had to skip every other line. This kind of visual sobriety really stood out. It was different from what people

expected to see in public space. Advertisements are usually in full color. If they use text, it's just a few words. Such extensive use of text was unusual, and it garnered the work a lot of attention. There were some media reactions, in newspapers and magazines, and Martin and I did interviews on public radio. I had just finished art school and had to learn quickly to deal with my new public role.

SF: *These projects required viewers to slow down, which creates a new awareness. You're not supposed to linger in public space; you simply traverse it on your way to or from somewhere else. Everything is made to keep you moving. Was this slowing down part of your strategy?*

OR: We presented the work in very specific public locations. There were a lot of billboards in Vienna, but we only used those that were close to bus, train, subway, and tram stops, places where people are waiting. Most people sit and wait, listen to music, or talk to friends, but some stand and observe, and they check out the billboards. We wanted to cast public space as a place for serious societal discussions, which does not happen very often. With the Occupy movement and the demonstrations in the squares of Madrid and Athens, public space is once again being considered by large groups of activists. We were fighting for this already in the mid-'90s, but very few people took public space seriously as a place for meaningful conversations.

SF: *Many of your projects have been facilitated or funded by art institutions. These works rely on a network linking the art institution, public space, and media space. How do arts institutions function in this extended sphere?*

OR: *Materials for the Dismantling* was not commissioned by an institution. It was a very specific situation: a federal arts program in Austria provided curators with a substantial budget, allowing them to support what they thought would be important, without all the bureaucracy. Stella Rollig, who is now at the Lentos Kunstmuseum in Linz, took quite a risk by giving two recent art school graduates the opportunity to present a critical intervention in public space. We installed billboards in 36 locations and 13 smaller-format posters in the subway.

Oliver Ressler and Martin Krenn, *Institutional Racism*, 1997. Billboard-object in front of the State Opera, Vienna.

With *The New Right—Materials for the Dismantling*, we won a prize that included a solo exhibition at the Neue Galerie Graz the following year. Martin and I connected this exhibition, "Learned Homeland," with a public billboard-object in the main square of Graz, which was just 200 meters from the museum. Among other elements, the show featured two videos: one documenting reactions to the billboard-object on the main square, the other offering discussions of the central issues—the construction of nationalism and homeland and the role of school books in manipulating kids from a very early age in Austria.

SF: *After the billboards, you moved on to banners in the "Boom!" project with David Thorne, in your interventions at international summits, and in your work with the Holy Damn It project. The intervention is no longer stationary— it is now mobilized and infiltrates public space. How does the poster become a banner, which then becomes a prop? What does that shift say about changes in public space?*

OR: It started in 1999 with Seattle and the anti-globalization movement. From the very beginning, I knew that I would want to do more than simply participate, which I did for many years: I would anchor my artistic production in this movement. I was not interested in neutral representation; instead, I thought about different ways to produce works that could be used by the movement or serve to mobilize it. I tried a variety of different projects over the years. The most well-known are probably the three films that I made about the anti-globalization movement: *This is what democracy looks like!*, *Disobbedienti* (both 2002), and *What would it mean to win?* (2008).

The posters, billboards, and banners that I produced for various occasions are less well known. The "Boom!" banners that I made in collaboration with David Thorne were originally produced for a demonstration in New York against the World Economic Forum in 2002. We did three different banners, each one displaying a long, completely dysfunctional URL address in which we embedded our own texts to bring some complexity into certain discussions that we thought were important.

The Holy Damn It collaboration was part of a larger, self-organized project by 10 artists, including Petra Gerschner, Marina Grzinic, and Alan Sekula. My poster, which was published some months before the 2007 G8 summit in Heiligendamm, Germany, called on activists to organize blockades; it was a mobilization tool. We had learned from the blockades at the 2005 summit in Gleneagles—it is possible to shut down a summit by blocking all of the roads into the small villages where the G8, IMF, and World Bank choose to meet. This generates a lot of attention and visibility for your ideas. A blockade is a symbol saying that the politics carried out at a G8 summit or World Bank meeting are not the kind of politics you would like. Our posters were printed 10,000 times, and copies spread quite widely. When we were in Heiligendamm for the blockades, we realized that our images and posters—10 in all—were key materials used by the activists and political groups. We saw our work numerous times in pamphlets and in public space without having put it out there ourselves. Protestors just downloaded the files from our Web site and used them for their own purposes.

SF: Institutional Racism *(1997)* and Resist to Exist *(2011) engage "situation-specificity." In* Institutional Racism, *you chose a site close to a prison where political asylum-seekers were incarcerated; this was in response to a new law that criminalized them. There's a relationship to place but also to the state apparatus and to a particular moment in time. Something similar happens in* Resist to Exist, *which was installed in a disused railroad yard close to a Fotex shopping mall owned by a subsidiary of the Danish shipping giant Maersk. Local residents/activists had attempted to transform this site into a park, which led the police to order them to leave. Can you elaborate on these complex, yet precise and subtle interventions?*

OR: In the case of *Institutional Racism*, another collaboration with Martin Krenn, we chose a site next to the State Opera in Vienna, a central public square where many people walk and spend time. Tens of thousands of tourists also pass through there every day. Visibility was more important than proximity: we did not necessarily choose the location closest to the prison, but one that would be visible. Still, the prison was close by, but on a street with fewer tourists. The prison, which is somehow invisible, looks like many large, late-19th-century houses in Vienna. It is one of a number of detention centers that house foreigners who have committed no crime — namely asylum-seekers or undocumented migrants. We tried to make their existence visible, to make it a subject of public debate, through text interventions that cast their incarceration as an instance of state racism. We did it in three languages — German, English, and Italian — the most common languages of passersby. We also provided details about how the laws were changed to allow for the six-month incarceration of innocent foreigners.

The site for *Resist to Exist* in Copenhagen was chosen for its proximity to a Maersk-owned shopping center. The public intervention tried to make a link to the resistance of the *piqueteros* in Argentina, who, among other activities, dismantled fences and re-used them as platforms for barbecues during street blockades that lasted for weeks. My assault on the barrier between private and public included a huge billboard showing fenced-in Maersk containers with extracted fence parts. A sculptural component lies close to it: 12 meters of the fence that you can see on the billboard is now placed on the ground, next to the billboard, which makes it look as though the place had been dismantled, as if a riot had just taken place. The fence doubles as a huge, functioning platform for barbecues, which local residents, who are primarily migrants, had requested in their park plans.

A couple of years ago, the Italian-based, Luxembourg artist Bert Theis transformed the idea of site-specificity to "fight-specificity." His term makes a lot of sense for my work, which is not really site-specific in the way of the 1970s or '80s. It refers to certain struggles and specific fights that take place in public space. In *Resist to Exist*, I'm interested in making connections between contemporary struggles and fights that took place 10 years ago in Argentina. I try to see how those strategies would work in a completely different context, like a Scandinavian country, where the levels of confrontation and poverty are not the same, but where, in the context of a global economic crisis, institutions are not working as well as they did 20 years ago.

SF: *The history of revolution or struggle is usually written as a series of localized, tenuously connected episodes set against the ongoing story of capitalist expansion. Your work, however, tries to show the history of revolution as a global continuum. I would say that your project challenges historiography by positing revolution as the norm and by linking contemporary struggles to those of the past around the world.*

OR: That's a good point. For example, my poster *Elections are a Con* recapitulates a slogan from 1968. I wanted to bring this slogan back into discussion in relation to the current situation with the global crisis. Political parties and government institutions are becoming increasingly illegitimate because they appear to have lost the power to make key decisions. National sovereignty is a dead dream. Other players — primarily banks, corporations, and financial institutions — have seized that power and tell us that certain things are inevitable. In this case, I tried to present a series of posters in public space in Innsbruck, the capital of the Austrian province of Tyrol, in which the very sober slogan "Elections are a con" would appear over images of the Tyrolean mountains. After I won a competition to produce this project, the provincial government decided not to pay me for my poster campaign,

Holy Damn It poster, 2007. English version, 59.4 x 42 cm.

THOSE POLITICS ADVISORS, SECURITY OFFICERS, TRANSLATORS AND CATERING FIRM EMPLOYEES WHO WILL NOT STAY OVERNIGHT IN THE SECURITY ZONE OF THE G8 SUMMIT MAY BE PREVENTED BY

BLOCKADES

FROM REACHING HEILIGENDAMM.

↑ G8

FOR A DEMOCRATIZATION OF SOCIETY, SOCIAL WELFARE, DISMANTLING CAPITALISM AND THE CREATION OF FREE SPACE

G8 HEILIGENDAMM 2007
WWW.HOLY-DAMN-IT.ORG ROSTOCK-LAAGE AIRPORT

which was scheduled for the 2012 election period.

SF: *This was not the first time that your work had been censored. What kind of resistance strategies have you been able to propose or develop?*

OR: My show "Nachhaltige Propaganda" ("Sustainable Propaganda") at the Museum of Applied Arts in Frankfurt, Germany, in 2000, was also censored. The museum director, who I think considered the show to be too explicitly political, dismantled it on the second day after the opening without informing me. He would not respond to any of my attempts to contact him, until he realized that the media were interested in it as a censorship case.

Another incident happened in 2006 when I collaborated with the political analyst Dario Azzellini for the project "Now-Time Venezuela: Media along the Path of the Bolivarian Process," curated by Chris Gilbert for the Berkeley Art Museum and Pacific Film Archive. The museum administrators were, I think, quite shocked by how artists and the curator could take sides. They harassed Gilbert and made his life a kind of hell. He finally resigned, and his letter of resignation circulated through newsletters and the Internet, which caused an international controversy about the function of museums and how they restrict certain kinds of knowledge production, political works, and viewpoints. This was Gilbert's last act within the confines of the art system. Since then, he has become directly involved in political processes in Venezuela, where he now lives. He doesn't need art as a vehicle to do political work anymore.

SF: *Two reasons were given for censoring* Elections are a Con: *the information conveyed by the title was factually incorrect, and the work wasn't experimental enough. Doesn't it signal a turning point when an elected official censors a work because it is not experimental enough? In the old days, work was censored because it was too experimental.*

OR: Yes, this is a quite funny turn. The provincial minister for culture adapted her arguments over time. Even to conservative media, it was quite clear that this was a case of censorship. Over a period of weeks, this politician was asked repeatedly to explain what happened, and she soon realized that none of her arguments were convincing enough for people to side with her. At the beginning, a representative of the cultural department of the government of Tyrol even argued that the information I supplied was incorrect, because elections should not be confused with "election advertising," which

is a con. This rather unexpected position from a provincial administration was abandoned as the public debate continued.

SF: *I'm interested in how performance has entered your work. Once posters and banners become objects in demonstrations, bodies interact with them as props. Your recent project,* Take the Square, *relies on re-enactment. How do you understand the growing theatrical and performative dimension in your work?*

OR: For *Take the Square*, I put together my own working group—re-enacting a central structure of the "square movement" and of Occupy. Four to six participants hold discussions in public space, usually in spaces where these occupations took place. For this piece, which eventually became a three-channel video installation and a film, I wanted the groups to tackle certain questions. I was specifically interested in discussing forms of organizing and decision-making processes, in the structure of the Assembly, and in international cooperation. I created a set for the discussions, and it worked very well. Even though it was a completely staged situation, I didn't know what people would say, and they didn't know either because they reacted to the arguments of other occupiers. In some of the sessions, which I recorded in New York, Athens, and Madrid, I tried to combine activists from different groups that would not necessarily agree. The experiment worked really well. I'd never relied on such scenarios before, but I was quite happy with the outcome.

SF: *In this case, public space becomes the stage. It's no longer the site of the work or a destination for viewers—public space is a catalyst for other things to emerge.*

OR: This is true. When I conceptualized the project, I was focusing on the square movement and Occupy, movements that at the beginning were primarily trying to occupy and use public space. I used the

Resist to Exist, 2011. Billboard and fence/barbecue grill next to the S-train station, Bispebjerg, Copenhagen.

Wahlen sind Betrug (*Elections are a Con*), 2011.
Poster censored by the provincial government
in Tyrol, Austria.

same strategy — namely to occupy space — to produce the artwork. My working sessions were filmed without permission, which kept me from producing them in all of my chosen locations. For example, I was not allowed to record the working session at Zuccotti Park in New York. First, the private security guards told me to stop, but I just ignored them. After 10 or 15 minutes, though, they came back with the police and I had to give in. We went somewhere else in the neighborhood and continued shooting there. But in Athens, we did a three-hour recording at Syntagma Square, where all of the demonstrations against the government and austerity measures imposed by the European Commission and the International Monetary Fund take place.

SF: *What is most important to you about public space?*
OR: To sustain it as a public space or to reoccupy it in those cases where it has already transformed into something else. Over the last 15 years or so, I've tried to find different ways to approach public space, by tackling different themes and topics and by varying the formats. I've tried to change the parameters in order to grasp what is specific about a particular space and how to best relate to it. Each space calls for very particular language. You cannot repeat it in different works. You have to discover a language for every specific situation.

Just Say No: A Conversation with Santiago Sierra (2013)

by Paula Llull-Llobera, translated by Tatiana Flores

Since Santiago Sierra's first actions in the 1990s, the words "anxiety," "discomfort," and "irritating" have been the most frequent responses to appear in critical texts, interviews, and the general press. For Sierra, public reaction, whether positive or negative, is fundamental; without it, the work cannot be fully realized and cannot act as a mirror to the world in which we live.

Art, when it comes down to it, always appeals to the senses. Sierra notes that works of art "use neither 300 pages nor 20 chapters to explain themselves. There is only the one instant, so it must be expressive and forceful, strong enough to stimulate a feeling that is followed by whatever reflection."* His works are so forceful that on occasion they have drawn the public's ire. At the 2003 Venice Biennale, he limited entry to the Spanish pavilion, admitting only Spanish nationals able to confirm their citizenship with the proper papers. In 2006, he filled a historic synagogue and exhibition space in the town of Pulheim-Stommein near Cologne with carbon monoxide from auto emissions, forcing visitors to enter with gas masks and provoking protests by the German-Jewish community that led to the closure of the installation. Then there are the many "useless actions" in which he pays disadvantaged people (drug addicts, sex workers, victims of racial discrimination, and undocumented immigrants) to undertake absurd tasks such as repeating a phrase, dyeing their hair, making holes in the ground, or letting their backs be tattooed with a line. In these and other works, Sierra does not hesitate to bring public attention to pressing issues of social justice and the sociopolitical panorama of which, he emphatically notes, we are all part. Nevertheless, he is convinced that art has no power to change the world and insists that he is not an activist.

The social impact of Sierra's actions takes on a deeper meaning if we keep in mind that, to date, he has only one sculpture on permanent display in a public space. He prefers to focus on developing temporary projects in carefully chosen places, whether artistic institutions or public spaces with particular social or political-economic connotations. Despite the ephemeral nature of his work, it may be perceived through a modality of "expanded" public art, in the sense that the traces are left in the memory of the space through media and especially, as Sierra emphasizes, through the blogosphere or word of mouth. In the same way that an important event can shape the history of a city, Sierra's actions leave a collective imprint, even for those who have not personally seen the work but know of and have formed an opinion of it.

It is important, however, not to fixate on this "shock aesthetic," as Sierra calls it, and the controversies that it engenders in regard to the ethics of his work. If we take into account the meticulous formal aspects of his actions, we may note a trajectory strongly associated with the conceptual rigor of Minimalism. This is evident in the documentation of his actions in black and white photographs and videos, the use of structural and industrial materials, the repetition and prevalence of geometric

shapes, and the inclusion of actual human beings as sculptural units. Without a doubt, the latter is a key element. Along with clear influences from American Minimalism, Sierra's work incorporates the so-called "ideological conceptualism" traditionally associated with Latin American art, which contributes a critical reflection on society and capitalism.

Paula Llull-Llobera: *Why did you move to Mexico in 1995? What did that city offer in comparison to Madrid or Hamburg, where you had previously resided?*

Santiago Sierra: In Madrid at that time, art with Duchampian roots had been marginalized. Sometimes this marginality was exhibited with pride, but I think that is the attitude of the fox who could not reach the grapes. It was an inbred atmosphere; one day, it was your turn to be the artist and mine to be the audience, and the next day, it was the reverse. Gallerists and collectors would not allow themselves to be seen, so I had to leave or I would never develop my career. It was not a good time to return to Germany after the fall of the Berlin Wall, and from the perspective of life experience and politics, Mexico was a very good option. Things sped up when I refused to be a soldier of the monarchy, for which I risked going to jail. I left, really, because I had no other choice. Mexico is a country full of people who have no other choice. It gave a perspective on life and politics to my work, which in those days felt strangled, in part because of the German influence, but mostly because of the exhausting need to explain everything that didn't stink of oil to a reluctant Madrid. The famous Movida Madrileña [in the transition after Francisco Franco's death in 1975] was a reactionary movement to ideologically disarm the masses. In Mexico, even though I was poorer, I felt freer, and that freedom was strongly contrasted by a reality in which life is a sentence for many and a stroke of luck for a few. Mexico has been my principal teacher, and I lived it with as much intensity as I could.

PLL: *The traditional concept of a monument lost its meaning long ago. Nevertheless, there still exists a need to publicly share certain social or political concerns that have nothing to do with the*

250 cm line tattooed on 6 paid people, 1999. Espacio Aglutinador, Havana, Cuba.

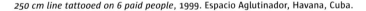

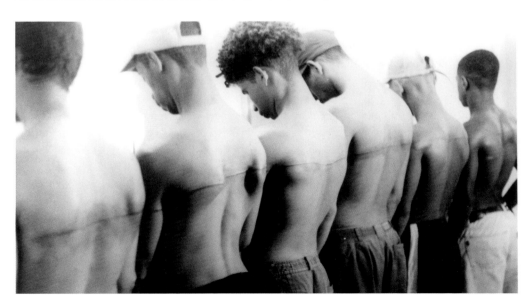

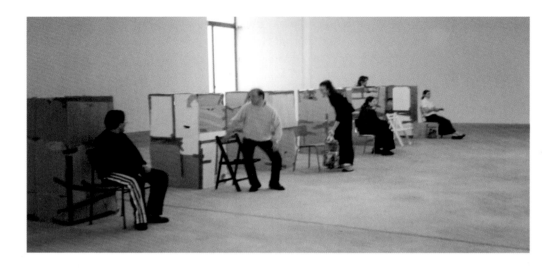

Workers who cannot be paid, remunerated to remain inside cardboard boxes, 2000. Kunst-Werke, Berlin.

homages of previous generations. What is your point of view on the role of art in this regard? Does the idea of a contemporary monument exist?

SS: Public monuments tend to be celebrations of genocide, exaltations to established power structures dressed up by some illustrious poet to disguise them, with "saints" all around. This is not due to the artist's lack of creativity, but to the false sense that the land is public property. What is public has owners who are none other than the historical beneficiaries of holocausts and mass theft. The problem, therefore, is not the loss of the meaning of what is monumental, but its potent meaning, that is to say, its submission to the status quo. It is an art that is complicit, and many artists avoid it. Others say, "What the hell, it pays well." The problem with all this, as always, is authority or the absence of a free society with the capacity to decide for itself what to do with its space. Not long ago, I created a public monument in Reykjavik without asking for permission and as a gift to the people of Iceland. The monument, dedicated to civil disobedience, read, "When the government violates the rights of the people, insurrection is the most sacred of the people's rights and the most indispensable of its duties." These are the necessary monuments—enough of continuing to laugh at the elite's jokes.

PLL: *Did you conceive of* Submission, *in Ciudad Juárez, as a monument? Is it still there despite the fact that it could not be completed as planned? You do not have any other works of a permanent nature; instead, they are documented in videos and photographs. Have you ever thought of doing more projects of this type? What motivates you to do them or not?*

SS: *Submission* remained in place for five months while I negotiated whether to set it on fire or not; but for five months, it was perfectly visible to planes landing at the American airbase. So, it wasn't an absolute failure. It did not have the characteristics of a monument because it was not planned to be there permanently. Leaving a piece in public space forever is something to think about; I work more in the short term. A permanent piece requires another strategy and other contents. A problematic image is only acceptable for a short period of time—there's no need to spoil people's views forever. The monument in Iceland, the only one I've done to date, is amenable to coexistence and even to the

spirit. It is problematic for the powers that be, but not for the people. If I do something like that again, I would follow that basic idea. If something is to remain in the public's view for a long time, whatever it is, whatever we put up, it should not make the environment more unpleasant. For temporary works, on the other hand, we can distort things as we please. At least that's how I see it.

Submission could not remain. My team and I were expelled from the area and threatened with a heavy fine if we didn't leave the place exactly as we found it. We followed every legal requirement to realize this work, but it was censored. Censorship is an old travel companion of mine that I have no intention of internalizing.

PLL: *The impact caused by the process and context of your works seems to leave the formal aspect, with its Minimalist aesthetic, in the background. Can it be said that with* NO, Global Tour, *the object is recovering its prominence in your work?*

SS: The object has always been prominent. What I make most of all is sculpture. Perhaps my use of people as a recurring material is confusing. The object may be a person at work, not only for conceptual reasons, but also because the person has a specific physicality, just like a block of marble. If you wanted to fill a space with material, filling it with people would be a good option, for reasons of economy and simplicity. In my work with people, I don't think of performance; I think of sculpture and its process. I tend not to neglect the form; it is an important component of the work, giving a presence and clarity to everything. A strong work will be strong throughout, or it will be slack. *NO*

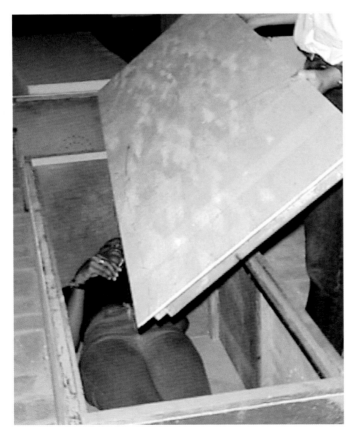

is a huge object, without a doubt, but it is precisely in this work that other aspects abound, because what was done with *NO* was a grand tour from which a road trip movie resulted. This film is a retrospective catalogue of the whole of my work.

PLL: *Aside from the film, the* NO *sculpture will remain. It has, as you say, an important physical presence and is surrounded by nuances from the journey and the places you have passed through. Francisco Javier San Martín, in his text for the catalogue, has emphasized the idea of the work's mobility and its incapacity to become a monument by estab-*

Three people who were paid to lie motionless in boxes during a party, 2002. Kunsthalle Wien, Vienna.

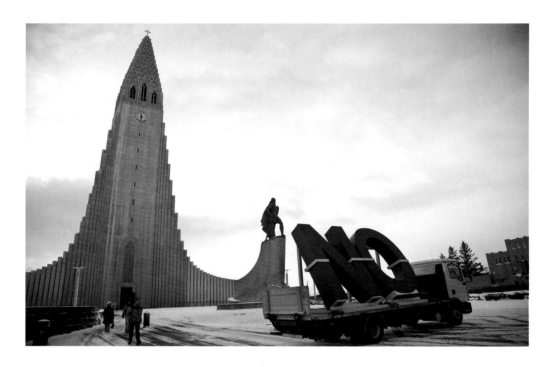

NO, Global Tour, 2012. Reykjavik, Iceland.

lishing roots in a specific place. Once NO, Global Tour *ends, what will happen to the sculpture? If it is sold, is it possible that it will end up exhibited in a public space, like the entrance to a museum or in a garden? Will it acquire a permanent nature that contradicts the initial ideal? Have you placed any sorts of conditions on future owners?*

SS: Yes, it's a bit like someone who collects butterflies. It is a relic of a past action, a tangible testimony. My instructions to the collectors is that they enjoy it. I was thinking of telling them to take their sculpture out on a procession once a year, but I don't want to be like the computer industry, which doesn't let clients use products as they see fit. Future owners will do whatever they want with the sculpture, just as I could while I had it.

PLL: *Your projects have always had a great impact in the media. How do you feel about the attention of the non-specialized press? Do you think it is beneficial that your works reach the general public in this way, though the reaction will not necessarily be positive?*

SS: No, it does not benefit me. The press has greater access to the public than I do, so they can completely change the meaning of a work and have done so. I don't even want to tell you about television. I don't conceive of my work as a whistle to call forth journalists, but it is, and each time I have to be more careful. From another perspective, the righteous questions of the press annoy me. The "media which shapes the masses," as Agustín García Calvo would say, cannot give lessons in ethics to anyone. I prefer to speak with my work and occasionally with the alternative or specialized press.

PLL: *Would you like to reach a public beyond art specialists?*

SS: I think I already reach a public wider than specialists, not because of the commercial media, but through the blogosphere and word of mouth. But the art public still interests me.

NO, Global Tour, 2012. Reykjavik, Iceland.

PLL: *Do you think the current social and economic crisis and subsequent questioning of the system intersect with your work? Beyond the debate about activism and art, don't you think this situation gives a new perspective to your work?*

SS: As José Luis Velasco would say, for the proletariat there is always a crisis. I must have missed that golden age everyone talks about. In Madrid, there was a crisis when I left and a crisis when I returned. I have no recollection of living in a society without crisis. We should call that the norm. I've seen places get worse, but none has improved. Elites stealing from the people is now universal. The difference is that what once sounded radical is now much better understood because fear has heightened empathy. As you see me, you shall see yourself. It seems as though the destitute speak to us without words.

I'll take this opportunity to clarify that I do not consider myself an activist, not even a political artist. As is natural, I speak about my environment, but I do not subordinate what I do to any particular political action. I am an artist. Nevertheless, the current situation is pre-fascist, and I think none of us sees this positively.

Notes

* Interview with Santiago Sierra by Hilke Wagner in *Santiago Sierra*, exhibition catalogue, (Spain: CAC Malaga, 2006).

Jeremy Deller: Art For the Man on the Street

(2013)

by Régine Debatty

The most gobsmacking work to come out of Great Britain's nationwide celebration of the Cultural Olympiad was a life-size, inflatable replica of Stonehenge. Aptly named *Sacrilege*, the fully operational prehistoric monument recast as a bouncy castle appeared, as if by magic, in a different location every day, without much advance publicity. Anyone who happened to pass by was welcome to jump in and jump around to their heart's content.

There was much to wonder at in regard to this massive inflatable. Its blatant kitschiness, of course, but also the fact that it was a work by a Turner Prize-winner and Great Britain's official selection for the 2013 Venice Biennale, Jeremy Deller. The strength of *Sacrilege* doesn't depend on its sculptural qualities. We can quietly agree that they are questionable, but Deller won't mind the judgment. He likes to tell art critics that he is not "technically brilliant," that he has never been a good draftsman, a decent sculptor, or a talented painter. In fact, his teacher strongly advised against art school. It doesn't matter to him: he has no ambition to produce artifacts and focuses his attention, instead, on experiences, happenings, and interventions.

Deller prefers to situate his work outside art galleries and museums—out there on the street, in popular processions and parties, where people might or might not care about contemporary art. His practice thrives in "low culture," and his work is usually ambitious, socially engaged, and unexpected. Indeed, he has built his career on looking for art in the most unpredictable places, working with the general public or with people who have very specific knowledge or skills, but who wouldn't otherwise be associated with the contemporary art world. Over the years, Deller has worked with unemployed miners, unrepentant smokers, boy scouts, a brass band, a steel band, a wrestler wearing pig tails, Russian fans of Depeche Mode, bored teenagers, German gardeners, and even bats.

Sacrilege lays contemporary art, history, and archaeology at the doorstep of people who might not have any interest in the fact that this is the work of a famous artist. People queued, took off their shoes, and capered into their cultural heritage. It was infinitely silly and brassy, but it also provided an unaffected opportunity for people of any age, education, and opinion to get reacquainted with ancient Britain.

It would, however, be unfair to present Deller's work solely under this whimsical light. After all, the project that made him famous in England deals with a much darker moment in the country's history. In 2001, with the help of historical re-enactment expert Howard Giles and filmmaker Mike Figgis, Deller painstakingly re-created one of the most brutal and controversial labor battles of Margaret Thatcher's reign. The Battle of Orgreave occurred on June 18, 1984 in South Yorkshire. Some 5,000 miners and supporters had been striking and protesting for weeks outside the Orgreave steel coking plant. That day, a few bricks were thrown. And from there, events quickly escalated, with police getting out of control, delivering baton beatings to unarmed miners, and sending the cavalry to charge

head-on into the village. The event came to symbolize the end of the British coal industry, as well as resistance to a reactionary police apparatus and a Thatcherite policy bent on crushing the rights of labor, particularly miners.

The participants in Deller's re-enactment included not only members of amateur historical re-enactment groups, but also former miners who returned to the site of the battleground to relive a pivotal episode in the destruction of their livelihoods and community. A few ex-policemen were brave

Sacrilege, 2012. Plastic and air system, 140 ft. wide. 2 views of life-size replica of Stonehenge.

Baghdad, March 5th 2007, 2007. Bombed car from Baghdad, installed at Imperial War Museum North, Manchester, U.K.

enough to come back to the scene as well.

As an action, Deller's *Battle of Orgreave* hovered between good-humored village fête, historical investigation, and a cathartic ritual in which painful, unresolved feelings were made to re-emerge. The same qualities survive in the film footage. Although the film focuses on a very precise episode in Great Britain's recent history, it strikes a chord with the widest audience possible: not only was the video screened on national television as a documentary told from the participants' perspective, it has also spent the last decade on a relentless, worldwide tour of biennials and other rendezvous points for contemporary art aficionados.

Not all of Deller's projects have met with such success (at least at the beginning)—the most striking example being his proposal for Trafalgar Square's Fourth Plinth. Originally intended to hold an equestrian statue, the platform remained empty for over 150 years until it was repurposed as a site for temporary new commissions. In 2008, Deller suggested to top the plinth with the wreck of a car destroyed a year earlier in the bombing of Baghdad's historic Al-Mutanabbi book market. Thirty-eight people were killed in the explosion. Deller's work—which he would have called *Spoils of War (Memorial for an Unknown Civilian)*—was rejected. So was his other proposal: a life-size statue of Dr. David Kelly preparing to jump off the plinth. (Kelly was the biological warfare expert who committed suicide in 2003 following the media frenzy provoked by his criticisms of the official government dossier on alleged Iraqi weapons of mass destruction.) Both projects were probably deemed too provocative, too uncomfortable to appear slap-bang in the middle of a major tourist destination.

A year later, Deller found U.S. sponsors, including Creative Time, whose support made it possible for him to take the rusted car carcass on a cross-country tour of America. Accompanied by an American veteran of the Iraq War and an Iraqi artist and journalist, Deller towed the mangled vehicle on the back of a truck and used it as an entry point to in-depth discussions about the war, the occupation, and related issues. At regular intervals along a contorted route that led from the New Museum in New York to the Hammer Museum in Los Angeles, the tour would stop, people would gather around, and conversations would ensue. Significant cultural gaps might not have been bridged in *It Is What It Is: Conversations About Iraq*, but the video documentation of the experiment

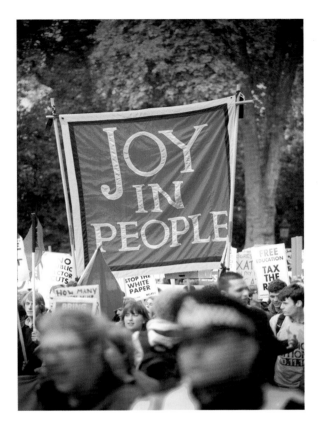

Joy in People banner (made by Ed Hall), London, 2011.

(posted on YouTube) makes for compelling viewing.

The car has since been shown at several art venues, and it is now part of the permanent collection of the Imperial War Museum in England. Reduced to a pitiful ruin, it offers a sharp contrast to the artifacts that surround it: sparkling, unblemished airplanes and vehicles from World War II, polished weapons and machines that hardly ever saw a battlefield. It nevertheless feels right to see this relic in the context of an institution dedicated to the understanding of "wartime experience." Inside the museum, the car adopts yet another role, commenting on the increasingly harsh impact of war on civilian and cultural life. The accompanying text states that at the start of the 20th century, 10 percent of war casualties were civilians. Today, they make up 90 percent.

Deller, it seems, has managed to carve himself a niche that enables him to explore his personal interests, questions, beliefs, nostalgic leanings, and curiosities and inoculate the public with them. Everyone can share personal passions, but very few have such a contagious enthusiasm. What is puzzling, however, is that neither the "broad public" nor the punctilious art critic is immune to Deller's stratagems. Here is an artist who strives to be a people-pleaser, someone who dedicated a movie to Adrian Street (the "Queen Bitch of pro-wrestling" and the author of the song "I'm Only Happy Breakin' Bones"), someone who built a steam-powered Internet machine, convinced the members of a brass band to play acid house music hits, and collaborated on an art project with a nightclub owner who gained fame all over England for wearing thongs on the beach and silky leopard-print shirts everywhere else. Such an artist should exasperate an art elite so gloriously absent from his thoughts. Yet Deller almost never fails to surprise, interest, and eventually seduce the opinion-makers. Why? Because for all his "by the people and for the people" tricks, the man never makes a concession. Because he bridges the personal and the universal, collective memory and individual experience. Because his artistic ego never gets in the way of his work. And most importantly, because he has expanded the idea of how an artist can work by adopting the roles of curator, storyteller, anthropologist, and catalyst of human experiences.

Philadelphia Social Art (2013)

by Becky Huff Hunter

Whether institutional or artist-led, Philadelphia's contemporary public art initiatives reject conventional, decorative forms to intervene in a physical, social, and temporal matrix defined by economic extremes. In a city where vacant lots butt up against prime real estate, where historic sites and university campuses lie adjacent to low-income housing, public projects must not only respond to pressing civic issues, but also negotiate the gap between a difficult present and a weighty, colonial heritage. It is almost too easy to interpret Philadephia's public art situation provincially, as the necessarily self-conscious production of a low-rent, tight-knit city uncomfortably cast as New York's "Sixth Borough."[1] Yet, locally grounded as it is, social practice in Philadelphia raises important, general questions about what we consider "public" and who has agency in these ever-shifting spaces. Taking political activism as a model, artists investigate who controls the city's public resources and whose voices are heard in the public sphere. Working with and disrupting metaphorical and implied meanings of contemporary sites—through both physical and virtual means—they explore shared emotional experiences across social groups, while blurring boundaries between public and private. Their most successful work might be described as "social-specific," a hybrid form combining the aesthetic strategies of site-specific public art and the relational strategies of social practice.

Precedents for this localized, critical practice emerged in the 1970s, in part through institutional efforts to connect with wider audiences outside of galleries and museums. The Philadelphia Museum of Art's (PMA) Department of Urban Outreach, for instance, organized a number of temporary exhibitions and community art projects, including *Franklin's Footpath* (1972–76), a huge, striped street painting covering the museum district portion of the Benjamin Franklin Parkway.[2] By co-producing the piece with Philadelphia School District students, Gene Davis energized local youth to rethink the area's significance. The Institute of Contemporary Art's (ICA) "Street Sights" program (1980–81) placed art in conversation with the history and current use of the city's shopping areas. The nonprofit Association for Public Art (APA), formerly Fairmount Park Art Association (est. 1879), has spearheaded several major commissioning programs that value the social specifics of particular sites as much as their topographies. APA's "Form and Function" (initiated in 1981) encouraged artists to propose permanently installed sculptural works that creatively supplied a local need. Examples of realized projects include Siah Armajani's *Louis Kahn Lecture Room* (1983) and *Fingerspan* (1987), a bridge designed by Jody Pinto for a site identified through the drawings of local residents.

In tandem with these new, institutionally supported art forms, independent artists and collectives developed experimental work informed, in part, by their experiences with activist and feminist organizations. Artist-led NEXUS Gallery (founded in 1975), Bricolage, Étage (Environmental Theater and Gallery), and Old City Arts all nurture live and temporary projects in the public forums of Center

2 views of Megawords installation at the PMA, part of "Zoe Strauss: Ten Years," 2012.

City vacant lots, empty streets, and construction sites. Bricolage's one-night-stand *Taking Tiger Mountain* (1978) took its inspiration from protests stalling construction of the I-76 highway, hijacking a heap of earth designated for the highway ramp.[3] The performance and its civic parallel provided early models for tackling questions about the constitution and control of public resources that Philadelphia's artists, and the Occupy movement, continue to pose in the present.

As part of the exhibition "Zoe Strauss: Ten Years" (2012), the PMA offered a residency to the Philadelphia-based duo Megawords, artists Dan Murphy and Anthony Smyrski. It was a perfect pairing: Strauss is known for her photographic portrait series of South Philadelphia residents, which she hung on the support columns of the I-95 highway (2007); Megawords' publications, installations, and events deal explicitly with "public space, public intervention, and who gets to do what where."[4] Turning the mission of the now-defunct Department of Urban Outreach inside out, the duo interrogated the museum's function as a civic space, negotiating free admission for visitors and providing a notary service from within their office-like installation.[5] By hosting public discussions on issues such as "What Belongs in a City" inside the museum, the artists symbolically returned metropolitan decision-making from the cultural elite to the ordinary citizen.

Commissioned through APA's "New•Land•Marks: public art, community and the meaning of place program" (initiated in 2000), Pepón Osorio's *I have a story to tell you...* (2003) addressed the Latino community's self-perceived lack of a positive, public voice. The project fostered a sense of group value and visibility, as Osorio listened to shared histories and experiences and collected photographs of meaningful events. Updating sacred stained glass and traditional memorials, he printed the black and white images on transparent panels and incorporated them into an illuminated *casita*. A meeting room and a monument to communal suffering and strength, the "little house" is located on the grounds of the Congreso de Latinos Unidos headquarters.

Jody Pinto, *Well Projects*, 1973–76. Excavated 19th-century watering holes and cisterns, brick, canvas, and found elements.

Philadelphia's independent curators also work to reshape the meanings of significant sites and to reclaim them for public use. In a dramatic example of this transformational, curatorial agency, Julie Courtney and Todd Gilens's exhibition "Prison Sentences: The Prison as Site/The Prison as Subject" (1995) began with a 1990 visit to the 11-acre Eastern State Penitentiary. At the time, this contested site was caught between its status as a historic landmark and its reality as a vacant, near derelict property, under the joint care of the commercial Redevelopment Authority and the conservationist Eastern State Task Force. After five years of planning and fundraising, 21 artists installed temporary projects within individual blocks and cells, teasing out the building's contemporary associations, from sexual politics to adult literacy. Fiona Templeton's *Cells of Release* (1995), which drew attention to prisoners of conscience, encouraged visitors to advocate on their behalf through Amnesty International, another example of an activist model of intervention translated into public art. The show, which was featured in the *New York Times* and on the BBC, doubled the number of visitors to Eastern State and paved the way for its World Monument Fund listing in 1996.

Several "Prison Sentences" pieces addressed the collective trauma surrounding crime and punishment, alluding to broken families and the mental stress of solitary confinement. Richard Torchia's later, long-running exhibition of 18 works in Eastern State's cell block two, "Daylights: Camera Obscura Projections and Other Interventions" (1997–2001), encouraged a similar empathy. *Arbor* and *Watching (The Watch Tower)* cast cells as primitive camera obscuras, using the original skylights and specially installed lenses to throw outside views onto walls, floors, and beds. One carefully focused projection even appeared to dissolve a window's iron grille, providing an illusory means of escape.[6] Demonstrating how architectural divisions double as social divisions, Torchia immaterially disrupted age-old boundaries between public and penal space, guard and guarded, and convict and contemporary prison visitor.

Jody Pinto, who co-founded Women Organized Against Rape in 1971, paved the way for such temporary interventions into unused spaces and prepared the ground for more recent site-based works that attempt to process traumatic, shared feelings of loss, failure, and threat. In the late 1960s and 1970s, she sought healing reciprocation between the social body and Philadelphia's derelict land. For *Well Projects* (1973–76), she excavated 19th-century watering holes and cisterns in locations such as the PENDOT landfill, sometimes leaving handmade artifacts and canvas bundles inside the brick-lined hollows. Never reifying a static past or site, Pinto treated the city as an "exciting 'live' workshop" in which shifting metaphorical material spoke to contemporary emotional needs: "The excavated

wells and abandoned buildings were like closed mouths, slowly opened, admitting new breath, exhaling experience."[7]

Martha McDonald's *Lament* (2006), created in collaboration with Katie Holten, extended this therapeutic form of public practice into spoken and sung performance. Created for the historic Bartram's Garden in West Philadelphia, the piece was part of ICA's "Soft Sites" exhibition, which sought to contrast the fluidity of contemporary sites with the weighty significance of traditional landmarks. Wearing a white linen costume and green gardening gloves embroidered with the technical terms for flowers and feelings, McDonald dropped a trail of seeds as she led visitors on a botanic tour. Her research into 18th-century naturalist William Bartram's preservation of near-extinct plant species sparked personal and global narratives of grief, destruction, and inadequacy, loosening the historically loaded site into a catalyst for free association and emotional expression. She wrote: "*Lament* drew on the Victorian language of flowers—a means of communicating through coded messages that allowed people to express feelings they were not free to speak aloud."[8]

The "Space Savers Project" (2011–12), initiated by Christopher P. McManus, used sculpture to encourage residents to reassess their fraught, emotional investment in the illegal, but ingrained, practice of saving parking spaces with cones, cement blocks, and other street items, fostering gentle, but meaningful dialogue about the objects' implied physical threat. Adhering to the standard 7.5-by-9-foot dimensions of a Philadelphia parking space, 11 artists installed alternative space savers around the city. Brent Wahl's *MINE* (2012) spelled out the childishness of the custom with Tinker Toy pieces, while landscape architect Chris Landau's bright tangerine *Table* (2012) turned traditional space saving materials, such as recycling bins, buckets, and an old door, into "a riff on a picnic table." As McManus explains, "Space saving is territorial, even alienating, but Chris's sculpture had the opposite effect. It brought people together."[9]

New technologies mark a further evolution in how we individually and collectively process emotional, temporal, and spatial experiences. Phillips Simkins's *Public Center for the Collection and Dissemination of Secrets* (1975), a response to Watergate-era phone tapping, was a pre-Web meditation on the somewhat threatening commingling of public and private space in modern communications. Based at 30th Street Station as part of the ICA's "Made in Philadelphia" (1973-87) program, Simkins invited travelers and visitors to anonymously record their secrets and listen to the confessions of others via telephone booths.[10] Many public projects emerging from Philadelphia now, though they remain grounded in locality, explore the ability of new media to

Richard Torchia, *Cell 14: Arbor*, 1997–2001. Camera obscura projection in prison cell, approx. 15 x 8 x 10 ft. From "Daylights," Eastern State Penitentiary.

destabilize perceptions of phys-
ical space and catalyze group
activity. Less critical of commu-
nications structures than
Public Center, these new works
inherit both the strengths and
the flaws of their parent tech-
nologies.

Philadelphia Masque
(2010) is an urban model and
interactive game produced by
Ibañez Kim Studio architects.
Picture a city on screen, as
detailed as any three-dimen-
sionally mapped video game or
movie setting; as you navigate
the terrain, you notice that vacant lots are inhabited by strange creatures that appear to be con-
structed from glass, metal, and other architectural materials. They form a network of digital "agents"
in a critical update on the Renaissance courtly masque, in which allegorical characters interact
on an elaborate stage. These characters are determined by, and fixed to, their locations; for example,
"Romulus"—a towering crystalline structure—embodies Philadelphia's founding and occupies Indepen-
dence Mall. When activated, the agents visually disrupt and rearrange the city's grid, proposing new
alignments between areas typically separated by physical distance and real estate value. As a purely
virtual model, *Masque* reduces these differentials to mere data. In an egalitarian move, the programmed
flexibility showcases the bold, imaginative leaps in redefining public space facilitated by digitization.
Dealing in data might risk glossing over the concrete problems of struggling districts, but according
to Kim, the game demonstrates civic realities: "As players move the characters, they cannot consistently
'force' the outcomes as they would wish. In this way, there is a higher order of exposing the attempts
by organizations and advocates of making or fixing an ideal city."[11]

Still glitchy after three years of development, augmented reality (AR) smartphone technology
requires the viewer to be simultaneously on-the-spot and logged-on. Using GPS and visual recognition
to capture the user's surroundings on screen, AR adds supplemental images and data to visualize
site-specific, networked fantasies. On-line collective Manifest.AR, known for its guerrilla digital instal-
lation of open submission art at MoMA, recently intervened in Philadelphia's physical and temporal
space by contributing AR apps to "Distributed Collectives" (2011), independent curator Kelani
Nichole's exhibition at artist-led Little Berlin. Visitors to the gallery's grassy, vacant lot could capture
the green space via smartphone camera and watch as the above-ground elements of a virtual subway
station, *Metro-NeXt* (2011) were cut and pasted into the on-screen scene. This "wormhole" was an
invitation from Caroline Bernard, Lalie S. Pascual, and John Craig Freeman to link up with viewers in
other definite locations, as if in a multi-player video game. By shrinking the parameters of site-speci-
ficity to a personal, handheld scale, AR art constitutes an oddly private, illusory form of transforming
public space, while offering a somewhat detached social experience familiar to consumers of social
networking.[12]

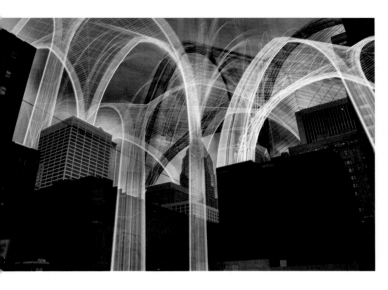

Rafael Lozano-Hemmer's *Open Air* (2012), another APA commission, worked on a larger scale with the interweave of physical and virtual experiences in everyday life. Collected and analyzed via a free app, GPS and spoken signals from participants' mobile devices choreographed a display of long-range, evolving searchlight patterns projected from 24 robotic bulbs in Philadelphia's central museum district, visible within a 10-mile radius. A city-scale equivalent to the popular iTunes Visualizer, or the standard graphic equalizer on any stereo, *Open Air*, with its use

Mariana Ibañez and Simon Kim, *Rittenhouse Square*, 2010. Climate-controlled glass canopy for Philadelphia's prized real estate. Left: before construction; right: after construction. From the *Philadephia Masque* computer game/model.

of voices and light as media fluctuating between materiality and immateriality, underscored the still equivocal status of our networked connections. Lozano-Hemmer's democratic ambition to promote "tolerance, participation, bottom-up control, and the sense of public agency" laudably echoes the ethos of the on-line commons, exemplified by Web sites like Wikipedia.[13] However, only smartphone owners (less than 50 percent of U.S. adults) could add their unique vocal imprint to the mix. In a city as economically polarized as Philadelphia, many were left to observe from the margins.

A common criticism of conventional site-specific practice is exactly this, that despite being out-doors—*in* public—it does not necessarily engage *the* public, or those constituents most in need, in helpful or lasting ways. Despite their flaws, whether on-line, on the street, within museums, or a mix of all three, the social-specific forms of public art produced by Philadelphia artists and curators strive to effect change and engender meaningful participation. The City of Philadelphia is lending assistance to their endeavors through its Office of Arts, Culture and the Creative Economy, which recently commissioned FutureFarmers' *Soil Kitchen* (2011), a multifaceted project promoting healthy soil, food saftey, community dialogue, and renewable energy—all based around a redefined local landmark.

Not all art must be measurably useful, but producers of intentionally public art in any form have responsibilities to their potential audiences. Temple Contemporary, a program connected to Tyler School of Art, demonstrates how art can stretch to meet the public where it is most needed. The space hosts events and displays that go in-depth into topics such as Philadelphia's failing school system, voting, and the politics of incarceration; it also provides services such as free bicycle overhauls and celebrates forms of creativity—candy making, graphic design, baking—that lie outside the fine art corral. Temple Contemporary director Robert Blackson outlines the reasoning behind his mission and the type of thinking that will propel the strongest forms of future public practice: "Much public art

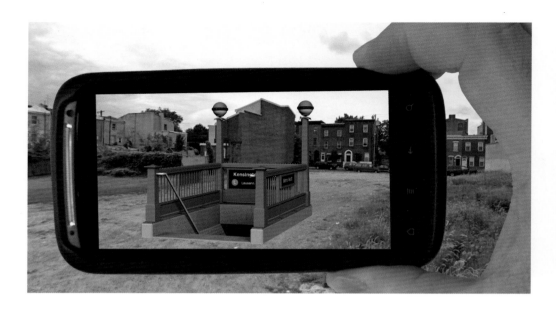

John Craig Freeman, Lalie S. Pascual, and Caroline Bernard, in association with Manifest.AR, *Metro-NeXt: Kensington Station*, 2011. Augmented reality technology, Kensington, PA.

discourse relies on architectural space to define what is and is not *public*. Such a polarity of inside/outside distracts from what are critical questions of creatively addressing urgent concerns of the public, in other words, re-imagining art's social function."[14]

Notes

[1] Jessica Pressler, "Philadelphia Story: The Next Borough," *New York Times*, 14 August, 2005. I would like to acknowledge Richard Torchia for generously sharing his time and extensive knowledge, as well as Penny Balkin Bach, Linda Yun, Anna Neighbor, James Johnson, Jay Hardman, and Anita Allyn.

[2] Penny Balkin Bach, *Public Art in Philadelphia* (Philadelphia: Temple University Press, 1992), p. 149.

[3] Richard Torchia, "Timeline & Index of Philadelphia-based Artist-Run Spaces," in *Vox Populi: We're Working On It* (Philadelphia: Vox Populi Gallery, 2010), pp. 98–100.

[4] Dan Murphy, interview with the author, 2012.

[5] See <http://megawordsmagazine.com/great-things-ahead>.

[6] Richard Torchia, exhibition text accompanying "Daylights: Camera Obscura Projections and Other Interventions."

[7] Jody Pinto, interview with the author, 2012.

[8] Martha McDonald, artist statement, 2006.

[9] Christopher P. McManus, interview with the author, 2012.

[10] Balkin Bach, op. cit.

[11] Simon Kim, interview with the author, 2012. See also <http://www.ikstudio.com/philadelphiamasque_images>.

[12] For a more detailed discussion, see Becky Huff Hunter, "Philadelphia: Distributed Collectives," *Art Papers*, November/December, 2011.

[13] See <http://associationforpublicart.org/open-air>.

[14] Robert Blackson, interview with the author, 2012.

The Light that Blinds: A Conversation with Rafael Lozano-Hemmer (2013)

by Sylvie Fortin

Rafael Lozano-Hemmer's work operates at the intersection of architecture and performance, recording the radical transformation of space and bodies under neo-liberalism. His site-sensitive and relation-ship-specific installations create ephemeral platforms for participation in variously public spaces, from museums to city squares and the sky, while exploring alternative uses of the technologies of control, including surveillance (remote viewing, biometrics, social networks), robotics, and telematics. Inspired by phantasmagoria, his public commissions create anti-monuments premised on negotiation: rehearsal spaces for subjectivity-constitution.

Lozano-Hemmer was the first artist to officially represent Mexico at the Venice Biennale (2007). His work has also been featured in many other biennials, including Havana, Istanbul, Liverpool, New Orleans, and Seoul. He has received two awards for Interactive Art from the British Academy of Film and Television Arts (BAFTA), a Golden Nica at the Prix Ars Electronica in Austria, and a Rockefeller Fellowship. His commissioned work has appeared around the world, from Mexico City, Philadelphia, and Vancouver to Rotterdam, Lyon, and Dublin.

Sylvie Fortin: *"Relational Architecture" is the concept under which you've been producing temporary, what I would call "transactional," works in public space since 1997. How do you understand public space?*
Rafael Lozano-Hemmer: I grew up studying people like Antonio Negri, who have advocated for a takeover of space in general, and of public space in particular. Though I'm not so engaged with his writings anymore, and not reading theory as much, I've always been inspired by the idea of taking and, more importantly, making space. Space cannot be taken for granted. The idea of public space that emerged after the French Revolution is in crisis. Cicero, Churchill, and many others have said that we make buildings and buildings make us. But in the globalized economy, buildings are no longer related to identity or to citizenship—they're the result of equations for the optimization of capital. For develop-ers, architects, and urban planners, building solutions are the same in Singapore, Montreal, or Miami—it's a matter of optimizing investment. The result is homogenization of space. The flipside of this approach is a necrophiliac, vampiric, and nostalgic desire for authenticity, history, and identity. To "sell themselves," cities often go for late-19th-century lampposts and cobblestones and GAP stores instead of doing something passionately eccentric that interrupts the homogeneity. From my per-spective, the artist needs to create interruptions—temporary platforms, as I call them.
SF: *The notion of platforms recalls the stage. You've discussed the importance of dance, theater, and puppetry in your work, and you define* Body Movies *(2001) as a kind of reverse-puppetry. Yet your work seems to open up a rehearsal space rather than produce a stage for performance. Does this make sense to you?*

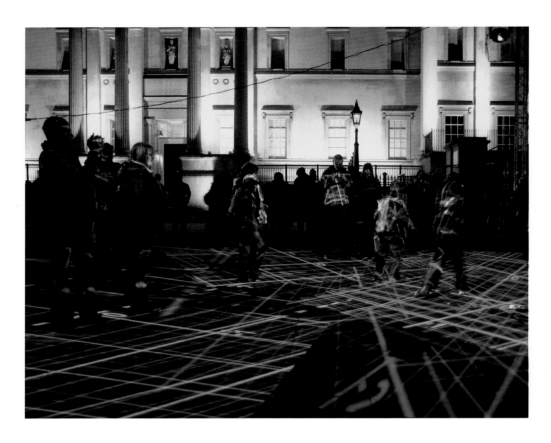

Under Scan, Relational Architecture 11, 2008. Robotic projectors, media servers, Pani 12kW projectors, scissor lifts, computerized surveillance system, and custom software, dimensions variable. View of work in Trafalgar Square, London.

RLH: I love that — "platform" gives too much emphasis to the actual stage, but "rehearsal" shifts the focus to the people and recasts the work more performatively. These interruptions, or rehearsal spaces, are community building. Some of the metrics at work in assessing the global city are quite problematic because they systematize all of the city's functions into very specific datascapes, mostly fed through surveillance. The democratic potential of public space is premised on heterogeneity. That prerequisite is disappearing — not only in traditional public space, but also in new public spaces such as the Internet. The public space of the electromagnetic spectrum is similarly besieged. For instance, if I want to distribute my content through the iTunes store, I need to have Apple's permission. Corporatization is at work not just in physical city spaces, but also in virtual, symbolic, and communicational spaces.

I'm not really a theorist of public space — I'm more interested in relationships. This word, "relationship," is very complicated. My first relational architecture texts and pieces came two years before Nicolas Bourriaud's texts. For me, the word comes from another lineage, including artists Lygia Clark and Hélio Oiticica and neurobiologists Maturana and Varela. It comes from the relational database platform, where things operate as a network of variables, not hierarchically. From the perspective of public art, I've been calling my work relationship-specific rather than site-specific.

My heroes of art in public space include Krzysztof Wodiczko, Jochen Gerz, Hans Haacke, and Rachel Whiteread. But I want to propose something different and not so site-specific. Working with a site, I am inspired by certain accidents, but I think of my work as something that can and should travel. This kind of nomadic life gives meaning to the larger experiment. My approach has always been experimental in that I never try to outline the final objective politically or socially—my works are not prescriptive. The kind of politics that I'm interested in is not the idea of a deconstruction of the power narratives of a space or some kind of moral visualization of the technologies at work, but a search for the micropolitics of relationships—of tiny relationships that happen when we share disparate realities. For example, when people stumble into one of my works, they are briefly surrounded by a certain artificiality. This breeds complicity—and that's the moment that I'm looking for.

SF: *You make three types of public work. One uses biometrics to interact at the level of the body. Another involves acts of self-representation. And the third is a kind of message in a bottle, a representation that's launched into the universe. All three combine acts of love with acts of violence. In* Pulse Park *(Madison Square Park, 2008), one of the biometric projects, the decision to step into the rehearsal space of self-representation means that you will kick someone out, symbolically kill them. How does this work model the kind of politics that we're talking about?*

RLH: For me, what's really important is interpenetration. In art, participation is an act of creation—what you give is what you get. To get anything out of this work, you need to give. Many times that symmetry hasn't worked, but it does in *Pulse Park* because it becomes a metaphor, like a memento mori. It is "romantic," insofar as it ignores the impossibility of capturing the ephemeral essence of who we are. It's passionately useless, it takes the pulse—a measurement used for control, classification,

Last Breath, 2012. Motor, bellows, Plexiglas, digital display, custom circuitry, Arduino processor, respiration tubing, and brown paper bags, apparatus: 60 x 27.5 x 23 cm, tube: up to 15 meters long.

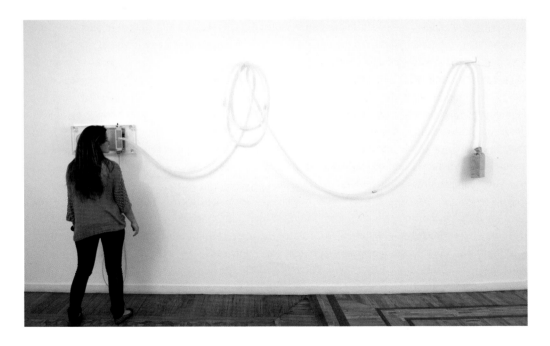

and health monitoring—and converts it into a matrix of light beams. Every time someone gets recorded, someone else is kicked out. You can say that the expelled person dies, or you can say that you liberate them.

(*Last Breath*, 2012), a project that I just did in Cuba, stores the breath of a person. Many Cubans are extremely superstitious, and the idea that someone's breath would keep circulating even after death was quite shocking. The moment when you unplug the work and let that breath go away is also a liberation. These two concepts—liberation and death—are intricately intertwined. In that sense, the work is suicidal rather than vampiric.

SF: *In* Pulse Park, Pulse Front *(Toronto, 2007), and* Articulated Intersect *(Montreal, 2011), the mechanisms and the event are co-present. The sculpture shares the space-time of the event. In* Pulse Park, *the killing or liberation is symbolic; in* Articulated Intersect, *playful sky drawing can turn into territorial conquest. When the search-*

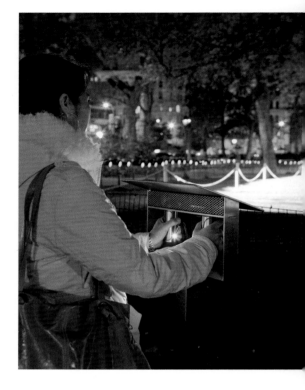

light that I manipulate crosses another one, the mechanism locks and the controller produces a physical feedback. Struggle resets the piece. Could you talk about the one-to-one relationship between the performer and the space in real-time? What is the role of feedback here?

RLH: Most of my pieces present displacements. Translations come into play between inputs and out-puts. In my earlier searchlight projects, the design was mostly done on an individual's computer—you sent it, and it was rendered up in the night sky. But I was criticized for creating an asymmetry of power—even though the project was interactive and the lights only moved if someone was partici-pating. It is true, however, that a power asymmetry was in play insofar as technologies that have a dark provenance in military applications were being used to create a spectacle. The power asymmetry lies in the relationship of one to many. In *Pulse Front* and *Articulated Intersect*, I'm trying to change that dynamic by physically manifesting your causality and its effect. I don't think that this resolves the problem, though. If remote participation leads to a power asymmetry, local participation leads to a Pavlovian response—which needs to be avoided.

In *Articulated Intersect*, there's still a translation—you're ultimately acting through an avatar—light—but that avatar happens to be co-present, sharing your space in the form of a large articulated lever with haptic feedback. In Montreal, *Articulated Intersect* was part of an art event, but my fantasy is to bring it to the U.S.-Mexico border. If you put three of those levers on the Mexican side and three on the American side, the locking of light beams gains in symbolic and political importance. My approach to light differs from that of Robert Irwin or James Turrell—whom I admire very much. This is not a spiritual light or the light of enlightenment. I'm interested in the violent light of interrogation, of police helicopter searchlights looking for Mexican migrants at the border. I'm interested in the

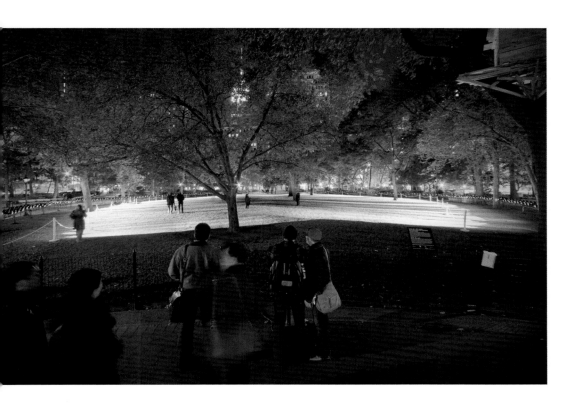

Pulse Park, Relational Architecture 14, 2008. Heart-rate sensor, computer, DMX controller, custom software, dimmer rack, 200 Source Four spotlights, and generator, lawn: 80 x 60 meters. 2 views of work in Madison Square Park, New York.

light that blinds you, the light of explosions, light made up of schizoid photons that are neither particle nor wave, or perhaps both.

SF: *Open Air (Philadelphia, 2012) uses geolocation for the first time. This light work goes one step further in addressing surveillance by staging our complicity: we've internalized surveillance to such an extent that we willingly volunteer our locations through social networks, from Foursquare to Facebook. Why did you decide to use geolocation in this particular way?*

RLH: Philadelphia has a very long tradition of democracy and free speech; its residents are proud of their history of resistance and abolition. Simultaneously, and despite much promise, the city faces enormous challenges—from poverty and gangs to racial segregation. I wanted to make a project that proudly upheld and visualized free speech, especially now when the media are concentrated into a very few hands. To highlight free speech is very simple, it's predictable, a platitude, even; but at the same time, it's really urgent because our channels for free expression are being eradicated.

Open Air questions two phenomena: first, reality TV and the desire to be in the limelight and, second, the idea of police tracking and location. When you send a message from your phone, *Open Air* records your voice and tracks your GPS. When your message appears, the lights are automatically oriented toward you. They find you on the parkway, for instance, and create a halo that follows you everywhere you go. On the one hand, it's seductive because it stages participation—you feel like you're in the limelight. On the other, it's Orwellian and predatory. When 240,000 watts of power are

directed at you, you begin to think about how to come to terms with this kind of *metric*. This word is important for me. We're being measured. Our challenge is to make that measurement visible.

SF: *The notion of rehearsal looks toward future relationships or performances, which is a nice way to think of the work's political dimension. In* Open Air, *when the searchlights turn on you, you suddenly realize that it involves more than you thought: you're also being tracked and surveilled. How can the work's modeling of political futures coexist with—or come about through—self-spectacle and surveillance-complicity?*

RLH: That's a fascinating question. It depends on the project, though I consistently take aim at a certain kind of idealism about entitlement. My objection lies in its uneven distribution: idealism is the privilege of people who are too entitled. Many other people are not entitled enough. For instance, *Voz Alta* (2008), a memorial commissioned for the 40th anniversary of the student massacre in Tlatelolco, is extremely specific about its interruption of a political process of dismissal or erasure, of an economic and historical reality, of a lack of media representation. How do we interrupt that situation? How do we create a platform for people to be entitled to their voice? In Mexico, this was very straightforward because everyone—from survivors to intellectuals, neighbors, and firefighters—needed this voice. In Philly, where the political process and the struggle for visibility and voice have unfolded differently, the project is abstracted. Here, you may find over-entitlement: people think it is their God-given right to say whatever they want. I don't feel comfortable with that. I don't think that this particular inoculated perversion of free speech—the reduction of freedom of expression to an empty entitlement and the redefinition of speech as meaningless blabber—is a universally important political message. Sometimes, like in Mexico, it's fundamental. If *Open Air* becomes a mere extension of reality TV— shout-outs and singing auditions—then I'm not doing it right. My project—my interest as a citizen— is to open up spaces for other voices to be heard. In Philly, every night, we have different things going on. We've worked really hard with different communities—seniors, Hispanics, women's empowerment advocates, cyclists, the homeless—to make sure that their voices are included. We understand that the platform itself is not going to solve the problem of disentitlement; to be successful, the project requires an intensive and sensitive outreach program.

SF: *It seems that in order to succeed politically, the platform has to mobilize conflict. Is there a danger that your work might, instead, become a therapeutic or cathartic space? How do you build antagonism into the interface?*

RLH: We go back to Brecht. He would say that you avoid hallucination or catharsis by making people aware of artificiality. This is one of the most important avenues for being self-critical, while simultaneously contributing to the dialogue. My work clearly relies on special effects, and so the simulation refuses a cathartic narrative. On one hand, the scale of my projects is often seductive, which makes them easy to compare to a Pink Floyd concert or a light-and-sound spectacle. At the same time, since I want people to engage the work with a certain intimacy, it fails to deliver on the promise of the fireworks display. That's why I keep referring to my work as a "fountain," as opposed to the proscenium, because the fountain does away with privileged viewpoint, linear narratives, and catharsis—it's simply constant transformation. The political expectations are very different, too, because the work neither asks a specific question nor seeks a given response. It does not stage a traditional adversarial conflict. Instead, it opens onto the work of agonism.

It's like Derrida said: deconstruction is the activity performed by texts that ultimately acknowledge their own partial complicity with what they denounce. If you are highlighting the predatory nature

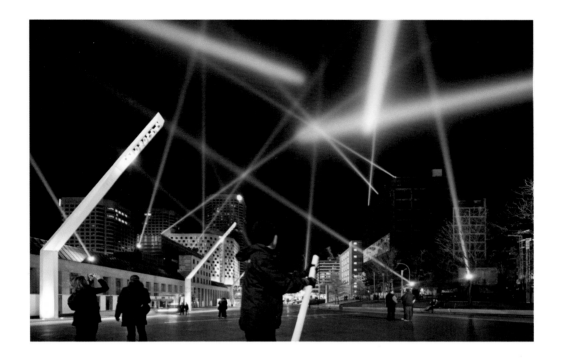

Articulated Intersect, Relational Architecture 19, 2011. Custom-built haptic levers, computers, searchlights, and DMX distribution, dimensions variable. View of work at the Triennale Québécoise, Musée d'art contemporain de Montréal.

of police control, *you* are police control. That doesn't mean you can't do it, it just means that you know that you're complicit. You know that developing tracking systems, which my studio does, feeds a vicious circle. The futility of what I do gives it the freedom to be transgressive.

SF: *Your work always concretely materializes a space while activating a number of less predictable, immaterial dimensions, including the history of the site, imported memories, and on-line presence. Does this evolving work trigger moments of awareness, when certain potentialities might open up? Can the simulation empower people to carry that experience with them into other parts of their lives?*

RLH: It depends on the project. In Mexico, when we did our first searchlight project, we made a Web page for each participant, with photos of their designs and personalized, uncensored comments. This was crucial, because the Mexican people had been voting against the PRI for 70 years without any result. In this context, the fact that your participation produced actual transformation was symbolically meaningful to people. In other places, there is a sense of over-representation. For example, new technologies are almost always under corporate control. When you turn the corporate monologue into something interactive, you activate space. The most important political thing that I can do is to make my projects out of control. In them, nobody tells you what to do or what not to do. There's *never* censorship. In making that a fundamental part of the project, I'm hoping that people will become more aware of the pervasiveness of censorship, that they come to expect citizens to take a stance on the policing of interactions they can have with each other or with public space. If there's any hope, it's in designing malleable, weak—which also means flexible—forms that can be taken over in unanticipated directions.

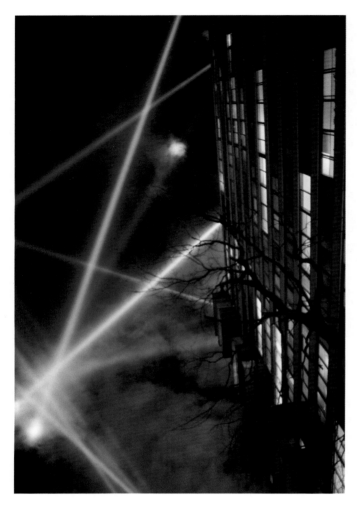

Open Air, 2012. Xenon 10kW robotic searchlights, Turbulent Heap content manager, webcams, Linux servers, GPS, Google Earth 3D DMX interface, iPhones, custom software, and cloud computing and storage, interactive area: 1 sq. mile, 10-mile visibility radius. View of work in Philadelphia.

SF: *What is the role of memory in your work?*

RLH: Memory is malleable, it's a projection; in any given space, it's different for each observer. When you observe a memory or you make a monument to it, you change it, privilege different aspects. Brecht said, "Great Rome was filled with arches of triumph…who built them? Over whom did the Caesars triumph?" Every one of those monuments was erected on the repression of other, different experiences and worldviews—histories that have been erased, marginalized, or not represented. This is crucial to understanding memory.

In my projects, memory is a place that can be visited. In *Voz Alta*, I wanted to make sure that those memories, which are recordings of survivors and witnesses to the massacre, were being played back, reactivated, reappropriated, mixed with the current situation in Mexico, which is still dire. I don't think about the preservation of memory, but about its perpetration. In Latin, "perpetration" means an act committed, and here it's a memory performed. It's a little bit criminal-sounding, but it also gives a sense of indeterminacy, of not knowing the outcome. "Preservation," on the other hand, is all about hindsight and the extension of objectivity. When I work with memory, I make sure that it is an active ingredient—one more reality (or bunch of realities) that needs to be co-present.

SF: *Public space and digital/social media space are absolutely entwined, but there has been a shift in their relationship. It seems that in order to effectively claim physical space, you have to first take over social media. How do you address this shift?*

RLH: The recent Mexican election was a very sad moment. We had a bit of democratic hope and now we're going straight back to the PRI. It happened, of course, through the normal manipulations pioneered by the PRI in everything from vote-buying to bullying, to making critics disappear and infiltrat-

ing opposing movements. Having said all that, something really hopeful and exciting did happen: social media were used to distribute information in an unprecedented way. We—all Mexicans who care, which is the majority—*occupied* YouTube, Facebook, and Twitter. Thousands of documents show how the PRI stole the presidency. What I like is the change from raising our fists to putting up our phones. I finally got to see this icon, which we'd seen in the Balkans and in the Arab Spring, at work in Mexico. I don't think the PRI will be able to pull this off again. The ability to distribute this kind of alternative take on current events is only now reaching a significant part of the population. Of course, there will be a new kind of cyber war to stop this kind of expression, as we've seen with Ai Weiwei. Still, there is room to be optimistic about how these technologies put a check on monolithic power.

And so, I'm making drones as part of my art practice. In the studio, we are thinking about how to integrate helicopters into a project because we believe that whenever a new technology, especially a military technology, enters the world stage, it is our challenge to create something poetic with it. We need to use that technology to produce something critical that advances aesthetics by engaging our political and technological reality, which are one and the same. It's no coincidence that the first flocking algorithms were made at the same time as the first successful simulations of humans and the first intelligent bombs—these things go hand in hand. Technology today is imbued with our prejudices. We need to make that evident and inflect it with different prejudices.

SF: *Simulation, shape-shifting, mistaken identities, and dissimulation in plain sight characterize the rehearsals that take place in your relationship-specific works. Could you explain why these ideas are so crucial?*

RLH: The simulation is the hoodie, giving a certain kind of anonymity. But it is also the make-believe that allows you to penetrate, like a Trojan horse, into our reality—to dissimulate, but with a healthy sense of disgust or distance, have a shower after, and live your life. Great artists have always had alter-egos and created masquerades, and dissimulation is the key element that will allow the Bakhtinian carnivalesque to create spaces for variation, for creativity, for expression, for experimentation. Dissimulation, this shared pretense, which connects us to others, is a great source for hope.

Acknowledgements

We would like to thank all of the writers and artists featured here for their contributions to *Artists Reclaim the Commons*. We also thank editorial assistants Amanda Hickok and Elena Goukassian, designer Eileen Schramm, Rachael Levay and the University of Washington Press, Johannah Hutchison (Executive Director of the International Sculpture Center) and the ISC Board of Trustees, and the National Endowment for the Arts for its generous support of this publication and the ISC.

All articles dated 2013 are published here for the first time. The following articles previously appeared in *Sculpture* magazine (in a different form):

Photo Credits